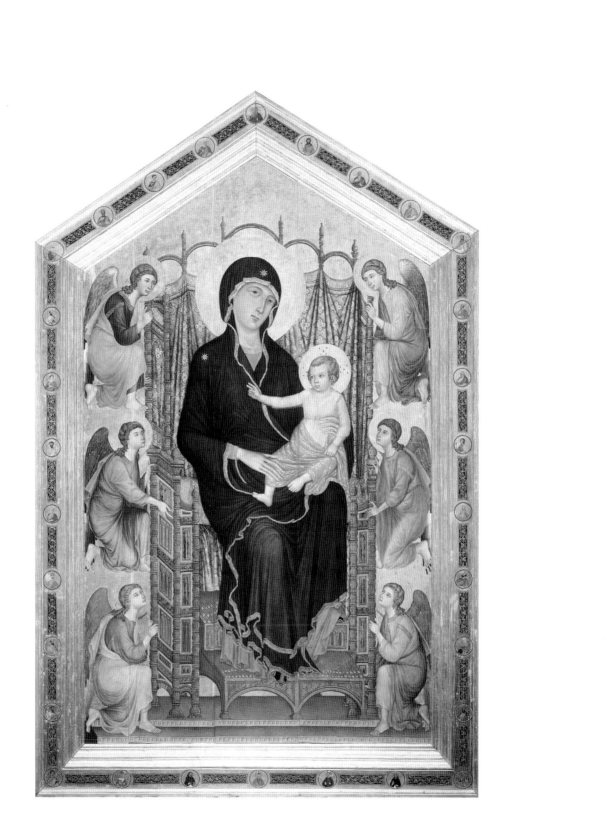

Jane Immler Satkowski

Duccio di Buoninsegna
The Documents and Early Sources

Edited and with an Introduction by
Hayden B.J. Maginnis

William U. Eiland, General Editor
Issues in the History of Art

Georgia Museum of Art, University of Georgia

Cover: Duccio di Buoninsegna
 Rucellai *Madonna*
 Galleria degli Uffizi, Florence
 (Photo: A. Quattrone)

Design: Kudzu Graphics

Department of Publications: Bonnie Ramsey and Jennifer Freeman

Editorial Interns: Hillary Brown, Camille Goswick

Printed in an edition of 1000 by Pacifica Communications

Printed in Korea

Generous funding for this publication was provided by the Samuel H. Kress Foundation and the W. Newton Morris Charitable Foundation. Partial support for the exhibitions and programs at the Georgia Museum of Art is provided by the Georgia Council for the Arts through appropriations of the the Georgia General Assembly and the National Endowment for the Arts. Individuals, foundations, and corporations provide additional support through their gifts to the University of Georgia Foundation.

Library of Congress Cataloging-in-Publication Data

Satkowski, Jane.

Duccio di Buoninsegna—the documents / Jane Satkowski ; edited by Hayden B. J. Maginnis.

 p. cm.

 Includes bibliographical references.

 ISBN 0-915977-38-9

 1.a Duccio di Buoninsegna, d. 1319—Criticism and interpretation—History. 2. Painting, Italian—Italy—Siena—Sources. I. Title: Documents. II. Maginnis, Hayden B.J. III. Georgia Museum of Art. IV. Title.

ND623.D8 S28 2000 99-056383
759.5—dc21 CIP

CONTENTS

FOREWORD

The Georgia Museum of Art is pleased to present this important volume in its series *Issues in the History of Art*. Certainly, the problem of Duccio di Buoninsegna has been and, in some senses, continues to be one of those issues. As this volume illustrates, much misinformation has been published about this great Sienese master, and even though scholars in the nineteenth and twentieth centuries have untangled the confusion between him and other artists, his life and career remain problematic. Thus, this volume is meant to serve both advanced scholars and beginning students as they continue to study and to attempt to unravel the mysteries surrounding Duccio. The layman, also, should he or she be undaunted by the documents herein, can read these essays for valuable lessons on method and historiography.

The editor and author join me and the staff of the Georgia Museum of Art in grateful acknowledgment of the generous assistance of the Samuel H. Kress Foundation in publishing this volume. We also thank the W. Newton Morris Charitable Foundation and its directors, Jack Sawyer, William Torres, and Edward S. Hallman, for the necessary additional support. Among the works in the collection of the museum are twelve Italian paintings that form the Samuel H. Kress Study Collection. These pictures have prompted intense interest in Italian and European art on the part of the staff of the museum and have led us to numerous exhibitions and publications in cooperation with our colleagues at the Lamar Dodd School of Art at the University of Georgia.

I am grateful to Bonnie Ramsey and Jennifer Freeman of our department of communications for their ready and able assistance. And it has been our pleasure to work with Jane Satkowski and Hayden B. J. Maginnis in the presentation of what we believe to be a major contribution to Duccio and Sienese studies.

WILLIAM U. EILAND

Director, Georgia Museum of Art, and General Editor

Editor's Acknowledgments

I should like to thank the Social Sciences and Humanities Research Council of Canada for support that facilitated my work on this project.

It is rare today to find a museum that publishes more than exhibition and collection catalogues, that sponsors works of a broader art historical scope. Although curators and art historians are both committed to illuminating works of art of the present and from the past, an artificial barrier often divides a scholarship that should be seamless. Thus, the Georgia Museum of Art is to be commended for its *Issues in the History of Art* series, for a unique program that makes available to an international audience material sometimes growing out of, or related to, exhibitions, and sometimes arising from lectures the museum has sponsored. I am therefore very grateful that the museum and its director, William U. Eiland, have deemed this volume worthy of a place in the series, and I here express my sincere thanks to Bonnie Ramsey, Jennifer Freeman, and other members of the museum's staff who have guided this work through publication.

I would also like to thank Robin Boyko and Edward Sernie who, on the Canadian front, were of great assistence in the preparation of the manuscript.

HAYDEN B. J. MAGINNIS

PREFATORY NOTES

DATING

Although the Treasury of Siena, the office of the Biccherna, kept records according to two semesters, January to June and July to December, the Sienese year began on March 25 rather than on January 1. Thus, documents dated between January 1 and March 24 often carry the date of the preceding year. For example, February 15, 1310, is, in modern reckoning, February 15, 1311. In the documentary citations, such instances are indicated by the following formulation: 15 February 1310/11.

MONEY

Sienese currency was organized in the fashion of English pounds, shillings, and pence. Twelve *denari* (pennies) equaled a *soldo* (a shilling), and twenty *soldi* equaled a *lira* (a pound). The lira, however, was not a coin, but a money of account. The relation between the Sienese lira and the gold florin of Florence changed significantly. In Siena, it was the Merchants' Guild, the Mercanzia, that set the daily exchange rate. The following abbreviations for currency are used in the main body of this volume:

f. or F. = florin, fiorino, fiorini

l. or £ = lira, lire

s. = soldo, soldi

d. = denaro, denari

MEASUREMENT

The Sienese *braccio*, the basic unit of measurement, was equal to 60.1 centimeters and was divided into 24 *oncie* of roughly 2.5 centimeters each.

TRANSCRIPTIONS

Every effort has been made to retain the original spellings of the documents.

TRANSLATIONS

English translations have been provided for all of the Duccio documents. In the Sources chapters, only material in Latin has been translated.

FREQUENTLY USED ABBREVIATIONS

AAS = Archivio Arcivescovile, Siena

AODS = Archivio dell'Opera del Duomo, Siena

ASF = Archivio di Stato, Florence

ASS = Archivio di Stato, Siena

BC = Biblioteca Comunale degli Intronati, Siena

BNF = Biblioteca Nazionale, Florence

Internal References

Internal cross-references found in the first four chapters of this book are signaled as I.1, I.2, etc., where the roman numeral signals the relevant chapter and the arabic numeral belongs to the entry within that chapter.

Citations

Given the numerous citations in this volume, we have abbreviated references to published works by using only the authors' surnames, dates of publication, and page numbers. Full information appears in the Bibliography.

Bibliography

The Bibliography is organized chronologically by when certain early works were written, rather than when they were first published. In the case of the Sienese chronicles, there remains considerable scholarly disagreement about the dates of the original texts. Such controversy is indicated by (?) after the date. We have, therefore, given the dates of the earliest surviving manuscripts.

PREFACE

The archival documents that specifically relate to Duccio di Buoninsegna have been gradually published in several venues over the last two centuries; we know from citations in manuscripts that, as early as the sixteenth century, many of these documents were known and had been consulted. Gaetano Milanesi, in 1854, and Alessandro Lisini, in 1898, each published comprehensive reviews of the documents available to them in the nineteenth century, in chronological order, that enable a logical reconstruction of Duccio's career and establish the parameters of his lifetime. Milanesi and Lisini set the precedents and the standards of accuracy that would be generally respected by later scholars. In 1979, James Stubblebine and John White published essentially the same collection of documents, albeit with variances in their transcriptions and translations. No important discoveries have been made since their monographs were published.

Why, then, produce yet another compendium of these well-published documents? The primary goal of this book is to provide a working manual for students of trecento painting, with newly verified transcriptions, precise translations, and an updated bibliography. The authors also hope that this aggregation of factual material will contribute in some measure to a growing and necessary trend in art history today: a return to fundamentals in an age in which often unstructured theories seem to dominate and proliferate.

This volume has still another purpose: to help us to get as close as possible to the artist and his works. Most of these documents deal with aspects of Duccio's personal and civic life. Who was Duccio, after all? Probably a man quite small in stature but physically strong, with skillful hands and a strong Tuscan accent, who unceremoniously walked the steep stone streets of Siena that we still walk today. Duccio was a brilliant nonconformist, a genius indispensable to the commune and church, but was unable to manage the generous recompenses he received for his masterpieces and left his family deeply in debt—not the sort of superstar public figure so admired in our own time. Why, then, should we try to make him topical, and why should we care how many fines he paid or identify the places in Siena where he lived? Because to understand the work of art, we must also try to understand the artist behind it and the circumstances that fostered this surge of genius. The further we go back in time, the more we must rely on incontrovertible evidence.

This project began more than twenty years ago as my thesis for completion of the laurea at the University of Siena. My research in those years was partially funded by the Centro Nazionale della Ricerca. The thesis combined two topics

then very much in vogue: archival documents and *fortuna critica*. Aspects of both approaches survive in this volume. Although my advisor, Professor Fabio Bisogni, intended from the first that this thesis be published, it was delayed by my return to the United States and eventual entrance into museum work. Now, many years later, I owe the resuscitation of this project to the determination of Fabio Bisogni and Hayden B. J. Maginnis; to them both I owe the greatest debt of heartfelt thanks.

Many friends and colleagues in both Italy and the United States have provided assistance in many forms, and I wish to extend deep gratitude to each. The original co-readers of my thesis, Luciano Bellosi and Laura Corti, offered much valuable criticism and advice. From the earliest days of my research efforts, the superb staff of Villa I Tatti gave me constant encouragement and the benefit of their expertise, especially Susan Arcamone, Kathryn Bosi, Nelda Ferace, Heidi Flores, Amanda George, Craig Hugh Smyth, and Anna Terni. Fiorella Superbi Gioffredi typed the original manuscript in those arduous pre-computer days. Every transcription has been supervised at different times by Gino Corti and Paolo Brogini.

I am indebted to many more friends in Florence for hospitality and unflagging moral support: Enrica and Giuseppe Forti, Mary Ann and Amadeo Pinto, and Maurizia, Norman, and Sergio Pizzi. The companions of my laurea days, Caterina Chiarelli, Helga Meighorner, and Anna Valeri, are still esteemed comrades-at-arms. Patrizia Muzzi occupies a special category of steadfast friendship.

My colleagues at The Minneapolis Institute of Arts have provided another bulwark of help and support. Evan M. Maurer, director, and Richard Campbell, curatorial chair, have always encouraged and greatly facilitated my research and my completion of the manuscript. Again, I had a patient and accurate angel to help with the typing, in the person of Caroline Wanstall. Nanette Scott Goldman, Emily Rush, and Morgan Stuart furnished and verified the translations of the Latin texts. Treden Wagoner and Ted Thorson have repeatedly cajoled and disciplined my computer. Of course, no work of this kind is possible without the help of a great librarian, in my case, Harold Peterson.

I am grateful to Dr. William U. Eiland and the Georgia Museum of Art for sponsoring this publication, thereby making the following an accessible tool for further scholarship on early Italian painting.

It must often happen that the unsung heroes of any scholarly effort are the members of the author's family. My heroes are my husband, Leon, and my daughter, Christina.

JANE IMMLER SATKOWSKI
The Minneapolis Institute of Arts
November 1999

For Eugene B. Cantelupe.

INTRODUCTION

History is kinder to some artists than to others; each painter's place in that collective memory we call the past depends on the authority of those who have proclaimed a reputation and often on the number, frequency, and volubility of such declarations. So it is that a reader knowing something of the fourteenth-century origins of the Renaissance will know of Giotto. Far fewer will know of Duccio di Buoninsegna. Many will assert that Florence alone gave birth to the Renaissance; only a few will have more than the dimmest apprehensions concerning the role of Siena, Duccio's city, in that history. For in spite of the voices of Sienese writers raised through four centuries (many of them heard again in these pages), the achievements of neither city nor painter were much heralded abroad, and their advocates were barely heard amid the clamor of Giorgio Vasari and his many followers, all bent on making the history of the Renaissance a Florentine tale. There is, most assuredly, an injustice in that still-prevailing view. Siena and its early trecento painters count for more than that historical construction would allow. Duccio stands at the head of the Sienese achievement.

From Duccio's shop and circle came forth painters—so Sigismondo Tizio said in the early sixteenth century—as numerous as the men who once issued from the Trojan horse. Nearly all of Duccio's pictures were of high invention, and his works, particularly his *Maestà*, completed in 1311, for the high altar of Siena cathedral, proved not merely sourcebooks for painters of a younger generation, but also provoked a series of reactions and responses that shaped the great Sienese masters to follow: Simone Martini and the Lorenzetti brothers. All three of these younger artists traveled widely and created pictures for many places in central Italy; all three modified their style as a result of experiences "abroad." But their artistic vision remained, sometimes more, sometimes less, focused on Duccio's accomplishments; their contributions to the course of early Italian painting were frequently structured by the ambitions of the older master.

Duccio was, however, much more than the founder of a regional tradition. In a single early work, he abruptly and dramatically altered both the underlying conception of the thirteenth-century image and the descriptive means of figural articulation. I speak, of course, of the Rucellai *Madonna*, commissioned in 1285. In that enormous panel painting, created for the confraternity of the Laudesi of Florence's Santa Maria Novella, Duccio re-envisioned the painted image as a depiction of a space moving back from the picture plane: the radical first step that would lead to the Renaissance equation of picture and window. As his depicted space was made subject to the laws and logic of the space we inhabit, he created a continuum that

binds our world to that of the image. With all this, he also produced what is unde-niably the most beautiful panel picture of the thirteenth century.

These achievements were not lost on his Florentine contemporaries. Cimabue and his shop quickly responded to the challenge of Duccio's picture and, roughly a quarter-century later, Giotto di Bondone's Ognissanti *Madonna* was created as com-mentary on Duccio's panel. Still later, Vasari recognized the incomparable genius of the work when he made it the cornerstone of Renaissance painting, but, by then, fate had stolen the picture from Duccio. By the early sixteenth century, Florentine writ-ers had appropriated the panel for the Florentine Cimabue, and it was with that attri-bution that it appeared in Vasari's *Lives of the Most Eminent Painters, Sculptors and Architects*.

Needless to say, the Florentine appropriation of the Rucellai *Madonna* had enor-mous consequences for later scholarship. So, too, did Vasari's very brief discussion of Duccio in his *Lives*. In truth, Vasari knew almost nothing of the painter. He placed the artist's career ca. 1350 (roughly thirty-two years after Duccio's death); he had heard of Duccio's *Maestà* for Siena cathedral, but claimed that, in spite of a diligent search, he could not find the work (it was still in Siena cathedral); and he expressed his unfounded, and quite erroneous, belief that Duccio had originated the technique for the inlaid marble floors in the Sienese duomo. For Vasari, Duccio was an isolated figure, without master or followers; he stood, as it were, on the margins of art's progress. Moreover, Vasari had no concept of a Sienese school of painting. Ambrogio Lorenzetti appears in his pages as another solitary figure. Pietro Lorenzetti, whom Vasari styled "Pietro Laurati," and Simone Martini, whom he called "Simone Memmi," are described as followers of Giotto. These views were to prove a very significant impediment to discovering the actual Duccio and defin-ing his contribution to the Sienese school. Still other factors complicated that task: the very materials of this book. Before I turn to those larger matters, I must first say something regarding the genesis of this volume.

In 1979, two monographs on Duccio di Buoninsegna appeared, one by James Stubblebine, and the other by John White. At that time, it had been over a quar-ter-century since Cesare Brandi's volume on Duccio, the last major monograph on the artist, had appeared in 1951, and sixty-eight years since Curt Weigelt's con-sideration (1911) of the painter. Brandi published a digest of documents relating to Duccio, but without transcriptions; while he identified his sources in a general way, he did not include full archival citations. Similarly, Weigelt included sum-maries without precise citations. Thus, scholars were grateful that both White and Stubblebine devoted sections of their works to remedying the problem. Moreover, they both included English translations of documents, thereby making the material available to English-speaking students. In 1984, Florenz Deuchler published another

monograph on Duccio, but did not include transcriptions of the documents.

Anyone who has studied the Duccio monographs in hopes that the combination might clarify the documentary situation knows the extraordinary confusion that those works produce. Even in the case of the 1979 monographs, there are problems. White and Stubblebine each had documents that the other had not seen. In some instances, the archival citations varied. I noted that a relevant document (I.45) published by Bacci in 1944 appeared in neither. In 1970, William Bowsky had published two documentary notices (I.49-50) concerning Duccio and land rented from the commune of Siena. They are summarized in White's volume, but are absent from Stubblebine's. Both writers described one document (I.41) relating to the *Maestà* as lost and/or untraced; in fact, it survives in the archives of the Sienese Opera del Duomo. On top of all this, there are problems concerning folio numbers.

From the Treasury of the Sienese Commune, the office of the Biccherna, many account books survive in the *Entrata e Uscita* (credit and debit) series. Nearly all of them have more than one set of numbers for the folios: original numbering, usually in ink, and modern numbering, in pencil. Since many folios have been lost over the centuries, the numbers in each set can vary significantly. Scholars have often cited only one folio number, however, without indicating to which set it belongs. In addition, the same payments by the commune to a painter sometimes appear in more than one volume of the Biccherna's accounts. In a few instances, scholars have found one but not the other of these double entries, and thus their citations are incomplete. To this point, the problems and discrepancies could be resolved only by working in Siena's Archivio di Stato and the Archivio dell'Opera del Duomo.

In her *tesi di laurea* (1982) for the University of Siena, Jane Satkowski took on the complex task of reviewing the archival materials, making new transcriptions, and assembling a complete corpus of the archival evidence. That work constitutes the core of this volume. Siena alone, of all the major cities of central Italy during this period, preserves documentation rich enough to allow us a glimpse of a painter's life, and the documents give us access to, and an understanding of, circumstances impossible to map elsewhere. In at least some measure, they constitute a case-study for a painter of the period. Satkowski did still more: she compiled a history of the *fortuna critica* of Duccio and his works to the mid-nineteenth century, and that material forms the second part of this study, Chapters Two through Four. Because Siena developed a long tradition of local historians and antiquarians, one can trace the preservation of Duccio's fame across the centuries. In many ways, the historiography of Duccio is also representative of local scholarship in cities throughout Italy, and it has, most decidedly, lessons to teach us that apply elsewhere.

For this publication, Satkowski again reviewed the material quoted in Chapters Two through Four, and reviewed again all the transcriptions of the documents that are currently available. Unfortunately, structural restorations in the Archivio di Stato di Siena make a few documents presently inaccessible, and at least one important document disappeared during the last two years. Being aware, for several years, of Satkowski's important but unpublished work, I happily agreed to act as editor for this volume. I hope that my notes, this essay, and an editor's vigilant eye have contributed something to this worthy project.

Should the reader suspect that a volume of documents and sources makes dry matter, let me hasten to say that is not so. Readers with an eye for both detail and the larger view will find the particulars in what follows revealing and suggestive. They afford us glimpses of a major painter's life and of the values of his society. I shall not try to present an exhaustive survey of those facts and issues, but I do want to comment on aspects, first of the documents, and then of the secondary sources.

———

The contract for the Rucellai *Madonna* (I.7) is the earliest surviving document of its type from central Italy, and one of the very few complete contracts that we have from the late thirteenth and early fourteenth centuries. It tells us that the Confraternità delle Laude, resident in Florence's Santa Maria Novella, commissioned the work from Duccio on 15 April 1285. The confraternity supplied the painter with a panel already made "for the painting of a most beautiful picture to the honor of the blessed and glorious Virgin Mary." Slightly later in the document, we learn that the image is to be of the Virgin "and her omnipotent Son and other figures, according to the wishes and pleasure of the lessors." In other words, the content of the picture is not completely spelled out. It probably depended on verbal instructions after the contract was signed, an arrangement that surely caused a tussle between painter and patron, one wishing to produce the fewest figures for the agreed price, the other wanting to maximize the figures and decorative elements. Duccio was to be paid 150 lire in small florins (about 91 florins). The sum was not large, and Duccio's real income was even less, for he was to paint the panel, gild it, and "do everything that will enhance the beauty of the panel, with all the expenses and costs being his own." In sum, the painter had to provide pigments and gold leaf as well as pay any assistant he engaged. The agreement was still harder on the artist: ". . . if the said panel is not beautifully painted and if it is not embellished according to the wishes and desire of the same lessors, then they are in no way bound to pay him the price or any part of it, or to reimburse any of

the expenses that may have been incurred by him in working on the panel. [In this case], the panel remains in the possession of Duccio."

The arrangements here are similar to those in the contract of 1320 for Pietro Lorenzetti's high altarpiece for the Pieve of Arezzo. Pietro, too, had to provide the materials as well as his labor. As the Laudesi of Santa Maria Novella supplied Duccio with the panel itself, so Guido Tarlati, bishop of Arezzo, provided the wooden support for Pietro's altarpiece. Where Duccio had received 150 lire in small florins for the *Madonna*, Pietro's polyptych brought him 160 Pisan lire (roughly 54.2 florins). Both artists committed themselves to work on no other commission until they had finished the work at hand, although that promise may have reflected only a pious hope on the patrons' part; both painters executed more than one work within the same period. The similarities between the two contracts suggest that they reflect widespread practice. We know, however, that other arrangements were possible. In 1302, Duccio was paid for "a panel or, indeed, a Maestà that he made, and for a predella, which are located on the altar of the palace of the Nove" (I.36). The notice of the 48-lire payment itself specifies that the amount is for salary and suggests that the commune had supplied the materials to the painter.

Documentation for Duccio's *Maestà* for Siena cathedral offers several insights. The earliest document (I.39), dated 9 October 1308, states that ". . . Duccio shall be bound to put nothing into it except his person and his work," while the Opera del Duomo agreed to supply the necessary materials. Nominally, Duccio was to receive 16 soldi a day "except that if he should lose any part of the day there should be a deduction from the said salary, established in proportion to the part, or of the time, lost." In fact, and as the notice says, the painter was to receive only 10 lire a month because there were regular deductions of money owed to the Opera del Duomo. Had the painter been free of that obligation, and had he worked approximately 250 days a year, his annual salary would have been roughly 200 lire (approximately 74.7 florins); as it was, he actually received 120 lire. The gap between Duccio's likely income from the Rucellai *Madonna* (the largest panel painting of the duecento) and his remuneration documented here is large. Obviously, the Sienese of 1308 were willing to pay much more than the Florentines in 1285. It is also possible, however, that the 1308 rate was novel in Siena. At 1308 rates, Duccio's 1302 *Maestà* would have represented only sixty days' work, a period that seems too short for an altarpiece.

A second document (I.41), of uncertain date, for the duomo high altarpiece seems to reflect a different arrangement. The document is an estimate (?) by "Buonaventura Bartalomei and Parigiotto," who declare that, for the back of the *Maestà*, Duccio should receive 2.5 gold florins for each of the thirty-four "storie"

and a further 10 florins for "the little angels on top," amounting to 256 lire, but this did not include payment for the predella. If the nine panels of the predella were evaluated at the same rate, the total payment for the back would have been 117.5 florins, or roughly 317 lire. The Opera del Duomo is obliged to supply the painter with colors and "all else that might be necessary." If, as seems likely, this estimate reflects a change in payment arrangements, it would have had significant consequences. While paid by the day, Duccio had a vested interest in prolonging the project; paid by the scene, he had every reason to see it finished quickly. It seems likely that the latter was the intent of the change, for another document (I.44), of 28 November 1310, indicates the Nove's great desire to see the commission finished.

We should always remain mindful that the accidents of history have surely deprived us of original documentation, but neither documents nor early sources record a major Sienese commission given to Duccio between the Rucellai *Madonna* and the beginning of the fourteenth century, unless it was for the stained-glass oculus of Siena cathedral (I.60-63). The other thirteenth-century documents relate exclusively to small projects: the decoration of coffers for civic documents or the painting of wooden panels for the state treasury, the Biccherna, commissioned every six months as book covers for the official account volumes of revenues and expenditures. By contrast, after 1300, Duccio emerges clearly as Siena's dominant painter. His *Maestà* of 1302 was followed by the commission for the cathedral *Maestà*, which was followed by the creation of a polyptych (now, Siena Pinacoteca no. 47) for the high altar of the chapel attached to the Ospedale di Santa Maria della Scala, Siena's most prestigious charitable foundation. While working on the cathedral *Maestà*, he apparently finished and signed a polyptych of 1310 that was once in Siena's church of San Donato (IV.12). Since various frescoes in San Francesco, Assisi, have been attributed (erroneously, in my view) to Duccio, I would note that nowhere in the sources do we find record of his having executed frescoes. During the late duecento, the ruling regime in Siena, the Noveschi, twice commissioned what seem to have been frescoes, the subject matter being a *Maestà*, but neither commission went to Duccio. Much later, in 1315, when the Nove wanted another *Maestà* painted in their new permanent seat of government, the Palazzo Pubblico, they turned to Simone Martini. It is also telling, I believe, that no major fresco has been attributed to those of Duccio's followers whose style and production remained thoroughly informed by his vision.

The documents tell us a fair amount about Duccio as a person. It would seem that he was less than an ideal citizen. In 1285, he may have been fined 20 soldi (1 lira) for breaking the civic curfew (I.6). In 1289 (I.12), he was penalized for not attending the Council of the People, of which he was a member, and for failing to

swear an oath of fealty to the Captain of the People (I.13). Apparently, he was in no hurry to pay his fines. In 1294 (I.21), one of these fines was increased to 6 soldi and 8 denari for non-payment of the original penalty, while the other was also increased for non-payment (I.24). In the next year, he paid another fine of 10 soldi (I.29). In 1302, he was fined 5 lire (I.34) for obstructing a city street and 18 lire and 10 soldi (I.35) for not being present at the mustering of communal forces at Monteano, by Collecchio, and at Roccastrada; he also paid a total of 15 soldi as a penalty on three unpaid debts (I.30-31, I.33) and 5 soldi more for a condemnation (I.37). Duccio's fines were not necessarily small. In 1281 (I.5), in connection with an unspecified offense, he was fined 100 lire, likely more than his actual income from the Rucellai *Madonna*; in 1309, he again incurred a 100-lire penalty (I.42), more than a half-year's payment for the *Maestà*. Another offense in 1310 brought a penalty of 24 lire (I.43).

One has the impression that, after 1300, during the period of Duccio's greatest success, his financial affairs were their most chaotic. Indeed, the century begins with a cluster of notices from 1302 that speaks to Duccio's financial circumstances. One of the 1302 documents concerning unpaid debts (I.31) specifies the amount that Duccio had borrowed: 42 lire. If, as would appear from the various fines at that moment (I.30, I.33), Duccio had turned to other lenders for similar amounts, his debts may have reached over 100 lire. Three other transactions, all on 4 December 1302, reveal more. On that day, the painter received 48 lire from the commune for a panel, "or, indeed, a Maestà" (I.36). But communal officials seem to have seized the opportunity to satisfy themselves over two of Duccio's out-standing debts (I.34-35); on that day, the Biccherna records payment of two fines, one for 5 lire, the other for 18 lire and 10 soldi. The bookkeeping, therefore, indicates that Duccio received only 24 lire and 10 soldi, roughly half of what he otherwise would have earned.

The document of 9 October 1308 (I.39), concerning the *Maestà*, suggests that Duccio had a debt to the Opera del Duomo, as his ostensible 16 soldi a day were reduced to 10 and the difference returned to the Opera. Then, in December 1308 (I.40), Duccio acknowledged a debt to the clerk of works of the Opera del Duomo in the significant amount of 50 florins (approximately 134 lire); this seems to be in addition to the debt recorded in October. In June 1313, just two years after he completed the *Maestà*, he borrowed 40 lire for a six-month period from a Ser Tomuccio Dini (I.47). We know the consequences of this financial history. When Duccio died, in 1318, the only immovable property he left his widow was half a house valued at a mere 110 lire (I.52). On 16 October 1319, his seven children renounced their inheritance, presumably so that what little there was could go to their mother (I.54).

Perhaps I can best clarify the meaning of the sums above by comparing Duccio's situation with that of Simone Martini, who, following Duccio, became the unofficial painter to the commune. In 1324, just six years after Duccio's death, Simone made arrangements for his intended marriage to Giovanna Memmi, daughter of Memmo di Filippuccio and sister to Lippo and Federigo Memmi. Simone provided a dowry of 220 florins and bought a house from his future father-in-law for another 120 florins. His total documented outlay came to approximately 1,133 lire. After his death in distant Avignon, in 1344, a summary of his property and bequests in Siena indicate that the value of his Sienese holdings came to roughly 934 lire. But Simone must also have had property in Avignon, where he resided for the last eight years of his life, for in 1347/48, Lippo Memmi bought a house and lands on behalf of his sister Giovanna for 750 lire. Thus, we know that Simone's wealth came to at least 1,684 lire. It seems likely, however, that this sum is low, as it does not include movable property or funds available for daily living expenses, and there is nothing to indicate that the 750 lire paid for property in 1347/48 exhausted Simone's wealth.

The documents map another aspect of Duccio's life that may reflect the state of his finances or, less likely, a restless spirit: I refer to the somewhat erratic pattern of the location of his residences. The earliest relevant documents date to 1286 and indicate he paid 7 lire in taxes in the parish of Sant'Egidio, in the Terzo di Camollia, although the first item suggests that he was residing in the Terzo di Città (I.9-10). By 1289, Duccio was living in the parish of San Donato (I.12-13), immediately adjacent to Sant'Egidio. In 1292, he was resident in the Terzo di Camollia (I.17-18); in 1293 and 1302, he is again documented in San Donato (I.19, I.30, I.33, I.35). A notice of 1304 (I.38) indicates that he had property just outside the city walls on the south at Castagneto on the Tressa river. He is recorded in San Donato in 1309 (I.42); in 1310, he moved to the parish of San Quirico in Castelvecchio and the tax district of Stalloreggi di dentro (I.43). Documents of 1311 and 1313 place him in the same parish, while ca. 1311 he had a workshop just outside the city gate in San Quirico, in an area known as the Laterino or Stalloreggi di fuore (I.45). In 1315, he was repaid a forced loan to the commune, recorded in a volume dealing with the Terzo di Camollia (I.48), although he no longer lived there. On 15 October 1315, and in January through March 1317, Duccio rented rural land at Pian del Lago from the commune (I.49-50).

This pattern is unusual for the period. Documents for other Sienese painters of the time suggest that they settled in one area of the city and remained there. The most successful painters also seem to have followed a practice common among their social betters by acquiring rural lands as an investment against the future, particularly old age, but where they bought land outright, Duccio rented. Was our

protagonist a spendthrift? Or did he, his wife, and their seven children eat and drink their way through a handsome income and then some? (The cost of living in late thirteenth- and early fourteenth-century Siena was high.) Were painters of Duccio's generation paid less than Simone and his contemporaries? Were the size and number of fines the artist paid financially crippling, so that his finances never rested on a firm foundation? Duccio's situation probably resulted from a combination of all these elements.

Before leaving financial matters, we must return briefly to the documentation surrounding the cathedral *Maestà* and specifically to documents I.40 and I.41. As noted above, the first involves 50 florins Duccio borrowed from the *operaio* of the cathedral, apparently for only twelve days. The document is dated 20 December 1308; the sum was to be repaid on 1 January 1309. Given the existence of the undated notice (I.41) concerning an estimate for the back of the *Maestà*, it is tempting to think that the loan of December 20 was an advance on money owed the painter, but not yet calculated. That undated document specifically states that Duccio should be paid 50 florins immediately and the remainder as each scene was completed.

The rediscovered document (I.41) is puzzling in various ways. First, it is not a contract, for it lacks legal form, notice of witnesses, and a notary's name. White styles it an "estimate" for work on the back of the altarpiece. If that were the case, it is odd that no painter was involved. At this period, one would expect to find a fellow artist on such a commission. Moreover, the document suggests that the back of the *Maestà* was in an advanced state of execution, although still incomplete. If this document is related to that of 20 December 1308, and thus to be placed sometime around January 1309, it would dramatically alter our conception of the period the *Maestà* was in production. John Pope-Hennessy suggested, some years ago, that the period between October 1308 and June 1311 was far too short for the execution of an altarpiece of the *Maestà's* size: an acute observation. It seems possible that the document of October 1308 only clarifies or modifies earlier arrangements.

There is a further issue connected with the documents that deserves attention. Between the mid-nineteenth and mid-twentieth centuries, there was a scholarly tendency to assume that every reference to a "Pietro" was a reference to Pietro Lorenzetti, every "Simone" a reference to Simone Martini, and so forth. There was also an unstated assumption that there was only one "Pietro Lorenzetti" or "Simone Martini" in Siena during the early trecento, and thus that any documentary evidence in which such names were involved related to the same person. But we now know, for example, that in addition to Simone Martini the painter, Siena was also home to Simone Martini the carpenter. Likewise, it seems possible that Siena was home to two individuals named Segna di Bonaventura. We know of a

Mino di Buonaventura, who was the *scrittore* for the Opera del Duomo in Siena in 1324, 1335, and 1339/40, but there is nothing to indicate that he was related to Segna. Similarly, one of the *operaii* of the cathedral during the first half of the trecento was a Segna (i.e., Buoninsegna) di Lino. There is nothing connecting him with the painter. Just a year before Andrea Vanni and Bartolo di Fredi jointly rented a workshop to pursue their trade (1353), the civic account books contain record of another Andrea Vanni, a goldsmith.

Those observations take us to what was another fashion among earlier scholars: the creation of genealogies. In Duccio's case, it was Pèleo Bacci who, in 1932, sought to create a family tree. As White has pointed out, however, the Duccio genealogy that Bacci assembled is, in many ways, suspect. In a document (I.1) of 31 January 1229, that refers to a "Boninsegna quondam Boninsegne Lucensis," Bacci claimed to have found Duccio's father living in Camporegio, in the Terzo di Camollia. White notes, however, that Buoninsegna was not an uncommon name and points to a notary and an ambassador of the name. During Duccio's lifetime, there is reference to a Malfarsetto Buoninsegna, who was, in fact, one of the musicians paid to accompany the *Maestà* from Duccio's shop to the cathedral on 9 June 1311 (I.46). Thus, a reference to Buoninsegna is not necessarily a reference to a relation of the painter. Similar problems attend references to "Duccio" or to various individuals styled "di Duccio," as there are references to other individuals of that Christian name and various notices of figures such as a Duccio Sacchetti, a Vanuccio Duccii, a Niccholaio Duccii, Duccio di Donato, a very successful goldsmith, and a Giovanni di Duccio, a marble worker at the cathedral in 1337 and 1340.

Because a tax assessment of ca. 1318 (I.53) in the parish of Sant'Antonio refers to a Domina Becta Bonisegne, and because the document concerning Boninsenga quondam Boninsegne places him in Camporegio (I.1), Bacci assumed Domina Becta was Duccio's sister, living in a family dwelling. But while the 1318 notice places the "populo et contrata de Camporegio" in the tax district of Sant'Antonio, I.42 seems to place the "contrata de Ca[m]poregio" in the parish of San Donato. Thus, there can be no precise identification of the whereabouts of the "Campo reggi" as in I.1. (See the notes to I.53.)

Because a notice of May 1326 listing those who were subordinate to the Merchants' Guild includes a "Segna di Tura Buoninsegna dipegnitore," Bacci assumed Duccio was Segna di Bonaventura's uncle. This is the only place in which Segna's name is so formulated, however, and may well be a confusion or a scribal error; we simply do not know. Although when Duccio's children refused their inheritance, only seven were named. Bacci added a possible eighth by referring to a picture once in Carpentras, near Avignon, signed "IOHES DUCCII DE SENIS ME PINXIT." On the other hand, he was likely correct in identifying "Ambrogio di

maestro Duccio," "Galganus filius quondam Duccii, pictor," and "Giorgio di Duccio, dipentore" as the painter's sons, since there are three children of those names mentioned in the 1319 renunciation of inheritance. In general, however, one should approach such genealogies with extreme caution.

Is it possible that Siena was home to two individuals named Duccio di Buoninsegna? I cannot answer that question with certainty. While Duccio's pattern of changing residences makes it difficult to tell where he might be found at any one moment, the 1279 document (I.4) that places a "Duccius Boninsengnie" in "Sanctam Mariam ad Sestam" does not specify that individual's trade or profession and appears to place him outside the city itself. We should also note that the document of 1285, concerning the breaking of curfew (I.6), actually refers to "Guccio Boninsegne" and does not state that individual's trade or place of residence. For the moment, there is no definitive answer to our question, but we should remain aware of the possibility that they refer to other individuals.

The documents tell us a great deal, in fact quite a remarkable amount about a painter who lived seven centuries ago. When it comes to the matter of surviving works of art, though, the documents relate to only two commissions: the Rucellai *Madonna* and the *Maestà*. The contract for the former, although first published in 1790, was regarded for a century thereafter as documentation of a lost picture. The reader needs to keep these circumstances clearly in mind when turning to the secondary sources.

The attentive reader will note the absence of two documents, originally published by K. Michaelsson and included by Stubblebine in his collection of documents. One notice places a "Duch de Siene" in Paris in 1296; the other refers to a "Duch le lombat" in Paris in 1297. While Stubblebine regarded these as notices concerning Duccio di Buoninsegna, neither the author nor editor of this volume believes that to be the case.

I would here make note of two special documents that are included in the chapter on unpublished sources: inventories of Siena cathedral compiled in 1420 and 1423 (III.1, 2). These are the earliest inventories extensive enough to allow us a glimpse of Duccio's altarpiece in its surroundings. The adornment of the space was rich and varied and quite unlike our often "purified" visions of the past. The altarpiece stood below a canopy of three compartments, each containing an angel that descended to the altar, to "assist" in the mass. There were also candle-bearing angels, two before and two behind the *Maestà*, on the altar table. Four more angels, again two behind and two before the altarpiece, were suspended from the vaults and also carried candles. Further illumination was provided by three hanging lamps, two before and one behind, and a new lamp-standard that bore nine lights. A vermillion cloth covered

the altar, and another, with silk fringes and decorative painting, covered the predella. There were benches of different types, two chests for donations, a sculpted *Annunciation* group, a place for wax votive images, two ostrich eggs suspended before the altar, and a "most beautiful pair of organs."

Just as the eighteenth century altered our notions of antiquity by "purifying" its remains, the nineteenth century altered our notions concerning the late medieval and early Renaissance experience of altarpieces. Modern literature frequently sweeps away all the objects, sometimes including other pictures, that composed the environment of altarpieces. But what we might consider clutter, the contemporary viewer must have regarded as appropriate embellishment. The inventories of 1420 and 1423 are, therefore, important documents that allow us to re-envision the complex viewing conditions of the *Maestà*.

<center>⸻</center>

The historiography of early Italian art was, for many centuries, a dialogue between Vasari and scholars from centers other than Florence. The Aretine's vision of the Renaisssance, kept alive by reprintings and revised editions of the *Lives*, was one component, one side of a debate that non-Florentine writers challenged again and again with, one must confess, comparatively little success. Local historians and antiquarians joined the fray, particularly in Siena, long an archrival of Florence, combing first early secondary and then primary sources for evidence that Siena had produced painters of high quality and great importance chronologically earlier than or contemporary with the major Florentines. Sienese and pro-Sienese authors had two principal weapons in their arsenal: the date of Duccio's *Maestà* (1310 or 1311, depending on which chronicle was consulted) and the large *Madonna and Child Enthroned* from San Domenico, Siena, that bears the name of Guido da Siena and an inscribed date of 1221. (The date is not the date of the work's creation, although it was so regarded until the late nineteenth century.) For many, the latter work proved that Sienese painting had flourished even before Cimabue's birth in 1240, according to Vasari. The *Maestà* proved that a great painter lived in Siena at the time of Giotto. But because the *Maestà* was initially (and for a long time) the only panel by Duccio that they knew, those writers took from Vasari the notion that Duccio had originated the inlaid marble pavements of Siena cathedral.

The altarpiece and pavements were, for centuries, the two main components in notions of Duccio; many times, they were the only two components. The ease with which we today recognize that the two are incompatible and irreconcilable, that the author of one could never be the author of the other, is only record of the strides of art history in the last century. For a long time, Duccio scholarship

froze around these works, partly because Ghiberti's *I Commentarii* and Vasari's *Lives* were of little help. Ghiberti misidentifed the subject of the front of the *Maestà* as a *Coronation of the Virgin*, and recorded "many pictures" in Siena, without specifying subject matter or precise locations. Vasari, as I have noted, knew very little about the painter. Moreover, the only panel other than the *Maestà* that was signed and dated (1310) was an altarpiece that enters the literature ca. 1625 and then disappears ca. 1752 (IV.12, IV.19).

I venture to suggest that present-day students of early Italian painting will find the Published Secondary Sources section surprising on several levels. First, we can watch one author repeating another and generally regarding anything by earlier scholars as authoritative. (Ironically, this view paralleled the treatment of Vasari by his adherents.) The same mentality infuses discussions of the chronicles, although by the eighteenth century a more critical approach was turned toward determining the reliability of each. Second, even after scholars turned to archival research, they failed to discover documents that related to surviving works. Third, most writers before the end of the eighteenth century were concerned with Sienese painting as part of a larger strategy. I shall return to this last issue.

There are still other aspects of the sources that deserve attention. Many authors seem unconcerned over matters of chronology that strike us at once. They had from the chronicles a date of 1310 or 1311 for the *Maestà*; from Vasari, they had a date for Duccio's works of ca. 1348 or ca. 1350; by 1717, Montebuoni had discovered the payment for the lost *Maestà* of 1302; and by 1782, Della Valle had found the 1282 payment to Duccio for a Biccherna cover. Had Duccio been born twenty years earlier, ca. 1262, by the time of Vasari's date for his works, ca. 1350, he would have been nearly ninety. Della Valle must have recognized another chronological problem of his own making. He described Duccio's cathedral altarpiece as possessing the "maniera di Guido da Siena, sebbene di molto rammorbidita, e migliorata [manner of Guido da Siena, although much softened and improved]," but he accepted the date of 1221 on Guido's *Madonna* in San Domenico. To preserve the continuity of the Sienese school, he argued that, in 1289, the Sienese artist Mino da Torrita painted what is, in fact, Simone Martini's *Maestà* fresco in the Palazzo Pubblico and that Mino might have been trained by Guido. Mino thus filled the chronological gap and assured the continuity of the tradition.

The assembled sources raise yet another fascinating issue. Underpinning many modern iconographical studies is the assumption that we must unveil hidden meanings that once were comparatively transparent in an earlier age. But the secondary sources are rather alarming for those who hold that view. Even while the *Maestà* was on the high altar, the anonymous author of the Sienese chronicle from

1202 to 1362 (II.1) could say that the altarpiece was painted with scenes from the New and Old Testaments. Agnolo di Tura said that the back showed "the Old Testament with the Passion of Jesus Christ" (II.3). Ghiberti recognized that the events on the back were from the New Testament, but when he wrote, he remembered the face as a *Coronation of the Virgin* (IV.1). This confusion surfaced periodically in the centuries that followed. As late as 1818, Fratini and Bruni said that the work contained "diverse Storie del Vecchio Testamento" (IV.37).

Perhaps the most astonishing thing to emerge from the sources is a demonstration of how incomplete, inaccurate, and incoherent notions of Duccio were until the twentieth century. This simple fact is of great importance to the historiography of early Italian painting.

Before the late eighteenth century, the historians and antiquarians of Siena were concerned with painting as part of a larger strategy that sought to preserve and elevate the history of Sienese culture. They were little concerned with matters of style; even had such matters attracted their attention, there was little they could have achieved. The language of criticism was the language of Vasari. With Della Valle's *Lettere Sanesi*, however, came a new sensitivity to style. Della Valle's strategy in dealing with Guido, Duccio, and Mino da Torrita, described above, can be used to illustrate the inadequacies of earlier scholarship. But Della Valle's position was designed to explain things he had observed. Without knowing that the heads in Guido's *Madonna* had been repainted in the early trecento by a follower of Duccio, he saw connections between that work, supposedly of 1221, and Duccio's *Maestà*. Recognizing similarities between the Palazzo Pubblico *Maestà* and Duccio's, while associating the former with a 1289 payment to a certain Mino for creating a *Maestà*, Della Valle could only see Mino as the figure who guaranteed the continuity of the Sienese tradition between Guido and Duccio. Della Valle thus foreshadowed one critical aspect of nineteenth-century scholarship: the rise of connoisseurship.

The last item in Chapter Four comes from Ettore Romagnoli and dates to ca. 1832. It combines a survey of earlier secondary sources with a wide-ranging search for original documentation. Romagnoli was, thus, the precursor to Gaetano Milanesi who, in 1854, published the three-volume *Documenti per la storia dell'arte senese*. Taking his cue from Giovanni Gaye's *Carteggio inedito d'Artisti dei sec. 14. 15. 16.* that had appeared, also in three volumes, between 1839 and 1840, Milanesi offered his readers nearly complete transcriptions of important documents and, in the notes that followed, often commented on the content of other documents and/or made further remarks about the artist concerned. Volume 1 contains the three documents that deal with Duccio's *Maestà*. To the first, of 9 October 1308, he added notes wherein he mentioned the contract for the Rucellai *Madonna* (still uncon-

nected with the surviving picture), the 1302 panel for the altar of the Nine, and a signed panel in San Donato: "Ora da gran tempo è perduto." He cited documents concerning the procession for the installation of the *Maestà* and quoted Agnolo di Tura on that event. He also moved beyond the documented to attribute to Duccio the magnificent triptych that is now in the Siena Pinacoteca and known as Tabernacle 35. It seems, however, that Milanesi was not confident about stylistic matters. When he published an edition of Vasari, in 1885, Tabernacle 35 disappeared and was replaced by a triptych purchased by Prince Albert, consort to Queen Victoria. (This is the work now on loan to the National Gallery, London, from the Royal Collection.)

It was only with Crowe and Cavalcaselle's *History of Painting in Italy* (1864) that connoisseurship genuinely began to shape the modern conception of Duccio. Among the surviving works, emphasis naturally fell on the *Maestà*, but the authors assembled a list of other works that they attributed to the painter: a small triptych now in the collection of the Società di Pie Disposizione, Siena; Tabernacle 35 in the Pinacoteca of Siena; the triptych in the English Royal Collection; two altarpieces now in the Siena Pinacoteca, numbers 28 and 47, the latter still in the Ospedale di Santa Maria della Scala at that time; the very beautiful triptych, number 566, in the National Gallery, London; and three panels in the Ramboux Collection. When Bernard Berenson published *The Central Italian Painters of the Renaissance* in 1897, he produced a short list of works by Duccio that included a few pictures no longer attributed to the painter, and that was otherwise heavily dependent on Crowe and Cavalcaselle. Hindsight explains the (unstated) problem. There was only one secure work by Duccio, the *Maestà*. Neither Berenson nor Crowe and Cavalcaselle connected the 1285 contract at Santa Maria Novella with the Rucellai *Madonna*, though the former must have known that the idea was circulating. In 1889, Franz Wickoff had published his "Über die Zeit des Guido von Siena," in which he argued a stylistic connection between the *Maestà* and the Santa Maria Novella panel. As it happened, however, the influence of Vasari proved so strong that it was well into the twentieth century before the majority of art historians accepted the new identification.

I want to underscore the extent to which the current understanding of Duccio is a product of the last century and a half, and, with that, the way in which that understanding has arisen from connoisseurship. Over the last several decades, connoisseurship has been both neglected and decried and less and less taught to North American students, but the historiography of Duccio vividly demonstrates how much we owe to that scorned approach to works of art. For all their concern with early sources such as the chronicles, for all their concern (in time) with documents, scholars in the five and a half centuries following Duccio's death could

not form anything resembling an accurate conception of the painter. One of the great lessons to be learned from the material of this volume is thus to be derived from an absence that points to the enormous benefits of nineteenth- and twentieth-century connoisseurship to our understanding of early Italian painting.

It is unquestionably the very late definition of the painter that explains his comparatively humble reputation with a general audience. Modern scholarship has not been able to counter the sheer number of voices raised in praise of Giotto. There was another problem with numbers. Where Vasari and his followers had vast lists of works supposedly by Giotto, Duccio's exponents had been unable to muster a catalogue that comes close to the number of pictures ascribed to the Florentine. In Crowe and Cavalcaselle's *History of Painting in Italy*, twenty-five pages of Volume 2 are given over to Duccio and Ugolino di Nerio, but Volume 1 devotes 143 pages to Giotto; this contrast vividly points toward attitudes that lingered into the twentieth century.

The material of this volume is much more than a collection of documents and a record of scholarship concerning a great painter. The history it composes had far-reaching consequences. Elsewhere, I have argued that a combination of Vasari's authority and Berenson's recasting of Vasari's vision led to a constant under-evaluation of Sienese achievement. To that mix must now be added the historiography mapped in these pages. It helps explain the discrepancy between what early Sienese painters actually accomplished and the reputation of the school in general. The comparatively late clarification of Duccio's career and thus of the careers of many other Sienese painters indebted to him meant that early Sienese painting has struggled against the much longer emphasis on the Florentine contribution. (A contribution, I might add, less well understood for not acknowledging the Sienese achievement.) As art history takes account of the genius of Duccio's recently restored Rucellai *Madonna* and slowly absorbs all that the historiography of early Italian painting reveals, we will, of necessity, find ourselves faced with large-scale re-evaluations.

———

The core of this volume's Bibliography comes from Satkowski's thesis, updated by the author to include more recent literature. As editor, I have added many items to make it a working bibliography that will enable students of early Italian painting to explore larger issues of historiography and the historical and art historical contexts of Duccio's career. That said, however, it would require a separate volume to publish every item related to those issues; the reader should not assume that every relevant item is published here.

The Bibliography is instructive in several ways. For example, all the major edi-

tions of Vasari's *Lives* have been included to demonstrate the repeated reappearance of that text, a circumstance critical to any understanding of the historiography of early Italian painting. Similarly, a complete record of the catalogues for the Pinacoteca of Siena points to the information available to Siena's citizens and to foreign visitors throughout the nineteenth century. The various editions of Séroux d'Agincourt's great study of Italian art show how familiar his views must have been to a very large audience. The scholarship from the twentieth century demonstrates the great enthusiasm for early Sienese art during the first decades of the century and how often that material dealt with questions of attribution. It shows how the great exhibitions of Sienese art in 1904 and 1912 stimulated a flurry of scholarship, which diminished during World War I. Between the two World Wars, the literature devoted to early Sienese art in particular is rather thin, but after 1945, interest in that art grew significantly, stimulated in part by the complete restoration of Duccio's *Maestà* in the late 1950s. Indeed, the reader will find many similar patterns in the Bibliography, all equally enlightening.

This volume will be of great utility to both scholars and students. To the former, it offers a complete and accurate record of the surviving documentation as well as a study in historiography. To the latter, it offers a glimpse of the types of documents that survive in Siena, the language of such documents, and an understanding of the contributions that archival research and connoisseurship have made to the modern understanding of the history of art. There is also interest for a larger audience. The Published Sources section speaks to a larger cultural strategy and then to its part in defining cultural history in the city of the Virgin. It shows how, from the sixteenth century on, those who explored the history of Sienese painting largely did so to construct a cultural identity. Thus, this volume affords glimpses into the ways in which Italian cities, long after they had ceased to be independent communes, constructed histories that gave them a sense of individuality, of independence, when that dream was long severed from reality.

NOTE: For both the general situation regarding Siena's place in the history of early Italian painting and a fuller, documented version of much of the material discussed above, see my *Painting in the Age of Giotto* (University Park, PA: The Pennsylvania State University Press, 1997) and my *The World of the Early Sienese Painter* (University Park, PA: The Pennsylvania State University Press, 2001).

HAYDEN B. J. MAGINNIS

THE SCHOLARLY TRADITION

The scholarly literature concerning Duccio di Buoninsegna is, to a great extent, a product of the great rivalry between Florence and Siena, one of the defining elements in the history of central Italy and of Tuscany. It originated in the thirteenth century, when merchants and bankers of both cities struggled for dominance in foreign trade and vied for the lucrative post of bankers to the papacy; it arose when Siena, for two-thirds of the duecento, was Ghibelline and, thus, pro-imperial, while Florence was Guelph and, thus, a supporter of the papacy.[1] From Siena's viewpoint, its finest moment had been the famed Battle of Montaperti (1260), when the Sienese had defeated the Florentines. Soon, however, the Florentines were to find satisfaction in the defeat of the imperial cause at the Battle of Colle Valdelsa (1267) and in a consequent realignment of Siena as a Guelph faction came to rule in that city. Yet the memory of the victory at Montaperti, the one time when Siena gained ascendancy over its archrival, never dimmed over the centuries.

A competitive mentality came to characterize relations between the two cities, not merely in the thirteenth and fourteenth centuries, but for many centuries to follow. That competition, rooted in the differing values of differing cultures, was further strengthened by Siena's eventual loss of independence. In 1555, Siena's status as an independent republic came to an end, when the city finally surrendered to the Florentines and was annexed to the Duchy of Tuscany by Cosimo I de' Medici. This humiliating defeat turned Sienese writers and scholars back to what became equated with a golden age in Sienese history, to the city's institutions and culture of the thirteenth, fourteenth, and even fifteenth centuries. In a manner difficult for North Americans to comprehend, the sense of being separate (and better) was nurtured by the Sienese such that the rivalry between the two cities was to extend into the twentieth century.

It is within this context that the reader should follow the material provided in Chapters Three and Four of this volume, aware that what we separate as the historiography of art is only a portion of a much larger cultural strategy. Both published and unpublished material on Duccio belongs, in many instances, to more comprehensive historical studies. The majority of authors quoted are Sienese; of those, many turned to the history of Sienese painting as only one element in Siena's glorious past. In their discussions of artists, these writers were often less interested in the roles these artists played in the evolution of style than in defining them as eminent citizens whose heroic deeds should be celebrated. In the case of Duccio di Buoninsegna (ca. 1260-1318) the process of his definition and evaluation

was gradual, as authors over the centuries struggled to resolve recurring problems of chronology and attribution.

Duccio, who worked during the early decades of Siena's golden age, apparently enjoyed limited recognition during his lifetime, at least not enough to inspire mention in any contemporary accounts that have come down to us. By contrast, the Florentine painter Giotto di Bondone (1267-1337) was praised during his lifetime as a genius, an innovator worthy of immediate fame. Slightly younger than Duccio, Giotto lived nearly twenty years longer. He was one of the first to benefit from the Florentine literary tradition of singling out important painters, begun early and long continued. The oft-cited passage in Dante's *Purgatorio*, in the *Divine Comedy*,[2] stating that Cimabue's fame had been eclipsed by Giotto's, also established the line of succession that transmitted a new art: Cimabue first, followed by an even greater Giotto.

Giovanni Boccaccio (1313-75), in his *Decameron*, claimed that Giotto had "brought back light" to painting, creating the new art by imitation of nature, a theme also found in his *Amorosa Visione*.[3] Boccaccio saw Giotto's achievement as the triumphant revival of the classical tradition, vanquishing the barbarous style of non-naturalistic painting that had characterized the post-classical centuries.

Petrarch (1304-74), who knew Giotto personally, took the position of an informed connoisseur, that of a non-artist appreciating the merits of an artistic prodigy. In his *Itinerarium syriacum* (1358), Petrarch advised readers to visit Giotto's frescoes in the Castelnuovo Chapel of Santa Barbara in Naples. In his will, Petrarch described a *Madonna* in his possession as a work whose great beauty appealed only to the knowledgeable.[4] Petrarch's tendency to eulogize individual merit reflects the underlying principle of a literary genre that gained popularity during the trecento: biographies of famous men. When translated into the lives of artists in chronological order, the biographical format was to prove an enduring one for Italian art history. Although Petrarch did not include Giotto in his own *De viris illustribus*, near the end of the trecento, Filippo Villani devoted a passage to Giotto in his discussion of famous Florentines in his *Liber de origine civitatis Florentie et eiusdem famosis civibus*.[5]

The fifteenth century saw the appearance of Lorenzo Ghiberti's short history of art in *I Commentarii*.[6] Ironically, it was this Florentine who was the first author to take Duccio into consideration by devoting a short paragraph to him. Writing from the viewpoint of an early Renaissance artist, Ghiberti nevertheless recognized the admirable qualities in Duccio's *Maestà* in the Duomo of Siena, which he had apparently seen in person.[7]

Art and artists were strong components of the literary tradition that evolved in Florence during the sixteenth century, which brought the earliest extant guide-

book to Florence, Francesco Albertini's *Memoriale di Molte Statue et Picture sono nella inclyta Cipta di Florentia* (IV.4), and the manuscripts known as the *Libro di Antonio Billi* (IV.2-3) and the *Codice Magliabechiano* (IV.5).[8] The first edition of the work that was to prove most influential of all, Giorgio Vasari's *Lives of the Most Eminent Painters, Sculptors and Architects*, appeared in 1550.[9]

Siena produced little that could compare to the strong literary output of Florence. One genre did exist in Siena that cannot be ignored, in the form of various anonymous chronicles (Chapter Two), later compilations perhaps based on trecento material, many of whose dates have not been definitively established. In these writings, notices dealing with art and artists are included in the context of conventional history, and pivotal events, originally transmitted through oral tradition, are narrated in colloquial style. These chronicles contain the earliest reference to the installation of Duccio's *Maestà* on the high altar of the cathedral in Siena—clearly a sensational episode in the city's history and one that generated a long-held memory. It must be emphasized that the information set down in these chronicles was accepted as credible fact by generations of Sienese historians who repeatedly cited them as unquestioned authorities. Particularly in the case of Duccio, these compilations proved to be the source of erroneous beliefs that, long after, would be disproved by documentary evidence.

The installation of the *Maestà* and a few other paintings were mentioned in Sigismondo Tizio's *Historiarum senesium* (III.4), produced before 1528, all of them in very short passages.[10] The *Historiarum senesium* was the first serious history of Siena and the one most utilized by subsequent authors. Thus, when Tizio stated that Segna di Bonaventura was Duccio's master, this error was transmitted and accepted by generations of future authors. The identification of the master of Duccio proved to be a recurring quandary that would never be conclusively resolved.

Unlike the authors of the chronicles, the identity of Sigismondo Tizio is known. Tizio represents the first of a long line of dilettante historians, cultivated and well-read by the standards of their times. Usually either wealthy aristocrats or well-placed clergy, these *eruditi* flourished in the seventeenth and eighteenth centuries in Siena and elsewhere in Italy: passionate and tireless laborers in the pursuit of reconstituting their local histories.

Siena, small as it was in the early sixteenth century, already had numerous libraries, both private and institutional, to which Tizio had access, and indeed, some of his sources can be identified. The disparate character of the *Historium Senesium* can be partially explained by his indiscriminate use of miscellaneous sources, all credited with equal weight: works of classical literature and philology, theological treatises, and diplomatic letters, with heavy reliance on the anony-

mous chronicles. In addition, Tizio was, perhaps, the first historical author to avail himself of the newly constituted Sienese archive, created by an act of 8 January 1485, the city's attempt to establish a centralized depository for the surviving historical documents, at that time dispersed among municipal offices and private owners throughout the city. Even at this early date, it was recognized that a deplorable number of documents had already been lost or destroyed during popular uprisings.[11] Sadly, the loss of documents did not stop here, but recurred each time the records were moved or re-ordered. Therefore, it is likely that Tizio, as well as subsequent authors who consulted archival material, saw records concerning Duccio that no longer exist.[12]

In spite of the strong Florentine tradition sketched above, it is doubtful whether the history of painting would have played an important role in Sienese scholarship of the seventeenth century onward had it not been for Vasari's seminal *Lives* (IV.6-7). Vasari's vision of the Renaissance's origins was fundamentally a history of painting in Florence, and the hero of the *Prima Parte* of the *Lives* was unquestionably Giotto.[13] Moreover, the sheer size and scope of Vasari's *Lives* suddenly made the history of art a major component in cultural history. There was, however, in Vasari's vision no significant place for the non-Florentine and certainly no place for a Sienese tradition.

In fact, as we now know, Vasari disassembled—and rearranged —the history of Sienese art. He made Pietro Lorenzetti and Simone Martini followers of Giotto. That move effectively dealt with what otherwise might have been a troubling circumstance: Petrarch had praised both Giotto and Simone, whom he also knew. But any claim for Sienese painting was neutralized by Vasari's assertion that Simone was a follower of Giotto. Ambrogio Lorenzetti appears in Vasari's pages as a solitary figure without master or followers.

Duccio is similarly isolated. Vasari listed Duccio as active around 1349 in the first edition and around 1350 in the second, thereby depriving this artist, who had trained or influenced painters of the younger generation of Simone and the Lorenzetti, of the chronological position that would have made that possible. Furthermore, Vasari picked up on Ghiberti's remark, in *I Commentarii* (IV.1), that Duccio "tenne la maniera greca [held to the Greek manner]," but the "maniera greca" represented, for Vasari, the deplorable state of painting from which first Cimabue and then Giotto were to rescue Italian art. As Cimabue, according to Vasari, had been born in 1240, Duccio's "Greek manner," of more than a century later, reduced the painter to the status of a very old-fashioned artist, working in an idiom that had long been supplanted by an art that held the key to the future, that would bring Italian painting to the genius of Michelangelo.

In the first edition of the *Lives*, Duccio's entire career was treated in the equivalent of three paragraphs; the treatment in the second edition, of 1568, is not much longer. Vasari claimed he could not find the Siena cathedral's *Maestà* and, therefore, cited Ghiberti's description in *I Commentarii* (IV.1), even though the *Maestà* was still in the cathedral.[14] Vasari attributed to Duccio the earliest of the intarsia pavements in the Duomo of Siena, an inaccuracy destined to be much repeated until the nineteenth century, and he made a few other attributions that we now know were wrong. In sum, Vasari actually knew almost nothing about Duccio.

Two important and related circumstances contributed to the successful reception of the *Lives*. Between 1568 and 1900, ten major editions of the *Lives* were published. In other words, Vasari's reading of history was continually placed before scholars of later generations; it remained a current viewpoint. Vasari's vision was also furthered in Filippo Baldinucci's *Notizie de' professori del disegno da Cimabue in qua* (1681). In a fanatical and fantastic attempt to flatter the ruling Medici, Baldinucci "revised" Vasari to show that the patterns of connections among artists were even closer than Vasari knew. From the Cimabue/Giotto lineage, thirty-seven painters rose and, once more, most of the major Sienese painters were included in that line.[15] Baldinucci quite specifically placed Duccio among Giotto's followers. This work, like Vasari's *Lives*, was kept before the public audience; it went through four complete editions before 1900.[16]

Vasari's assertions spurred a predictable strong reaction among the Sienese, but the literary elite of Siena did not galvanize and mount a counter-attack until the following century. The first to react in writing was Giulio Mancini in his *Considerazioni sulla pittura* (IV.10), of 1621.[17] Mancini did not borrow the Aretine's model of writing artists' biographies; instead, he expounded his theories and his vision of history in a treatise somewhat resembling a modern art historical survey. His primary purpose was to demonstrate that the Sienese school, having its origins demonstrably earlier than the Florentine, was the true site of the rebirth of painting. He had potent evidence; he pointed out that the church of San Domenico in Siena had a large panel of the *Virgin and Child Enthroned* that bore the name Guido da Siena and an inscribed date of 1221, and noted that this evidence was proof of a Sienese school active earlier than Cimabue.

In an attempt to provide a lineage of Sienese painters who could effectively counter Vasari's declared line of descent from Cimabue to Giotto and Giotto's disciples to Masaccio and beyond, Mancini compiled chronological lists of celebrated painters, carefully separating them into schools. Guido da Siena is listed as active in 1240, while Cimabue's activity is placed at ca. 1280-1300. Duccio remained grouped with Simone Martini and Ambrogio Lorenzetti. Despite Mancini's efforts to confute many of Vasari's arguments that, in Sienese eyes, obscured a true com-

prehension of the evolution of painting, he in fact accepted Vasari's attributions of the cathedral pavements and the design of the Cappella di Piazza in Siena to Duccio. He did not mention the *Maestà* and seems to have been unaware of any other paintings by Duccio.[18] Finally, as we recognize in retrospect, he focused attention on Guido. For several centuries, Guido, not Duccio, would provide the best evidence for Siena's claims to precedence. But Mancini made a long-lasting and seminal contribution: he introduced the notion of local schools of painting independent of the Florentine tradition. Although the *Considerazioni* remained in manuscript form until the twentieth century, it circulated in numerous copies, and its contents were well known to those both in and outside Mancini's native Siena.

In 1625/26, in a rather less ambitious project, Fabio Chigi, the future Pope Alexander VII, prepared a list of works of art in Siena (IV.12). In that document, he recorded the *Maestà* as in the cathedral and a "tavola de la Madonna con 4 Santi *Duccius Boninsegnae de Senis 1310*," as being located in the Abbadia a San Donato. The latter is the first notice of a work that is now untraced and presumed lost.

Chigi is one of a number of seventeenth-century Sienese writers who delved into local history. Following the lead of Tizio (d. 1528), a restricted group of dilettante historians set about excavating municipal archives in an enthusiastic, if not always systematic, examination of government records. They were interested in anything that shed light on the origins and past of Siena, not only its conquests, saints, and heroes, but also its buildings and churches and its works of art. Despite the fact that the results of these early research efforts often remained in manuscript form with limited circulation, they were to have a great impact on subsequent knowledge of early Siena. The most extensive consideration of Sienese history was provided by Giugurta Tommasi in his *Dell'Historie di Siena*, written before 1621 and published in 1625.[19] Tommasi's comments (IV.11) on the installation of the *Maestà*, the only work by Duccio he discussed, appear to come from the early Sienese chronicles, with one important difference: he knew that the artist was named Duccio di Buoninsegna, not "Duccio di Niccolò," as in the chronicles. (Chigi also identified Duccio by his proper name.) In 1655, Alfonso Landi prepared a description of Siena cathedral that reflects both knowledge of the chronicles and firsthand observation of the *Maestà* (IV.14).

It was, however, the eighteenth century that saw art historical discussions evolve into a branch of regional history, as art literature responded to the intellectual character of the Enlightenment. It was conditioned by the transfer of objective methodologies and deductive reasoning that, having achieved so much in mathematics and science, were now applied to other disciplines. The new reliance on factual evidence encouraged scholarly interest in the search for and publication

of documentary materials as a function of historical literature.

In an ambitious study (1709-20) of the churches of Siena, one of the first of its kind, Girolamo Macchi recorded the fruits of his research in the cathedral archives. In the first of two passages on the *Maestà* (III.7), he demonstrated precise knowledge of at least two documents, those of 9 October 1308 and of 28 November 1310,[20] the first citations of those documents. In the second passage, he accurately noted that the *Maestà* had been removed from the high altar in 1506 and was then next to the altar of Sant'Ansano in the left transept of the cathedral. There is another fascinating aspect to his accounts: he noted that the *Maestà* was begun in 1303. Today, there is no evidence to support his statement. Had Macchi seen a document that no longer exists?[21]

Related studies quickly followed, and in a way that allows a glimpse of the intellectual community in what was a small Tuscan town. The prevailing anti-Baroque sentiment helped to prompt a revived interest in medieval art. Among the patrician historians of Siena, a formidable group was collating their new-found data with clear goals in mind. In their voluminous writings, they set out to define and confront the major issues concerning Italian art of earlier centuries. Inevitably, because these writers copied and quoted each other, many errors persisted, but thanks to their assiduous pursuit and divulgence of documentary evidence, details concerning Duccio's career began to emerge. In his *Notizie de' Pittori e Statuarij* (1717), F. Montebuoni was the first to paraphrase the document of 4 December 1302 that records payment to Duccio for a *Maestà* for the "house of the Nine" (III.8). In his *Sulla Scuola Pittorica Senese* (ca. 1724), Umberto Benvoglienti cited a document of 1305 recording a payment to Segna di Buonaventura (III.10).[22] Tizio had said that Segna "was called" the master of Duccio; Benvoglienti wanted to demonstrate that such a connection was chronologically possible. Citing the 1308 document regarding the *Maestà*, he also corrected Duccio's name from the "Duccio di Niccolò" of the chronicles. Strangely, this manuscript does not include an argument about the relation of Duccio to other Sienese artists, nor an argument concerning his lifespan, both part of a letter written by Benvoglienti on 24 February 1710, but first cited by Guglielmo Della Valle (IV.25), as discussed below.[23]

Benvoglienti was part of a European network of correspondents who continually exchanged information. This network included the major literary personalities throughout Italy as well as English, French, and German scholars and other gentlemen of wealth and discernment who were seriously interested in Italian art. Some, such as the archeologist Sir Richard Rawlinson, spent long periods in Italy, immersed in scholarly pursuits. Others were voraciously buying Italian works of

art and exporting them.[24] In a fashion that now perplexes us, Benvoglienti was among the Italians who facilitated this plunder of Italian heritage by arranging purchases and even selling works from their own collections. We may deplore this situation, but it had the benefit of securing Italian art an interest and prestige across Europe and would, in time, draw foreign scholars to contemplate Italian artistic history.

Among Benvoglienti's younger colleagues was Giovan Antonio Pecci, himself the author of a voluminous literary output.[25] Pecci, a man of means who held various posts in the municipal government, devoted his leisure time to the tireless examination of documents in the city's public, private, and ecclesiastic archives, patiently compiling inventories and transcriptions. Near the middle of the eighteenth century, Pecci published his *Relazione delle cose più notabili della città di Siena*, which included mention of the altarpiece of 1310, first mentioned by Fabio Chigi, and provided the correct name for Duccio (IV.19). But most of his discussion centered on the cathedral pavements and the chapel on the Campo of Siena, before the Palazzo Pubblico. Once again, but not for the last time, Vasari's erroneous attributions of those works to Duccio lead the author and reader in directions unprofitable for a definition of the real painter.

The late eighteenth century saw the production of two works of very different quality and importance: G. G. Carli's *Selva di Notizie per la Compilazione della Storia delle Belle Arti a Siena*, and Della Valle's *Lettere Sanesi*. Carli's manuscript (III.12) constantly refers to a source he called *"Mem. Benv."* In large part, such references are, in fact, to Montebuoni's *Notizie de' Pittori e Statuarij*, discussed above, but in Duccio's case, Carli had other information. It is likely that he knew the letter of 24 February 1710, written by Benvoglienti to place Duccio in his proper chronological place and later quoted by Della Valle. He also attributed to the *Mem. Benv.* a notice of 1280 regarding a Biccherna cover and a notice of 1304. The source or sources of these remarks are as yet unidentified. Surveying various identifications of the painter in the preceding literature, Carli concluded that the painter named in documents merely as "Duccio" was the same as the "Duccio di Niccolò" mentioned in the Sienese chronicles; "Duccio di Buoninsegna" he described as another figure, an architect and sculptor who lived some time after the painter.

Strangely enough, the eighteenth-century historian who made the greatest contribution to the study of Duccio was not Sienese, but rather an emigrant from Piedmont.[26] Guglielmo Della Valle's interest in the visual arts began around 1775, when he spent time in Assisi studying the great fresco cycles in the basilica of San Francesco. Soon after his arrival in Siena, in 1780, he became immersed in exploration

of the history of Sienese art. In addition to his diligent search for documents regarding Sienese artists, he carefully reviewed earlier secondary literature; he also traveled widely to examine paintings and sculptures firsthand. The result of his labors was the *Lettere sanesi di un socio dell'Accademia di Fossano sopra le belle arti*, which appeared in three volumes between 1782 and 1786, a collection of eighty-two essays in epistolary form, addressed to prominent intellectuals of the period, in Italy and abroad.

The *Lettere sanesi* was a vehicle for its author to expound upon his theories concerning the origins and priority of the Sienese school; it was the most radical contribution to the anti-Vasari movement that had begun elsewhere more than a century earlier.[27] In the preface to the second volume (1785), he clearly stated his ambition: to prove the chronological precedence of innovative Sienese painters, and thus to demonstrate that Siena, not Florence, was the original seat of the artistic revolution. Della Valle's essay on Duccio, actually written in 1782, represents the first attempt to present comprehensively all the known information and opinions about Duccio, derived from both published and unpublished sources. He tackled the recurring problems that had plagued Duccio scholarship: his historical position, the span of his career, his possible relation to Segna di Bonaventura, and the respective artistic contributions of Duccio and Giotto. He also cited the text of Benvoglienti's 1710 letter, in which that writer placed Duccio's career earlier than those of Simone and Lippo Memmi and cited a document of 1342 that demonstrates Duccio had died by that year. He also included transcriptions of several documents that, although known to earlier scholars such as Benvoglienti, had never found their way into print.

This last observation points to the enormous importance of Della Valle's work. Here, after more than a century of Sienese scholarship that remained in manuscript form, were three volumes that made much of that tradition available not only to Italian readers, but to those throughout Europe. The *Lettere* remained the standard source for subsequent historians. In this way, Della Valle represents the beginning of modern scholarship on the artists of Siena. Yet, for Duccio in particular, his work was perhaps less substantial. Given his larger purpose, Della Valle's key figure had to be Guido da Siena, and his key work had to be Guido's San Domenico *Madonna*, supposedly of 1221. He was unable to situate Duccio clearly within the overall historical context. While he opined that the style of the cathedral *Maestà* was an improved version of Guido's, he apparently saw no connection between Duccio and Ugolino di Nerio, Simone Martini, or the Lorenzetti.

Della Valle's own section on the history and technique of the *Maestà* (IV.25) was an important contribution, for it was during the years when Della Valle was preparing his *Lettere* that the *Maestà* suffered its most extreme indignity. In 1777, the altarpiece was removed from the cathedral, cut into various portions, the face and

back separated, and the panels crammed into an attic of the Opera del Duomo.[28] Della Valle denounced this act of vandalism against the artistic heritage of Siena, and it may well have been at his prompting that the panels were returned to the Duomo.[29] Yet his discussion of Duccio contributed nothing new or significant to general knowledge of the artist. In spite of all the years he spent combing the archives in Siena, he had not discovered any new documents to clarify and raise Duccio's historical importance, nor had he transcribed several of the major documents already known.[30]

Before leaving our survey of eighteenth-century contributions, we must return to Florentine literature to note an obscure publication by a Dominican priest of the convent of Santa Maria Novella (IV.30). In his *Memorie istoriche* (1790), Vincenzo Fineschi included the partial transcription of a document that would eventually solve one of the most controversial questions surrounding Duccio: the authorship of the Rucellai *Madonna* (I.7). This document, the original contract for the altarpiece, clearly stipulates "Duccio da Siena" as the sole artist. Fineschi's interest in the document was peripheral to his discussion of the Compagnia dei Laudesi that had commissioned the painting. In his reading of the document, he did not identify it with the altarpiece still in that confraternity's chapel in the mid-eighteenth century, believed by all to be a masterpiece by Cimabue. Fineschi's assessment of the foreign artist was otherwise astute: a contemporary of Cimabue who was working in the same church in Florence, but *not* a pupil of Giotto.

Even after Fineschi's publication, however, this crucial document went almost unnoticed for several decades. Only the Swiss historian Johan Rudolf Füessli, writing at the beginning of the nineteenth century, seems to have been aware of it (IV.32). There was no immediate reaction on the part of any author to Füessli's citation, and indeed, even Gaetano Milanesi, who published the contract in its entirety in 1854, did not perceive the connection between it and the Rucellai *Madonna*.[31] Not until 1899 would another non-Italian scholar, Franz Wickoff, make a positive identification.[32]

By the end of the eighteenth century, real understanding of Duccio had made little progress. Even before Della Valle's *Lettere*, Guido da Siena, due to his chronological position, outranked Duccio in historical stature. A Duomo inventory of 1741 lists the *Maestà* as a work of Guido. The unresolved attribution of the Rucellai *Madonna* demonstrates that, despite the advances made in archival research, the information on Duccio in Vasari's *Lives* remained largely unchallenged. Vasari's statement that Duccio painted many things in Pisa and Pistoia[33] led several nineteenth-century authors to credit paintings to Duccio without further authority.[34] I refer in this context to the 1810 publication of a document from the Duomo archives in Pisa by a local historian, Sebastiano Ciampi. According to his reading, a

certain "Duccius pictor" is listed among the artists working on the apse mosaic of the Duomo. Although this document has not been verified by any subsequent scholar, its appearance gave rise to the interpretation that Duccio and Cimabue collaborated, since Cimabue executed the mosaic figure of San Giovanni for the apse in 1301.[35] However, in Ciampi's transcription, the other non-Pisan painters are recorded with their city of origin (e.g., Lapus Florentia), whereas "Duccius" was not followed by "de Senis" or "Senensis." This is but the first instance of an author eager to equate the generic appelative "Duccius pictor" with the Sienese master.[36]

Although the theory that Duccio was active in Pisa was eventually dismissed in later criticism, the interest in a working association between Cimabue and Duccio was destined to remain strong.[37] Increasingly, it became one of the recurring points of critical discussion about Duccio within the broader context of persistent, unresolved problems. Who was the master of Duccio? How do we explain the formation of his style? What is his relationship to Florentine painting?

The tradition of local scholar turned cultural archeologist had become an institution in the eighteenth century and continued into the nineteenth; foremost of the Sienese *eruditi* of the new century was Ettore Romagnoli. Like his predecessors, his motivation was the glorification of the artists of Siena. In his exhaustive coverage of Duccio's life and work (IV.42), Romagnoli demonstrated his knowledge of everything ever written about Duccio, material culled from every conceivable source. He had personally examined all the known documents, especially in the Archivio delle Riformagioni, where the Biccherna volumes were stored. Romagnoli was in constant correspondence with other scholars across Europe who were interested in the early history of art, among them Gaye, Repetti, De Angelis, Rumohr, and Séroux d'Agincourt. Thus, his views and "findings," not always reliable, were widely disseminated.

Although Romagnoli's ambitious effort is indispensable for its completeness, it was nevertheless regressive, seemingly unresponsive to the technical transformation of scholarship that was taking place in Europe. Romagnoli composed his work in an erratic manner, indiscriminately incorporating both legend and fact, and without careful handling of archival sources and their identification. Romagnoli compiled but did not interpret this immense amount of data and arrived at essentially no new conclusions. He never published his lengthy *Biografia Cronologica*, which has remained in manuscript form to this day and was not reproduced in a facsimile edition until 1976.

A new world of scholarship concerning early Italian painting had already begun to emerge through the work of younger men, both in and outside Italy. At the close of the previous century, figures such as Füessli (IV.32), who belonged to an eminent family of Swiss painters,[38] represented the imminent shift from patri-

otic local historians to international scholars, especially German-speaking, in the field of Italian art. They began to present scholarship in lexical format and to supplant the repetitive cataloguing of information and the biographical approach with deductive reasoning and formal analysis. The fact that Füessli had consulted an obscure religious publication (Fineschi's *Memorie istoriche*) presaged the greater objectivity and thoroughness in systematic research that distinguished the new generation of foreign scholars.[39]

One scholar who exemplified this trend was Karl Friedrich von Rumohr, more or less a contemporary of Romagnoli. Rumohr, who has been called the founder of modern archival research in art history, was an innovative theorist.[40] He used his *Italienische Forschungen* to examine single problems in depth and to emphasize problems of interpretation and attribution. Rumohr's work also disclosed his interest in the work of art as an aspect of the artist's personality. In the field of Ducciesque studies, these aspects of his methodology influenced the change in emphasis from biographical issues to those of interpretation and attribution.[41]

The great Sienese scholar who embodied a similar change was Gaetano Milanesi, whose three-volume *Documenti per la storia dell'arte senese* appeared from 1854 to 1856, and his *Sulla Storia dell'arte toscana* in 1878. Essentially the result of archival research, Milanesi's publication of documents was attended by notes and essays with further material and discussion of the artist or project. In his transcriptions of documents, Milanesi introduced new standards of precision and accuracy. Modeling his research on a systematic methodology of the type first utilized by foreign, particularly German, scholars, he brought a new lucidity to the study of Italian art, an approach that carried over into his famed edition of Vasari's *Lives* (1878-85).

Both Milanesi's outlook and his motivations were wider in scope than those of his Sienese predecessors. He belonged to the mid-century generation that put faith in the future of a unified Italy and participated in the accompanying intellectual renewal of the Risorgimento.[42] It is due in large part to his efforts that the city's archival information was conserved and made more accessible to scholars. Since the Napoleonic suppression, this vast, miscellaneous array of documents, which included the surviving records from governmental and judicial agencies as well as from suppressed convents and monasteries, had been housed all over the city. In 1858, shortly after the publication of Milanesi's *Documenti*, the Sienese archives were reconstituted in a central location, and four years later, the new state archives were opened to the public.

Milanesi effectively closed a literary tradition, that of the subjective and eclectic *erudito*, and replaced it with that of the professional, trained historian. Thus, the full

account of his activities, which leads into the modern historiography of Duccio, lies beyond the scope of this book. Notwithstanding his achievements in modernizing historical scholarship, Milanesi's work is still characterized by the common thread running through all Sienese literature concerning medieval painting: the affirmation of fierce civic pride. Like Della Valle and Romagnoli, Milanesi approached the task of classifying and organizing archival documentation with selfless and tireless devotion—in his own words, ". . . lietamente e con amore di cittadino."

The material that follows is documentation, in two forms, that concerns one of history's greatest painters. It tells of a life and career that had an enormous impact on the course painting would follow and of a reputation that became, for centuries thereafter, a key component of Siena's self-definition. It also proves deeply revealing for the history of art history, for the following pages speak eloquently of things not done, not accomplished, through the five centuries after Duccio's death. Those absences typify much of the scholarship on early Italian painting, down to the modern era.

<div style="text-align: right">Jane Immler Satkowski</div>

NOTES

1 For a highly readable account of the Sienese economy between 1260 and 1310, see D. Waley, *Siena and the Sienese in the 13th Century* (Cambridge: Cambridge University Press, 1991), 168-212.

2 *Purgatorio*, Canto XI: 94-96.

3 Boccaccio, *Decameron*, trans. J. Payne; revised C. S. Singleton (Berkeley and Los Angeles: 1982), 2: 459. For the *Amorosa Visione*, written in 1342-43, see H. Maginnis, "Boccaccio: A Poet Making Pictures," *Source* XV, no. 2 (1996): 1-7.

4 Petrarch bequeathed this painting to his last patron, Francesco I of Carrara.

5 F. Villani, *Liber de origine civitatis Florentie et eiusdem famosis civibus*, ed. G. Tanturli (Padua: Editrice Antenore, 1997), 153-55.

6 See Source IV.1.

7 Ghiberti's description of the *Maestà* cited a *Coronation of the Virgin* on the *recto*. Subsequently, some scholars have included a *Coronation* as the subject of the uppermost central panel in their theoretical reconstructions of the *recto*. See E. DeWald, "Observations on Duccio's Maestà," in *Late Classical and Medieval Studies in Honor of A.M. Friend* (Princeton: Princeton University Press, 1955), 362-66; F. Cooper, "A Reconstruction of Duccio's *Maestà*," *Art Bulletin* 47 (1965): 168.

8 The appelative "Magliabechiano" does not refer to the author of the codex, whose identity and dates are not known, but rather to the collection in the Biblioteca Nazionale, Florence, which once belonged to the seventeenth-century literary figure Magliabechi.

9 For references, see the Bibliography.

10 See III.4. For a detailed discussion of Tizio and his sources, see P. Piccolomini, *La Vita e l'Opera di Sigismondo Tizio* (Rome: Ermanno Loescher and Co., 1908).

11 Many Biccherna volumes were left behind during the transfer of government records from the church of San Cristoforo to the Archivio delle Riformagioni and were presumably deposited in other government offices. Another grave loss occurred when some of the Biccherna volumes were taken to Paris on the orders of Napoleon; many were lost on the return trip. See *Inventario. Archivio della Biccherna del Comune di Siena* (Rome: 1953), xxv.

12 For example, I.46. This Biccherna entry, dated 9 June 1311, was seen and transcribed by Milanesi (1854) and Lisini (1898) but cannot be traced today.

13 See H. Maginnis, *Painting in the Age of Giotto: An Historical Reevaluation* (University Park, PA: The Pennsylvania State University Press, 1997), ch. 1.

14 The *Maestà* was removed from the main altar of the cathedral and permanently replaced by a bronze tabernacle by Vecchietta in the summer of 1506, as documented by three deliberations of the Balia in June and July 1506. At that time, the altarpiece, still in one piece, was hung on a wall in the left transept, next to the altar of San Sebastiano (today del Crocifisso), as confirmed by Duomo inventories for 1591 and 1594. In 1655, Alfonso Landi (IV.14) in an obvious rebuff to Vasari's professed inability to find it, notes that the *Maestà* ". . . è stata sempre esposta a chi l'ha voluto vedere."

15 Baldinucci's family tree of painters was refuted by proponents of other local schools as well. The Vasarian primacy of Tuscan origins was resolutely rejected by the Bolognese writer Cesare Malvasia in his *Felsina Pittrice* (1677-78). Malvasia, a friend and correspondent of Mancini, extolled the noble origins of the Bolognese school of painting as part of his thorough, if subjective, examination of the art. For a reprint of the original edition, see C. Malvasia, *Felsina pittrice, Vite de' pittori bolognesi*, ed. M. Brascaglia (Bologna: Alfa, 1971).

16 Maginnis, *Painting in the Age of Giotto*, 39-41.

17 Mancini's *Considerazioni* was not published until 1956 (IV.10).

18 This seems particularly odd, as in a nearly contemporary manuscript of 1620-25, entitled *Breve ragguaglio delle cose di Siena* (III.5), Mancini discusses the *Maestà* in a passage heavily dependent on Tizio.

19 See the Bibliography.

20 For the documents, see I.39 and I.44.

21 See the related discussion of the chronology of the *Maestà*'s execution found in the Introduction of this volume and John Pope-Hennessy's thoughts in "A Misfit Master," *New York Review of Books* 207, no. 18 (20 November 1980), 45. Pope-Hennessy maintained that the work was begun several years before the traditionally held date of 1308 and that the 1308 document was, in fact, an agreement made subsequent to the original (presumably now lost) contract.

22 The document is actually dated 26 April 1306: ASS, Biccherna 119 (January 1305/06–June 1306), f. 70v (ink), f. 233 (pencil). It was first published by P. Bacci, *Fonti e commenti per la storia dell'arte senese* (Siena: Accademia degli Intronati, 1944), 34.

23 The letter is found in G. Della Valle, *Lettere Sanesi di un Socio dell'Accademia di Fossano Sopra le Belle Arti* (Rome: Generoso Salomoni, 1785), 2: 69.

24 See P. Provasi, "Lettere ad U. Benvoglienti di R. Rawlinson e d'altri raccoglitori d'opere d'arte stranieri," *Bullettino senese di storia patria* 6 (1935): 33-34.

25 A large part of G. A. Pecci's manuscripts are conserved in the Biblioteca Moreniana in Florence. For a discussion of Pecci's career see G. Catoni, "Giovanni Antonio Pecci: Contributo allo Studio dei Rapporti fra Storiografia Erudita e Archivi nel Settecento," *Bullettino senese di storia patria* 22 (1963): 13-28.

26 Biographical information on Della Valle is found in the entry by G. Fagioli Vercellone, "Della Valle, Guglielmo," in *Dizionario Biografico degli Italiani*, 37: 751-75. See also Giovanni Previtali, "Guglielmo Della Valle," *Paragone* 77 (1956): 6 and Previtali's *La fortuna dei primitivi*, 2d ed. (Turin: Giulio Einaudi, 1989). Previtali, in the latter, includes material on Giulio Mancini, Isidoro Azzolini-Ugurgieri, and Benvoglienti.

27 Giuliano Ercoli provides a complete analysis of Della Valle's challenge to Vasari in "L'Edizione delle Vite di Guglielmo Della Valle," in *Il Vasari Storiografo e Artista. Atti del Congresso Internazionale del IV Centenario della Morte* (Florence: Istituto Nazionale di Studi sul Rinascimento, 1974), 93-100.

28 A note added after the fact, in the margin of the Duomo inventory compiled in 1776, records the mutilation of the altarpiece, which took place in the auxiliary church of Sant'Ansano on 18 July 1777 (IV.24). Bacci published a document that would appear to be relevant, but which has not been traced: ". . . un conto di Mo Galgano Casini legnajolo, del 4 agosto 1777, lessi 'per aver mandato un maestro per disfare il quadro di tavola che fu portata dal Duomo, fattone più parti, fattoci due opere col fattorino, lire 5.'" Bacci, Siena, 1936, 186, n. 1.

29 According to the Duomo inventory of 1798, two groups of small panels, one group taken from the top registers and another eight from the predella, were then located in the sacristy.

30 For example, Della Valle does not cite the document regarding Duccio's *Maestà* in the Casa dei Nove (I.36) and two of the agreements regarding the Duomo *Maestà* (I.40 and I.44).

31 G. Milanesi, *Documenti per la storia dell'arte senese* (Siena: Porri, 1854-56), 1: 158-60.

32 F. Wickoff, "Über die Zeit des Guido von Siena," *Mitteilungen des Instituts für österreichische Geschichtsforschung* 10 (1899): 277-78.

33 The phrase is found in the 1550 edition of Vasari's *Lives*, 200 (IV.6) and in the 1568 edition, 293 (IV.7).

34 Already in 1787, Alessandro da Morrona, who championed the cause of the Pisan school of painting, had ascribed to Duccio a painting in a private collection in Pistoia; this work has never been identified (IV.28). Again, in 1821, Francesco Tolomei (IV.39) cited two paintings, a *Deposition* and a *Madonna and Saints*, "forse opera di Duccio di Siena." This statement was immediately negated by Romagnoli (IV.42).

35 Crowe and Cavalcaselle were the first to advance the opinion that, "It is not unlikely that he laboured in Cimabue's company at the mosaics of the Cathedral in Pisa in 1301." In a note to his edition of their work, however, Langton Douglas asserted that "there are no grounds for the statement that Duccio worked in Cimabue's company in Pisa." J. A. Crowe and G. B. Cavalcaselle, *A History of Painting in Italy* (London and New York: Scribner and Murray, 1903-08), 3: 8, n. 5.

36 See the discussion in the Introduction concerning archival documents in Paris published by Michaelsson.

37 Because of the technical similarities perceived in the paintings of Cimabue and Duccio, other works were variously attributed to one or the other. Millard Meiss and Roberto Longhi debated the authorship of the small *Flagaellation* in the Frick Collection. See M. Meiss, "A New Early Duccio," *Art Bulletin* 33 (1951): 95-193; R. Longhi, "Prima Cimabue poi Duccio," *Paragone* 23 (1951): 8-13; M. Meiss, "Scusi ma sempre Duccio," *Paragone* 27 (1952): 63-64. The design of the oculus in the Sienese Duomo, attributed to Duccio by Carli, has been given to Cimabue by White. (See I.60-63 and my comments on pp. 229-30).

38 Among his relatives was the Swiss painter known as John Henry Füessli, professor of painting at the Royal Academy in London and a leading proponent of Romanticism.

39 One result would be the kind of Ducciesque problems they would eventually take on, such as hypothetical reconstructions of the *Maestà*. The first reconstruction proposal was published by E. Dobbert: "Duccio's Bild 'Die Geburt Christi,' in der Königlichen Gemälde-Galerie zu Berlin," *Jahrbuch der Königlich Preussischeen Kunstsammlungen* 6 (1885): 153-63.

40 See M. Podro, *The Critical Historians of Art* (New Haven and London: Yale University Press, 1982), 27.

41 Other European scholars who made significant contributions at the turn of the century to the understanding of trecento Sienese painting were E. Dobbert, Carl Frey, Henry Thode, and Wilhem Suida. See the Bibliography.

42 Milanesi, ashamed that foreign art historians were turning up new information about Italian artists and monuments, produced over one hundred publications concerning every phase of medieval and Renaissance art. See Alessandro Lisini's informative eulogy, "Gaetano Milanesi," *Bullettino senese di storia patria* 2 (1895): 182-85.

I THE DOCUMENTS

A. REGARDING DUCCIO AND HIS WORKS

1. 1228/29, 31 January

ASS, Notarile antecos. (1227-29) *Libro di Imbreviature notariali* 1227-1229 (Notarile 2), f. 33v (pencil):

> MCCXXVIIII, pridie kalendas februarij, indictione II. Eodem die, locovit coram Forte Guerusi, Bonifacio Bonnomi et Malfreduccio milife Malevolte testibus. Dominus Braccius Fortisbrachii, dominus Uguiccione Fortisbrachii et dominus Orlandus Malevolte pro se ipsis et dictus dominus Orlandus pro se et pro domino Renuccio Filippi dederunt et concesserunt, nomine locationis, Castellano Pieri et Castellano Tignosi, Brunaccio Pieri, Aldobrandino Johannis et Bonavollie Albertini, eorum ortum de Campo reggi quem dictus Castellanus Tiniosi cum Riccardo de Bonconvento olim ab eis habuerunt et tenuerunt nomine locationis, cui ex una parte vie et ab aliis partibus habet Boninsegna quondam Boninsigne Lucensis, ut ab istis proximis kalendis januarii venturis ad quinque annos continuos habeant [etc.].
> Pensione di 16 1/2 lire.

> 1229, 31 January, Indiction 2. On the same day, he called as witnesses Forte Guerusi, Bonifacio Bonnomo and the soldier Malfreduccio, son of Malevolta. Lord Braccio Fortisbrachio, Lord Uguiccione Fortisbrachio, and said Lord Orlando Malevolta, on their own behalves, and said Lord Orlando also on behalf of Lord Renuccio Filippo, granted and conceded, by authority of a [land] lease, to the chatelain of the Pieri and to the chatelain of the Tignosi, to Brunaccio Pieri, Aldobrandino Johannis, and Bonavollia Albertini, their garden in Camporegio, which the said chatelain of the Tignosi and Riccardo of Bonconvento formerly used and kept by the authority of a [land] lease, on one side of which [garden] are streets and on the other side of which is land, which is held by Boninsegna, [son] of the late Boninsegna of Luca, so that they may use it from the preceding January 1 to the coming January 1, for five consecutive years. Rent of 16 1/2 lire.

Published: Bacci, Siena, 1944, 15-16.[1]

2. 1278, July-August

ASS, Biccherna 75 (Entrata e Uscita, July-August 1278), f. 42v (pencil), f. 164v (ink):

> Item X S[olidos] Duccio pictori pro pactura [*sic* = pictura] librorum camerarii et iiii[or].

> Item, 10 soldi to Duccio the painter for painting the books of the Treasurer and the Four.[2]

Published: Davidsohn, 1900, 314; Weigelt, 1911, 9 (as 1279); Brandi, 1951, 77 (as 1279, f. 42; without transcription); Romagnoli (ca. 1800-35), 1976, 1: 351 (cited without transcription); Stubblebine, 1979, 1: 191-92 (as 1279); White, 1979, 185 (as 1279).

3. 1278, 16 November (circa)

ASS, Biccherna 73 (Entrata e Uscita, July-December 1278), f. 56r (pencil), f. 118r (ink):

> Item xl sol[idos] Duccio Pictori quos debebat habere pro pictura duodecim cassarum in quibus stant instrumenta Comunis.[3]

> Item, 40 soldi to Duccio the painter, which he was to have for painting twelve coffers in which are kept the documents of the commune.

Published: Lisini, 1898, 43; Brandi, 1951, 77 (as 1278 and f. 34; folio number actually from Biccherna 74); Stubblebine, 1979, 1: 191 (as folio 34); White, 1979, 185.

4. 1279

ASS, Biccherna 725 (Libro delle Condanne, 1270-96), f. 239v (pencil), f. 241v (ink):

> [Condempnationes facte . . . in anno Domini MCCLXXVIIII]

> Duccius Boninsengnie, qui moratur ad Sanctam Mariam ad Sestam, condempnatus in X libras denariorum pro accusatione facta a Rodolfino Mangetti de dampno dato, et introitu cuiusdam petie terre, ut patet in f[o] [o]vxxvii.[4]

> [Fines . . . in the year of the Lord 1279]

> Duccio di Buoninsegna, who is living at Santa Maria ad Sestam, fined in the sum of 10 lire of denari for the accusation made by Rodolfino Mangetti concerning the financial loss and initiation of a lawsuit over property, as appears in folio [o]vxxvii.[5]

Published: Lisini, 1898, 47 (citing "Biccherna 9291," f. 241v, and considering the notice as one not referring to the painter); White, 1979, 185 (as f. 239v).

5. 1280/81, March-April

ASS, Biccherna 79 (Entrata e Uscita, March 1280/81-April 1281), f. 11r (pencil), f. 67r (ink):

> Item C libras a Duccio Boninsengne pictore pro condemnatione de eo facta in quantitate predicta.[6]

> Item 100 lire from Duccio di Buoninsegna the painter for the fine levied on him in the aforesaid sum.

Published: Lisini, 1898, 46-47 (erroneously cited as f. 241v, and dated to 1280); Weigelt, 1911, 9 (copied from Lisini);[7] Brandi, 1951, 77 (repeating the erroneous citation found in Lisini); Stubblebine, 1979, 1: 192 (as March/April 1280); White, 1979, 185 (repeating Lisini's citation and date and noting the document as untraced).

6. 1284/85

ASS, Biccherna 88[8] (Entrata e Uscita, January 1284/85-June 1285), f. 1v:

> Item XX soldos quos habuerunt a Guccio Boninsengne quia fuit per inventus beberivarios potestatis post tertium sonum campane.[9]

> Item 20 soldi they [of the Treasury] have from Guccio Boninsegne because he was found by the soldiers of the Podestà after the third sounding of the bells.

Published: Stubblebine, 1979, 1: 192 (missing "quos habuerunt").

7. 1285, 15 April

ASF, Diplomatico (S. Maria Novella di Firenze, 15 April 1285) (previously cited as: ASF, Archivio di S. Maria Novella, 16, Uscite, Compagnia di S.P. Marturi, vol. I, ad annum, 1285):

> *The following is written on the* verso *of the document in a fourteenth-century hand:*

> > Charta chome la Compagnia diede a dipingere la tavola grande dela Vergine Maria a Duccio da Siena.

> *On the* recto:

> > In Christi nomine amen. Millesimo ducentesimo octuagesimo quinto, indictione tertiadecima, die quintodecimo mensis Aprilis: feliciter. Lapus quondam Ugolini, populi sancte Marie Novelle et Guido magister quondam Spilgl[i]ati, populi Sancti Laurentii, rectores sotietatis sancte Marie Virginis ecclesie sancte Marie Novelle, et Corsus magister quondam Bonagiunte et Dinus quondam Benivieni, populi sancte Marie predicte,

operarii ut asseruerunt electi de voluntate Sotietatis predicte ad infra-
scriptum opus fieri faciendum pro Sotietate predicta, rectorio et operario
nomine pro sotietate predicta, locaverunt ad pingendum de pulcerima
pictura, quandam tabulam mangnam ordinatam fieri pro Sotietate pre-
dicta ad honorem beate et gloriose Virginis Marie, Duccio quondam
Boninsengne pictori de Senis. Promictentes et convenientes eidem
Duccio, operario et rectorio nomine, ut dictum est, dare et solvere eidem
et eius heredibus aut cui dederit et concesserit, pro pretio et nomine pretii
picture dicte tabule ab eo infrascripto modo pingende et fiende et in ter-
mino quo picta et completa fuerit, libras centum quinquaginta floreno-
rum parvorum; constituentes se rectorio et operario nomine, ut dictum
est, solutuos Florentie et alibi ubique locorum, eos seu alterum eorum et
sotietatis predicte invenerit et convenire voluerit; et solutionem vel abso-
lutionem, finem seu conpensationem in totum vel in partem non pro-
bare, nisi per scripturam publicam inde factam vel per hanc sibi redditam,
cancellatam de voluntate creditoris. Et versa vice dictus Duccius, con-
ducens dictam tabulam ad pingendum a predictis rectoribus et operariis
locantibus, ut dictum est, promisit et convenit eisdem recipientibus pro se
et sotietate predicta, dictam tabulam pingere et ornare de figura beate
Marie Virginis et eius omnipotentis Filii et aliarum figurarum, ad volun-
tatem et piacimentum dictorum locatorum; et deaurare et omnia et sin-
gula facere, que ad pulcritudinem dicte tabule spectabunt, suis omnibus
sumptibus et expensis. Hoc videlicet pacto et condictione habitis inter eos,
quod si dicta tabula non erit picta pulcra et laborata ad voluntatem et
placibilitatem eorundem locatorum, quod ad dictum pretium nec ad ali-
quam eius persolvendum nullatenus teneantur, et ad nullam refectionem
aliquarum expensarum ab eo in eadem tabula factarum: set ad ipsum
Duccium ipsa tabula remaneat. Et hoc sit in arbitrio et ad electionem iam
predictorum rectorum et operariorum. Et promiserunt inter se vicissim
et ad invicem, silicet dicti rectores et operarii, rectorio et operario
nomine, ut dictum est, se contra predicta vel aliquod predictorum
quidquam datum aut factum non habere nec dare vel facere in futurum.
Si vero contra fecerint, in totum, ut dictum est, non observaverint et
adimpleverint, promiserunt et convenerunt inter se vicissim et ad invicem
dare et solvere pro pena et nomine pene, silicet dicti locatores eidem
Duccio, si fallerent et in fide non starent; ac idem Duccius, eisdem loca-
toribus si falleret et in fide non staret, ipsis servantibus et in fide stantibus,
libras quinquaginta florenorum parvorum et dapmna omnia et expensas

ea de causa resarcire. Obligantes dicti locatores pro predictis servandis
adimplendis et firmis tenendis se et homines et universitatem sotietatis
predicte; et dictus Duccius, se suosque heredes et bona presentia et futu-
ra, que constituerunt inter se vicissim et ad invicem; silicet dicti locatores
pro dicto Duccio et dictus Duccius pro dictis locatoribus et sotietate, pre-
cario possidere. Renuntiantes inter se vicissim et ad invicem exceptioni
non celebrati contractus et non facte locationis et coductionis, fori privile-
gio et nove constitutionis benefecio et epistolis divi Adriani, et omni ilio
legum, et juris auxilio eis constitutionis et cuique eorum et sotietati pre-
dicte pertinenti vel competenti.

Tandem ego Iacobus iudex et notarius infrascriptus predictis Lapo,
Guidoni, Curso et Dino locatoribus et Duccio conductori, volentibus et
confitentibus omnia et singula suprascripta, precepi pro quarantigia et
nomine juramenti, ut michi licebat ex forma capituli constitutionis civi-
tatis Florentie, quatenus predicta omnia faciant firmaque teneant et
observent, ut scripta sunt et superius promiserunt.

Actum Florentie, justa schalas fratrum Predicatorum ecclesie sancte
Marie Novelle, presentibus testibus Terio Compagni, Bandino Bonfantis,
Lippo Boninsengne et fratre Paulo converso ordinis Predicatorum con-
ventus sancte Marie Predicte.

Ego Iacobus Melioris de Mungnone, imperiali autoritate judex et notar-
ius, predicta omnia coram me acta rogatus publice scripsi.

<hr>

On the verso:

Document of how the company gave the great panel of the Virgin Mary
to Duccio of Siena to paint.

On the recto:

In the name of Christ, amen. In the year one thousand two hundred
eighty-five, the thirteenth indiction, the fifteenth day of the month of
April: the omens being good. Lapo, son of the late Ugolino, of the Parish
of Santa Maria Novella and Master Guido, son of the late Spigliato, of the
Parish of San Lorenzo, Rectors of the Society of the Holy Virgin Mary of
the church of Santa Maria Novella, and Master Corso, son of the late
Bonagiunta, and Dino, son of the late Benevieni, of the above-mentioned

Parish of Santa Maria, the supervisors elected, as they assert, according to the wishes of the above-mentioned Society for the purpose of having the work described herein carried out for the above-mentioned Society, in their capacity as supervisors of the said Society, consigned to Duccio, of the late Buoninsegna, painter from Siena, a certain large panel ordered to be made for the said Society for the painting of a most beautiful picture to the honor of the blessed and glorious Virgin Mary. They promise and agree, in their capacity as rectors and supervisors, as has been said above, to give and to pay the same Duccio and his heirs or to whomever he might give or concede the right, as the payment and price of the painting of the said panel that is to be painted and completed, in the manner described herein, 150 lire of small florins. They determine in their capacity as rectors and supervisors as said above that they will pay in Florence or anywhere else that he [Duccio] should find or agree to meet them or anyone of those of the above-mentioned Society; and they agree that the payment, the release from terms of the contract, the termination, and the compensation, in total or in part, cannot be authorized except by means of a public document drawn up for this purpose, or by this present document being returned to them and being canceled by the wishes of the creditor [the Society]. Conversely, the said Duccio, undertaking to paint the above-mentioned panel at the behest of the said rectors and supervisors, agreed and promised them, receiving the promise on their own and on behalf of the said Society, to paint and embellish the panel with the image of the blessed Virgin Mary and her omnipotent Son and other figures, according to the wishes and pleasure of the lessors, and to gild [the panel] and do everything that will enhance the beauty of the panel, with all the expenses and costs being his own. With, of course, this agreement and condition arrived at between them, that if the said panel is not beautifully painted and if it is not embellished according to the wishes and desires of the same lessors, then they are in no way bound to pay him the price or any part of it, or to reimburse any of the expenses that may have been incurred by him in working on the panel. [In this case], the panel remains in the possession of Duccio. And this is to be at the judgment and choice of the said rectors and supervisors. And they promised among themselves in turn, one after another, that is, the rectors and supervisors, as has been said, that they will not in the future have, give, or do anything not in conformity with the above [agreements] or any part of them. If, in fact, they should do anything against the agreements, or, as has been

said, not fully observe and fulfill them, they, namely the said lessors, have agreed and promised among themselves, in turn and one after another, to give and pay a fine of fifty lire of small florins by way of penalty and to reimburse all damages and expenses resulting therein, if they violate [the agreements] and break faith. Likewise, Duccio [promises] to the lessors to pay a similar penalty and to reimburse damages and expenses should he violate [the agreements] and break faith, providing that they continue to observe them and remain in good faith. The said lessors pledge themselves and the men and the whole Society to observing, fulfilling, and upholding the above [agreements]; and the said Duccio pledges himself, his heirs, and his present and future goods, those which they agree among themselves, in turn and one after another, that is, the lessors for Duccio and Duccio for the lessors and the Society; by sufferance. They renounce, in turn and one after another, taking exception to this contract ever having been written and of the leasing and accepting ever having been made, and [they renounce] the privilege of forum, the benefit of the new constitution, the epistles of the Divine Hadrian, and every other aid of laws and right pertaining or applicable to them or any one of them or the above-mentioned Society.

Finally, I, Jacopo, the underwritten judge and notary, enjoined the said Lapo, Guido, Corso, and Dino, lessors, and Duccio, the contractor, [being] willing and acknowledging all the above, by guarantee and oath, as is allowed me by the form of the Florentine constitution, to do, uphold, and observe all the above, as is written and as they have promised.

Drawn up in Florence, by the stairs of the Church of Santa Maria Novella of the Preaching Friars. Present as witnesses are Terzio Compagni, Bandino di Bonfante, Lippo di Boninsegna,[10] and Fra Paolo, a lay brother of the order of Preachers of the above-mentioned convent of Santa Maria Novella.

I, Jacopo Meliori of Mungnone, judge and notary under imperial authority, publicly requested, have written all the foregoing enacted in my presence.

Published: Fineschi, 1790, 118; Füessli, 1806, 2: 304 (with partial transcription); Milanesi, 1854, 1: 158-60 (who cites the document as "Pergamena spettante al Convento di S. Marco," since it entered the Archivio di Stato under this signature after the Napoleonic suppression); Perkins, 1903, 457; Weigelt, 1911, 10; Stubblebine, 1979, 1: 192-94 (with the old archival signature cited by Milanesi); White, 1979, 185-87 (with the current ASF signature).

8. 1285, October 8

ASS, Biccherna 90 (Entrata e Uscita, July-December 1285), f. 374v (ink), f. 376v (pencil):

> Item viii sol[idos] die lune octavo octubris Duccio pictori, quos ei dedimus pro pictura quam fecit in libri[s] camerarii et iiii[or].

> Item, 8 soldi, Monday, October 8, to Duccio the painter, which we gave to him for painting that he did in the books of the Treasurer and the Four.

Published: Della Valle, 1782, 1: 277 (cited as 1282); Von Rumohr, 1827, 2: 11 (as Biccherna 75, f. 374r); Lisini, 1898, 43 (as f. 27); Weigelt, 1911, 11; Brandi, 1951, 79 (as "ad. an. c. 27" and no Biccherna number); White, 1979, 187-88 (cited from Biccherna 91, f. 389v, but saying 10, rather than 8 soldi); Stubblebine, 1979, 1: 194 (citing Biccherna 90 but with the folio number from Biccherna 91, and f. 389r instead of 389v).[11]

9. 1285/86

ASS, Biccherna 92 (Entrata e Uscita, January-June 1285/86), f. 6v and f. 8v (ink and pencil):

> f. 6v:
> Tassationes terçerii[12] civitatis.

> f. 8v:
> Item iii libras a Duccio pictore libre Sancti Gilii ex latere Malavoltorum.[13]

> f. 6v:
> Taxations for the Terzo di Città.

> f. 8v:
> Item, 3 lire from Duccio the painter of the *lira* of Sant'Egidio a lato dei Malavolti.

Published: Stubblebine, 1979, 1: 194; White, 1979, 188.

10. 1285/86

ASS, Biccherna 92 (Entrata e Uscita, January 1285/86-June 1286), f. 32r (pencil):[14]

> Item iiii libras a Duccio pittore libre Malavolti
> (In the right margin: "Pro tertia muta")

> Item, 4 lire from Duccio the painter, of the *lira* Malavolti
> (In the right margin: "For the third installment")

Published: White, 1979, 188.

11. 1286/87

ASS, Biccherna 95 (Entrata e Uscita, January 1286/87-June 1287), f. 96r (pencil), f. 299r (ink):

Item X s[olidos] Duccio pictori pro libris iiii[or] et eorum pictura.

Item, 10 soldi to Duccio the painter for painting the books of the Four.

Published: Lisini, 1898, 43; Weigelt, 1911, 11 (as 1286); Brandi, 1951, 195; Stubblebine, 1979, 1: 195 (incorrectly as Biccherna 92, f. 96r, and reading the last words as "causa picture"); White, 1979, 188 (reading the last two words as "causa picture").

12. 1289

ASS, Biccherna 725 (Libro delle Condanne, July 1270-June 1296), f. 632v (pencil), f. 644v (ink); f. 663v (pencil), f. 674v (ink):

f. 632v (pencil), f. 644v (ink):
Condempnationes facte tempore domini Baronis de Sancto Miniate potestatis et capitanei comunis Senarum in anno Domini millesimo cclxxxviiii.

f. 663v (pencil), f. 674v (ink):
Magister Duccius pictor de populo Sancti Donati[15] quia non fuit a consilium populi con[dempnatis] in v soldis et quidam alii cum eo in eadem quantite pro quolibet in folio xli.

f. 632v (pencil), f. 644v (ink):
Fines levied during the time of Lord Barone of San Miniato, Podestà and Captain of the Commune of Siena in the year 1289.

f. 663v (pencil), f. 674 (ink):
Master Duccio, the painter, from the Parish of San Donato, because he was not present at the meeting of the Council of the People, fined in the amount of 5 soldi, and certain others with him, each in the same amount, as appears on folio 41.

Published: Stubblebine, 1979, 1: 195.[16]

13. 1289

ASS, Biccherna 725 (Libro delle Condanne, July 1270-June 1296), f. 617r (pencil), f. 628r (ink); f. 647v (pencil), f. 658v (ink):

f. 617r (pencil), f. 628r (ink):
Condempnationes fatte tempore domini Tomasii de Inciola potestatis et domini Baronis potestatis et capitanei comunis Senarum in anno Domini MCCLXXXVIIII.

f. 647v (pencil), f. 658v (ink):

De contrata Sancti Donati

Duccius Boninsegne, in folio LI.

Quia predicti de dictis terçeriis et contratis, vel aliquis eorum, non iuraverunt mandata domini Capitanei e sequentium populi Senarum, fuerunt condempnati quilibet eorum in x s[olidis] ut patet in foliis supradictis cuilibet nomini appositis etc.

f. 617r (pencil), f. 628r (ink):

Fines levied in the time of Lord Tomasio from Inciola, the Podestà, and of Lord Barone, the Podestà and Captain of the commune of Siena in the year of the Lord 1289.

f. 647v (pencil), f. 658v (ink):

From the district of San Donato

Duccio Boninsegne, on folio 51.

Since the above-mentioned [plural] from the indicated Terzi and districts, or anyone else of them, did not swear allegiance to the orders of the Lord Captain and to the lesser officials of the people of Siena, they were fined, each one of them, in the amount of 10 soldi, as appears in the folios mentioned above, placed next to each person's name respectively, etc.

Published: Lisini, 1898, 48 (partially transcribed, with the year 1299); Brandi, 1951, 81 (repeats Lisini's error); Stubblebine, 1979, 1: 195 (with ink number f. 658v); White, 1979, 188 (with f. 647v).[17]

14. 1289, November (?)

ASS, Biccherna 101 (Entrata e Uscita, July-December 1289), f. 132r (pencil), f. 140r (ink):

Item X solidos Ghuccio pittori pro pittura quam fecit de duobus libris camerarii et iiii[or].

Item, 10 soldi [to] Guccio the painter for painting the two books of the Treasurer and the Four.[18]

Previously unpublished.

15. 1290/91, 24 January

ASS, Biccherna 104[19] (Entrata e Uscita, January 1290/91-June 1291), f. 64v (pencil), f. 76v (ink):

Item X s[olidos] eodem die Duccio pictori pro singnis libri camerarii et iiii[or].[20]

Item, 10 soldi on the same day to Duccio, the painter, for the emblems of the books of the Treasurer and the Four.

Published: Von Rumohr 1832, 2: 11 (with the date 26 January 1291); Lisini, 1898, 43 (as f. 54r in Biccherna 107); Weigelt, 1911, 11 (as 1292); Brandi, 1951, 79 (as Biccherna 105, f. 68v and 24 January); Romagnoli (ca. 1800-35), 1976, 1: 352; Stubblebine, 1979, 1: 195 (with the date 27 January 1292); White, 1979, 188-89 (as lost, but citing Lisini for the Biccherna number as 107, dated 24 January 1292).

16. 1291, 6 August

ASS, Biccherna 106[21] (Entrata e Uscita, July-December 1291), f. 113r (ink), f. 121r (pencil):[22]

> Expense mensis Agusti[23]
> Item X solidos die dicta [6 August] Duccio depictori, pro pictura quam fecit in libris camerarii et iiii[or].

> Expenses for the month of August
> Item, 10 soldi on the said day [6 August] to Duccio, painter, for painting he did for the books of the Treasurer and the Four.

Published: Von Rumohr, 1827-31, 2: 11 (again cited as Biccherna 345); Lisini, 1898, 43-44; Weigelt, 1911, 11 (cited as Biccherna 345); Brandi, 1951, 79 (as f. 9); Romagnoli (ca. 1800-35), 1976, 1: 353 (cited as Biccherna 345); Stubblebine, 1979, 1: 195 (as f. 9); White, 1979, 188.

17. 1292

ASS, Consiglio Generale 43 (8 December 1291-21 June 1292), f. 116v (pencil); f. 119v (pencil):[24]

> f. 116v:
> In nomine Domini amen
> Infrascripti L de radota Consilio Canpane[25]

> f. 119v:
> De terçerio Camollie
> Duccius pictor

> f. 116v:
> In the name of the Lord, amen
> The following fifty [are] supplementary members of the Council of the Bells

f. 119v:

From the Terzo di Camollia

Duccio, the painter

Published: Stubblebine, 1979, 1: 195 (as ff. 117v and 120v).

18. 1292, 9 November

ASF, Notarile antecos. D 53a (Protocollo di ser Diedi di Gioffredo da Monte San Savino, 1284-1321), f. 21v:

[In left margin]: Procuratio Andree ad vendendum

> In nomine Dei eterni, amen. Anno a nativitate eiusdem millesimo ducentesimo nonagesimo secundo, indictione quinta, vacante Romana ecclesia, die nono mensis novembris in cassaro de Montegiovi, coram Borgognone domini Ildibrandini de Radi, Lorenzo de Pontremolo, Ranerio Galluzi de Bononia, Guillelmo dicto Preite de Castilione Piscarie et Contro Maffei olim de Chisure testibus adhibitis. Evidenter appareat quod vir potens et nobilis dominius Nicolaus olim Bonifazii de Bonsignoribus de Senis pro se ipso constituit et ordinavit Andream Bonaguide de Senis licet absentem suum verum et legittimum procuratorem et nuntium spetialem ad vendendum et tradendum pro eo et nomine suo cui vel quibus ipse procurator voluerit, quandam plateam sui dicti domini Nicolai positam Senis in contrata de Camporegio cui platee ex duabus partibus est ecclesie sancti Antonii ex alia est via et desuper Guillelmi Bencivennis et Duccii Bonensegne et Nuccii Ildibrandini Cigonis et Ugonis Ugolini et res que fuit Venture de Cerreto et est etiam ex eadem parte Alexi domini Renaldi et si qui alii sunt confines, pro pretio quod dictus procurator voluerit etc. Ego Dedi condam Goffredi de Monte Sancti Savini, imperiali auctoritate iudex ordinarius et notarius, predictis interfui et ut supra legitur, mandato dicti domini Nicolay, scripsi et publicavi.[26]

[In left margin]: Andrea's authorization for a sale

> In the name of the eternal God, amen. The year from his birth, 1292, the fifth indiction, the Holy See being vacant, on the ninth day of November, in the Castle of the Montegiovi, in the presence of Borgognone, son of Lord Ildebrando from Radi, Lorenzo of Pontremoli, Raniero Galluzzi from Bologna, Guglielmo the above-mentioned priest from Castiglion

della Pescaia, and Contro Maffei, formerly of Chiusure, summoned as witnesses. Let it be openly recognized that the powerful and noble man, Ser Niccolò, son of the late Bonifazio of the Bonsignori of Siena, on his own behalf designated and appointed Andrea Bonaguide of Siena, despite his [Andrea's] absence, as his true and legitimate agent and special representative for the purpose of selling and transferring on his own and in Niccolò's name a certain open area belonging to the said Ser Niccolò and located in Siena in the Contrado of Camporegi, to such person or persons as this agent himself shall desire. The area is bounded on two sides by the church of Sant'Antonio, on another by the street, and above it the property of Guglielmo Bencivenni, Duccio di Buoninsegna, Nuccio son of Ildebrandino, the son of Ghigho, and Ugo Ugolini, and also on the same side by property that used to belong to Ventura of Cerreto but now to Alessio, son of Ser Renaldo, and any others who might be adjacent. For the price that the said agent wishes, etc. I, Dedo, son of the late Goffredo of Monte San Savino, judge ordinary and notary by imperial authority, was present at the foregoing and, as appears above, have written it and made it public by order of the said Ser Niccolò.

Published: Lisini, 1898, 49 (with partial transcription); Bacci, 1932, 243; Brandi, 1951, 79; Stubblebine, 1979, 1: 196; White, 1979, 189.

19. 1293, September

ASS, Biccherna 109 (Entrata e Uscita, July-December 1293), f.102v (pencil and ink), f. 103v (pencil and ink):

f. 102v:
Infrascripta sunt datia vetera et presatio[nes?] de terçio Camollie.

f. 103v:[27]
Item XL s[olidos] dicta die a Duccio Boninsengne, pictore [in the margin]: de libra S. Donati ex parte ecclesie et Montanini, pro eorum presta de xxxM librarum.[28]

f. 102v:
Herein are the old dazii and preste for the Terzo di Camollia.

f. 103v:
Item, 40 soldi on the said day from Duccio Boninsegne, painter
[in the margin]: of the district of San Donato on the side of the church and Montanini, for the presta of 30,000 lire.

Published: Stubblebine, 1979, 1: 196.[29]

20. 1293/94, 2 March

ASS, Biccherna 110 (Entrata e Uscita, January 1293/94-June 1294), f. 111v (ink), f. 116v (pencil):

> [at top of page]: die secundo marçii
> Item X solidos dicta die Duccio pictori pro pictura librorum camerarij et iiij[or] provisorum comunis Senarum.

> [at top of page]: the second of March
> Item, 10 soldi on the said day to Duccio the painter for painting the books of the Treasurer and of the Four Procurators of the commune of Siena.

Published: Lisini, 1898, 44; Weigelt, 1911, 11; Brandi, 1951, 80; Stubblebine, 1979, 1: 196 (as fol. 111r); White, 1979, 189.

21. 1294, 15 May

ASS, Biccherna 110 (Entrata e Uscita, January 1293/94-June 1294), f. 63v (ink), f. 65v (pencil):[30]

> [at top of page]: de mensi maii
> Item vi so[lidos] viii den[arios] die dicta a Duccio pictore pro una condem[natione] facta de eo in v solidis et pro tertio pluri occasione unius consilii tempore domini Baronis folio xli.

> [at top of page]: the month of May
> Item, 6 soldi and 8 denari on the said day from Duccio the painter for a fine levied against him in the amount of 5 soldi, plus a third more, at a council meeting during the time of Lord Barone, as on folio 41.

Published: Stubblebine, 1979, 1: 197.[31]

22. 1294, 24 May

ASS, Curia del Placito 397[32] (Ragioni e Rendiconti dei Tutori), f. 11v (pencil), f. 19v (ink):

> Item vii libras, viii solidos, dentibus duobus denariorum de uno modio vini vermilii quem emit Ducius pictor, pro vi solidos dentibus duobus denariorum starium et solvit indici pro portatura et zenzalatura.

> Item, 7 lire, 8 soldi, in double-coin for a moggio of red wine, which Duccio the painter bought for six soldi in double-coin for each stario, and he paid the steward for the transport and delivery.

Published: Lisini, 1898, 49-50 (without transcription); Weigelt, 1911, 13-14; Brandi, 1951, 80 (with the date 27 April and without transcription); Stubblebine, 1979, 1:

197 (with the date of 11 November and the last seven words in brackets); White, 1979, 189 (with the date of 27 April and described as untraced, thus without transcription).[33]

23. 1294, 24 May[34]

ASS, Curia del Placito 397 (Ragioni e Rendiconti dei Tutori), f. 11v (pencil), f. 19v (ink):

> Item solidos novem de uno discho quem emit Ducius pictor.[35]

> Item, 9 soldi for a counter that Duccio the painter bought.

Published: Lisini, 1898, 49-50 (incomplete transcription); Stubblebine, 1979, 1: 197 (with the date 11 November).

24. 1294, 5 June

ASS, Biccherna 110 (Entrata e Uscita, January 1293/94-June 1294), f. 77r (ink), f. 79r (pencil):

> [At beginning of page] die Va junii
> Item xiii sol[idos] iiii denarios die dicta a Duccio pictore pro unum condempnatione facta de eo in x sol[idis] et pro tertio pluri quia non iuravit ad Capitanium populi tempore domini baronis.
> fo. Li[36]

> [At beginning of page] day 5 June
> Item, 13 soldi and 4 denari on the said day from Duccio the painter for a fine levied against him in the amount of 10 soldi, plus a third more because he did not swear the oath to the Captain of the People during the time of Lord Barone, [as on] fol. 51.

Published: Stubblebine, 1979, 1: 197.

25. 1294, 7 September

ASS, Curia del Placito 397 (Ragioni e Rendiconti dei Tutori), f. 16r (pencil), f. 24r (ink):

> Anno Domini MCC nonagesimo quarto, indictione vii, die septimo mensis septembris ab eius ingressu. Ego Beccha quondam Deodati, uxor olim Magini quondam Michelis Item debito trigintatrium soldorum denariorum senensium et sex denariorum, quos dictus Maginus mutuo recepit a Duccio pictore.

> In the year of the Lord 1294, the seventh indiction, the seventh day after the beginning of the month of September. I, Becca of the late Deodatus, wife of the late Magino of the late Michele Item, I owe 33 soldi of Sienese money and

six denari that the said Magino borrowed from Duccio the painter.

Published: Lisini, 1898, 49-50; Weigelt, 1911, 14 (with the erroneous citation of Curia del Placito 379); Brandi, 1951, 80; Stubblebine, 1979, 1: 198 (with the erroneous date of 11 November); White, 1979, 189 (with the erroneous citation of Curia del Placito 379).

26. 1294, 21 October[37]

ASS, Curia del Placito 397 (Ragioni e Rendiconti di Tutori), f. 14r (pencil), f. 22r (ink):

Item xxxiii solidos, vi denarios Ducio pictori, quos sibi dare tenebatur Maginus ex causa mutui, et fecit iud. cartam quitanze ser Salvi predictus notarius die xxi Octubris, et dictum debitum scriptum est in inventario.[38]

Item, 33 soldi, 6 denari to Duccio the painter that Magino was obligated to give him because of a loan; and the judge, Ser Salvi, the above-mentioned notary, prepared the legal quittance on October 21, and this debt is written in the inventory.[39]

Published: Weigelt, 1911, 13-14; Stubblebine, 1979, 1: 197 (with the date of 11 November).

27. 1295

ASS, Biccherna 501 (Libri di Mistura, July-December 1295), f. 8r (pencil):

In nomine Domini amen. Hec est concordia habita inter dictos VI officiales et sicut data fuit ab eis scripta, non tamen licteraliter, sed vulgariter.

Nos VI electi ad providendum locum in quo ponatur fons aque que exit in Valle Roçci etiam in plano de Ovile, habita diligenti provisione cum consilio magistri Iohannis et magistri Chasolesis et magistri Soçci et magistri Insegne, magistrorum Operis, et magistri Vannis de Camporegio et magistri Duccii pictoris, propterea videtur nobis quod dictis fons fiat et fieri debeat in platea ubi facta est domus domestici que est ante boctinum superius sursum ate boctinum in costa, cui domui de subtus sunt platee Ughi Paçci giollaris et ex aliis partibus est via, et quod dicte platee Ughi Paçci mictantur in habilitatem et acconcium dicti fontis.

In the name of the Lord, amen. This is the agreement reached between the six officials and was thus submitted, written by them, not as an official but as an unofficial document.

We six, chosen to determine the place in which is to be set the fountain for the water that comes out in Valle Rozzi and the flat ground of Ovile, after careful consideration [and] with the advice of Master Giovanni and Master Casolese and Master Sozzo and Master Insegna,[40] of the masters of the Opera del Duomo, and of Master Vanni of Camporegio and of Master Duccio, the painter, accordingly, it seems to us that the said fountain should and ought to be made in the flat place where the steward's house is built, which is before the spring where it comes out of the ground, rising on the front of the slope, beneath and before which house are the grounds of Ugo Pazzi, the jeweler, and on the other side of which is the road, and that the said grounds of Ugo Pazzi should be put into proper state and order for the said fountain.

Published: Milanesi, 1854, 1: 168 (without transcription); Lisini, 1898, 45-46; Bargagli-Petrucci, 1906, 295; Weigelt, 1911, 12; Brandi, 1951, 80-81; Stubblebine, 1979, 1: 198 (with minor variations in spelling and the omission of "superius sursum ate"); White, 1979, 190.

28. 1295, 19 October

ASS, Biccherna 112 (Entrata e Uscita, July-December 1295), f. 112r (ink), f. 116r (pencil):

Item X sol[idos] die XVIIII Octubris [1295] Duccio depegnitori, quia pinxit libros camerarii et iiii[or].

Item, 10 soldi on the 19th day of October [1295] to Duccio the painter because he painted the books of the Treasurer and the Four.

Published: Lisini, 1898, 43; Weigelt, 1911, 11; Brandi, 1951, 81 (with the date 18 October); Stubblebine, 1979, 1: 198; White, 1979, 190.

29. 1295, 16 December

ASS, Biccherna 112 (Entrata e Uscita, July-December 1295), f. 72r (ink), f. 73r (pencil):

[Found in a payment above]: de mense decembris, die xvi
Item x s[olidos] Die dicta a Duccio dipignitore pro banno et decima in libro novo it [sic = et?] folio clxxxxiiii.[41]

[Found in a payment above]: Day 16 of the month of December
Item, 10 soldi on the said day, from Duccio, the painter, as penalty and tenth in the new book, f. 194.

Note: The month is given as "di mese decebr" at the top of the page, and the day is indicated by an entry three places above that referring to Duccio.

Published: Lisini, 1898, 47; Weigelt, 1911, 12; Brandi, 1951, 81 (without Biccherna signature); Stubblebine, 1979, 1: 198; White, 1979, 190.

30. 1302, 7 April

ASS, Biccherna 116 (Entrata e Uscita, January 1301/02-June 1302), f. 131v (pencil and ink):

Sabbato vii dì d'aprile[42]

Item V soldi da Duccio Buoninsegnie dipegnitore del populo di Sancto Donato per uno bando dato a llui per devito a ppetiçione di Lapo Chiari, sicome appare nel livro dele decime S, fo. cvi. La decima si scontiò sicome appare nel livro dele cavallate del Terço di Città, fo. lxxxxiii.

Saturday, 7 April

Item, 5 soldi from Duccio di Buoninsegna, the painter, of the Parish of San Donato, for a condemnation proclaimed against him on account of a debt, according to the petition of Lapo Chiari, as appears in the Book of the Decima S, folio 106. The fine was paid, as appears in the Book of the Cavallata of the Terzo of Città, f. 93.

Published: Lisini, 1898, 47; Brandi, 1951, 81; Stubblebine, 1979, 1: 199; White, 1979, 190.

31. 1301/02, 7 April

ASS, Biccherna 116 (Entrata e Uscita, January 1301/02-June 1302), f. 131v (ink and pencil):

Item V soldi dal detto Ducio per un altro bando dato a llui di xlii lire per devito a petiçione di Pacino Chiari, sicome appare nel livro delle decime S, fo. cxxviiii. La decima scontiò, sicome appare nel detto livro dele cavallate fo. lxxxxiii.[43]

Item, 5 soldi from the same Duccio for another condemnation made against him on account of a debt of 42 lire, according to the petition of Pacino Chiari, as appears in the Book of the Decima S, f. 129. The fine was paid, as appears in the Book of the Cavallata, f. 93.

Published: Lisini, 1898, 7; Weigelt, 1911, 13; Stubblebine, 1979, 1: 199; White, 1979, 190.

32. 1302, May

Untraced

Introitus et exitus facti e habiti a Burgundio Tadi Operaio Opere S. Marie pisane majoris ecclesie sub an. D. MCCCII. Indict. XIII de mense madii incepti.

Magistri magiestatis Majoris

Magister Franciscus pictor de S. Simone porta maris cum famulo suo pro
diebus V quibus in dicta opera magiestatis laborarunt ad rationem soldi x pro
die—Lib. II sol. X. Victorius eius filius pro se et Sandruccio famulo suo etc.
Lapus de Florentia etc. Michael pictor etc. Duccius pictor etc. Tura pictor etc.
Datus pictor etc. Tanus pictor etc. Bonturus pictor etc. Puccinellus pictor etc.
filius magistri Cioli etc. Vannes florentinus pictor etc. Michael pis.[44]

<hr/>

Book of Revenues and Expenditures Made and Kept by Burgundio Tadi,
Director of the Opera of the Church of Santa Maria Maggiore in Pisa in A.D.
1302, the 13th indiction, begun in the month of May.

Masters of the great Maestà

Master Francesco, painter from San Simone Porta Mare, with his helper, for
the five days during which they labored on the above-mentioned Maestà, at
the rate of 10 soldi per day. 2 lire, 10 soldi. Vittorio, his son, for himself and
for Sandruccio, his helper, etc. Lapo of Florence, etc., Michele, the painter,
etc., Duccio, the painter, etc., Turo, the painter, etc., Dato, the painter, etc.,
Tano, the painter, etc., Bonturo, the painter, etc., Pucinello, the painter, etc.,
the son of Master Cioli, etc., Vanni, the Florentine painter, etc., Michele
Pisano.

Published: Ciampi, 1810, 144, Doc. XXV (without folio number); Stubblebine,
1979, 1: 199-200 (quoting Ciampi).

33. 1302, 4 May
ASS, Biccherna 116 (Entrata e Uscita, January 1301/02-June 1302), f. 155r (pencil
and ink):

Venardi iiii dì di magio [1302]
Item v soldi da Duccio dipegnitore del populo di Sancto Donato, per bando
dato a llui per devito a ppetiçione di sere Bruno Ranucci, procuratore di Neri
Orlandi, si come appare nel livro dele decime N, foglio lxxv; la decima si
scontrò si come appare nel livro delle cavallate del Terço di Città fo. lxxxxiii.

Friday, 4 May [1302]
Item, 5 soldi from Duccio, the painter of the Parish of San Donato, for a con-
demnation against him on account of a debt, according to the petition of Ser
Bruno Ranucci, the procurator of Neri Orlandi, as appears in the Book of the

Decima N, folio 75. The fine was paid as appears in the Book of the Cavallata of the Terzo of Città, f. 93.

Published: Lisini, 1898, 47; Brandi, 1951, 81-82; Stubblebine, 1979, 1: 199; White, 1979, 190-91.

34. 1302, 4 December
ASS, Biccherna 117 (Entrata e Uscita, July-December 1302), f. 182r (ink):[45]

martedi quattro dì di diciembre
Ancho v libre da Duccio Buoninsignia dipegnitore di Champoregi, per una chondanagione fatta di lui per domino Donodeio dela Cittae di Chastello, sinda-chocho [sic] del Chomune di Siena, per chagione che sopraprese via di Chomune, sichome apare nel livro dele Chiavi del Terço di Cittae segniato dell'enne, in fo. lxiii.[46]

Tuesday, 4 December
Also, 5 lire from Duccio Buoninsegna, painter from Camporegio, for a condemnation made against him by Lord Donodeo of Città di Castello, the Syndic of the Commune of Siena, for the reason that he obstructed the communal road, as appears in the Book of the Keys of the Terzo di Città, marked with an "N" on f. 63.

Published: Lisini, 1898, 48 (without archival citation); Weigelt, 1911, 13; Brandi, 1951, 84; Stubblebine, 1979, 1: 200 (inaccurately calling the volume a book of condemnations); White, 1979, 191.

35. 1302, 4 December
ASS, Biccherna 117 (Entrata e Uscita, July-December 1302), f. 182r (ink):[47]

Ancho xviii libre, x soldi da Duccio di[48] Buoninsegnia, dipegnitore del popolo di San Donato, per una chondanagione fatta di lui per domino Lamfrancho Ranghoni, capitano che fue del Chomune e del popolo di Siena dela Guerra, per chagione che non fue a neuna mostra nell'oste fatto a Monteano ed al Cholechio et a Roccha Istrada, né ala guardia nela detta oste fatta a Roccha Istrada, et detti danari paghò sechondo la provisione et istançiamento de' Signiori Nove.

Also, 18 lire and 10 soldi from Duccio Buoninsegna, painter of the Parish of San Donato, for a condemnation made against him by Lord Lanfranco Ranghoni, the Captain of the Commune and of the People of Siena and of War, for the reason that he was not present at any mustering of the army at Montiano, Collecchio, or Roccastrada; nor at the watch of the guard of the said army convened at Roccastrada, and the said money was paid according to the order and command of the Nove.

Published: Lisini, 1898, 49; Weigelt, 1911, 13; Brandi, 1951, 84 (incomplete); Stubblebine, 1979, 1: 200 (inaccurately calling the volume a book of condemnations); White, 1979, 191.

36. 1302, 4 December

ASS, Biccherna 117 (Entrata e Uscita, July-December 1302), f. 347r (pencil), f. 357r (ink):

> martedì quatro dì di diciembre
> Ancho xlviii libre al maestro Duccio dipegnitore, per suo salario d'una tavola ovvero Maestà che fecie e una predella,[49] che si posero nell'altare nela chasa de' Nove, là due [=dove] si dicie l'ufficio, et davemone puliçia da' Nove.[50]

> Tuesday, 4 December 1302
> Item, 48 lire to Master Duccio, the painter, as his salary for a panel, or indeed, a Maestà that he made, and for a predella, which are located on the altar of the house of the Nove, where the service is said; and we have a voucher for it from the Nove.

Published: Von Rumohr, 1827-31, 2: 11-12; Milanesi, 1854, 1: 168 (without transcription); Lisini, 1898, 45; Weigelt, 1911, 13; Bacci, Siena, 1944, 4; Brandi, 1951, 82-83 (incomplete transcription and with a bizarre argument concerning Segna di Bonaventura and this work); Romagnoli (ca. 1800-35), 1976, 1: 354 (incomplete transcription and as Biccherna 190); Stubblebine, 1979, 1: 200; White, 1979, 191.

37. 1302, 22 December

ASS, Biccherna 117 (Entrata e Uscita, July-December 1302), f. 201v (ink):[51]

> Sabato vintedue dì diciembre
> Ancho v soldi da Duccio Buoninsegnie dipegnitore per uno bando dato a llui dinançi al giudice del Malificio del Terço di Chamollia.[52]

> Saturday, 22 December 1302
> Also, 5 soldi from Duccio di Buoninsegna, the painter, for a condemnation proclaimed against him before the criminal judge of the Terzo di Camollia.

Published: Lisini, 1898, 49 (without full citation); Weigelt, 1911, 13; Brandi, 1951, 84 (strangely associating the fine with witchcraft); Stubblebine, 1979, 1: 200; White, 1979, 191.

38. 1304, 16 August

ASS, Diplomatico, Archivio Generale, Parchment 948:

> In nomine Domini amen. Anno Domini millesimo ccc.º quarto, indictione secunda, die xviº mensis Agusti. Appareat omnibus evidenter quod in presentia mei notarii et testium infrascriptorum ser Ghuccius Bonfilioli de Lestinis et domina Olliente uxor eius, ut dicxit [sic] filia Gionte Rustichelli de Castellina,

dederunt et tradiderunt Mino, filio quondam ser Bonamichi notarii, civi senen-
si, vocato Donugo, tenutam et corporalem possessionem unius petie terre et
vinee posite prope Senas in contrata de Castagneto prope Tressam, cui ex una
parte et accapite est Duccii pictoris et ex alia via et a pede magistri Nerii ling-
naminis et Signorelli Mochi, vel si qui alii sunt confines, et ipsum in eam
induxerunt, capiendo eum per manum et ducendo eum in dictam terram et
vineam et per eam et dando et mictendo in manibus suis et ipse recipiendo de
glebis et vitibus et uvis dicte terre et vinee. Et ipse sua auctoritate ingressus fuit et
apprehendit dictam tenutam et possessionem dicte vinee et terre, et alia faciendo
que ad veram tenutam et corporalem possessionem fieri pertinent et expectant.
Quam vineam terram dicti ser Ghuccius et donna Olliente vendiderant dicto
Mino, de qua venditione factum fuit instrumentum manu ser Fey magistri
Gratie notarii, ut dicxerunt [sic] predicti venditores et emptor.

Actum in dicta vinea et terra, coram Ghuccio Teste et Lando olim Guidonis
testibus presentibus et rogatis.

Ego Palmerius notarius, filius quondam ser Palmerii vive notarii, predictis inter-
fui et ea rogatus scripsi et publicavi.

In the name of the Lord, amen. A.D. 1304, the second indiction, the sixteenth
day of the month of August. Let it appear manifestly to all that in the presence
of my notary and of the witnesses inscribed below, Ser Guccio Bonfigliolo of
Lestine and Mistress Ollienta, his wife, as stated, the daughter of Giunta
Rustichelli da Castellina, gave and transferred to Mino, son of the late Ser
Bonarvico, the notary and citizen of Siena, called Donugo, the tenancy and
physical possession of one piece of land and a vineyard situated near Siena, in
the district of Castagneto, near Tressa, adjoined on one side and at the top by
[the property of] Duccio, the painter, and on the other by the road and at the
bottom by [the property of] Master Nerio, the carpenter, and of Signorelli
Mochi, or whoever else are the neighbors. And they have brought said man
into possession of the property by him into the same land and vineyard and
through it and by giving him and putting into his hands and the same receiv-
ing some of the soil and vines and produce of the said land and vineyard. And
he by his own authority entered upon and took possession of the said tenancy
and physical possession of the vineyard and land and doing the other things
which should and are required to be done for a true tenancy and physical pos-
session. This vineyard and land the said Ser Guccio and Mistress Ollienta sold

to the said Mino, of which sale the deed was made by the hand of Ser Fei di Maestro Grazia, notary, in accordance with the aforesaid vendors and buyer.

Transacted in the said vineyard and land in the presence of Guccio Teste, and Lando di Guido, who were present and called as witnesses.

I, Palmerio, notary, son of the late Ser Palmerio Viva, notary, was in the presence of the aforesaid and, as requested, wrote and published this.

Published: Lisini, 1898, 49; Weigelt, 1911, 13; Brandi, 1951, 82 (without transcription); Stubblebine, 1979, 1: 200-201 (as Parchment 478); White, 1979, 191-92 (with the old signature of the Opera Metropolitana and minor variations).

39. 1308, 9 October
ASS, Diplomatico, Opera della Metropolitana, Parchment 603, 9 October 1308:

On the recto:

Carta di pacti fatti col maestro Duccio per cagione dela tavola Scte Marie

On the verso:

Anno Domini MCCCVIII, indictione vii, die viiii mensis octubris. Appareat omnibus evidenter, quod dominus Jacobus quondam domini Giliberti de Mariscottis de Senis, operarius operis sancte Marie civitatis Senarum, nomine et vice dicti operis, et pro ipso opere ex una parte; et Duccius pictor, olim Boninsegne civis senensis ex altera parte; cum ipse Duccius accepisset a dicto operario ad pingendum quandam tabulam, ponendam supra maiori altari maioris ecclesie sancte Marie de Senis; comuniter et concorditer fecerunt inter se pacta et conventiones infrascripta et infrascriptas, et pepigerunt et promiserunt sibi invicem inter se, occasione laborerii dicte tabule faciendi et complendi, prout, inferius continetur.

In primis videlicet, quod dictus Duccius promisit et convenit dicto Domino Jacoppo operario, recipienti et stipulanti pro dicto opere sancte Marie, et eius nomine, pingere et facere dictam tabulam quam melius poterit et sciverit, et Dominus sibi largietur; et laborare continue in dicta tabula, temporibus quibus laborari poterit in eadem; et non accipere vel recipere aliquod aliud laborerium ad faciendum, donec dicta tabula completa et facta fuerit. Dictus autem dominus Jacoppus operarius, nomine dicti operis et pro eo, dare et solvere promisit dicto Duccio, pro suo salario dicti operis et laborerii, sedecim soldos denariorum senensium pro quolibet die, quo dictus Duccius laborabit suis manibus in dicta tabula; salvo quod, si perderet aliquam doctam diei, debeat exconputari

de dicto salario, pro rata docte sive temporis perditi. Quod quidem salarium, idem operarius, nomine quo supra, dare teneatur et promisit dicto Duccio, hoc modo videlicet: quolibet mense quo dictus Duccius laborabit in dicta tabula, dare eidem Duccio decem libras denariorum in pecunia numerata, et residuum dicti salarii exconputare in denariis, quos idem Duccius dare tenetur operi sancte Marie supradicto. Item promisit dictus operarius nomine supradicto, furnire et dare omnia que necesse erunt pro dicta tabula laboranda: ita quod dictus Duccius nihil in ea mictere teneatur, nisi suam personam et suum laborem.

Et predicta omnia et singula sibi ad invicem inter se actendere et observare et facere et adimplere promiserunt, dictus dominus Jacoppus, nomine dicti operis, et dictus dominus Jacoppus, nomine dicti operis, et dictus Duccius pro ipso et suo nomine: et unus eorum alteri promisit nominibus supradictis, sub pena et ad penam XXV librarum denariorum senensium: quam penam sibi ad invicem inter se antedictis nominibus dare et solvere promiserunt, et unus eorum alteri promisit in quolibet et pro quolibet articulo predictorum, si conmissa fuerit; et ea data, commissa, soluta, vel non, predicta firma perdurent; et in predictis omnibus et singulis, et pro eis servandis obligaverunt sibi ad invicem, et unus eorum alteri obligavit: scilicet dictus dominus Jacoppus, tamquam operarius, se et successores suos, et dictum opus et bona eius presentia et futura; et dictus Duccius se et suos heredes et bona omnia presentia et futura, pignori; et renunctiaverunt exceptioni non factorum pactorum dictorum, et non factarum promissionum et obligationum, rei dicto modo non geste, fori privilegio et omni jurium et legum auxilio.

Insuper dictus Duccius ad maiorem cautelam, juravit sponte ad sancta Dei evangelia, corporaliter tacto libro, predicta omnia et singula observare et adimplere bona fide, sine fraude, in omnibus et per omnia, sicut superius continetur. Quibus domino Jacoppo et Duccio supradictis volentibus, et predicta confitentibus, precepi ego notarius infrascriptus, nomine juramenti, guarentigie, secundum formam capituli Constituti senensis, quod hoc instrumentum observent per singula, ut supra continetur.

Actum Senis, coram domino Ugone de Fabris, judice Nerio domini Gabrielli et Tura Bartalommei testibus presentibus et rogatis.

Ego Paghanellus notarius filius Dietifecis notarii predictis interfui et ea rogatus scripsi et publicavit.[53]

On the verso:

Document of agreements made with Master Duccio by reason of the panel of Santa Maria.

On the recto:

A.D. 1308, indiction 7, day 9 of the month of October. Let it appear manifestly to all that Lord Jacopo, son of the late Giliberto de Mariscotti of Siena, clerk of works of the Opera of Santa Maria of the city of Siena, in the name of and for the said Opera and for this work, on the one part, and Duccio di Buoninsegna, the painter, citizen of Siena, on the other part—whereas the same Duccio undertook from the said clerk of works the task of painting a certain panel to be placed on the high altar of the great church of Santa Maria of Siena, they jointly and amicably made between them the contract and agreements written below and covenanted and pledged and promised mutually, each to the other, concerning the execution and completion of the said panel, as is contained below.

In the first place, that the said Duccio promised and agreed with the said Lord Jacopo, clerk of works, who is presiding and stipulating for the debtor's guarantee on behalf of the said Opera of Santa Maria and in its name, to make the said panel to the utmost of his capability and faculty, which the Lord bestowed upon him—and to work continuously upon the said panel at such times as he was able to work on it—and not to accept or receive any other work to be carried out until the said panel shall have been made and completed. Moreover, the said Lord Jacopo, clerk of works, in the name of and on behalf of the said Opera, promised to give and pay the said Duccio, as his salary for the said project and labor, 16 soldi of Sienese money for each day that the said Duccio shall work with his own hands on the said panel, except that if he should lose any part of the day there should be a deduction from the said salary, established in proportion to the part, or of the time, lost; in fact, the same clerk of works, as named above, is bound and promises to give this salary to the said Duccio in this way, namely, for any month that the said Duccio shall work on the said panel, to give to the same Duccio 10 lire of denari in cash and to deduct in denari those parts of the said salary which the said Duccio binds himself to give to the aforesaid Opera of Santa Maria. In like manner, the said clerk of works, named above, promises to supply and to give all those things that shall be needed for the working of the said panel, so that the said Duccio shall be bound to put nothing into it except his person and his work.

And the said Lord Jacopo, in the name of the said Opera, and the said Duccio, for himself and in his name, promised each other reciprocally to carry out and observe and to do and to fulfill each and all of the aforesaid, and each one promised the other, in the names of the aforesaid, under penalty and for a penalty of 25 lire of Sienese denari, which penalty they promised reciprocally, each to the other, in the aforesaid names, to give and to pay, and each promised this to the other in every and for every article of the aforesaid, if it shall have been contracted, and whether it has been given, contracted, paid, or not, the afore-mentioned agreements shall continue binding. And they pledged themselves each to the other, with respect of each and all of the aforesaid and for their keeping the pledges, and each of them bound himself to the other, namely the said Lord Jacopo, as clerk of works, binding himself and his successors and the said Opera and its present and future goods and the said Duccio binding himself and his heirs and all present and future goods as security, and they renounced the exception of non-completion of contracts and non-fulfilment of promises and obligations, if the matter is not performed in the said way, by right of the court and with all support of the codes and laws.

Moreover, the said Duccio, for greater precaution, swore voluntarily on the Holy Gospels of God, physically touching the book, that he would observe and implement each and everything stated above in good faith and without fraud, in respect to all things and in all things as contained above—Lord Jacopo and Duccio, as above-mentioned, desiring and agreeing to the aforesaid, I the under-signed notary, admonished them by way of oath and guarantee, according to the form of the established chapters of the Sienese constitution, to observe this contract in every respect, as is entered above.

Transacted in Siena, in the presence of Lord Ugone de' Fabri, judge, Neri di domini Gabrielli, and Tura Bartolomei, who were present and called as witnesses.

I, Paganello, notary, son of Dietifeci the notary, was present with the aforesaid and wrote and published these things as requested.

Published: Gigli, 1723, 428 (cited); Della Valle, 1785, 2: 75-76; Milanesi, 1854, 1: 166-68; Lisini, 1898, 21 (cited without transcription); Brandi, 1951, 84-85 (with incomplete transcription, but Parchment 603 cited); *Catalogo della Mostra e del Museo delle Tavolette Dipinte*, 1956, no. 94, tav. XIII; Romagnoli (ca. 1800-35), 1976, 1: 356-59 (cited as "cartapecora 399"); Stubblebine, 1979, 1: 201-2 (as Parchment 603); White, 1979, 192-93 (as Parchment 603).

40. 1308, 20 December
ASS, Diplomatico, Opera della Metropolitana, Parchment 608, 20 December 1308:

Anno Domini MCCCVIII°, indictione viia, die xxa mensis decembris. Ego magister Duccius, pictor, olim Boninsegne, civis senensis, pro me ipso facio et constituo me principalem debitorem et pagatorem vobis domino Iacoppo quondam domini Giliberti de Mariscottis, operario Operis Sancte Marie de Senis recipienti et stipulanti pro dicto Opere et eius nomine, in quinquaginta florenis de bono et puro auro et recto pondere, quos a vobis dante et mutuante pro dicto Opere et de ipsius pecunia mutuo numeratos de vero et puro capitali, non spe future numerationis, habuisse et recepisse confiteor. Et dictos L florenos auri vobis recipienti ut dictum est, reddere et solvere promicto hinc ad kalendas januarii proxime venturi in civitate Senarum vel alibi cumque locorum et terrarum me inveniretis pro dicto opere et volueritis convenire. Et reficere et restituere promicto vobis recipienti ut dictum est omnia et singula dampna expensas et interesse que et quas in curia et extra, feceritis et substinueritis pro dictis florenis rehabendis vel eorum occasione, ut vestro simplici verbo sine alla probatione, dixeritis vos fecisse. Et in hiis omnibus et singulis et pro eis me et meos heredes et bona mea omnia presentia et futura vobis, dicto modo recipientibus, pignore obligo. Quorum liceat vobis, recipientibus ut dictum est propria auctoritate, sine iudicis vel curie inquisitione seu alterius contradictione, possessionem et tenutam ingredi et accipere corporalem, et ea et ex eis vendere distrahere et alienare. Et interim dicta bona pro vobis dicto opere et vestro et euis nomine prodictis me constituo possidere. Renuntians exceptioni non habite et non recepte et non numerate dicte quantitis florenorum mutuo, ut dictum est, et non factarum promissionum et obligationum dictarum, rei dicto modo non geste, fori privilegio et omni juris et legum auxilio. Cui Duccio debitori predicto, volenti et predicta confitenti, precepi ego notarius infrascriptus, nomine iuramenti guarantisie secundum formam capituli constituti Senarum, quod dictos florenos reddat et solvat dicto creditori recipienti ut dictum est, in termino supradicto et hoc instrumentum observet per singula ut superius continetur.

Actum Senis coram Andrea magistro lapidum olim Venture et Naldo ser Pagni, testibus presentibus et rog.

Ego Paghanellus notarius filius Dietifecis notarii predictis omnibus interfui et ea rogatus scripsi et publicavi.

——◦——

A.D. 1308, the seventh indiction, the twentieth day of the month of December. I, Master Duccio di Buoninsegna, the painter, a citizen of Siena, on my own

behalf, make and constitute myself principal debtor and payer to you, Lord Jacopo, son of the late Lord Giliberto de Mariscotti, clerk of works of the Opera of Santa Maria of Siena, receiver and stipulator for and in the name of the said Opera, in the sum of 50 florins of good and pure gold of true weight, which I acknowledge that I have had and received from you as giver and lender for the said Opera, which money having been mutually counted with true and honest addition with no expectation of future counting. And I promise to return and pay the said 50 florins of gold to you, the receiver as aforesaid, henceforth to the next forthcoming first of January, in the city of Siena or elsewhere, in whatsoever place or territory you, on behalf of the said Opera, shall find me and shall wish me to meet you, and I promise to return and restore to you, as the aforesaid receiver, each and all losses, expenses, and interest which and whichever you shall have made and sustained, in court or out of court, for repossession of the said florins or on account of them, as you shall say you have made, by your simple word, without other proof. And in each and all these things and for them, I bind myself and all my present and future goods as pledge to you, the receiver, in the said manner. It shall be lawful for you the receiver of which things, as has been said, with the proper authority, to enter into and to take over physical possession and ownership without investigation by judge or court or opposition of another, and to sell, divide and transfer ownership of them or part of them, and in the meantime, I agree that I possess the said goods on behalf of you and of the said Opera, in your name and in its name as aforesaid, renouncing the counterclaim that the said quantity of florins has not been had, received, or counted out between ourselves and that the aforementioned promises and obligations have not been carried out by reason of the affair not being executed in the aforementioned way; by the prerogative of the court with every assistance of law and right. I, the undersigned notary, by way of oath enjoined this guarantee, according to the chapters of the Sienese constitution, on the aforesaid Duccio, who as debtor desired and agreed the aforesaid, that he should return and pay the said florins to the said creditor and receiver, as is said, within the aforesaid limit and that he observe this contract in every respect, as is contained above.

Transacted in Siena, in the presence of Andrea di Ventura, master mason, and Naldo di Ser Pagno, who were called and present as witnesses.

I Paganello, notary, son of Dietifeci the notary, was present for all the aforesaid and have written and published these things as requested.

Published: Milanesi, 1854, 1: 169-70; Weigelt, 1911, 14; Brandi, 1951, 85 (incomplete transcription); Romagnoli (ca. 1800-35), 1976, 1: 360 (cited only); Stubblebine, 1979, 1: 202-3; White, 1979, 194.

41. 1308/09 (?)

AODS, 25, "Libro di documenti artistici," Document I, f. 1r (pencil) [not dated]:

> In nomine Domine amen. Questa è la concordia che Buonaventura Bartalomei e Parigiotto ebero inssieme [*sic*] del fatto dela tavola de' lavorio dela parte dietro.
>
> Conosconno ce sono trenta quatro storie principalmente, le quali stimano per la magioreçça d'alcuna d'esse storie ale comunali et per li angieletti di sopra et per alcun'altra opera se vi si richedesse di penello, che le dette storie sieno trentaotto, et per trentaotto siea [*sic*] pagato, et abia et aver debia di ciasceduna storia due fiorini d'oro et meçço, fornendo esso maestro Duccio tutto ciò che ffa [*sic*] mistiero di penello, e l'Operaio dell'Opera debia fornire di colore et d'altro che bisognasse. Del quale pagamento debia avere il maestro Duccio ora contanti cinquanta fiorini d'oro, e l'altri debia avere scontati questi sicome servirà per storia.[54]

<div align="center">⟶◆⟵</div>

> In the name of the Lord, amen. This is the agreement that Buonaventura Bartolommei and Parigiotto arrived at together concerning the work on the back side of the panel.
>
> They acknowledge that there are, in essence, thirty-four scenes, but because a few of these are larger than the average scene and also because of the little angels on top and because of any other work that might require painting, the said scenes shall be valued as thirty-eight; and he is to have and is owed two and one-half gold florins for each scene, Master Duccio furnishing all that is necessary to the craft of the brush; and the clerk of works of the Opera must furnish the pigments and all else that might be necessary. Of the total sum he is owed, Master Duccio is to receive 50 gold florins now, and he shall receive the rest, with the deduction of these [50 florins], as the work proceeds, scene by scene.

Published: Romagnoli (ca. 1800-35), 1976, 1: 360, (as "N⁰ 125r,"[55] with the date 1308); Milanesi, 1854, 1: 178 (indicating the document is found in the "Libro dei documenti artistici, 1" and proposing the date 1310?); Lisini, 1898, 36 (quoting Milanesi but with no date); Weigelt, 1911, 15; Brandi, 1951, 85 (incomplete transcription, with the date of 1308-9, and rejecting Milanesi's proposed date of 1310?); Stubblebine, 1979, 1: 203-4

(with the date 1310?); White, 1979, 195 (with the date 1308-9).

42. 1309
ASS, Biccherna 727 (Libro delle Condanne, 1309), f. 116r (pencil), f. 164r (ink); f. 121r (pencil), f. 169r (ink):

> f. 116r (pencil), f. 164r (ink):
> In nomine Domini amen. Infrascripti sunt debitores solventes banna et decimas extracti de libris Ser Antonii Jacobi notarii.

> f. 121r (pencil), f. 169r (ink):
> Duccius pictor de populo Sancti Donati et contrata de Ca[m]poregio, fuit exbannitus in C libris denariorum senensium.

> Nello predicto, in folio cx[56]

> f. 116r (pencil), f. 164r (ink):
> In the name of the Lord, amen. The following are those who must pay penalties and court costs, taken from the books of Ser Antonio di Jacopo, notary.

> f. 121r (pencil); f. 169r (ink):
> Duccio the painter from the Parish of San Donato and the contrada of Camporegio was penalized in the amount of 100 lire.

> In the above-mentioned register, on folio 110.

Published: Stubblebine, 1979, 1: 203.

43. 1310
ASS, Biccherna 728 (Libro delle Condanne, 1310), f. 151r (ink); f. 154r (ink):

> f. 151r (ink):
> In nomine Domini amen. Infrascripti sunt exbanniti extracti de libris ser Mini Bandini notarii, scribe et offitialis Comunis senensis ad bancum assessoris terçerii Camollie.[57]

> f. 154r (ink):
> Duccius Bonensegne, pictor de populo Sancti Quirici Castri Veteris et contrata de Stallereggio, fuit exbannitus in xxiiii libras denariorum senensium, dicto Minuccio procuratori predicto, folio dicto xxxviii.[58]

> f. 151r (ink):
> In the name of the Lord, amen. The following are those penalized, taken from the books of the notary Ser Mino Bandini, a scribe and official of the Commune of Siena in the Court of the Terzo of Camollia.

f. 154r (ink):

Duccio di Buoninsegna, the painter, from the Parish of San Quirico in Castelvecchio and the contrada of Stalloreggi was penalized in the amount of 24 lire of the coinage of Siena, to the said Minuccio, the aforementioned administrator, in said folio 38.

Published: Stubblebine, 1979, 1: 204.

44. 1310, 28 November

ASS, Diplomatico, Opera della Metropolitana, Parchment 614, 28 November 1310:

In nomine Domini amen. Omnibus appareat evidenter quod cum ad officium dominorum Novem gubernatorum et defensorum comunis et populi Senenarum et ad ipsos dominos Novem pro Comuni Senarum pertineat et expectet habere curam, sollicitudinem et amorem circa Operam beate Marie semper Virginis et circa conservationem dicti operis seu opere et circa cessandas expensas inutiles que incumbunt opere supradicte et ad expensas utiles acceptandas et volendas pro ipsa opera conservanda, consiglio dominorum Novem gubernatorum et defensorum comunis et populi Senensis choadunato in eorum consistorio novi palatii dicti comunis, in quo dicti domini Novem morantur ad eorum officium exercendum dictum consilium dictorum dominorum Novem, nemine discordante, audita et diligenter inspecta provisione facta per discretos et sapientes viros de civitate Senarum, electos et deputatos specialiter super providienda utilitate et commodo dicte opere et super necessariis et opportunis operibus faciendis in opere supradicta. Et habita super predictis deliberatione plenaria, invocato nomine Yesu Christi et beate Marie Virginis matris sue et habito tractatu solempni de predictis, voluit, firmavit atque decrivit, consideratis redditibus et facultatibus et expensis dicte opere, facto diligenti partito secundam formam statuti quod in operando et faciendo et fieri facendo opera su opus musaicum quod est inceptum, et etiam in laborerio nove et magne tabule beate Marie semper Virginis gloriose, sollicite et cum omni diligentia procedatur, ita quod quam citius fieri poterit compleantur, ad laudem et reverentiam Salvatoris et Beate Virginis matris sue et omnium sanctorum et sanctarum Dei. Et quod in laboreris omnibus faciendis et super eis complendis, stent et remaneant solum decem magistri de melioribus et utilioribus dicte Opere, tantum et non plus, consideratis facultatibus, redditibus et proventibus dicte Opere; aliis vero magistris omnibus detur commiatum et quod removeantur a laboreriis opere supradicte, cum ipsius opere redditus, facultates et proventus non sint sufficientes ad tales et tantas et sic intollerabiles substinendum. Quorum decem magistrorum nomina hec sunt.

Magister Chamainus Crescentini Magister Vannes Palmerii

Magister Andreas Venture Magister Tura Paghaniscii

Magister Vannes Bentivegnie Magister Corsinus Guidonis

Magister Tofanus Manni Magister Ciolus Maffei et

Magister Cieffus Venture Magister Tuccius de la Fava

Ego Ioannes Paghanelli notarius et nunc scriba dictorum dominorum Novem superdicte riformationi et concordia dicti consilii interfui ut supra continetur,[59] de mandato discreti et sapientis viri Antonii magistri Pacis, prioris dictorum dominorum Novem mihi facto Senis in dicto[60] Concistorio coram[61] ser Pasquali Fedis notario et Ventura Guitonis, testibus presentibus. In anno Domini MᵒCCCXᵒ, indictione VIIIIᵃ, die XXVIIIᵒ Novembris, sub scripsi et publicavi, rogatus.[62]

⸻ ✦ ⸻

In the name of the Lord, amen. Let it appear manifestly to all that, since it is expected of and pertains to the office of the Nove, the governors and defenders of the Commune and people of Siena and to the same Nove, for the Commune of Siena to have care and solicitude and love concerning the Opera of the Blessed Mary ever Virgin and concerning the maintenance of the said work or works and concerning the cessation of useless expenses, which weigh upon the aforesaid works, and for the accepting and determining of useful expenses for the maintenance of the same Opera, with the counsel of the Nove, the governors and defenders of the Commune and people of Siena, gathered together in their council chamber in the new palace of the said Commune, in which the said Nove remain for the purpose of exercising their office, the said council of the said Nove, with no one in disagreement, having heard and diligently inspected the provision made by the distinguished and judicious men of the city of Siena, specially elected and deputed to provide for the said works with utility and profit and for the doing of necessary and appropriate works in the aforesaid Opera. Having had a full deliberation on the aforesaid, the name of Jesus Christ and of the Blessed Virgin His mother having been invoked, and having treated solemnly of the aforesaid, the Council wished, confirmed, and decreed, having considered the income and means and expenses of the said Opera and made careful allocation according to the form of the statute, that, as regards carrying out and doing and commissioning of the works or work in

mosaic, which is begun, and also as regards the work on the new and great panel of the blessed and glorious Mary ever Virgin, it should be carried out carefully and with all diligence, so that they should be completed as speedily as it can be done for the praise and reverence of the Savior and of the Blessed Virgin His mother and of all the men and women saints of God, and that for the doing of all these works and for their completion, there shall stay and remain only ten of the best and most useful masters of the said Opera, so many and no more, the means, income, and provision for the said works being considered; to all the other masters, indeed, leave of absence is granted, and the council decrees that they be removed from the undertakings of the aforesaid Opera, since the income of the same Opera and its means and provision are not sufficient to sustain such and so great and so intolerable burdens.

Of which ten masters these are the names:

Master Camaino di Crescentino	Master Vanni di Palmerio
Master Andrea di Ventura	Master Tura di Paganiscio
Master Vanni di Bentivegna	Master Corsino di Guido
Master Tofano Manni	Master Ciolo Maffei
Master Ceffo di Ventura	Master Tuccio de la Fava

I, Giovanni di Paganello, the notary, and now the scribe of the said Nove, was present at the above-mentioned decision and agreement of the said council as is contained above, at the command of the distinguished and judicious man Antonio di Maestro Pace, Prior of the said Nove, executed by me at Siena in the said council chamber, in the presence of Ser Pasquale Fedi, the notary, and of Ventura di Guido, present as witnesses, in the year of the Lord 1310, the 9th indiction, on the 28th day of November, I wrote and published this as requested.

Published: Füessli, 1806, 2: 304 (cited only); Von Rumohr, 1827-31, 2: 9; Milanesi, 1854, 1: 175-76; Lusini, 1909, 75; Stubblebine, 1979, 1: 204-5 (as Parchment 614, and with several passages of the text above omitted); White, 1979, 195-96.

45. 1311, after 21 March–1 December[63]

ASS, Lira 7 (1311-1312), f. 117r (ink); f. 123r (pencil); f. 158r (pencil):[64]

> f. 117r (ink):
> Livra di Stallereggi dentro

> f. 123r (pencil):
> Duccio Dipegnitore

> f. 158r (pencil):
> Livra di Stallereggi di fuore
> Maestro Duccio dipegnitore

> f. 117r (ink):
> Lira of Stalloreggi dentro

> f. 123r (pencil):
> Duccio the painter

> f. 158r (pencil):
> Lira of Stalloreggi di fuore
> Master Duccio the painter

Published: Bacci, Siena, 1944, 100-101.[65]

46. 1311, 9 June

ASS, Biccherna 125 (Entrata e Uscita, January 1310/11-June 1311), published as f. 117r (pencil), f. 261r (ink):[66]

Untraced

> Ancho viii sol. a Malfarsetto Buoninsegne, a Pericciulo Salvucci, a Certiere Guidi, a Marco Cierreti, trombatori et ciaramella et nachare del chomune di Siena, per una rinchontrata che feciero de la tavola de la Vergine Maria, a ragione di due soldi per uno, sechondo la forma de' patti ch'ene tra 'l chomune di Siena e loro.

> Also, 8 soldi to Malfarsetto Buoninsegna, to Periciuolo Salvucci, to Certiere Guidi, to Marco Cierreti, trumpeters and players of shawms and kettledrums of the Commune of Siena, for greeting the panel of the Virgin Mary, at the rate of two soldi for each, according to the agreements on the matter between the Commune of Siena and them.

Published: Milanesi, 1854, 1: 169 (incomplete transcription, without precise cita-

tion, as 1310, and as 12 lire and 10 soldi); Lisini, 1898, 22; Brandi, 1951, 87 (incomplete transcription); Stubblebine, 1979, 1: 205 (as untraced); White, 1979, 196-97 (with month but not day and as untraced).

47. 1313, 9 June

ASS, Notarile antecos. 25 (ser Colletto di Chele, 1310-11), f. 39r (pencil):[67]

> Die VIIII Iunii, Senis. Coram Mino Niccholai et Meo Co[m]pagni testibus presentibus. Ego magister Duccius quondam Buoni[n]segne, de populo Sancti Quirici Castri Veteris, facio me debitorem tibi Ser Thomuccio quondam Dini in XL libris denariorum senensium causa mutui hinc ad VI menses.

> The ninth day of June, in Siena. In the presence of Mino Niccoli and Meo Compagni, I, Master Duccio, of the late Buoninsegna, of the parish of San Quirico of Castelvecchio, constitute myself as debtor to you, Ser Tomuccio of the late Dino, in the amount of 40 lire of the Sienese denari, on account of a loan, henceforth for a period of 6 months.

Published: Lisini, 1898, 50; Weigelt, 1911, 18 (cited only); Brandi, 1951, 87 (as 8 June); Stubblebine, 1979, 1: 205 (stating that "the specific day was unaccountably omitted by the scribe"); White, 1979, 197.

48. 1315, 16 September

ASS, Gabella 3, f. 225v:

Untraced[68]

> Rimessi per lo libro de' residui d'Arciano.
> Maestro Duccio dipentore die avere per mezo settembre trecento xv, ne' libro de' residui fo. xv, col terzo più, xviii sol. iiii.den.
> Scritti nel libro di Camolia fo. cccxi.

> Reimbursements for the book of residues of Arciano.
> Master Duccio, the painter, has to have for the month of September 1315, in book of residues folio 15 with the added third, 18 soldi, 4 denari.
> Entries in the book of Camollia f. 311.

Published: Bacci, 1932, 243; Stubblebine, 1979, 1: 205-6; White, 1979, 197 (citing the volume as lost).

49. 1315, 15 October

ASS, Consiglio Generale 86, ff. 121v-125v (pencil and ink):

This lengthy document concerns the leasing of agricultural land by the Commune of Siena in Pian del Lago, a few kilometers north of the city. The annual rent was 3,240 florins. The names of the seventy-four tenants are registered on folios 122r and 123r, without specifying the individual rents. The name "Duccio Boninsegne pictori" appears on folio 123r. During this time, the Commune of Siena rented land for short periods as a source of income. The date is established as "millesimo CCCXVº, indictione[a] xiiii, die quintodecimo mensis octubris" on folio 117r.

Published: Bowsky, 1970, 61 (in summary); White, 1979, 197 (in summary).

50. 1316/17, 25 January and 9 March
ASS, Consiglio Generale 88, ff. 33v-37v (ink), ff. 58v-62v (pencil); ff. 117r-120r (pencil), ff. 102-105 (ink):

This lengthy document refers to the same collective rent described in the preceding document concerning Pian del Lago.

The total rent owing the commune is again fixed at 3,240 florins, although in this case, eighty-three tenants are listed. Duccio appears as one of the tenants on f. 61v (pencil) (25 January 1316/17) and in another on f. 119r (pencil) (25 March 1317).[69]

Published: Bowsky, 1970, 61 (in summary); White, 1979, 197 (in summary).

51. 1318
ASS, Estimo 105 (Stalloreggi di dentro), f. 1r (pencil and ink); f. 30r (pencil and ink):

f. 1r (pencil and ink):
In nomine Domini, amen. Tabula et extimatio omnium et syngularum possessionum patrimoniorum hominum et personarum libre Stalleregii Intus, composita et ordintata et sumpta ex auctenticis libris dicte tabule per discretos viros ser Duccium Buonfigliuoli, Ser Petrum Jacobi et Ser Nosum Orlandi, notarios ad hoc deputatos per offitium dominorum Novem gubernatorum et defensorum Comunis et populi Senensi et per sotios superadiunctos per dictum offitium sub annis Domini millesimo trecentesimo octavo decimo, indictione prima et secunda.

f. 30r (pencil and ink):

Libri. CXXVI	Franciscus et Petrus Bindi habent unam
Sol. xiii	domum positam in populo Sancti Quirici
Den. iiii	et contrata de Stalleregio, qui ex uno

Magistri Duccii pictoris ex heredum Arriguccii, et alio murus Comunis, extima-
tum in libris centum-vigenti sex, sol. tredecim et den. quattuor, ut patet in libro
domorum terçerii civitatis, fo. cclxxvii.

——✦——

f. 1r (pencil and ink):

In the name of the Lord, amen. The register and estimation of each and all of
the possessions and inheritances of the men and persons in the lira of
Stalloreggi within the walls, the said register being composed and ordered and
cited from the authentic books by the distinguished men Ser Duccio
Bonfiglioli, Ser Pietro di Jacopo, and Ser Noso Orlandi, the notaries assigned in
this matter through the office of the Nove, the governors and defenders of the
Commune and people of Siena, and by the associates additionally attached
through the said office, in the year of the Lord 1318, the first and second indictions.

f. 30r (pencil and ink):

Lire 126 Francesco and Pietro Bindi have a house
Soldi 13 located in the parish of San Quirico and in
Denari 4 the district of Stalloreggi, on the one side

of which is [the house] of Master Duccio, the painter, and of the heirs of
Arrigucci, and on the other side is the city wall, estimated at 126 lire, 13 soldi,
and 4 denari, as appears in the book of the houses of the inhabitants of the
Terzo di Città, fol. 277.

Published: Lisini, 1898, 50-51 (partial transcription and either an old or erroneous
citation); Bacci, 1932, 246; Brandi, 1951, 87-88 (without transcription and using
Lisini's citation); Stubblebine, 1979, 1: 207; White, 1979, 197.

52. 1318

ASS, Estimo 105 (Stalloreggi di dentro), f. 153r (pencil and ink):

Lib. CX Domina Taviana, uxor olim Duccii pictoris, habet medietatem
unius domus posite Senis ad Duas Portas et libra et contrata Stallereggii Intus,
quam habet cum Bernardino et Pino Arrigucci Dietisalvi, qui ex uno Lenzi
Venture et ante strata, extimatum in centum decem libris, ut continetur in
libro repertorum domorum Terçerii Civitatis, fo. viiii. Licet dicat uxor olim
Duccii pictoris.

 Summa dicte domine Taviana—libre centum decem.

Lire 110 Mistress Taviana, wife of the late Duccio, the painter, has half of a house located in Siena at the two gates[70] and in the lira and district of Stalloreggi within the city walls, which she owns with Bernardino and Pino Arrigucci Dietisalvi, on the one side of which is that of Lenzi di Ventura and in front of which is the street, estimated at 110 lire, as is entered in the book of the lists of houses of the inhabitants of the Terzo di Città fol. 9, namely where it says the wife of the late Duccio, the painter.

Total for the said Taviana—110 lire.

Published: Lisini, 1898, 50-51; Bacci, 1932, 246; Brandi, 1951, 87-88 (without transcription, and as volume 110); Stubblebine, 1979, 1: 207; White, 1979, 198.

53. 1318
ASS, Estimo 135 (Sant'Antonio), f. 1r (ink); f. 115r (ink):

f. 1r (ink):

In nomine Domini amen. Tabula et extimatio omnium et syngularum possessionarum et patrimoniorum hominum et personarum libre Sancti Antonii, compilata ordinata et sumpta ex auctenticis libris dicte tabule. In anno Dominé [sic] mille CCCXVIII°, indictione prima et secunda, per prudentus viros ser Ducium Buonfigliuoli Ser Petrum Jacobi et Ser Nosum Orlandi notarios ad hech deputatos per offitium dominorum Novem defensorum et gubernatorum Comunis et populi civitatis Senarium et per sotios sibi adiuntos per dictum offitium dominorum Novem.

f. 115r (ink):

Domina Becta Bonisegne det [sic] libra et contrata sancti Antonii habet unum hedificium positum in dictis libra et populo et contrata de Camporegio,[71] super platea Buonsignorum, cui ex uno Guidi Guidarelli, ex alio domine Cicilie uxoris olim Lençi, ante via et retro tresepium, extimatam in octuaginta sex libris, tredecim soldis, quactuor denariis, ut patet in libro domorum Terçerii Chamollie fo. CXL. Summa pro dicta domina Becta—lib. lxxxvi, sol. xiii, den. iiii.[72]

f. 1r (ink):

In the name of the Lord, amen. The register and estimation of each and all of the possessions and inheritances of the men and persons in the Lira of Sant'Antonio, the said register being compiled, ordered, and cited from the official books of the said register. In the year of the Lord 1318, first and second indictions. By the authority of the prudent men Ser Dino Buonfigliuoli, Ser Pietro

Jacobi, and Ser Noso Orlandi, notaries assigned to these matters by the office of the Nove, the defenders and governors of the Commune and of the people of the city of Siena, and by the authority of the colleagues associated with them through the office of the Nove.

f. 115r (ink):

Mistress Betta di Buoninsegna of the lira, parish, and district of San Antonio has a building, located in the said lira and parish and district of Camporegio on the street of the Bonsignori, with the house of Guido Guidorelli on one side, and that of Mistress Cecilia, the wife of the late Lenzi, on the other, with the road in front and the path behind, estimated at 86 lire, 13 soldi, and 4 denari, as appears in the book of the houses of the inhabitants of the Terzo di Camollia f. 140. The total for the said lady Betta—86 lire, 13 soldi, 4 denari.

Published: Lisini, 1898, 50-51; Bacci, 1932, 246; Bacci, Siena, 1944, 15;[73] Brandi, 1951, 88-89 (as Estimo di Sant'Antonio, no. 30); White, 1979, 198.

54. 1319, 16 October

ASS, Consiglio Generale 92 (June-December 1319), ff. 89r-94v (ink), ff. 120v-125v (pencil):

f. 120v (pencil), f. 89r (ink):

In nomine Domini, amen. Anno ab incarnatione Domini mcccxviiii, indictione tertia, die sexta decima mensis octubris, secundum morem et consuetudinem civitatis Senarum.

f. 123v (pencil), f. 92v (ink):

Item cum Ambrogius, Andreas, Galganus, Thomè, Giorgius, Margarita, et Franciscus fratres, filii olim Duccii Buoninsegne pictoris, de populo Sancti Quirici in Castro veteri, solverint inter omnes in generali cabella Comunis Senarum viginti soldos denariorum Senensium pro repudiatione seu abstinentia hereditatis dicti olim Duccii patris eorum, et ipsum hereditatem repudiaverint seu se ab ea abstinuerint in generali consilio campane comunis Senarum, prout exinde dicitur esse carta facta manu ser Raynerii Barnardi notarii sub anno Domini MCCCXVIIII, indictione secunda, die tertio mensis Augusti vel alio: si videtur et placet dicto presenti consilii quod auctoritate, vigore et baylia huius presentis consilii, dicta repudiatio seu abstinentia dicte hereditatis facta per dictos filios olim dicti Duccii sit firma et rata et fit quod per hoc presens consilium approbetur et per approbata habeatur et iusta, in Dei nomine consulatis.

f. 124r (pencil), f. 93r (ink):

Dominus meus Tighi Lei, judex, surgens in dicto consilio ad dicitorium, arrengando super dicto tertio dicte proposite articulo de facto approbandi dictam repudiationem seu astinentiam dicte hereditatis factam per dictos filios dicti olim Duccii, et super hiis que et de quibus in dicto tertio dicte proposite articulo continetur et mentio fit, dixit et consuluit quod dicta reputiatio seu astinentia dicte hereditatis sit firma et rata et quod auctoritate presentis consilii approbetur et pro approbata habeatur et justa, prout in dicto tertio dicte proposite articulo plenius continetur et mentio fit.

f. 124v (pencil), f. 93v (ink):

Bonaventura Bartholomei surgens in dicto consilio ad dicitorium, arengando super dicto tertio dicte proposite articulo de facto dicte repudiationis seu astinentie dicte hereditatis facte per dictos filios olim Duccii Boninsegne pictoris, et super hiis que et de quibus in eo continetur et mentio fit, dixit et consuluit, quod subspendit dictum tertium dicte proposite articulum de hinc ad unum mensem proxime venturum et quod in fine dicti mensis ad simile consilium reponatur.

f. 125r (pencil), f. 94r (ink):

Summa et concordia predicti consilii super dicto tertio dicte proposite articulo de facto approbandi dictam repudiationem seu astinentiam dicte hereditatis, factam per dictos filios dicti olim Duccii Boninsegne pictoris, et super hiis que et de quibus in dicto tertio dicte proposite articulo continetur et mentio fit, fuit, voluit et firmavit cum dicto et consilio et secundum dictum et consilium dicti domini Meie consultoris, et fuit dictum consilium in concordia hoc modo, videlicet: Quia facto et misso de predictis et super predictis sollenni et diligenti scrutinio et partito ad bussolos et palloctas, secundum formam Statutorum Senensium per consiliarios in dicto consilio existentes, et se cum dicto et consilio dicti domini Mei consultoris ad hec concordante, misse et reperte fuerunt in bussolo albo del sì centum triginta tres pallocte et in bussolo nigro del no, in contrarium, misse et reperte fuerunt septuaginta sex pallocte. Et sic dictum consilium fuit et est obtentum, firmatum et reformatum secundum dictum et consilium dicti domini Mei consultoris, ut supra patet et plenius continetur.

———

f. 120v (pencil), f. 89r (ink):

In the name of the Lord, amen. The year from the incarnation of the Lord 1319, the third indiction, the sixteenth day of the month of October, according to the use and custom of the city of Siena.

f. 123v (pencil), f. 92v (ink):

Item, since Ambrogio, Andrea, Galgano, Tommé, Giorgio, Margherita, and Francesco, children of the late Duccio di Buoninsegna, the painter, of the parish of San Quirico di Castelvecchio, have between them all paid 20 soldi of Sienese denari into the general treasury of the Commune of Siena for the repudiation of, or restraint from, the inheritance of the said Duccio, their late father, and have repudiated or declared their restraint from the inheritance itself in the general civic council of the Commune of Siena, then according to what is said in the document made by the hand of Ser Rainerio Bernardi, the notary, on the third or on another day of the month of August, A.D. 1319, or elsewhere, you should take counsel in the name of God whether it seems good and pleasing to the said council now in session that, by the authority, force, and power of this aforesaid council, here present, the said repudiation of, or restraint from, the said inheritance carried out by the said children of the late Duccio, should be confirmed and ratified, and that through this present council, it shall be approved and taken to be approved as just.

f. 124r (pencil), f. 93r (ink):

Lord Meo di Tigo Lei, the judge, rising to the rostrum in the said council to speak on the said third article of the said proposal concerning the matter of the approval of the said repudiation of, or restraint from, the said inheritance, made by the said children of the said Duccio, deceased, and concerning those things which and about which is contained and mention made in the said third article of the said proposal, said and counseled that the said repudiation of, or abstinence from, the said inheritance should be confirmed and ratified and that, with the authority of the present council, it be approved and be taken to be approved as just, as is more fully contained and set out in the said third article of the said proposal.

f. 124v (pencil), f. 93v (ink):

Bonaventura Bartolomei rising to the rostrum in the said council to speak on the said third article of the said proposal concerning the matter of the said repudiation of, or restraint from, the said inheritance, made by the said children of the late Duccio di Buoninsegna, the painter, and concerning those things which and about which is contained and mention made in it, said and counseled that the said third article of the said proposal be suspended from this time until the next coming month and that at the end of the said month it be placed again before a similar council.

f. 125r (pencil), f. 94r (ink):

There was conclusion and agreement of the aforesaid council on the said third article of the said proposal on the matter of approving the said repudiation of, or restraint from, the said inheritance, made by the said children of the said Duccio di Buoninsegna, the painter, deceased, and concerning those things which and about which is contained and mention made in the said third article of the said proposal, and approved and agreed with the word and counsel and according to the word and counsel of the said Lord Meo, the counselor, and the said council was in accord in this manner, namely: that when a solemn and diligent scrutiny had been made and completed concerning the aforesaid and upon the aforesaid and the box and the ballots being resorted to, according to the ordinance of the Statutes of Siena for councelors sitting in the said council, and with themselves agreeing to this, with the word and advice of the said Lord Meo, the counselor, there were cast and counted in the white box of the yes 133 ballots, and in the black box of the no, on the contrary, there were put and found seventy-six ballots, and thus the said counsel was and has been approved, established, and confirmed according to the word and advice of the said Lord Meo, the counselor, as appears above and is contained in full.

Published: Davidsohn, 1900, 313-14; Weigelt, 1911, 18; Bacci, 1932, 245; Stubblebine, 1979, 1: 208 (with transcription of only f. 92v); White, 1979, 198-200 (with minor omissions).

B. DUCCIO'S SONS

55. 1326
ASS, Mercanzia 12 (formerly *Libro di giuramento dei sottoposti alle Arti*), f. 14v:

Ambruogio del maestro Duccio, del populo di San Quirico [in Castelvecchio].

Ambrogio of master Duccio, of the popolo of San Quirico [in Castelvecchio].

Published: Lisini, 1898, 42 (summarized); Bacci, 1932, 247.

56. 1339, July 27
AODS 178 (Entrata e Uscita, 10 July 1339-30 June 1340), f. 52r:

Anco a maestro Ambruogio Ducci dipentore per uno candeliere adorato, che ttiene i' mano l'agniolo dela tavola [the *Maestà*] di Duomo II libre V soldi.

Also, to master Ambrogio di Duccio, painter, for a gilded candlestick held by the angel of the panel [the *Maestà*] of the cathedral 2 lire 5 soldi.[74]

Published: Bacci, 1932, 247.

57. 1343, 15 June–10 November

ASS, Gabella dei Contratti 50 (15 June 1343), f. 38r:

> Ser Angelus ser Iohannis, notarius, denumptiavit Item die XV mensis Iunii.
>
> Galganus filius quondam magistri Duccii pictoris, populi S. Donati, recepit in dotem a domina Iohanna magistri Buondi sponsa sua C libras.
>
> Die XIII settembris solvit I libram x denarios.
>
> Item dicta domina Iohanna, cum consensu propinquorum suorum, sub titulo dotis inextimate dedit dicto Galgano, medietatem pro indiviso cuiusdem domus posite Senis, in populo S. Quirici, et certas massaritias estimationis XXX librarum.
>
> Die X novembris solvit V soldos.

> Ser Angelus Johannis, notary, certified [the following] item, the fifteenth of the month of June.
>
> Galgano, son of the late master Duccio, the painter of the parish of San Donato, received as a dowry from Mistress Johanna, daughter of master Buondi, as his betrothed, 100 lire.
>
> On the thirteenth of September she paid 1 lira and 10 denari.
>
> Item, the said Mistress Johanna, with the approval of her relatives, according to the procedure of estimating dowry, gave to the said Galgano, her partial share of a certain house in the parish of San Quirico, and certain household goods, with the value of 30 lire.
>
> On the 10th day of November she paid 5 soldi.[75]

Published: Bacci, 1932, 447.

58. 1344, 13 March

ASS, Ospedale della Scala 851 (Entrata e Uscita, 13 March 1344), f. 21r:[76]

> Giorgio di Duccio dipentore, ebe i quali fecie dare miss. Mino nostro Rettore, per dio v soldi.
>
> Giorgio di Duccio, the painter, has [funds] that our rector miss. Mino had given to him, for [the love of] God 5 soldi.

Published: Bacci, 1932, 248.

59. 1354, 25 May

ASS, Ospedale della Scala 62 (Donazioni e Obblazioni, 1348-1437), f. 17r:

L'osspedale Santa Maria e la casa della misiricordia presero concordia insieme di fare uno baracto de due case, cioè che' l decto Spedale dia a la misiricordia una casa possta in fondaco[77] et popiolo di Santo Antonio, a la quale è dinanci la via et dietro el trasepio et da lato missere Binuccio Chalonaco di Duomo et dall'altro l'erede di Duccio dipintore apo la vita di monna mina molge che fu Digiunta per esstima di Duecento libre, la quale esstima die dare la misiricordia a l'osspedale dipo' la vita della dicta monna mina.

The hospital of Santa Maria[78] and the house of the Misericordia have agreed to make an exchange of two houses, that is, the said hospital shall give to the Misericordia a house located in the district and parish of Sant'Antonio, in front of which is the street, and behind which is the path, bordered on one side by [the house of] Ser Binuccio Chalonaco of the cathedral and on the other side by [the house of] the heir to Duccio the painter, after the death of Lady Mina, wife of the late Digunta, valued at 200 lire. The Misericordia must give this value to the hospital after the death of the said Lady Mina.

Published: Bacci, 1932, 244; Romagnoli, 1976, 1: 382 (summary).

C. The Stained-Glass Oculus in Siena Cathedral

60. 1287, September[79]

ASS, Statuti del Comune di Siena 16 (1286-1289), f. 11r (ink and pencil):

Item statutum et ordinatum est quod fenestra rotunda magna que post altare beate Marie Virginis maiorjs ecclesie debeat vitriari ad requisitionem Operarii Operis eiusdem beate Marie Virginis, hoc modo scilicet quod vitrum dicte fenestre debeat haberi et emi expensis Comunis Senarum, et totum alium laborerium expensis Operarii predicti. Et Camerarius et iiii[or] provisores Comunis Senarum teneantur et debeant ad petitionem Operarii Operis S. Marie de Senis eidem Operario dare et solvere omnes expensas que fieri opporterent pro emendo vitro dicte fenestre, et si non solverent condempnentur et puniantur ipsi iiii[or] provisores Comunis Senarum, videlicet quilibet eorum in X libris denariorum Comuni Senarum [sic], quos potestas teneatur eisdem et cuilibet eorum auferre et in utilitatem Comunis convertere.

Item, it has been decided and determined that a large round window behind the altar of the Blessed Virgin Mary of the great church is to be made from glass, according to the requisition of the clerk of works of the same Opera of the Blessed Virgin Mary. Consequently, it is thus determined that the glass for the said window is to be procured and purchased at the expense of the Commune of Siena and that all other labor is at the expense of the aforesaid overseer. Both the Treasurer and the Four of the Commune of Siena are bound and obligated, according to the petition of the clerk of works of the Opera of Santa Maria of Siena, to provide and pay to the same clerk of works all expenses that may inevitably arise in purchasing the glass for the said window. Should they not pay, the Four of the Commune of Siena would themselves be fined and punished, that is to say, each of them in the amount of 10 lire of the coinage of the Commune of Siena. The power is held by the same men, each of them, to appropriate the funds and turn them to the advantage of the Commune.

Published: Bacci, Florence, 1944, 22: Carli, 1946, 14; Van Os, *Marias Demut*, 1969, 157.

61. 1288, May

ASS, Statuti di Siena 7 (1288), f. 12v (ink), f. 14v (pencil):

Et Camerarius et iiij[or] Provisores Comunis Senarum teneantur et debeant ad petitionem Operarii Operis sancte Marie de Senis eidem Operario dare et solvere omnes expensas que fieri opporterent pro emendo vitro dicte fenestre et si non solverent condempnentur et puniantur ipsi iiii[or] Provisores Comunis Senarum Comuni Senensi, videlicet quilibet eorum, in X. Libris denariorum Comuni Senenarum, quos Potestas teneatur eisdem et cuilibet eorum auferre et in utilitatem Comunis convertere.[80]

Both the Treasurer and the Four of the Commune of Siena are bound and obligated, according to the petition of the clerk of works of the Opera of Santa Maria of Siena, to provide and pay to the same clerk of works all expenses that may inevitably arise in purchasing the glass for the said window. Should they not pay, the Four of the Commune of Siena would themselves be fined and punished, that is to say, each of them in the amount of 10 lire of the coinage of the Commune of Siena. The power to appropriate the funds and turn them to the advantage of the Commune is held by these same men, each of them.

Published: Bacci, Florence, 1944, 22; Carli, 1946, 13.

62. 1288, June

ASS, Biccherna 96 (formerly 90) (January 1287/88-June 1288), f. 95r (pencil), f. 409r (ink):

> Item C libras Fratri Magio Operario Operis Sancte Marie pro Fenestra de Vitreo que fieri debet supra altare Sancte Marie.

> Item, 100 lire to Brother Magio, the clerk of works of the Opera of Santa Maria, for the glass window that is to be constructed above the altar of Santa Maria.

Published: Lusini, 1911, 86.

63. 1288, July-December

ASS, Biccherna 97 (July-December 1288), f. 143r (pencil and ink):

> Item XXV lib. Operario Sancte Marie pro vitro fenestre fiende supra altare Sancte Marie ex forma statutorum.

> Item, 25 lire to the clerk of works of Santa Maria for the glass window being made above the altar of Santa Maria in accordance with the statutes.

Published: Carli, 1946, 14.

NOTES

1 See my remarks in the Introduction to this volume. [Ed.]

2 The reference here, and in many documents to follow, is to the four *provveditori* who controlled the state treasury, assisted by the *camerlengo*, the state treasurer. The *provveditori* served six-month terms that began on the first of January or first of July. Thus, although the Sienese calendar placed the new year on March 25, the financial records were organized from January to June and from July to December. [Ed.]

3 This item is repeated in Biccherna 74, at f. 34r, and early published versions have confused the volume and folio numbers. Periodically, Sienese documents record the acquisition of painted chests and/or boxes in which the commune kept cash and important documents.

4 Santa Maria ad Sestam was not a parish in Siena itself, and it has not been possible to locate it within the diocese. Duccio Balestracci has suggested that the reference might be to a church six miles beyond the city.

5 This translation differs significantly from that in White, 1979, 185.

6 Lisini, 1898, 47, linked this and the preceding document, claiming that they appeared on folios 241r and 241v of the Biccherna account book of 1279. As the documentary citations for these two documents indicate, he confused the folio number from Biccherna 725, a book of fines, with an ordinary Entrata e Uscita volume. Also note that Lisini assigned this document to 1280 when, in modern usage, the date is 1281.

7 In this case and that of subsequent documents, Weigelt refers to summaries and/or partial quotes.

8 The oldest volume number found in the volume is on the inside of the cover: B. 39.

9 This problematic document does not identify the trade or profession of the individual involved and, most definitely, refers to him as "Guccio," but the presence of "Boninsegne" seems to make it likely that this is a scribal error for "Duccio." On the other hand, "Guccio" was a name used in Siena, and in an unpublished document of 1289, transcribed below, we find a "Ghuccio pittori" paid for painting the books of the *camerlengo* and the *provveditori*: ASS, Biccherna 101, f. 132r. [Ed.]

10 Here is a case that reminds us how problematic the older fashion of creating genealogies can be. The painter is styled "Duccio quondam Boninsegne," the witness "Lippo Boninsengne," but it would be foolish to argue that the witness was related to Duccio. [Ed.]

11 This notice is repeated in ASS, Biccherna 91, f. 389v, and, once more, the problems with citations stem from confusing volume and folio numbers. [Ed.]

12 It is common in documents of this period to find "ç" where modern spelling uses a "z". Here, as elsewhere, we have retained the original form.

13 The notice is unusual in that Duccio is taxed in the Terzo di Città on property in the parish of Sant'Egidio in the Terza di Camollia. White has suggested that this indicates the painter also had property in the Terzo di Città, but we have no other documents to confirm that hypothesis. The parish of Sant'Egidio (also styled San Gilio) was divided into two tax districts: Sant'Egidio a lato dei Rustichetti and Sant'Egidio a lato dei Malavolti.

14 There is no original ink numbering in the volume.

15 The church of San Donato, which gave its name to the parish, was on the Via dei Montanini. In 1783, the parish of San Donato was suppressed and, in 1815, added to that of the Abbazia di San Michele Arcangelo. See A. Liberti, "Chiese, Monasteri, Oratori e Spedali Senesi," *Bullettino senese di storia patria* 66 (1959): 167-69.

16 Stubblebine notes that Barone Mangiadori of San Miniato was Podestà in Siena from July to December 1289.

17 While White published this notice from Biccherna 725, he did not include the notice from the same volume, here Document 12.

18 Editor's addition. As it has become customary to treat the "Guccio" of document 6 above as a scribal error for "Duccio," I include this new notice. Further reflection on this matter may be in order. [Ed.]

19 The oldest volume number for this manuscript is B. 45.

20 The exact date, 24 January, is given on f. 63v (pencil). This item is repeated on f. 68v (pencil), f. 54v (ink) of Biccherna 105 (Entrata e Uscita, January 1290/91-June 1291). There, the date is also 24 January, but someone has added 27 January at a later time. Stubblebine used that later addition as the date for this document; he also claimed, inaccurately, that Biccherna 104 covered the period of January to June 1292.

21 The oldest volume number for this mansucript is B. 46, which appears in the middle of the present manuscript.

22 This folio also has an old and canceled ink number of f. 9r.

23 The day, 6 August, appears on the previous folio.

24 There are no ink numbers for these folios, as the pages are torn in the upper right corner.

25 The number of members in Siena's Consiglio della Campana was intermittently enlarged with fifty members of the *Radota* (a specifically Sienese term meaning "addition") when matters of great importance came before it. Duccio is listed as one of those additional members. See D. Waley, 1991, 55, 170, and Bowsky, 1970, 86-87.

26 Here is another problematic notice. The trade or profession of the named "Duccio Bonensegne" is not recorded. There has been some discussion concerning the fact that this notice puts Duccio in the parish of Sant'Antonio, when notices of 1289 and 1293 place him in San Donato. But the parish of San Donato bordered that of Sant'Antonio to the north and, in that area, was on a hillside. It is clear from other documentation of the period that the "contrata de Camporegio" lay across that border; it is sometimes in documents concerning the parish of Sant'Antonio, sometimes in notices concerning San Donato. I would also note that this document does not actually place Duccio in Sant'Antonio; it says that Duccio's house was *above* the property being discussed. [Ed.]

27 The month, September, is specified on this folio.

28 This notice is odd concerning the painter's place of residence. San Donato contained two *lire* (tax districts): San Donato a lato alla chiesa and San Donato a lato dei Montanini. Here, however, they are treated as one. [Ed.]

29 Stubblebine points out that a *presta* was a forced loan to the commune. Here, Duccio is repaid his share of the earlier forced loan, a mere 40 soldi.

30 This document appears on a folio number lower than that of the preceding document because the volume binds together an Entrata and an Uscita manuscript. As a condemnation, this item is from the Entrata section; the preceding document is from the Uscita section.

31 Stubblebine points out that this document suggests Duccio had not paid the fine noted in document 13.

32 The Curia del Placito was the Sienese Court of Wards, charged with the care of minors and women.

33 A good deal of confusion surrounds this notice. Lisini indicated that Duccio had bought a *moggio* of red wine for 6 soldi, at the rate of 2 soldi a *staio*, and dated the transaction to 27 April. Brandi took this notice from Lisini, as did White. But the actual document, transcribed above, says Duccio paid 7 lire, 8 soldi, and 2 denari for a *moggio* of wine at the rate of 6 soldi a *staio*, paid with Sienese coins worth 2 soldi apiece. At that rate, the painter acquired roughly 25 *staia* of wine. Bowsky, 1970, xvii, points out that of dry measurement 24 *staia*, each about a bushel, equaled a *moggio*. [Ed.]

34 This document, like the preceding, comes from a report to the Curia del Placito made on 11 November 1294, but a report on transactions that took place in May.

35 Stubblebine translates "discho" as "disc," but it is most likely the same as "desco," meaning a counter on which goods for sale were displayed. Such counters appear in Ambrogio Lorenzetti's *Saint Nicholas and the Three Gold Bars* (Uffizi) and in his city in the *Effects of Good Government* (Sala della Pace, Palazzo Pubblico, Siena). [Ed.]

36 We here have another reference to document 13.

37 Another matter reported on 11 November.

38 This document relates to the notice in document 24.

39 Stubblebine points out that the notary, Ser Salvi, was judge of the Curia del Placito, as indicated on f. 13r of this volume.

40 This may or may not refer to the painter Segna di Bonaventura. The odds may be slightly in favor of the former, as Segna is recorded as having property in the Parish of San Pietro a Ovile (Stubblebine, 1979, 1: 209). On the other hand, a "magistro Insegne" is named as one of the officials and masters responsible for the waterways of the Fontebranda on 30 June 1294 (ASS, Biccherna 110, f. 162v). [Ed.]

41 For the *decima*, see Bowsky, 1970, 46.

42 This date appears on f. 131r (ink and pencil).

43 This notice immediately follows that of document 29. In this period, the *cavallata*, the obligation of citizens to maintain and provide a horse for military operations, was already replaced by a financial payment. See Bowsky, 1970, 49.

44 The transcription printed here is that of Ciampi (1810), who published it without a folio number. The document is puzzling and untraced. Folios 32r and 32v of the Pisan Opera del Duomo Entrata e Uscita 79 for 1302 contain names listed under the heading "Magistri pictores maiestatis." Duccio's name is not on that list. Even if Ciampi actually had another document, it is unlikely that it refered to Duccio di Buoninsegna from Siena. In the notice Ciampi published, the origins of the master in charge are named, as is the home of the Florentine Vanni. It seems reasonable to conclude that, where origins are not named, the artists came from Pisa. This item is included here only because earlier scholars have accepted Ciampi's interpretation and associated the notice with Duccio di Buoninsegna. Author and editor both believe that association is unwarranted.

45 There is no pencil number.

46 This document and the next, which comes from the same folio of the same Biccherna volume, demonstrate how Camporegi is associated with San Donato where, in document 53, it is associated with Sant'Antonio. [Ed.]

47 There is no penciled numbering in this volume.

48 The "di" can be seen, but it is canceled.

49 Stubblebine (1972 and 1979, 1: 9) argued that this predella was painted with narrative scenes on its face. But at this date, it is far from certain that a figured predella was meant. In 1284, the commune paid 12 soldi and 6 denari for a predella to be placed on the altar of the governing Fifteen (ASS, Biccherna 86, f. 101v, and

Biccherna 87, f. 104v). It is highly unlikely that this small sum represents payment for figures or scenes. In February 1294, the commune paid master Guccio Orlandi 36 soldi for a whole list of things, including a predella in the palace of the commune (ASS, Biccherna 110, f. 112v). Again, the sum is very small. In fact, most art historians pay too little attention to the problems connected with trecento documentary mentions of predellas, almost always assuming that figured predellas are involved and are connected with altarpieces; but in some cases, at least, a platform or step before the altar was more likely meant. [Ed.]

50 It is generally assumed that this document relates to a chapel in the Palazzo Pubblico, but at this date, the palace was under construction and the Nove resided elsewhere. The reference to the "chasa de' Nove" suggests, to me, that this *Maestà* was for an altar in the Nove's residence. Almost at the same time, on 31 December 1302, the commune paid a certain "lapa di cionnj" 3 lire and 3 soldi for repairing the textile furnishings of the "altar of the Nine." See ASS, Biccherna 117, f. 361v. [Ed.]

51 There is no numbering by pencil in this volume.

52 The Curia dei Maleficii was a tribunal of criminal law, composed of two laymen, one of whom was a judge. See L. Zdekauer, 1897, lxi.

53 This document can no longer be found. We are informed by the staff of the Archivio di Stato di Siena that it may be among several documents missing and presumed stolen over the last year (June 1999). In the Duccio literature, this document has been regarded generally as the initial contract for the *Maestà*, but Pope-Hennessy (1980, 45-47) argued that it is a clarification of an original contract that probably dated between 1304 and 1306. As he noted, the matter is important, for an earlier date for the commencement of work would help explain the stylistic transformations evident in the panel, as well as the extent of contributions by other artists of the shop.

54 This document has long been regarded as part of a lost volume of documents that Milanesi had cited (1854, 1: 178) as a "Libro dei Documenti Artistici." It was rediscovered by Stefano Moscadelli as he prepared a new inventory of the Opera del Duomo archives. The reference to an initial payment of 50 florins may be connected with the loan Duccio had on 20 December 1308, described in the preceding document. [Ed.]

55 Of course, this number and its form make no sense as a signature.

56 Here is another document that says the contrada of Camporegio was in the parish of San Donato.

57 Stubblebine prints as part of the notice, and after the quotation thus far: "In primus de libro querimoniarum dicti ser Mini Bandini notarii." This line does not appear in this context.

58 This document signals Duccio's move from the parish of San Donato in the Terzo di Camollia to the parish of San Quirico in Castelvecchio, Terzo di Città. It surely deals with a penalty incurred while Duccio lived in San Donato.

59 The passage "superdicte . . . supra continetur" is omitted by Stubblebine.

60 Stubblebine omits the phrase "mihi . . . Concistorio."

61 White says here, "in palatio senensi in dicto consistoro coram."

62 The document reflects the anxiety on the part of the Nove to see the project completed. In addition to the reference to Duccio's *Maestà*, the document speaks of a mosaic that some critics have associated with the pavement inside the cathedral; those scholars, including V. Lisini (1909, 74-91), have gone on to conclude that both works were by Duccio. For that argument, they found support in Vasari's attribution of the pavements to Duccio. However, Milanesi (1854, 1: 176-78) had already shown that documentation proved that the pavements were executed after Duccio's death.

63 For the complicated argument whereby Bacci attributed this date to the document, see Bacci, Siena, 1944, 64-69. [Ed.]

64 The cover page of this volume bears the date 1279, with a note in the hand of Celso Cittadini saying that this was the date on the spine of the old register, though the contents date to the second decade of the trecento. On the first folio, there is a faded and not clearly legible date: "131_."

65 This forgotten document, not cited in the Duccio literature after Bacci's publication of it, is very important. It supports Agnolo di Tura's statement that Duccio painted the *Maestà* outside the Stalloreggi gate, in the area known as Laterino, or Stalloreggi di fuore. It also raises a problem. The *lire* were prepared as the basis for direct

taxation of the *dazio* and therefore reflect ownership, but Agnolo says the *Maestà* was painted in the "casa de' Muciatti." I wonder if that statement is simply a confusion. In 1309 and 1310, just before the Palazzo Pubblico was inhabited by the Nove, the Nine were resident in a "casa de' muciatti." See Benvoglienti's note in Siena, BC, Ms C.IV.7, f. 263r, and items in ASS, Ms B 62 (Spoglie dei Contratti dello Spedale di S. Maria della Scala), ff. 60r, 65r. [Ed.]

66 This is an incorrect citation. F. 261r (ink) is missing from the cited volume, and f. 117r (pencil) corresponds with a completely different ink folio number, 215r. A search of the entire record for June 1311 failed to uncover this document. Thus, the transcription is Lisini's.

67 No ink numbering. The date 1313 appears on the preceding folio.

68 The present Gabella 3 contains statutes. All the books for the Gabella Contratti of 1315 are missing.

69 The date for the first mention of Duccio, appearing on f. 61v (pencil), is "Anno Domini MCCCXVI, indictione xvd, die vigesimaquinta mensis Januarii" [1316/17]. The date for the second mention is on f. 112r (pencil) and is "Anno Domini MCCCXVI, indictione xvd, die nona mensis martii" [1316/17].

70 The reference is to a specific place. In the district of Stalloreggi, the gate in the city wall was originally a double gate.

71 Here, we encounter again the problem of the location of the contrada of Camporegio. Camporegio probably lay at the southern boundary of San Donato, where it met the northern edge of Sant'Antonio. In other words, it was possible for someone to live in Camporegio and, at the same time, in either Sant'Antonio or San Donato. [Ed.]

72 The sums are placed vertically in the left margin, one over the other.

73 Bacci proposed that this was a reference to Duccio's sister and perhaps to their original family home.

74 In addition to these two notices, in which the painter is clearly identified as Ambrogio di Duccio, there survive a number of notices concerning simply "Ambrogio dipentore." The first is dated to June 1330 and records payment of 2 florins and 16 lire to "Maestro Ambruogio" for an unidentified task in the cathedral (AODS 491, Debitori and Creditori, 1 July 1329-24 July 1330, f. 64r). The second comes from December 1335 and records the payment of 20 soldi to "maestro ambruogio dipegnitore" for restoring the hands, face, and book of the Virgin of the cathedral, likely referring to the sculpted image that stood in the lunette over the central doorway (AODS 176, Entrata e Uscita, 1 July-31 December 1335, f. 59r). On 30 May 1337, the Biccherna records a debt and payment of 3 florins involving "maestro ambruogio e compagni" (ASS, Biccherna 402, January-June 1336/37, f. 45r). Subsequently, on 24 June 1337, the Biccherna notes that "maestro ambruogio" is to have 11 lire and 5 soldi as salary, although the bulk of it was not actually paid until 1 July (ASS, Biccherna 402, f. 153v). On 28 July 1338, the Biccherna paid "mastro anbruogio dipentore" 6 lire, 5 soldi, and 8 denari for unspecified work (ASS, Biccherna 198, f. 10v). The same payment is recorded in ASS, Biccherna 405, f. 77r. Finally, on 19 June 1344, the Ospedale di Santa Maria della Scala paid Ambrogio "dipentore in champoreggi" 1 lira for painting two candlesticks for use in the chapel of San Jacopo Interciso in the cathedral (ASS, Ospedale 851, f. 46v). It is, of course, tempting to associate all these notices with Ambrogio Lorenzetti, but they are just as likely to apply to Ambrogio di Duccio. [Ed.]

75 Like the September payment of 1 lira and 10 denari, this sum likely represents tax on the transaction. [Ed.]

76 This volume, the Uscita for the hospital for the period January to December 1344, has two sets of numbers, both in ink. The arabic numbering is incorrect for the present manuscript; the ink numbering in roman style is correct, and is thus cited here. [Ed.]

77 Although this word is usually translated as "warehouse," and while the warehouses of several important firms were in and around this area, the context surely indicates that it is used here in the broader sense of "district." [Ed.]

78 The reference is to the Ospedale di Santa Maria della Scala, Siena's most prestigious charitable foundation.

79 The month of September is only specified on f. 17r (pencil): "MoCCLXXXVII, inditione XVd, de mense septembris."

80 This appears to be a separate notice, not a repetition of that in Statuti 16 (I.60).

II THE CHRONICLES

A number of Sienese chronicles tell the story of Duccio's *Maestà* being installed in Siena cathedral, accounts that have long fascinated both historians and general readers. The longest version of the story, told in a chronicle attributed to Agnolo di Tura, seems to pull us into the very middle of things, into the festivities connected with the event, into the spirit of celebration. It takes us with the procession that apparently bore Duccio's enormous altarpiece through the city streets, around the Campo, and into the Duomo, as the whole citizenry followed, carrying candles or torches, and the city's bells rang out. Other versions in other chronicles are shorter, but very special nonetheless. Nowhere else, to my knowledge, did a fourteenth-century work of art receive such attention from contemporary chroniclers.

Immediately, I must qualify my last remark, for there have long been debates about the authenticity of the chronicles. The oldest surviving manuscript of a Sienese chronicle that treats Duccio dates to the early quattrocento. Many of the other chronicles exist only in sixteenth-, seventeenth-, or even eighteenth-century copies, and that circumstance has allowed much disagreement about the original dates of composition. When U. Benvoglienti selected works for inclusion in L. A. Muratori's *Rerum Italicarum Scriptores* (1729), he provided a preface that explained his reasons for including some works while excluding others. But when A. Lisini and F. Iacometti chose chronicles for the second edition of Muratori, they came to different conclusions regarding authenticity and reliability, rejecting material Benvoglienti had used and including material he had rejected. Then, in 1960, E. Garrison published a long discussion of various chronicles. Basing his analysis on accounts of the Battle of Montaperti (1260), Garrison came to conclusions different from those of Lisini and Iacometti.[1]

Benvoglienti created a running chronological narrative by publishing the *Chronicle of Andrea Dei*, up to 1350, two small portions of the *Chronicle of Agnolo di Tura* for 1350-52 and 1382-84, while filling the gap between 1352 and 1382 with the *Chronicle of Neri di Donato*. Lisini, in 1931, disagreeing with Benvoglienti's assessment of the chronicles, published the entire chronicle attributed to Agnolo di Tura, although he thought it an "authentic compilation of fifteenth-century origin." Garrison regarded the Agnolo text as "an anonymous highly embroidered and falsified concoction of the fifteenth century."[2] W. Bowsky, however, regards the historical value of the chronicle as credible, because in various instances stated facts can be confirmed by documents of the period and, indeed, a long-forgotten Duccio document (I.45) speaks to the accuracy of information in Agnolo's chroni-

cle.[3] Bowsky believes that the original text of this chronicle was composed around 1350, but was continued by Donato di Neri for the years 1352 to 1381.[4]

Regarding a chronicle, known as the *Croniche aggiunte di altri cronisti dall'anno 445 all'anno 1521* and often attributed to Buondono Buondoni and Giovanni Bisdomini, that covers the period of the installation of Duccio's altarpiece, Benvoglienti recognized that it was a compilation of other chronicles including, for the period from 1300 to 1325, Agnolo's text. The *Cronaca Senese conosciuto sotto il nome di Paolo di Tommaso Montauri* (II.4) was included by Lisini among the material for the second edition of Muratori. He felt that it was written ca. 1432, but argued that the portion up to 1315 was based on an original to which the later parts had been added. Garrison agreed about the dating, regarding it as an intermediary between the *Cronaca dal 1202 al 1362* and the so-called *Cronaca Aldobrandini*.

Another chronicle, known both as the *Cronica sanese final all'anno 1476 attribuita a Giovanni Bisdomini* and as the *Cronaca Aldobrandini* (II.5), is really a compilation of information taken from various other Sienese chronicles. As the last date in the work is 1479, Garrison felt the text originated ca. 1485. Finally, we come to a source that does not discuss Duccio per se, but does comment on the adorning of the high altar in the cathedral of Siena, prior to the installation of the *Maestà*: the description of the Battle of Montaperti by Niccolò di Giovanni di Francesco Ventura (II.6). Garrison and Gino Garosi, the latter in his catalogue of the manscripts in Siena's Biblioteca Comunale, regard this text as authentic and date it 1442/43.

This brief discussion of the chronicles, expanded in the individual items below, is important because, in the secondary source material, we shall encounter works by various Sienese historians and archivists who accepted the chronicles as authentic and accurate historical sources. Thus, knowledge of those chronicles must precede the later works, and it must be the foundation for consideration of other sources. The matter is all the more pressing because many later authors, when referring to the chronicles, simply cite "libri antichi," without indicating the particular source they mean. It is also necessary that the reader form some estimate of the accuracy or inaccuracy of the various texts, if the validity of later writers is to be assessed.

What are we to make of the general discussion of chronicles thus far? Obviously, we want to approach each source with caution. As so many texts are known only in copies—or so they claim—of earlier works, it is impossible to know if additions from other sources or even fabrications have crept into these texts. Clearly, there are some cases where we can recognize texts that have been assembled from others. (The *Cronaca Aldobrandini* is the most obvious instance.) We must exercise care, however, because the pages of the chronicles do contain reli-

able facts. Indeed, Bowsky has pointed out that the chronicle of Agnolo di Tura contains information confirmed by surviving Sienese documents and that an Agnolo di Tura was attached to the office of the Biccherna in 1339, 1348, and 1355. The anonymous chronicle for 1202-1392 and the *Chronicle of Andrea Dei* also contain information that must have been derived from genuine documents. The following material is, then, not merely the foundation of historiography to follow, but also contains, in varying degrees of reliablility, reports that may be accurate.[5]

1. *Cronaca Senese di autore anonimo dall'anno 1202 all'anno 1362 con aggiunte fino all'anno 1392*

This chronicle exists in five manuscript copies:[6]

1. Siena, ASS, Ms D. 55bis, transcribed in 1689 from a manuscript in the possession of A. Barci.

2. Siena, BC, Ms A.III.26, transcribed by A. Barci in 1697, and known as the Barci Copy.

3. Siena, BC, Ms B.III.5 (early eighteenth century).

4. Florence, Biblioteca Moreniana, Ms Pecci 126, transcribed by G. Pecci in 1715, and known as the Pecci Copy.[7]

5. Siena, ASS, Ms D.55, transcribed as directed by T. Mocenni in 1723, from a manuscript in the possession of the Piccolomini family, and known as the Mocenni Copy.

The relevant passage, from Siena, BC, A.III.26 (the Barci Copy), f. 43v (ink):

> COME LA TAVOLA DE L'ALTARE MAGIORE DEL DUOMO SI FINI E POR-
> TOSSI AL DUOMO. ANNI DOMINI A DI VIIII DI GIUGNIO D'ANNO
> DETTO DI SOPRA MCCCX

E anco del detto tenpo e della signoria predetta, si fornì di fare la tavola dell'altare magiore,[8] e funne levata quella la quale sta ogi a l'altare di S. Bonifazio, la quale si chiama la Madonna degli occhi grossi, e Madonna della Grazie. E questa Madonna fu quella, la quale esaudì el popolo di Siena, quando furo rotti e Fiorentini a Monteaperto. E in questo modo fu promutata la detta tavola, perchè fu fatta quella nuova, la quale è molto più bella e divota e magiore, ed è da lato dietro al testamento vecchio e nuovo. E in quello dì, che so portò al Duomo si serroro le butighe e ordinò el vescovo una magnia, e divota conpagnia di preti e frati con una solenne procisione, aconpagnato da' signori Nove e tutti e gli ufiziali del comuno, e tutti e' popolani. E di mano in mano tutti e' più degni erano apresso a la detta tavola co' lumi accesi in mano; e poi erano di

dietro le donne e fanc[i]ugli con molta divozione e aconpagniorno la detta tavola per fino al Duomo, facendo la procisione intorno al Chanpo come s'usa, sonando le chanpane tutte a gloria per divozione di tanta nobile tavola quanto è questa. La qual tavola fece Ducc[i]o di Niccolò dipentore, e fecesi in chasa de' Mucatti di fuore della porta a Staloreggi. E tutto quello dì si stette a orazione con molte limosine, le quai si feceno a povare persone, preghando Idio e la sua Madre, la quale è nostra avochata ci difenda per la sua infinita misericordia da ogni aversità e ogni male e ghurdici da mani traditori e nimici di Siena.

Published: Lisini, 1898, 22 (incomplete); Lisini/Iacometti, fasc.II, vol. XV, 1932, 90; Garrison, 1960, 37.

This was one of the chronicles best known to scholars of the seventeenth and eighteenth centuries. The author is unknown, and the events he narrates from the thirteenth century to the beginning of the fourteenth were surely gathered from older sources. The text was published in the second edition of Muratori's *Rerum Italicarum Scriptores*, as edited by Lisini and Iacometti.[9] Lisini believed that the chronicle was written in the mid-trecento, although the original manscript is lost. Garrison thought that the text originated between 1362 and 1400, but suggested that the surviving versions may contain interpolations and alterations from the original source.

This account is distinguished by its length and by its similarity to the account offered by Agnolo di Tura (II.3). Both indicate that the altarpiece on the high altar of Siena cathedral, before Duccio's *Maestà*, was a work transferred to the altar of Saint Boniface at the time of the *Maestà*'s installation. Both say that the *Maestà* was painted outside the Stalloreggi gate, in the area known as Laterino. This conforms to a documentary notice published by Bacci in 1944, and then ignored by scholars until this volume (see I.45). This information is so specific and surprising (because it seems that Duccio had property there for a very short period) that it must be based on some original report or on a very thorough knowledge of Sienese documents. Both also describe the procession that accompanied the installation. Finally, we come to the strangest portion of this account and of Agnolo's: the name of the artist, given as "Duccio di Niccolò."

2. *Cronaca Senese di Andrea Dei, Continuata da Agnolo di Tura del Grasso*
The relevant manuscripts are:

1. Siena, BC, Ms A.III.24 (eighteenth century), ff. 1r-150v.

2. Siena, BC, Ms A.VII.45 (seventeenth century), ff. 1rA-122vB. (The same text as in A.III.24.)

3.　　　Florence, Biblioteca Moreniana, Ms Pecci 1 (ca. 1730-50)

Note: Benvoglienti/Muratori, 1729, published ff. 1r-150v of A.III.24 as the *Chronicle of Andrea Dei.*

The relevant passage, from A.III.24, f. 28r (pencil), f. 53r (ink):

> [Anno 1310]
> E nel ditto anno adi 9 di Giugnio in Mezedima si pose la bella tavola dela
> Nostra Donna al Duomo all'Altare Maggiore, e fu la più bella tavola, che
> mai si vedesse, e faciesse, la quale costò più di tremila ff. d'oro, e penossi a
> fare più anni, e fecela Duccio Dipintore.[10]

Published: Benvoglienti/Muratori, 1729, vol.XV, 47

According to Benvoglienti, who followed the opinion of Celso Cittadini, this chronicle is one of the oldest texts in good vernacular. He believed that Andrea Dei wrote the parts treating the years 1186 to 1346.[11] The attribution to Dei rests on a passage, dated 1328/29, which includes: "e io Andrea Dei chomprai due stara di farina ciento soldi" (Siena, BC, Ms A.III.24, f. 71v).[12] Benvoglienti regarded this text as being derived from a trecento original.

Lisini, in contrast, considered this text suspect and excluded it from the second edition of Muratori, substituting instead the so-called *Cronaca di Bondone e Bisdomini.* Thus, the passage above does not appear in Lisini/Iacometti.

In this chronicle, we encounter two items of note. First, the writer says that Duccio's altarpiece took several years; second, the writer gives the cost of the work as more than 3,000 florins.[13]

3.　　*Cronaca Senese di Agnolo di Tura del Grasso*

The relevant manuscripts are:

1.　　Siena, BC, Ms A.III.23, only one section, the third, dealing with the years 1300 to 1325.[14]

2.　　Siena, BC, Ms A.XI.42, for the years 1300 to 1325.

3.　　Siena, ASS, Ms D.38-41 (1718). A copy that runs from A.D. 445 through 1351.

4.　　Florence, Biblioteca Moreniana, Ms Pecci 1.[15]

Note: Lisini/Iacometti, fasc. IV, vol. XV, 1934, 313-14, published the relevant folios from A.III.23, for the period from 1300 to 1325. Lisini/Iacometti also used A.XI.42.[16]

The text, from A.XI.42, ff. 91r-91v (ink):

[9 June 1311]

I Sanesi féro fare una bella e richa tavola da altare magiore del duomo. La qual tavola è fornita di dipegnare in questo tempo; la quale l'à dipenta maestro Duccio di Nicolò dipentore da Siena, el quale era de' più valenti dipentori si trovasse in questi paesi al suo tenpo. La qual tavola la dipense fuore a la porta a Stallaregi nel borgo a Laterino in casa de' Muciatti. E la detta tavola i Sanesi la condussero al duomo a dì 9 di giugno i' mezedima, con grandi divotioni e procissioni, col vescovo di Siena messer Rugeri da Casole, con tutto il chericato di duomo e con tutte le religioni di Siena, E signori co' gl'ufitiali de la città, podestà e capitano e tutti i cittadini di mano e mano più degni, co' lumi acesi i' mano; e così doppo le donne e' fanciulli con molta divotione andoro per Siena intorno al Canpo a procissione, sonando tutte le canpane a gloria; e tutto questo dì stero le buttighe serate per divotione, facendosi per Siena molte lemosine a povare persone co' molti oratoni e preghi a Dio e a la sua Madre, madonna senpre ve[r]gine Maria, che aiti conservi e accresca in pace e buono stato la città di Siena e sua juri[s]ditione, come avocata e protetrice d'essa città; e scanpi da ogni pericolo e da ogni malvagio contra esse. E così essa tavola fu posto in duomo su l'altare magiore, la qual tavola è dipenta dietro parte del testamento vechio co' la passione di Jesu Cristo, e dinanzi la vergine Maria con 'l suo figl[i]uolo in collo co' molti Santi dal lato, ornata tutta con oro fino; e costò tremila fiorini doro.

E la tavola vechia che era all'altare magiore fu levata e posta all'altare di San Bonifatio; la quale ogidì si chiama la Madonna de le Gratie.
E li di[s]cepoli del sopradetto maestro Duccio furono ancora soleni maestri di dipengnare.

Published: Milanesi, 1854, 1: 169 (cited, with partial transcription); Lisini/Iacometti, fasc. IV, vol.XV, 1934, 313-14; Garrison, 1960-62, 53.

Benvoglienti believed the *Cronaca di Agnolo di Tura del Grasso*, also called the *Cronaca Maggiore*, to be the continuation of the *Cronaca di Andrea Dei*. He did not include this chronicle in the first edition of Muratori and explained his decision in the preface to the Sienese chronicles by arguing that, while the *Chronicle of Dei* was authentic, the part that carried Agnolo's name was an insertion composed mainly of material from Giovanni Villani's chronicle of Florence.

Lisini took the opposite position and included Agnolo's text in the second edition of Muratori. He believed that it was an original compilation of the quattrocento, even if parts were taken from Villani.[17] He judged the *Chronicle of Andrea Dei* to be a fabrication of the seventeenth century and, therefore, excluded it from the new edition of Muratori.

This chronicle is correct in dating the procession connected with the installation of Duccio's *Maestà* to 1311, and "Ruggeri da Casole" was indeed the bishop when that event occured.[18] It is, however, difficult to explain why this chronicle, like that of Andrea Dei, calls the painter "Duccio di Nicolò."[19] One is also struck by the description of the *Maestà*, "dipenta dietro parte del testamento vechio co' la passione di Jesu Cristo." The reference to the Old Testament will recur.

A good deal of confusion surrounds A.III.23. On its spine is written "Buondone e Bisdomini. Chroniche dall'anno 445 al 1326." Thus, it has sometimes been called the *Chronicle of Buondoni and Bisdomini*. Only the second part, dealing with the years 802 to 1299, is attributed to Buondoni and Bisdomini.

4. *Cronaca Senese conosciuta sotto il nome di Paolo di Tommaso Montauri*

The relevant manuscripts are:

1. Siena, BC, Ms A.III.15 (sixteenth century), ff. 2r-59r (ink) for the years 1302 to 1330.

2. Siena, BC, Ms A.VII.44 (1490), for 1170 to 1431.

The text, from A.VII.44, ff. 32v-33r (ink), ff. 34v-35r (pencil):

> Mezedima a dì VIIII di g[i]ugnio, al nome di Dio fu arechata[20] la tavola della Vergine Maria da la porta a Laterino con grande p[r]ocisione; fuvi el vescovo Rugieri da Casole con tuti e canonici e cherichato di Duomo, con tute le relegioni di Siena, tutte nostre signor[i] e è VIIII populo, capitano, consoli e quatro [de la Biccherna] e altri ufiziali che per lo tempo erano, e tuti e cittadini chon grande onore, con divote prechi e orationi che lle piaca aiutare e ghuardare la nostra città d'ogno pericho[lo], e fu asisa in sull'altare magiore del Duomo; fecieta maestro Du[c]cio, che fu uno de' migliori maestri che fusino mai al mondo; così furo alquanti de' sua' gharzoni che lui inparo Questo fu l'a[n]no 1310.

Published: Lisini/Iacometti used both manuscripts for their publication in *Rerum Italicarum Scriptores*, fasc. I, vol. XV, 1933, 236.

Lisini described this work as a compendium of notices from various eras put together by different people at different times.[21] The manuscript here cited is a

copy, made by a certain Antonio di Martino d'Antonio, ca. 1490, which was itself a faithful rendition of a "libro antico." Since the chronicle stretches to 1432, Lisini supposed that that represented the date around which it had been written. However, he held that the part up until 1315 was based on an original with later additions.

Garrison agreed that the date for this manuscript is 1432 or slightly later, because he considered it an intermediate version between the *Cronaca dal 1202 al 1362* and the so-called *Cronaca Aldobrandini*.

Siena, BC, Ms A.III.15 belonged, in 1720, to G. A. Pecci. Ettore Romagnoli knew this chronicle from a "codice della Libreria" and partially quoted the passage above, (IV.42).

5. *Cronaca Senese detta degli Aldobrandini*

This chronicle exists in many copies. Some of the manuscripts are:

1. Siena, BC, Ms A.III.25 (sixteenth century).

2. Siena, BC, Ms A.III.28, ff. 2r-66r (sixteenth and seventeenth centuries), incomplete text.

3. Siena, BC, Ms A.VI.8-9 (fifteenth century).

4. Siena, BC, Ms A.VI.10 (seventeenth century), ff. 2r-212r.

5. Siena, BC, Ms A.VI.11. (seventeenth century).

6. Siena, BC, Ms A.VI.12 (sixteenth century).

7. Siena, ASS, Mss D.34-D.35 (a copy of BC, A.VI.8-9). The passage transcribed below does not appear in this copy.

8. Siena, ASS, Ms D.36.

9. Florence, Biblioteca Moreniana, Ms Pecci 123 (formerly Pecci 246).[22]

10. Rome, Biblioteca Vaticana, Ms Chigi G.I.13, ff. 4r-235v.

The text, from A.III.25, f. 37v (pencil and ink):

|1310|

In detto anno si fornì la Tavola di Duomo fuor della porta à Stalloreggi, e tutto un dì utile si fe' festa come la domenicha, e con grande divotione si condusse a Duomo.

Published: Milanesi, 1854, 1: 169 (partial quote); Garrison, 1960, 47, as copied from the Siena, Biblioteca Comunale, Ms A.VI.9, f. 9r.

This text is a compilation made by Domenico Aldobrandini, who used the older chronicles of Tisbio Colonna, Buondono Buondoni, Gallari di Pietro, Giovanni Bisdomini, Patrizio Patrizi, and others, which are found in the same

manuscripts as those listed above. There are no significant differences in the sections relating to the *Maestà* from the text cited above.

La *Cronaca Aldobrandini* was long considered by scholars to be a work of the trecento. Even Faluschi, ca. 1821, in his *Chiese Senesi* (IV.26), reproduced the section on the *Maestà* almost exactly.

6. *Cronaca di Niccolò di Giovanni di Francesco Ventura*

The manuscripts are:

1. Siena, BC, Ms A.IV.5, ff. 1rA-26rA (1442-43).

2. Siena, BC, Ms A.IV.6 (eighteenth century).

3. Siena, BC, Ms A.IV.7, ff. 2r-24r (sixteenth and seventeenth centuries).

4. Siena, BC, Ms A.VI.15, ff. 38r-82v (sixteenth century).

5. Siena, BC, Ms A.VI.19, ff. 2r-36r (seventeenth century).

6. Rome, Casanatense, Ms 5057 (1780).

The text, from A.IV.5, ff. 5r-6r:

> In quello tempo sappi lettore fu fatta una tavola aquello altare magiore di Duomo dove fu fatta tale donagione colla figura di nostra Donna madre Vergine Maria e fu dipinta dal mezzo in su e tiene il suo figliolo in braccia e in commemorazione della donagione della carta fatta a lei della città di Siena col suo contado fu dipinta una carta in mano al Bambino che ella tiene in braccio dipoi fu levata da quello altare magiore e fu posta all'altare che oggi si chiama di S. Bonifazio in Duomo lungo il campanile la quale si chiama la Madonna delle Grazie abivi devozione poich'ell'è più graziosa che non si dice La Madonna che stava all'altare magiore di Duomo la dove fu fatta tale donagione era una tavola più piccola e molto antica con figura di nostra donna di mezo taglio cioè di mezo rilievo, e chosi le figure dintorno, la quale sta attacata al Canpanile dentro in duomo allato alla Porta del Perdono senza altare, e quella è la Madonna a chui fu fatto tale donagione

Published: Aldobrandini, *La Sconfitta di Montaperto, Narrazione storica tratta da un antico manuscritto con note di Giuseppe Porri (per nozze Vagnali-Porri)*, Siena, 1836. This publication treats only the section dealing with the Battle of Montaperti and is, in fact, a conflation of the relevant texts in Siena A.IV.5 and A.IV.6. See also M. Bellarmarti, *Il Primo Libro della delle Storie Senesi*, Siena: Parri, 1844, 3-29; Garrison, "Historical Writings," 43.

The Biblioteca Comunale manuscript, with the signature A.IV.5, is the autograph, datable to 1442-43 and signed by Niccolò di Giovanni di Francesco Ventura. Although the text does not specifically refer to Duccio's *Maestà*, it offers a history of the earlier images that adorned the high altar of Siena cathedral. According to this account, the altar originally supported the image we know as the *Madonna degli occhi grossi*, created ca. 1215 and now in the Museo dell'Opera del Duomo. In the aftermath of the Battle of Montaperti, it was replaced with the image known as the *Madonna delle Grazie*, now in the chapel of Alexander VII in the Duomo.

NOTES

1 E. Garrison, "Sienese Historical Writings," in *Studies in the History of Medieval Italian Painting*, 1 (Florence: L'Impronta, 1960), 4: 23-58.

2 Garrison, 1960, 23.

3 Bowsky, 1964, 15.

4 Lisini said that the seventeenth-century Giugurta Tommasi (IV.11) possessed a copy of the chronicle quoted here. It was probably the copy from which the preceding quotation is drawn, as it has annotations in Tommasi's hand.

5 The following lists of manuscripts for each chronicle are compiled from Garrison's "Historical Writings" and G. Garosi, *Inventario dei Manoscritti della Biblioteca Comunale di Siena*, vol. 1 (Florence: La Nuova Italia, 1978); vol. 2 (Florence: La Nuova Italia, 1980). [Ed.]

6 Garosi, 1978, 1: 211 says only four copies.

7 On the first page, in pencil, is "Pecci 251."

8 In the Mocenni copy, f. 285r, after "altare maggiore," the phrase "e possa al detto Altare maggiore" is inserted before "e funne levata."

9 An unidentified version of this text was cited by Della Valle, *Lettere Sanesi*, 2: 67-68. But the folio number he cited, f. 45, may be an error for f. 43v of Siena, BC, Ms A.III.26.

10 Siena, BC, Ms A.III.24, f. 53r (ink) or f. 28r (pencil). This chronicle, like that of Agnolo di Tura (II.3), says that the Maestà cost 3,000 florins. With a few notable exceptions, historians would long repeat this information. The sum is, as Giugurta Tommasi (IV.11) said, "cosa ridicola," and in modern scholarship is often used to challenge the accuracy of the early chronicles. But I wonder if here, as in other instances, there is not some truth behind the statement. On 9 June 1311, the day of the *Maestà*'s installation, 300 florins equaled 815 Sienese lire, a sum, though high, that is possible. See "Matters Financial: The Cost of Altarpieces," in ch. 2 of my *The World of the Early Sienese Painter*. [Ed.]

11 In the preface to the Sienese chronicles of Muratori's original *Rerum Italicarum*, 5-6, Benvoglienti refers to Celso Cittadini's *Trattato della vera origine di nostra lingua* (Venice, 1601).

12 It is likely that Benvoglienti used this copy of the manuscript, as some words are corrected and some notes are added, both in his hand.

13 For discussion of the sum, see the Introduction. [Ed.]

14 This manuscript is an assemblage of various materials: from the chronicle of Giovanni Villani, from a chronicle that goes under the names of Buondono Buondoni and Giovanni Bisdomini (for the period 802 to 1299), and the section attributed to Agnolo for 1300-25.

15 This version does not contain the passage quoted below.

16 Cited, for the material concerning Duccio by Milanesi, 1854, 1: 169. Also cited by Garrison, "Sienese Historical Writings," 53.

17 Gino Corti, from studying the paleography of this manuscript, dates this particular version to the first decades of the fifteenth century. (Oral communication.)

18 F. Ughelli, *Italia Sacra: sive De episcopis Italiae* (Venice: Coletti, 1717).

19 There is another curiosity in this work. This chronicle, like Andrea Dei's, says that Duccio painted the *Maestà* in a house outside the Stalloreggi gate. That statement accords with the document published by Bacci (I.45) that was forgotten in modern discussions of the painter. Moreover, Duccio seems to have owned or leased property in that location for a brief time (see Introduction). With accuracy on so many points, we wonder all the more about the mistake in Duccio's name. In my experience, there is usually some documentary material behind these traditions. (I address one such case concerning Simone Martini in *The World of the Early Sienese Painter*.) [Ed.]

20 In Ms A.III.15 "portata" is found instead of "arechata."

21 Lisini/Iacometti, 1931-35, 175.

22 On f. 1r: "Cronache di Siena di Tisbo Colonna, Buondono Buondoni, di Galleri di Pietro, di Giovanni Bisdomini, di Patrizio Patrizi, e d'altri; raccolta da Domenico Aldobrandini, sopranominato Ghinussi, fino all 1260; del suddetto anno . . . fino al 1350."

III Unpublished Documents Concerning the Siena Cathedral *Maestà* and Unpublished Secondary Sources

1. 1420

ASS, Opera Metropolitana 28, Inventory of Siena cathedral, f. 1v (ink) and f. 13v (pencil and ink):

f. 1v:

1420, a di xiiiª di dicienbre nel mccccxx. Operaio Turino di Matteo.

f. 13v:

Segue inventario di tute le chosse e tavole e altari e chanpane. In prima:

Uno altare magiore, cho' la tavola istoriata da ogni parte, chor un sopracielo |a|dornato, e da la parte dina|n|zi tre tabernacoletti, dentrovi tre angnioli e quali di|s|ciendano ne' dì solenni al servigio del Sagramento. Ed ale spale del'a|l|tare, due pezi di gratichole di fero, chon chandelieri e chon tende rosse ala parte dina|n|zi e fero da chapo a ogni lato, per detta tenda.

Uno banco dina|n|zi a detto altare, due stanno e pretti a sedere quando si chanta la messa, adattato a sedie e di nocie, bele e ben fatte.

Ala mora dina|n|zi al'a|l|tare prodetto |*sic*| è la Madonna Anu|n|ziata dal'Agniolo, scholpite e bele, cho' ferri da chapo e tende rosse, bene adorne.

Due lanpanai beli, e l'uno e dina|n|zi al'a|l|tare |e l'altro| ripetto al |*sic*| Madonna.

Quatro agnioletti chon quatro chandelieri, che tenghono uno ciero per uno, che debano ardere chontìnovo: due drento ala|l|tare e due dina|n|zi ala chapela.

Uno choro di|n|torno a detto altare, civoriatto e figure rilevatte, molto adorno, fra le quali ve ne sono sei rilevate, di chomune statura, cho' tabernacholi, cioè Santo Piero, Santo Pavolo e Santo Savino, Vetorio e Cerecienzio |i.e., Crescenzio| e A|n|sano. E pieno d'angnioletti el detto choro, rilevati e profetti |i.e., perfetti|, tutti rilevatti, cho' molte tarsìe.

Uno paio d'orghani dina|n|zi a deto altare, grandi e beli e fornitti d'ongni forn-ime|n|to da sonare, e una bele inpeschiatta dipenta e civoriata, chon tende dina|n|zi, molto adorni.

2. 1423

ASS, Opera Metropolitana 29, Inventory of Siena cathedral (1423), ff. 16r-16v:[1]

Seguano tutte le cose del corpo della chiesa

E prima l'altare maggiore.

Una tavola dipenta da ogni parte co' le figure di Nostra Donna et di più Santi, co' le voltarelle da capo in IIII° bordoni di ferro, con tre tabernacoletti dentrovi tre agnoletti rilevati et dorati e' quali desciendano a ministrare ala sancta messa, colla eucaristia et lambicchi et pannicello per i mani.

E più quattro agnoletti con candelieri in mano che stanno a servito de' altare dietro et dinançi, con due graticolette di ferro ne' canti dietro a l'altare, con una tenda vermigl[i]a per cuprire el detto altare. Et una tenda per cuprire la predella, con frangie di seta di più colori, dipenta in mezo con due capsettine dipente che stanno in sul decto altare, co l'arme de l'Opera, per pigliare le elimosine. E due huova di sturzo dinanzi, per adorneça d'esso altare.

Quattro agnoletti rilevati, pendenti, con candelieri di rame in mano, de' quali ne stanno due dietro et II dinanzi al decto altare. Sono attaccati ala volta et debanno ardere continuamente dì et nocte.

Uno coro bellissimo, fermo, rilevato, intorno al detto altare, intarsiato et bene lavorato, con più civori intorno; et da capo a esso le figure di Sancto Pietro et Sancto Pauolo et IIII°ʳ Martiri tutti grandi, et belle et rilevate.

Due sedi, [in]tagliati e belli, di cinque sedi per uno: vengano uno per lato de l'altare maggiore, per li nostri Signori per quando odano la messa la mattina del loro entrare.

Uno sedio lavorato, intarsiato: sta rincontra al decto altare, per li preti quando si canta la messa, di circa a braccia IIII°.

Tre lampane pendenti, due dinançi, una dietro al decto altare.

Uno lampadario nuovo, di nove lampadi, di ferro stagnati, sta tra la Madonna et l'Agnolo.

Uno ferro piombato: sta in meço fra le due colonne dal'altare maggiore, a che s'attaccano imagini di cera per voti.

Una figura de la Nostra Donna Annunçiata da l'Agnolo, rilevata et grande et bella e bene ornata, in una colonna dricta, e simile quella de l'Agnolo nell'altra mora a mano sinistra. Le quali figure vengano a' piei el detto altare, con taber-nacoletti da capo di marmo, et ferri tondi per le tende d'essa, et ferri da tenere ceri e candeli a' piei la decta Madonna.

Una banchetta grossa di modello, di circa a braccia tre, al servigio d'accendare e' lumi a la detta Anunziata.

Uno piedistalletto di marmo, con uno ferro piombato, in che si pone l'anno per la festa el'cero del Comune.

Uno bellissimo paio d'organi grossi, e' quali vengano alti a mano dricta rincontro al detto altare, co l'armario da chiudare dipento, bello, ornato, et tenda figurata et messa ad oro a più colori, con ogni fornimento di ruote, mantaci et d'ogni cosa necessaria a' detti organi.

3. 1472

F. Piccolomini (Pope Pius III), *Senensis Historia Manuscripta ab Origine Civitatis usque ad Annum MCCCCLXXII*, Siena, BC, Ms B.III.3, f. 95v (ink):

> Pii Tertii Pontificis Senensium Annalium Pars Prima
> . . . et quinto nonas Iulias, tabula Beatae Virginis egregie picta, in ara maxima templi cum maxima populi Senensis veneratione et gaudio per Antistitem posita est, impensa trium millium aureorum.
>
> The Sienese Annals of Pius III, Part One
> . . . and on the third of July, the excellently painted panel of the Blessed Virgin was placed on the main altar, with great veneration and rejoicing of the people of Siena, at the public expense of 3,000 gold florins.

Quoted by Della Valle, 1785, 2: 68; and Romagnoli (ca. 1800-1835), 1976, 1: 362.

Romagnoli (IV.42) undoubtedly used the manuscript quoted above, as his citation of f. 95 corresponds to this notice, but he misidentified the author as Pius II. That error may have arisen from Della Valle (1785, 2: 68), who also identified the author as Pius II. This is the first time we encounter the date of July 3 for the installation of the *Maestà*. Although Della Valle and Romagnoli quote this passage without question, no other subsequent authors repeat this singular date.

4. ca. 1528

S. Tizio, *Historiarum senensium ab initio Urbis Senarum usque ad annum 1528*, Siena, Biblioteca Comunale, Mss B.III.6-B.III.15

> Tizio, Siena, BC, Ms B.III.7, 355:
>
> [1307]
> Mensi Iunii Palatium Nonarioram iuxta Vica Malborghetto Petro Sabolino

operi prefecto expeditio Palatii Nonariora cepta est. Duccius pictor tabule maioris Are Templi Senensis instabat pingende.[2]

[1307]

In the month of June, in the Palace of the Nove, next to the Vico Malborghetto, the plan was received by Pietro Sabolino, clerk and prefect, at the Palace of the Nine. Duccio, the painter, applied himself to the painting of the large panel on the high altar of the Cathedral of Siena.

Tizio, Siena, BC, Ms B.III.7, 367:

[1311]

Eam namque Tabulam Duccius Senensis inter ejusdem opificii artifices ae tempestate primarius pinxerat, ex cujus officina veluti ex equo trojano pictores egregii prodierunt.

[1311]

For truly the Sienese Duccio, the most eminent among artists of his time, painted this panel [the *Maestà*]. For out of his workshop came forth excellent painters, just as [men] out of the Trojan horse.

Tizio, Siena, BC, Ms B.III.8, 41-42:

[1311]

Hoc pratera anno tabula maioris arae in Senensi aede iam completa a Duccio Senensi pictore super eadem ara die Mercurij, quae fuit Iunii nona, magna celeritate locata fuit. Processio enim ea die per urbem solemnitate comitantibus ea die: Episcopus enim cum universo interfuit clero, feriae repentinae celebratae preces Deo porrectae, elemosinae pauperibus affatim erogatae: Pinzerat enim Duccius artifex illam in aedibus cibium qui Vacciantes nuncupantur, quae ad portam Stalloregii foris sitae erant. Praeerat enim in facie Maria Virgo Christum filium in ulnis tenens, circumstantibus Angelicis spiritibus; Virginem vero gloriosam, quae in parte qualibet consistentes intueri videbatur Advocati Senenes urbis comitabantur; A tergo autem Veteris ac Novi Testamenti misteria actaque Christi plurimum continebantur; Quantus autem plausus quantave eo die fuerit celebrata letitia, longum esse narrare, quoniam Vrbis Domini atque Matri honori impendebantur, quae Senenses continue protexit. Tabula autem pretium florenorum auri trium milium fuit: Tabula enim Virginis angustior, cui olim urbs donata fuit et claves porrectae atque oblatae ad Divi Bonifatii aram est translata quae usque hodie Domina Gratiarum

vocitatur et ad funalia magna devotione ostenditur Duccij autem Pictoris
Discipuli in pictores optimos evasere. Duccij magister Segnia vocatus et
Senensis, municipii mei Tabulam cum Imagine Gloriosae Virginis tam
egregia, atque tam celebri accuratissime depinxit.

—◆—

In this year [1311], the panel of the high altar of the church in Siena, hav-
ing been completed by the painter Duccio, was placed above the same
altar with great rejoicing on the day of Mercury [Thursday], which was on
the ninth of June. For on that exceptional day, there was a procession,
with those in attendance proceeding through the city with solemnity. On
that unexpected holiday, the bishop being present with the entire clergy,
special prayers were offered to God. Alms for the poor were dispersed in
abundance. Duccio the artist painted it in a building belonging to the citi-
zens who are called the "Vacciantes," that was located at the gate of
Stalloreggi. On the front side, the Virgin Mary presided, holding her Son
in her arms, surrounded by angelic spirits; the Sienese advocates [Saints
Ansano, Savino, Victor, and Crescenzio] accompanied the most glorious
Virgin, who seemed to gaze [at the people] in whatever place they were
standing. On the back of the altarpiece, however, were the mysteries of
the Old and New Testaments and many acts of Christ. Moreover, it is too
long to tell how great was the applause that day and how exceptional the
joy, which will long be talked about since the name of the city and the
honor of the Mother, who continuously protected the Sienese, were
being threatened. Moreover, the painting was valued at 3,000 gold florins.
The narrower painting of the Virgin, to whom the city was earlier dedi-
cated and to whom the keys [of the city] were extended and offered, was
taken to the altar of Saint Boniface, which [panel] is to this day called the
Lady of Grace and where candles are displayed with great devotion. But
the pupils of Duccio have emerged as the best masters. Segna has been
called the master of Duccio, and he has very accurately painted a picture
of my town of Siena with an exceptional and distinguished image of the
Glorious Virgin.[3]

Tizio, Siena, BC, Ms B.III.15, 96v:[4]

Anno vero trecentesimo undecimo supre millesimum Tabula Arae Maioris in
aede Senensi, dieque Ianuarii nona, opifice Duccio pictore, absoluta est, in
decuria, seu vico Stellae Regiae exterioris, feriae repentinae per urbem indictae.

In the year 1311, and on the ninth of January, the painting of the high altar in the church of Siena, the work of the painter Duccio, was completed in the district outside Stalloreggi, and an unexpected holiday was proclaimed throughout the city.

The Biblioteca Comunale's version of Tizio's *Historiarum senensium* is a good eighteenth-century copy of the original in the Biblioteca Vaticana: Mss G.I.31-35 and G.II.36-40. The final volume is actually a collection of notes, not an integral part of the *History* itself. The last sentence of the quote from B.III.8 was published by Bacci, Siena, 1944, 3.

Tizio's longest passage, though not a quotation, reminds us of material found in the chronicles, especially in the passage where he says that the back of the *Maestà* illustrated the Old and New Testaments. He also adds that Segna di Bonaventura "has been called" Duccio's master.

This work was known to and used by Benvoglienti, Girolamo Gigli, Della Valle, Romagnoli, and Crowe and Cavalcaselle. Bacci, Siena, 1944, 3-4, proposed that the "Tabulam cum Imagine Gloriose Virginis" could refer to the *Maestà* that Duccio painted for the Nove in 1302 (I.36).

5. 1620-25

Giulio Mancini, *Breve ragguaglio delle Cose di Siena, Siena*, BC, C.IV.18, f. 141v (ink):

> Tabula Beatae Virginis egregie picta in Ava Maxima Maioris Templi cum Maxima Senensis Populi Venerazione et gaudio per Antistem posita est publica impensa trium millium aureorum.

> The excellently painted panel of the Blessed Virgin was placed on the high altar of the cathedral, with great veneration and rejoicing of the people of Siena, at the public expense of 3,000 gold florins.

Mancini is here quoting Pius III (III.3). A copy of this manuscript is found in Rome, Biblioteca Vaticana, Cod. Barb. Lat 4315, ff. 292r-376v, it being the better copy with autograph notes. The Siena copy is considered later, but was known to Benvoglienti as it is annotated in his hand.

6. ca. 1638

Giulio Piccolomini, *Siena Illustre per Antichità celebrata dal Sig. Giulio Piccolomini Pub. Lettor' di Toscana favella nel Generale Studio Senese*, Siena, BC, Ms C.II.23, f. 39r (discussion of cathedral altars):

> Nel privilegiato una [tavola] di Lorenzo da Siena;[5] presso a questa si vede

l'antica Tavola all'Altare Grande Opera di Duccio di Buoninsegna Pittor' Sanese, che fiorì nel 1420.

Inventories of the cathedral, from the sixteenth century onward, record the placement of the *Maestà* near the altar of San Savino, which was adorned with Pietro Lorenzetti's *Birth of the Virgin*.

Della Valle comments on the superficiality of Piccolomini's treatise.[6]

7. 1709-20

G. Macchi, *Memorie (Notizie di tutte le chiese che sono nella città di Siena)*, Siena, ASS, Ms D.107, f. 73r (pencil), f. 139r (ink); Ms D.110, f. 187v:

D.107, f. 139r (ink):

L'Anno 1308 fu principata a dipegnare la tavola grande per l'altar maggiore del Duomo, con la Beata Maria Vergine e li 4 Avocati della città e molt'altri Santi e Sante. e dietro alla medesima c'è dipento il Testamento Vecchio e la Passione di Nostro Signore Giesù Christo. La quale dipense maestro Duccio pittore Sanese, che stava nel Laterino, e la terminò l'Anno 1310, a soldi sedici il giorno e in conto lire 10 il mese, come si vede il contratto al'Opera, al no. 399, rogato da ser Paganello Diodifece, notaio al tempo di fra Grazia, Operaio o Rettore del Duomo.

D.110, f. 187v (ink):

L'Anno 1506 fu levato dalla Cupola l'altar maggiore e fu posto sotto la tribuna, e nel mezzo a detto altare vi era una tavola grande, antica, con la Beata Vergine Maria con Nostro Signore in braccio e i 4 Santi Avvocati della città di Siena in ginocchio, con altri Santi, opera di maestro Duccio da Siena, dietro alla quale vi è dipinta la Passione di Nostro Signore e il Testamento Vecchio, con[?] oggi sta collocata vicino all'altare di S. Ansano. Sotto ad essa si legge: Salvet Virgo Senam veterem quam signat ancorum [?]. Del 1303 fu cominciata a dipingersi e l'anno 1311 fu terminata e portata a processione.

The most important aspect of Macchi's accounts is the fact that he had found the 1308 document dealing with Duccio's daily salary of 16 soldi (I.39). He recorded the *operaio* of the cathedral, the notary involved, and the inventory number of the document. Macchi was, in fact, the archivist of the Ospedale di Santa Maria della Scala, so attention to documents was part of his daily life.

He accurately stated that the *Maestà* was removed from the high altar in 1506 and that, in his time, it was near the altar of San Ansano, a fact confirmed by the cathedral inventories of the period. Of particular note is the fact that he said the altarpiece was begun in 1303.

8. 1717

F. Montebuoni, *Notizie de' Pittori e Statuarii copiate dal T. 13 delle mescolanze*, Siena, BC, Ms L.V.14, ff. 4v, 8v-9r, 29v, 60v, 67v, 75v:

> f. 4v:
> 1302. Si pagano s. 48—a Maestro Duccio Dipegnitore, per suo salario di una Tavola, ovvero Maestà che fece, et una Predella, che si posero nell'Altare della Casa dei Nove. fol. 357.

> ff. 8v-9r:
> 1310. Duccio dipinge nell'Anno 1310 la Gran Tavola per l'altar Maggiore del Duomo, e valse tre mila fiorini d'oro.

> f. 29v:
> 1311. a f. 479. Duccio di Buoninsegna dipinse la Tavola dell'Altar Maggiore; trovò il modo di far le figure nel pavimento di marmo, come si vede nel Duomo di Siena. Nell'Abbadia di San Donato dipinse la Tavola della Madonna con 4 S.S.; L'Imagine della Vergine, che stava già nel p.mo Altare, e la fece per il prezzo di tre mila fiorini d'oro. Vedi il Tommasi.

> f. 60v:
> 1310. Nell'Anno 1310 fù messa la Tavola della Beatissima Vergine Maria nell'Altare maggiore del Duomo per le mani del Vescovo con grandissima solennità. Spese la repubblica scudi $\frac{M}{300}$ d'oro. Ibidem.

> f. 67v:
> 1310. f. 479. T. 7. Duccio di Buoninsegna dipinse la Tavola dell'Altar Maggiore. Trovò il modo di far le figure del pavimento di marmo, conforme si vede nel Duomo di Siena.

> f. 75v:
> 1342. Galgano di gia Maestro Duccio al Libro di Denunzia di 1342 e 43, fol. 3.

Of these notices, the first is the most important. As Macchi found the 1308 document for Duccio's *Maestà*, Montebuoni located the 1302 record of payment to Duccio for a panel, "ovvero Maestà," and a predella for the Nove. His folio number, 357, on f. 4v, corresponds to the ink numbering in the relevant Biccherna vol-

ume (I.36), but he has confused the abbreviation for lire with an abbreviation of soldi. Oddly, such confusion is not uncommon.

9. ca. 1720

A.M. Carapelli, *Notizie della chiese e cose riguardevoli di Siena*, Siena, BC, Ms B.VII.10, Trattato 10, f. 44r:

> *Duomo, già Tempio di Minerva*, Il dì 9 Giugno 1310, mercoledì 'l Padre fra Ruggiero domenicano, Vescovo della città, con l'intervento del Statto, clero e tutte le religioni e numeroso popolo, condusse processionalmente la tavola della Madonna dall'Porta di Stalloregio, oggi del Laterino, in Duomo con solennissima festa, pitture di maestro Duccio, la quale in oggi si conserva vicino al Privilegiato, detta comunemente 'l Tavolone. Cronaca Patritii al 1310.

While Tommasi (IV.11) and a number of the chronicles (II.3-4) would have told Carapelli that the bishop of Siena when the *Maestà* was installed was Ruggiero da Casole, none of the earlier sources identify the bishop, correctly, as a Dominican.[7]

10. ca. 1724

U. Benvoglienti, *Sulla Scuola Pittorica Senese*, Siena, BC, Ms C.IV.12, ff. 192v-193v:

> Ma perchè più chiaramente apparisca che nella pittura si fece in Siena una Scuola da per se e assai più antica di quella de' Fiorentini, apporterò le seguenti notizie, e primieramente noterò quello che di Duccio dipintore disse il Tizio a f. 41 del 3 tomo delle sue storie. Costui [Tizio] era vera-mente di Castiglione Aretino, ma per la lunga abitazione egli stesso si chiamava Senese. Egli adunque dice all'anno 1311: "Hoc praeterea anno tabula maiori arae in Senensi aede Iam completa tabulam cum imag-ine gloriosae Virginis tam egregia atque tam celebri accuratissime depinx-it." [A quotation of the passage cited above, III.4] Duccio secondo il Baldinucci era uscito della scuola di Giotto o de' suoi discepoli, ma il Tizio vuole ch'ei fosse discepolo di Segna. Dovremo noi credere al Baldinucci, che ciò sostiene senza alcuna authorità, e non seguire più tosto il Tizio, pratico della nostra istoria per la lunga dimora che egli fece nella nostra città? Dovremo noi abbandonare il sentimento di uno storico antico e dili-gente, e abbracciare quello di un moderno appassionato e ignorante della nostra storia? Di vantaggio dirò che, come afferma il Tizio, Segna maestro di Duccio viveva e dipingeva nel 1305.[8] In un libro di Biccherna di 20 f. 30, si trova che si pagano in questo tempo lire dieci per una tavola dipinta per

tenersi in Biccherena, che è un maestrato de più antichi e più potenti della nostra città.

Questo Segna mi penso che sia quello che alle denunzia di Dogana dell'anno 1316, f. 180, si trova essere figliuolo di Tura, nome accorciato di Bonaventura.

Dirò ancora che fra gli strumenti dell'opera del Duomo al no. 399 evvi l'obligo di Duccio del quondam Boninsegna di fare la pittura della Vergine e che stipula a' 9 ottobre 1309: e con questo istrumento s'emenda un nostro cronista anonimo che pensa essere Duccio figliuolo di Niccolò, quandam veramente si riconoscere esser figliuolo di Boninsegna o Segna.

Along with the works of Macchi and Carapelli, Benvoglienti's manuscript clearly reveals the new intellectual climate of early eighteenth-century Siena, a climate in which the conventions of history were not only to be drawn from the work of other scholars and antiquarians, but also tested against surviving documentation. Here, Benvoglienti mixed the two. He quoted Tizio with respect, but also because he used him to counter Baldinucci's claim that Duccio was trained by Giotto or his disciples. Tizio said that Segna (a native son) "had been called" Duccio's master; to further that claim, Benvoglienti searched out documents that showed the relation to be chronologically possible. By going to the 1308 document for the *Maestà* (which he somehow confuses with 1309), he learned that Duccio's name was not Duccio di Niccolò as the early chroniclers claimed, but Duccio di Buoninsegna. He then arrived at the erroneous conclusion that Segna was not merely Duccio's master, but also his father.

11. 1730

G.A. Pecci, *Raccolta Universa. Le di tutte l'Iscrizioni: Arme, e Altri Monumenti si Antichi, Come Moderni, esistenti nel Terzo di San Martino fino a questo presente anno 1730, Libro Secondo*, Siena, ASS, Ms D.5, f. 159r:

> . . . all'altro angolo a destra del detto Palazzo [Pubblico] si scorge la cappella fabbricata in onore della Natività di Maria Santissima per voto della gran peste del 1340, i fondamenti della quale furono gittati nel 1352 del mese di luglio ponendovi nei medesimi molte monete d'oro. L'Architettura d'essa è mezza Gotica e mezza Romana, composta tutti di Marmi, l'invenzione della quale è di Duccio, e il fregio, e l'Archo di Francesco di Giorgio da Siena

This attribution of the chapel on the Campo and in front of the Palazzo Pubblico was by this time a long tradition; today, it may seem surprising that nei-

ther Pecci nor his contemporaries worried over the chronological problems raised by Duccio working on the *Maestà* in 1308 and being responsible for a structure that, by this account, was founded in 1352.

Pecci repeated this passage in his *Relazione delle Cose più notabili della Città di Siena* of 1752 (IV.19).

12. ca. 1750

G. G. Carli, *Selva di Notizie per la Compilazione della Storia delle Belle Arti a Siena*, Siena, BC, Ms L.V.16,[9] ff. 64r-67v (ink), f. 136r (ink):

ff. 64r-67v(ink):

Duccio Pitt. Si pagano 8 soldi a Duccio Pittore per la pittura che fece ne' Libri del Camarlingo, e de' 4. Entr. B. fo. 374. *Mem. Ben.* p. 1 ter. All'An. 1280. Ne' Libri de' Contratti della Sapienza, all'An 1304. Si ha che vivea Duccio pittore. *M.B.* p. 13.

Negli An. segg. si hanno memorie ora di *Duccio*, ora di *Duccio di Niccolò*, ora di *Duccio di Buoninsegna.* Communemente dagli Scritt. sono stati considerati per un solo pittore, ma io (riservandomi però a far migliori riscontri ne' Lib. Pub.i, e nelle Croniche Senesi, e nelle iscrizioni delle Pitture) per ora credo, che Duccio, e Duccio di Niccolò sieno lo stesso pittore, ma Duccio di Buoninsegna sia stato uno Scultore, ed Architetto vivuto alquanto dopo.

= Duccio nel 1310. dipinge la gran Tavola per l'Altar magg. del Duomo, e valse 3. mila Fior. d' oro. *Mem. Benv.* p. 8. (ora non si cita alcun documento). A p. 10. di d.te *Mem.* si riporta dalle Croniche d'Agnolo di Tura del Grasso: = e nel d. Anno a di 9 di giugno in mezzedima si pose la bella Tavola della Nostra Donna al Duomo all'Alt. magg., e fu la più bella Tavola, che mai si vedesse, e facesse, la quale costò più di 3. mila Fiorini d'oro, e ci volse a farla più Anni, e' fecela Duccio Dipintore =.

A p. 60.t. di esse *Mem.* si citano certi frammenti d'un *Diario* antico esistente presso il Benv., ove all'An. 1310 si ha, che = Nell'An. 1310. fu messa la Tavola della Bma Verg. M.a. nell'Alt. magg. del Duomo per le mani del Vescovo con grandissima solennità; spese la Rep.a Scudi 3. mila d'oro =.

- Il med.o Benv. p. 87, e 87.t. osserva, che quest'età (cioè del principio del sec. XIV) fu molto abbondante di eccellenti pennelli; nel 1311. Duccio fece la Tavola dell'Alt. magg.; il Baldinucci ne ha fatto la vita, ma lo dovea porre avanti di Simone, e di Lippo, perchè fiorì, e morì prima; egli non

poteva nell'An. 1348 dipingere la Cappella di Piazza, che non era peranche fabbricata, ed esso non era più in vita; ai Lib. delle Gabelle dell'An. 1342. (fralle Denunzie del 1342. e 1343. a fo. 3, come rip. lo stesso Benv. a p. 75. ter.) si trova nominato *Galgano del già M.º Duccio Pittore*; più in là del 1334. non si vede nominato questo Duccio, il quale in do. An. dipinse una Tavola per la Signoria, come apparisce dal Lib. di Bicch. B. n. 186, fo. 21. (Il med. Ben. a p. 4. ter. la riporta così: = Si pagano lire 48. a Mo Duccio Dipegnitore per suo salario di una tavola, ovvero Maestà che fece, et una Predella, che si posero nell'Altare della Casa dei Nove. Entr. B. 179. fo. 357. =); questo Pittore fece di eccellenti Scolari, che anvazarono di gran lungo il Maestro, onde fu molto maraviglioso, che il Baldinucci, seguendo alla cieca il Vasari, faccia presso che tutti i nostri Pittori scolari di Giotto; il Tizio all'An. 1311. così scrive di Duccio: = *Hoc praeterea Anno Tabula.*

Nelle dette *Mem.* a p. 150, si fa dire a Giugurta Tommasi (ma si confronti) che *Duccio di Buoninsegna* dipinse nel 1310 la Tavola del duomo; trovò il modo di far le figure nel pavimento di marmo del duomo; nell'Abbadia a S. Donato fece una Tavola con 4 Santi; e la Vergine del Duomo fu dipinta da lui per 3 mila fiorini d'oro. Poco uso secondo me può farsi di quest'asserzione del Tommasi.

Nelle dette *Mem.* a p. 10 t. si riporta il seg. passo dalle Cron. mss. del Barci all'an. 1310 = [Carli then quotes, from the Barci Copy, the passage of source II.1 above, finishing with "e facesi in casa de' Mucatti di fuore della Porta a Stalloreggi."] Da questo passo si vede che Duccio era figlio di Niccolò, e non di Boninsegna. Nondimeno riferirò qui sotto le testimonianze di Duccio di Buoninsegna, benchè io lo creda altra persona.

Nelle *Mem. Ben.* a p. 24 t. si dice (credo sull'autorità di certi ricordi del P. Montebuoni Servita) che Duccio di Buoninsegna dipinse la Tavola dell'Alt. mag., e trovò il modo di far le figure nel pavimento di Marmo, siccome si vede nel Duomo di Siena, e fece il disegno della Cappella di Piazza. A p. 43 del med. Benv. è chiamato scultore. Il Pecci nella *Rel. di Siena* p. 11, descrivendo il Duomo: = Lateralmente all'Alt. di S. Ansano si vede appesa un'antica Tavola coll'immagine di N. Signora e con molti Santi, e dipinta dalla parte opposta, che stava già collocata nel maggiore Altare, lavorata da Duccio di Buoninsegna Pittore Sanese nel 1310=.

Il med.º p. 116 parlando dell'Abbadia di S. Michele Arcangelo, ora tenuta da' Carmelitani Scalzi, dice, che = si vedeva già in questa chiesa una Tavola della Mad.a con 4 Santi di Duccio di Buoninsegna, dipinta nel 1310 =

Il med.º p. 18 e 19, parlando del pavimento del Duomo, dice che la Storia di Giosuè che fa appiccare 5 Re, fu intagliata da Duccio di Buoninsegna, Pittore e Scultore Sanese = di cui il Vasari scrisse la Vita, e affermò essere stato il primo che nel pavimento del Duomo dasse principio a' rimessi delle figure di chiaro e scuro, e ordinasse, e disegnasse i principi intorno all'An. 1350, conforme sta scritto ne' Libri dell'Opera =. A p. poi 20 lascia in dubbio se la storia delle prodezze di Sansone sia del d.º Duccio o d'altri. Il med. Pec. a p. 68 parlando poi della Cappella di Piazza, dice che fu eretta per voto della peste del 1348, e ne furon gettati i fondamenti nel 1352; l'architettura è mezza gotica e mezza romana, l'invenzione della quale (*cioè della Gotica*) è di Duccio; fu principata nel 1352, ma non riuscendo di sodisfazione universale, per 4 volte venne demolita, e finalmente nel 1376 rimase nella maniera che si vede compiuta. Io per ora noto che ciò non è vero perche la parte maggiore d'architettura romana vi fu aggiunta da Francesco di Giorgio un secolo dopo.

Nelle *Mem. Benv.* p. 26t si dice che la Tavola della Mad.ª fu portata in Duomo a dì 9 Giu. 1310 = e fu il Pittore Niccolò di Duccio = Credo che per isbaglio si sia scritto così invece di = Duccio di Niccolò =. Si vuole che facesse per Pistoia, quando eravi vescovo Tommaso Andrei di Casole, alcune tavole rappresentanti in campo d'oro la Deposizione della Croce, la Vergine, la Maddalena, Gio: da Me.da ed altri Santi nell'altra tavola. Nel 1290 (*Guida di Pistoia* del 1621, a pag. 84) si trovano nello spedale detto il Ceppo, in Sagrestia.

f. 136r(ink):

Galgano di già M.o Duccio Pitt. Fra' Libri del Proved.ri della Gabelle della Dogana al Lib. delle Denunzie del 1342 e 43. fo. ivi si trova = Galgano del già M.º Duccio Pitt. =. *Mem. Benv.* p. 75 t. Io credo, che questo fosse figlio di M.º Duccio di Niccolò, del quale si è parlato a suo luogo.

Carli compiled this account from many sources, in particular a source he refers to as *Mem. Benv. (Memorie Benvoglienti)*.[10] From that source he has drawn material also in the Barci Copy of the Cronaca dall'anno 1202 all'anno 1391 (II.1) and in the *Cronaca di Agnolo di Tura del Grasso* (II.3). Agnolo di Tura and Giugurta Tommasi (IV.11) have provided the cost of the *Maestà* at 3,000 florins. He has also consulted the *Notizie* of Baldinucci (IV.15), and the *Relazione delle cose più notabili della città di Siena* (IV.19) of Pecci.

The complex and internally contradictory remarks signal the confusion around knowledge of the painter at this date.

13. ca. 1800-10

A. Picchioni, *Notizie delle Chiese Senesi*, Siena, BC, Ms A.VIII.1, f. 34 (ink) and f. 19v (pencil):

[1310] I sigg.i Governatori di Siena deliberano, che si proceda con ogni dili-
genza nel fare il mosaico già incominciato, e nelle nuova, e gran Tavola
della B.V. Maria, e che al lavoro dell'Opera stieno 10 de' migliori Maestri
che si possino trovare, quali soni nominati nella presenta carta pecora Ms
9a, p. 27, n. 207. [Duccio's name in the margin]

The author's name is found only on the spine of this volume. Although it does
not contain a specific date, the manuscript has been dated to the early years of the
nineteenth century.

14. ca. 1821

G. Faluschi, *Chiese Senesi*, Siena, BC, Ms E.V.13, ff. 3r, 14v, 26r-v, 45r:

f. 3r:
Tavola della B.V. Maria di Duccio pittore. 1310. Iacomo del quondam
misser Giliberto Marescotti da Siena, Operaio di S. Maria, da una, e
Duccio pittore del quondam Boninsegna, dall'altra, avendo il detto
Duccio preso a dipingere dal detto Operaio certa tavola da porsi sopra l'al-
tar maggiore della chiesa maggiore di S. Maria di Siena, convengono
negl'infrascritti patti. Primieramente che esso Duccio la dipingerà meglio
che saprà e potrà e che Dio gli concederà, e di lavorare continuamente in
detta tavola e non pigliare a fare altr'opera finchè non sia finita detta
tavola; e detto Operaio promette pagarli per suo salario 16 soldi di denari
sanesi il giorno, salvo che se perdesse qualche dotta del giorno deva scom-
putarsi dal detto salario per rata della detta persa, e del detto salario
promette detto Operaio pagare il detto Duccio ogni mese lire 10, e il
restante scontarlo essendo esso pittore debitore di detta Opera, e il detto
Operaio si obbliga a tutto quello che va in detta tavola, non dovendovi il
pittore metter altro che la propria persona. Ivi, no. 399.

f. 14v:
Notizie del Duomo di Siena estratte dai Notandi del P. Buondelmonti.
1310. Fu messa la Tavola della B. V. Nell'Altar Maggiore del Duomo per le
mani del Vescovo con grandissima solennità, spese la Repubblica scudi
3,000 d'oro. Ibidem cioè appresso gli Eredi di Emilio Picc.

ff. 26r-26v:
Chronache Senesi raccolte da Domenico Aldobrandini, sopranominato

Ghinucci 1310. In detto anno si fornì la Tavola del Duomo fuori del Campo Reggi, et tutto dì si fe' festa. E la Domenica et con gran devotione si condusse in Duomo. fo. 6, fac. 2.[11]

f. 45r:

1310. Duccio Mosaico incominciato e Tavola della B. V. M. In d. 22. t., In d. 96.

NOTES

1 There is a later description of the high altar in an inventory of 1429 (AODS, 867, n. 2, f. 15v), but it is not as complete as this inventory of 1423.

2 This passage added by the editor.

3 This final sentence is remarkable in two ways. It apparently records a Sienese belief concerning the relation of Segna di Bonaventura and Duccio, for which there is no written source. I am also intrigued by the remark that Segna had painted an image of Siena. This is also something of which, to my knowledge, there is no other written record. [Ed.]

4 This passage comes from the final volume of Tizio's work, a collection of notices that form addenda to the main body of the text. It is impossible to say whether the reference to January is a mistake or a reference to some unnamed source.

5 Pietro Lorenzetti's *Birth of the Virgin* (1342). [Ed.]

6 Della Valle, 1785, 2: 28. Della Valle, however, misidentifies the pope as Pius II, and that error is repeated by Lanzi (IV.29) and Romagnoli (IV.42).

7 Carapelli may have taken this information from F. Ughello, *Italia Sacra sive de Episcopis Italiae* (Rome: Bernardinum Tanum, 1647), 3: 637.

8 Here we discover a shift in meaning that must have escaped many readers. Tizio actually reported that it was said that Duccio was Segna's pupil; Benvoglienti turned this into "Tizio said" that Segna was Duccio's master.

9 On f. 1r: "Selva di Notizie, e riflessioni Per la Storia de' Pittori, Scultori, e architetti Senesi per Ora divisa in 30 Articoli, cioè—XI Dal 1300 al 1325."

10 Without any further citation or explanation, Carli referred to the *Memorie Benvoglienti* as *Mem.* or *Mem. Ben.* or *Mem. Benv.* None of Benvoglienti's numerous manuscripts has been identified as this source. Although, in this case, there seems to be only a partial overlap, Carli's manuscript generally draws very heavily on Siena, BC, Ms L.V.14, the *Notizie de' Pittori e Statuarij copiate dal T. 13 delle mescolanze* by F. Montebuoni (III.8). [Ed.]

11 See II.5.

IV PUBLISHED SOURCES TO THE MID-NINETEENTH CENTURY

As this volume's purpose is not only to provide the reader with transcriptions and translations of documents, but also to provide insights into the historiographical tradition concerning Duccio, the following bibliography is not organized exclusively by date of publication but, in some instances, according to when the relevant text was written. For example, Ghiberti's *Commentaries* were not published until centuries after they were written, but they were known to Vasari and others in manuscript form. Giulio Mancini's *Considerazioni sulla Pittura* was first printed in 1956, but the manuscript dates to 1617-22. In a number of instances, it is clear that scholars and antiquarians, particularly those of Siena, knew the manuscript material well.

Where possible, the text involved is quoted, but limitations of space and purpose make it impossible to quote in entirety the lengthy texts of, say, Vasari or Della Valle. Thus, it is restricted generally to a digest/summary of content in those cases and, occasionally, to quoted passages. Most items in this section are also followed by a commentary and/or accompanied by notes.

1. ca. 1450

L. Ghiberti, *I Commentarii, Trattato di Scultura e Pittura*, Florence, BNF, Ms II.I.33, Magliabechiano XVII, 33, f. 9r (pen), f. 10r (stamped):

> Fu in Siena ancora Duccio, el quale fu nobilissimo, tenne la maniera greca; è di sua mano la tauola maggiore del duomo di Siena; è nella parte dinanzi la incoronatione di Nostra Donna et nella parte di dietro el testamento nuouo. Questa tauola fu fatta molto excellentemente et doctamente, è magnifica cosa et fu nobillissimo pictore. Moltissimi pictori ebbe la città di Siena et fu molto copiosa di mirabili ingegni, molti ne lasciamo indietro per no ne abondare nel troppo dire.

Published: J. von Schlosser, in Ghiberti, 1912; Morisani, in Ghiberti, 1947; Ghiberti, 1998.

2. 1481-1530

F. Benedettucci, ed., *Il Libro di Antonio Billi* (Rome, 1991), 111:

> [Cimabue dipinse] in Santa Maria Novella, e in Santa Trinita una tavola.

The manuscript source is Florence, Biblioteca Nazionale, Ms Magliabechiano XXV 636, f. 74r. The last phrase is a later addition to the manuscript. See the commentary to the next source.

3. 1563

F. Benedettucci, ed., *Il Libro di Antonio Billi* (Rome, 1991), 36-37:

> [Cimabue] Dipinse 'Sciesi nella chiesa di San Francesco, che la finì Giotto; et in Empoli nella Pieve; et in Santa Maria Novella una tavola grande con una Nostra Donna con angioli intorno, oggi posta alto fra la cappella de' Bardi et de' Rucellai. Andolla a vedere in Borgo Allegri, mentre che la dipigneva, il re Carlo d'Angiò, e fu portata in chiesa a suono di trombe; stava [Cimabue] a casa nella via del Cocomero.

The manuscript original for this text is Florence, Biblioteca Nazionale, Ms Magliabechiano XIII 89, f. 41r. Both this and the previous item relate to Duccio's Rucellai *Madonna*, which Billi gives to Cimabue. This passage has often been thought to be a source for Vasari's attribution of the same picture and for his account of Charles of Anjou's going to see the panel while it was being painted. But Benedettucci, the most recent editor of *Il Libro*, points out that this manuscript is a version of 1563. It is therefore likely that the last sentence is an interpolation, based on Vasari's first edition (1550) of the *Lives*. [Ed.]

Billi seems to have been unfamiliar with Ghiberti's *Commentaries*. Baldinucci knew this text and used it in his *Notizie de' Professori del Disegno*.

4. 1510

F. Albertini, *Memoriale di molte statue et picture sono nella inclyta Cipta di Florentia Per mano di Sculptori et Pictori excellenti Moderni et Antiqui* (Florence, 1510), unpaginated:

> In decta chiesa [Santa Maria Novella] è una tauola grandissima p[er] mano di Cimabue

This volume is the earliest printed guidebook to Florence and the first in Italy. The author was a priest who was a canon in the church of San Lorenzo. There are various reproductive reprints of this publication: G. Milanesi and C. Guasti, 1863; J. Crowe and G. Cavalcaselle, 1869, 2; C. Fabriczy, 1891; H. Horne, 1909; O. Campa, 1932; P. Murray, 1972.

5. 1537-42

Anonimo Magliabechiano, *Il Libro Magliabechiano*, ed. C. Frey, *Il Codice Magliabechiano* Cl. XVII, 17 (Berlin: Grote'sche Verlagsbuchhandlung, 1892), part 2, 49:

> Et tra l'altre sue [Cimabue's] opere si uede in Firenze una Nostra Donna grande in tauola nella chiesa di Santa Maria Nouella a canto della cappella de Rucellai.

The relevant manscript is Florence, Biblioteca Nazionale, Ms Cl. XVII 17. This source is distinct from *Il Libro di Antonio Billi*, although portions of the latter were used by the author. The author knew Ghiberti's *Commentaries*, inasmuch as he devoted a separate section to Sienese painters, but Duccio does not appear therein.

6. 1550

G. Vasari, *Le Vite de' più eccellenti pittori, scultori e architettori, nelle redazioni del 1550 e 1568*, ed. R. Bettarini and P. Barocchi, Testo II (Florence: Sansoni, 1967), 35-44 [Cimabue], 259-61, [Duccio].[1]

Vasari devoted only three paragraphs to Duccio and, perhaps influenced by Ghiberti, placed the painter at the end of his discussion of early Sienese painters. Vasari, in fact, knew almost nothing about Duccio. He described him as having invented the technique of decorating marble pavements with figures for the cathedral in Siena. This is untrue, but Vasari's authority would lead many scholars who followed him to include discussion of the inlaid floors in the Sienese Duomo in their treatments of Duccio. He did know that Duccio created the altarpiece for the high altar of Siena cathedral and that the panel was removed and replaced with the bronze tabernacle still there today. Regarding chronology, all Vasari said was: "Trovansi l'opere di costui fatte nel MCCCXLIX."

Duccio is shown as without a master who trained him and without followers. He is an isolated figure in the *Prima Parte* of the *Lives*.

7. 1568

G. Vasari, *Le Vite de' più eccellenti pittori, scultori e architettori, nelle redazioni del 1550 e 1568*, ed. R. Bettarini and P. Barocchi, *Testo* II (Florence: Sansoni, 1967), 35-44 [Cimabue], 259-61 [Duccio]; *Testo* V, 172 [Beccafumi].

The account of Duccio in the second edition of the *Lives* is considerably longer, although the Rucellai *Madonna* remained, to Vasari, a work by Cimabue. He referred explicitly to Ghiberti and based his description of the *Maestà* on Ghiberti's. Vasari said that, in spite of a diligent search, he was unable to find the altarpiece itself, a most peculiar remark, as the *Maestà* was still in the cathedral at this date, though not on the high altar. In addition to attributing to Duccio an *Annunciation* in the Florentine church of Santa Trinita (a work actually by Lorenzo Monaco) and discussing the marble pavement in Siena, Vasari also attributed to Duccio the design of the chapel on the Campo, in front of Siena's Palazzo Pubblico, and dated the design to 1348. That attribution also appeared in the work of other individuals, including Della Valle (IV.25). Vasari said that Duccio was still active in 1350.

In the *Life* of Domenico Beccafumi, Vasari said again that Duccio began the

process of marble intarsia floors, specifically around the high altar. This matter was not sorted out until the early twentieth century; the marble floors of Siena cathedral were begun in 1369.[2]

Note that at this time, 250 years after Duccio's death, accurate knowledge of him was almost nonexistent. The Sienese chronicles preserved his authorship of the *Maestà* and its approximate date of installation, but they were not in print. Ghiberti also knew of Duccio's work in Siena cathedral, although he associated no date with it; his work was not published. The same is true of Francesco Piccolomini (III.3), who knew the *Maestà* as well and who had picked up from the chronicles the supposed cost of 3,000 florins. The same circumstances apply in the case of Sigismondo Tizio (III.4).[3]

8. 1584

R. Borghini, *Il Riposo di Raffaello Borghini in cui della pittura, e della scultura si favella de' più illustri pittori, e scultori, e delle piu famose le loro opere si fa mensione; e le cose principali appartenenti a dette arti s'insegnano*, (Florence: Marescotti, 1584), Libro III, 290; Libro IV, 470:

> Libro III, 290:
> Fece in una tavola la Vergine Gloriosa con molti agnoli di maggior grandezza che figura, che foste mai stata fatta infino a quel tempo, la quale fu posta in Santa Maria Novella fra la Cappella de' Rucellai, e quella de' Bardi di Vernio, e fu quell'opera di tanta maraviglia à quei popoli, che non havevan veduto avanti migliore, che da casa Cimabue con molta pompa à suono de' trombe e co' gra[nda] festa in ordine di processione, fu portata alla Chiesa, onde egli ne aquisto chiaro nome, grand'honore, e molto utile, e si dice che mentre Cimabue facea questa tavola fuor di Firenze in un borgo appresso à Porta San Piero, passò per Firenze il Rè Carlo d'Angiò il vecchio, e fra gli altri honori, che gli furono fatti, fu menato a vedere questa pittura, dove, nel mostrarsi al Rè, per non esser stata più veduta, concorsero à vederla tutti gli huomini, e tutte le donne di Firenze, con grandissima festa. Laonde per l'allegrezza, che ne hebbero i convicini, chiamarono quel luogo Borgo Allegri, il quale essendo col tempo dentro alle mura, ha sempre ritenuto il medesimo nome.

> Libro IV, 470:
> Si mise dopo questo a seguitare il pavimento del Duomo, che già Duccio pittor Sanese havea con nuova maniera di lavoro cominciato; e perchè Duccio riempieva i vani taglianti nel marmo bianco di mistura nera, Domenico [Beccafumi] conobbe che col mettere in mezo i marmi bigi, più bello, e più stabile lavoro si potea fare

Borghini, for all intents and purposes, simply repeated Vasari's story of Cimabue, the Rucellai *Madonna*, and Charles of Anjou. In Libro IV, 470, and in the context of discussing Beccafumi, Borghini credited Duccio with inventing the technique used for the marble floors of Siena cathedral.

9. 1599

O. Malavolti, *Dell'Historia di Siena* (Venice: Marchetti, 1599), Parte seconda, 108:

> . . . la qual Cappella [before the Palazzo Pubblico], fù disegnata da Duccio pittore Sanese, quel che trovò modo di fare le figure nel pavimento di marmo co' rimessi di chiaro, e scuro, come si vede nel Duomo di Siena

This passage is based on the second edition of Vasari. Indeed, Vasari described the pavements as "di marmo ai rimessi delle figure di chiaro e scuro."

10. 1617-22

A. Marucchi, ed., *Giulio Mancini-Considerazioni sulla pittura* (Rome: Accademia Nazionale dei Lincei, 1956), 1: 176-78:

> Duccio fu coetano di Pietro[4] quale, che nascesse in Siena e fusse amorevolissino della sua patria, si vede dal pavimento del Duomo del quale, come vien detto, n'hebbe pochissima remunerazione fuor dell'aplauso e benvolenza della città e satisfation di se stesso d'haver con questa sua fatiga servito a Dio et alla patria; do[ve] con la pietà christiana accompagnò grandissim'arte, essendo per que' tempi reputatissimo
>
> Ne è vero quello che dice il Vasari che, quando fece in Arezzo la cappella de' Cerchi fosse così giovane, poichè intorno al 1330 fece li spazi e doppo, nel 48, dopo la peste, la Cappella di Piazza Morì intorno al 360.
>
> Di questo in Siena, oltre li spazi e cappella detta, si vedon' poche cose che, essendo vissuto assai ragionevolmente come s'è detto, bisogna concludere o che operasse fuor di Siena, o che per comodità di robba si curasse poco di lavorare, o che s'occupasse nell'architettura ponendosi solamente il nome di Duccio, perchè in quel tempo nella città, per legge di chi governava, chi volev'esser di governo bisognava che rinuntiasse all'arme et al casato, poichè il stato era populare che con il casato pareve loro che si togliesse questa popularità et equalità. Pertanto credo che fusse ancora il cognome di Duccio come s' usava in quei tempi, onde probabil cosa sarebbe che questi Ducci, che hoggi vivano in Siena, siano descendenti di questo artifice. Ugolino da Siena fu coetaneo di Duccio.

The manuscript version of this in Siena is: Siena, BC, Ms L.V.11, a contemporary copy, according to Marucchi, with notes in Mancini's hand. Marucchi (xv-lxii) lists the many surviving manuscript copies, including Siena, BC, Ms L.V.11 and L.V.12.[5] Much is based on Vasari, who, incidentally, attributed the Aretine chapel not to Duccio but instead to Moccio, whom he described as a Sienese sculptor and architect. No such person existed.

Mancini's work was well known. Certainly, Baldinucci (IV.15), Della Valle (IV.25), and Bottari (IV.21) used manuscripts of it, as did Romagnoli (IV.42). On f. 45v of Ms L.V.11, Duccio appears in a list of Sienese painters of the period from 1300 to 1320: "I pittori più celebri dei quali si ne posson vedere pitture."

As Satkowski points out in her essay, Mancini's discussion of Duccio is really extraordinary and a very important event in Sienese culture. He wove a wonderful tale around the sparse information provided by Vasari. Duccio's work in Siena cathedral brought him very little monetary remuneration but won him the applause and goodwill of the city, and he remained content in knowing that his labors had served God and the "patria." Having invented that pretty tale, Mancini felt the need to explain why one saw few works by Duccio in Siena. Perhaps Duccio worked outside Siena? Perhaps he did not work a great deal? Perhaps he occupied himself with architecture? Then, Mancini tried to explain why the artist was known only as Duccio, without a surname: because anyone who wished to govern had to renounce arms and noble station, since the government was popular and egalitarian. [Ed.]

11. 1625

G. Tommasi, *Dell'Historie di Siena* (Venice: Pulciani, 1625), part 2, 165-66:

> Aggiungesi a queste cose la consulta del modo di condurre dal Laterino al Duomo l'Immagine di Nostra Donna da gran numero di Santi adorata, per collocarla nel primo Altare. Questa dipentura famosissima in quel tempo haveva fatta Maestro Duccio di Buoninsegna dipentore Sanese, per prezzo (cosa ridicola da riferirsi) di fiorini tre mila d'oro, tanto fu quel secolo povero dell'eccellenza in quell'arte. Era da tutto il popolo con ardente desiderio aspettata; fu adunque risoluto, ch'andasse il Vescovo Ruggieri con tutto il Clero a levarla; il quale, come era stato ordinato, venne con la dipentura inverso il Tempio. I Sacerdoti a coppie sostenevano quella macchina molto grande, portata in effetto da gente prezzolata, e succedevano scambievolmente l'uno all'altro; ben tosto habbero incontra tutti gli ordini della Città accompagnati dal popolo, e seguitati dall turba delle donne, che per la strada, ond'ella portata, havevano ciascu-

na ornato inanzi alle porte delle case, e postovi fiori, e odori; e con allegrez-
za, e con lacrime ad alte voci pregavano la Vergine, che volontieri, e
favorevole alla Città entrasse dentro al suo Tempio. Con questa pompa la
condussero al Duomo, dove a' 9 di Giugno in Mercordi il Vescovo Ruggiero
dopo molte benedizioni di propria mano l'allogò nel prima Altare.

The manuscript source for this is Siena, BC, Ms A.III.34 (Libro IX), f. 253v. The
account given here is elaborated from that in the *Cronaca Aldobrandini*. Lisini claimed that
Tommasi also knew the chronicles of Agnolo di Tura and of Tommaso Montauri.[6]

12. 1625-26

Fabio Chigi (Pope Alexander VII), "Elenco delle pitture, sculture e architetture di
Siena," ed. P. Bacci, BSSP, n.s. X, 1939, 197-213; 297-337.

> (300-01) [l'altare privilegiato] La Tavola ivi, che era prima all'altar grande
> Duccio di Buoninsegna 1311 Lo spazzo antico di Giosuè. Ove è scritto
> come quanto sotto è di Duccio Così anco lo spazzo che li risponde dall'al-
> tra banda, e di Absalon, e di Betulia.
>
> (319) ABBADIA A S. DONATO.
> La tavola de la Madonna con 4 Santi *Duccius Boninsegnae de Senis 1310*.

The autograph manuscript for this work is Rome, Biblioteca Vaticana, Ms Chigiano
I.l.11, ff. 208r-208v, 219r. A copy, transcribed by G. Faluschi in 1821, is found in Siena,
BC, Ms E.VI.20.

The only novelty here is the altarpiece, apparently signed and dated, in the
Abbazia di San Donato, in Siena. Several later writers would note the one-time
existence of this work.

13. 1649

I. U. Azzolini, *Le Pompe Sanesi, o' vero Relazione delli Huomini, e Donne Illustri di Siena e suo
Stato* (Pistoia: Fortunati, 1649), 1: 655; 2: 331:

All of Ugurgieri's accounts of Duccio came directly from Vasari. The page cita-
tions of the second item are from the 1550 edition of Vasari.

14. 1655

A. Landi, *"Racconto" del Duomo di Siena*, ed. E. Carli (Florence: Edam, 1992), 28-29:

> A canto quest'Altare [of Sant'Ansano] sotto alla finestra, che gli viene a
> mano destra, è posata in staffe di ferro una pittura in tavola rappresentante
> Nostra Signora sedente con Gesù fanciullo ritto in grembo, e sostenuto da

essa con ambe le mani, con due ordini d'Angioli, e di Santi a' lati e a basso dinanzi con li Quattro Avvocati della Città genuflessi; e dalla parte di sopra con più storie d'essa Vergine, e con più Santi compartiti in più tabernacoli alla maniera greca; et è detta tavola dipinta ancora dalla parte di dietro con Storie del Testamento Nuovo, e con la Croce in mezzo. Fu dipinta dalla parte di dietro ancora, perchè fu fatta per l'Altare Maggiore di questo Tempio, dove fu tenuta più tempo; e perchè essendo isolato da ogni parte l'Altare, da ambe le parti si vedesse dipinta la Tavola. Questo fu opera di Duccio di Boninsegna, Pittore, e Scultore sanesi, fatta l'anno 1310, per prezzo di fiorini due mila, come a' più vecchi eruditi delle cose antiche ho sentito dire io stesso. Mi maraviglio assai, che Ms[7] Giorgio Vasari nella vita, che scrisse di questo Duccio asserisca di non haver potuto vedere quest'opera per ogni diligenza, che ne facesse quando fu in Siena; perchè levata che fu dall'Altare per nuova architettura fatta in esso, fu locata subito nella destra del Tempio, poco più a basso di dove è di presente, e però è stata sempre esposta a chi l'ha voluta vedere. Visse questo Pittore nel 1300, e come afferma il Vasari fu segnalato sopra ad ogni altro Pittore, poichè prima d'ogni altro diè principio a' rimessi di chiaro e oscuro di marmo, come si vedrà, quando si scriverà del pavimento del Tempio.

Manuscript copies of the work are Siena, BC, Ms L.IV.13; Ms L.IV.14; Ms C.II.3. Other copies are found at the Soprintendenza ai Beni Artistici, Siena, in the archives of the Archbishopric of Siena, and in the Bodleian Library, Oxford.

Landi obviously used the Sienese chronicles for the date of the *Maestà*. His description of the work, however, is clearly based on his examination of the altarpiece. One other matter of note: Landi said the *Maestà* cost 2,000 florins. Much later, Milanesi (1878, 1: 655, n. 1) would say that Francesco Piccolomini (here III.3) originally said that the altarpiece cost 2,000 florins, but the sum first appeared here, in Landi.

15. 1681

F. Baldinucci, *Notizie de' professori del disegno da Cimabue in qua* (Florence: Franchi, 1681), 1: 4, 58:

4:
A summary from Vasari on the Rucellai *Madonna*.

58:
Duccio da Siena Pittore
Non mancarono alla città di Siena in questi tempi [1340-50] suoi pittori, uno de' quali fu Duccio, che molto operò a chiaro scuro. Fece per il

Duomo di quella città una tavola, che fu messa all'altar maggiore, e poi dovendosi porre il tabernacolo, fu levata, ed in altro luogo di quella cattedrale appesa. Una sua tavola ci fu mandata a Firenze per la chiesa di santa Trinita, nella quale è dipinta Maria Vergine, e questa non lascia dubitare dell'eser costui uscito dalla scuola di Giotto, o de' suoi discepoli. L'anno della crudele mortalità del 1348 dipinse la cappella della piazza di quella patria. Operò finalmente per la città di Pisa, e furono anche portate le sue opere a Pisa e a Lucca.[1]

Note 1: Il Vasari attribuisce a questo arteficie la gloria di esser egli stato il primo, che insegnasse il modo di far ne' pavimenti di marmo figure di chiaroscuro, al quale lavoro diede principio nel duomo di Siena, ove poi si son fatte da migliori, e più moderni artefici le belle opere, che al dì d'oggio vi si vedono.

On page 4 of this volume, Baldinucci repeated Vasari's story concerning the Rucellai *Madonna* but indicated that the panel was in the Rucellai Chapel of Santa Maria Novella. Baldinucci's statement that Duccio was a follower of Giotto or of his disciples is part of the guiding strategy behind his *Notizie*.[8]

16. 1690

F. Baldinucci, *La Veglia o dialogo di Sincero Veri* (Florence: Pietro Martini, 1690), 10:

Or se voi osserverete il tempo in cui trovansi costoro nominati per Pittori, e darete loro gli anni della vita secondo un certo ragionevole riguardo, troverete, che molti di questi pottettero operare avanti a' tempi di Cimabue. A questi potrei aggiungnere un Duccio del Popolo di S. Maria Novella . . . che tutti operavano avanti, e poco dopo al 1300.

The origin and precise meaning of this reference to Duccio is unknown. Is this the Sienese Duccio or another of the same name? As Duccio seems to have created the Rucellai *Madonna* in Florence, perhaps Baldinucci knew some document placing the artist in that parish. There is no known documentation that would answer these questions.

17. 1704

P. A. Orlandi, *L'Abecedario pittorico* (Bologna: Costantino Pifazzi, 1704), 134:

Duccio di Siena Pittore Giottesco, si vedono sue opere in Siena, in Lucca, in Pisa, ed in Firenze: ne parlano di costui il *Vasari*, & il *Baldinucci* sec. 2, fol. 58. Fiorì nel 1348.

Baldinucci is, of course, the source of the idea that Duccio was Giotto's pupil. The citation given indicates that Orlandi was using the first edition of Baldinucci's *Notizie*.

18. 1723

G. Gigli, *Diario sanese* (Lucca: Venturini, 1723), 1: 280; 2: 428-30:

> Fu posta in Duomo nell'Altar Grande nell'anno 1310 la gran Tavola di nostra Donna, opera di Duccio da Siena, tolta da una muraglia della contrada del Laterino allato alle due porte; la quale poi da detto Altare fu levata per dar luogo al Ciborio del bronzo nel 1506 e posta accanto all'Altare di S. Ansano. Scrive Agnolo di Tura, e lo rafferma Sigismondo Tizio, che la sopradetta tavola fosse pagata a Duccio fiorini 3000. Che è prezzo oltre modo grande specialmente a quell'età.
>
> Nel 1308 Duccio pittore da Siena cominciò la tavola grande per l'Altare Maggiore, e finilla nel 1310 essendo pagato a soldi 16 il giorno a tempo di Fr. Grazia operaio (Contratto dell'opera num. 399). Trovasi però nell'antiche memorie, che questa tavola fosse pagata tremila fiorini d'oro, ma un tal somma di troppo è superior a' pagamenti che faceansi a quei tempi. Questa è la medesima, che sta adesso allato all'Altare di S. Ansano, ed è colorita ancora dalla parte di dietro. Prima della pittura di Duccio stava nell'Altar Maggiore l'altra Immagine di Nostra Donna che sta ora nella Cappella del Papa, la quale dall'Altare maggiore predetto fu trasferita in quel tempo all'Altare dove è oggi S. Francesco di Sales Nel 1350 Duccio da Siena cominciò a fare il pavimento, cioè l'istorie sotto l'Altare di S. Ansano.

Gigli's *Diario* was published in an expanded second edition in Siena (Landi e Alessandri) in 1854.

The first notice makes it clear that Gigli read Tizio's history of Siena, but the remark concerning the cost of the *Maestà* does not come from Tizio: "oltre modo grande specialemente a quell'età." It seems possible that this is in reply to Tommasi's remark (IV.4) that the sum was ridiculous. Indeed, in the second notice, Gigli says, "ma un tal somma di troppo è superiore a' pagamenti che faceansi a quei tempi," which changes the emphasis and seems to echo Tommasi more clearly.

From conversations with Macchi and/or from the latter's unpublished *Memorie*, Gigli could have identified the 1308 document regarding the *Maestà* as "contratto dell'opera num. 399," and noted both that it called for Duccio's salary to be 16 soldi per day and that the *operaio* was Fr. Grazia, but Macchi's *Memorie* does not include the 3,000-florin sum.

19. 1752

G. A. Pecci, *Relazione delle cose più notabili della città di Siena sì antiche come moderne* (Siena: Quinza and Bindi, 1752), 11, 18-21, 68, 116:

11:

Lateralmente all'Altare di S. Ansano, si vede appesa un antica Tavola coll'imagine di N. Signora, e con molti Santi, e dipinta ancora dalla parte opposta, che stava già collocata nel maggiore Altare, lavorata da Duccio di Buoninsegna Pittore Sanese nel 1310.

18-21:

Scendendo di poi i tre scalini dalla banda di Sagrestia, tra questi è lo scalino di sotto si vede effigiato Giosuè, che avendo debellato le genti de' cinque Re Amorrei, e facendoli trarre da una grotta vicina alla Città di Macada, ove si era ascosi, gli fece appiccare a cinque stipiti. Questa storia fu intagliata da Duccio di Buoninsegna Pittore, e Scultore Sanese, di cui Vasari scrisse la vita, e affermò esser stato il primo, che nel Pavimento del Duomo dasse principio à rimessi delle figure di chiaro, e scuro, e ordinasse, e disegnasse i principi intorno all'Anno 1350, conforme stà scritto ne' Libri dell'Opera . . . la prima storia che si presenta sopra lo scalino e sotto ai tre, esprime le prodezze operate da Sansone contro i Filistei. Non pochi intendenti si persuadono esser stata disegnata (conforme l'altra di Giosuè) da Duccio Sanese, altri poi di contrario sentimento, sicchè io non saprei precisamente fissarmi nè circa l'artefice, ne circa il tempo

68:

[Cappella nella facciata di Palazzo Pubblico] Nell'angolo destro si riguarda una Cappella aperta, e guisa, di portico, in onore della Natività di Maria Vergine, eretta per voto della peste del 1348, e gettati i primi fondamenti nel 1352. L'architettura di questa è mezza gotica, e mezza Romana, composta tutta di marmi, l'invenzione della quale è di Duccio

116:

Abbadia di Michel Arcangiolo, contenente una tavola di Madonna, con quattro Santi di Duccio di Buoninsegna, dipinto nel 1310.

Pecci's notices add little to the scholarly situation. He noted the *Maestà* in the cathedral, at the side of the altar of San Ansano, and dated the work to 1310; he discussed Duccio and the pavements in the Duomo, a discussion largely from Vasari. He also attributed the design of the chapel on the Campo to Duccio and

said that it was founded in 1352. The one novelty (116) is his statement that the Abbadia di Michel Arcangiolo contains a Madonna and four saints by Duccio di Buoninsegna, painted in 1310. This is surely the work that Fabio Chigi (IV.12) said was in the Abbadia a San Donato.

20. 1756

G. Richa, *Notizie istoriche delle chiese fiorentine* (Florence: Viviani, 1756), 4: 4:

> Or questo Guidotti compatendo alle angustie del luogo de' suoi Monaci in Firenze, voltò il persiero ad ampliare Chiesa e Convento in quella guisa, che ne ragione il Vasari nella Vita di Duccio Sanese, che ne fu l'architetto, scrivendone come segue: "S. Antonio era una Chiesa murata all'antica assai ragionevole"

The passage results from a confusion. In the second edition of Vasari's *Lives*, and specifically within the *Life* of Duccio, the author included a discussion of a certain Moccio, sculptor and architect of Siena, whom Vasari claimed built the church and convent of San Antonio in Florence. Richa ascribed those structures to Duccio.

21. 1759-60

G. Bottari, ed., *Vite de più eccellenti pittori scultori e architetti, scritte da Giorgio Vasari pittore e architetto aretino, corrette da molti errori e illustrate con note* (Rome: Pagliarini, 1759-60), 1: 1-6 (Vita di Cimabue); 1:138-39 (Vita di Duccio):

> 1: 2: (indicated as a note to p. 4, line 26)
> Di questa tavola, che anche di presente si mantiene bene in essere nella medesima cappella de' Rucellai, parlo lo stresso P. Richa, e la descrive a c. 62 del tomo 3.

> 1: 21: (indicated as a note to p. 138, line 30, line 37)
> Si trova questa tavola [the *Maestà*] dipinta da ambe le parti nel detto duomo allato all'altare di S. Ansano, e fu dipinta nel 1311 Morì Duccio in Siena nel 1357 e fu seppellito nella chiesa de' PP. Agostiniani. Il suo nome proviene da *Landuccio*, e questo *Lando* troncato dal celebre nome d'*Orlando*.

> 1:22: (indicated as a note to p. 139, line 32)
> Trovo che Duccio fu figliuoli di Buoninsegna di Siena. Morì nel 1357. e fu sotterrato nella chiesa de' PP. Agostiniani.

This is a separate section of footnotes, numbered independently of the text. These notes by Bottari, from his edition of the 1568 *Lives*, are particularly important. In part, they were carried over into Della Valle's (IV.31) and Milanesi's editions of Vasari, in 1799 and 1878, respectively.

Bottari claimed that Duccio died in 1357, and was buried at the church of San Agostino in Siena. No source is cited. Romagnoli disputed this dating in his *Biografia Cronologica de' Bell'Artisti Senesi* (IV.42). Romagnoli concluded that the date was wrong and argued that Duccio was dead by 1352, basing his argument on a document of 1354 that mentions the "erede del Duccio dipintore"(I.59).[9]

22. 1760

G. Pianigiani, *Il Duomo di Siena descritto per commodo de' forestieri da Giacomo Pianignani custode anziano del medesimo* (Siena: Bindi, 1760), 12-13:

> Nella parte laterale di d. Altare [of Sant' Ansano] vedesi una Pittura in tavola rappresentante Nostra Signora sedente con Gesù Fanciullo in grembo, e due ordini di Angeli, e di SS. allato, e abbasso: quest'opera dipinta alla Maniera Greca è di *Duccio di Buoninsegna* del 1310, ed è colorita parimente dalla parte di dietro con storie del Testamento nuovo, e con la Croce in mezzo, per esser stata fatta per l'Altare Maggiore, dove fu tenuta esposta lungo tempo.

Although there are minor variations in the two texts, this description is surely based on Landi's account (IV.14) of the Duomo from 1655. The source is revealed through the similar phrasing. For example, Landi says of the *Maestà*: "con due ordini d'Angioli, e di Santi a' lati, e a basso dinanzi con li quattro Avvocati della Città genuflessi." Pianigiani shortens this to: "e due ordini di Angeli, e di SS. allato, e abbasso: questa opera" [Ed.]

23. 1774

G. Provedi and G. Fratini, *Il Duomo di Siena* (Siena: Bindi, 1774), 14:

> Nella parete laterale di detto Altare [of Sant' Ansano] vedesi una Pittura in tavola rappresentante N.S. sedente col S. Bambino in grembo. Quest'opera fu cominciata nel 1308, e terminata nel 1310 da Duccio di Buoninsegna Sanese. Sono da notarsi in questa pittura gli Angioli per i loro vestiti, e per lo Scettro, che tengono nella destra, che quasi assomigliasi a quella verga usata dall'Imperatore dell'Oriente, e che *Ferule*, o *Nartheca* veniva chiamata: I Santi MM. S. Caterina delle Route, ed altri sono vestiti con abito monacale detto non tanto dai Greci, che dai Latini

Abito Angelico, e con una piccola Croce dall'uso greco, conforme si vede nei Santi riportati nella Tavola di Du-Fresne.

This account of the cathedral also includes a section on the pavements but does not mention Duccio in connection with them.

24. 1776-95

AODS, Inventario di beni mobili e immobili 1511, 1776-95, f. 44r:

> In choro
> A canto a detto altare [of Sant'Ansano] vi è il tavolone all'antica, dipinto da tutte due le parti, fatto da Guido da Siena, che dalla parte davanti dimostra la Beatissima Vergine con più Santi, con baldacchino e frangia cremisi.[10] In faccia a detto altare a [*sic* = e] tavolone vi è una lampada d'argento, di peso libbre cinque once 4. Ed altra lampada d'argento è in faccia a detto altare di S. Ansano. Al quale altare vi è la sua tenda, e la lampada è di peso libbre quattro e oncie 9, compresovi due toppe di rame.

In a marginal note to the passage above:

> Adì 18 luglio 1777 fu trasportato detto tavolone nella chiesa di Santo Ansano e la lampada fu messa in faccia all'altare del Sacramento. A dì primo agosto detto tavolone fu segato in più pezzi e furono trasportati nell'ultima stanza del quartiere a mezze scale del Sigr. Rettore per farne quadri: uno è all'altare di S. Ansano, l'altro presso l'altare del S.^{mo} Sacramento.[11]

Published: Bacci, 1936, 185-86; Stubblebine, 1979, 35-36.

Bacci (186, n. 1) added notice that in "un conto di M° Galgano Casini legnajolo, del 4 agosto 1777, lessi per aver mandato un maestro per disfare il quadro di tavola che fu portata dal Duomo a Sant'Ansano fattone più parti, fattoci due opere col fattorino, lire 5." Bacci does not give a citation. This information was repeated by Stubblebine.

25. 1782-86

G. Della Valle, *Lettere sanesi di un Socio dell'Accademia di Fossano sopra le belle arti* 1 (Venice: Pasquali, 1782), 277; 2 (Rome: Salomoni, 1785), 63-77.

> 1: 277:
> (1282) Comincia ad esser nominato il celebre Duccio, a cui gli si danno 8 soldi per una pittura fatta ne' libri del Camarlingo.

In conformity with his general procedure, Della Valle opened his principal discussion of Duccio (2: 63-77) by quoting Vasari. He then noted that Bottari, in his edition of Vasari, had said that the *Maestà* was painted in 1311 and was near the altar of San Ansano, but that Bottari was mistaken. Bottari also said that Duccio died in 1357, but from the "libri della Gabella" and the notes of Celso Cittadino, we know that Duccio was dead by ca. 1350, as an Ambrogio di Duccio and a Galgano di Duccio are mentioned at that time. He cited again the payment recorded above, then cited Biccherna payments of 1389 to another Duccio. Della Valle recorded Bottari's explanation of Duccio's name.

These passages precede quotations or summaries of earlier secondary sources: the Sienese chronicle for 1202 to 1391, the chronicle then attributed to Buondone and Bisdomini, the discussions of Francesco Piccolomini (Pope Pius III:III.3), Sigismondo Tizio (III.4), and Mancini (IV.10). Citing various letters by Benvoglienti, Della Valle recorded that author's views on Duccio and, in fact, copied several sentences from Benvoglienti's *Sulla Scuola Pittorica*, that begin "Duccio secondo il Baldinucci . . . " (IV.15).

Landi's description of the Sienese Duomo, quoted verbatim (see IV.14), is followed by the one section of any length that is original.

2: 71-73:

Ma siccome quello che ne dice questo scrittore, pare non basti a dare un dettaglio del merito intrinseco di questa pittura, vi aggiungerò alcune mie osservazioni. E prima di tutto diró che fù trasportata dal Duomo in certi mezzanini che sono al terzo piano della casa dell'opera, dove si lavorano i marmi. Dirò in secondo luogo, che fù un danno, che sia stata segata, e ridotta in più pezzi pet [*sic* = per] introdurla in quel luogo basso, e oscuro; perchè non avendo l'Italia, per quanto io ne abbia fatto ricerca per tutti gli angoli della medesimo, una tavola di quel tempo così istoriata, e così ben intesa, come è questa (eccettuata però sempre la pittura a fresco di F. Mino, che è nella sala grande del consiglio);[12] e inoltre avendo gli antichi Sanesi fatto tante feste per essa, e parlandone con tanta distinzione quasi tutti gli scrittori, che fecero la storia dell'arte del *medioevo*, dovevasi essa dai moderni conservare come un monumento prezioso, che fà epoca in essa. Quantunque però questa tavola e ne' taglj a' quali fù condannata, e ne' trasporti fattine in diversi tempi, abbia non poco sofferto; il danno però sarebbe rimediabile, e attesa la consistenza potrebbesi riattare facilmente, e ricomporre.

La sua grossezza è di due soldi, e 2. quattrini, se si tolga un quattrino per parte di impialliciatura. Il legno è albero, o pioppo ridotto a tavole lunghe tre palmi e alte nove circa; alcuni chiodi di castagno grossi quanto un pollice ordinario unisco o strettissimamente queste tavole così che di ferro non farebbero di più, perchè dopo tanti secoli avrebbe prodotto ruggine, o aggravato sovverchiamente dal peso di quella macchina sarebbesi allentato, mentre nella commettitura immaginata da Duccio non appare in essa, benchè lungo tempo stata sia isolata, alcuna sconessione, o disuguaglianza. E' da rimarcarsi anco la diligenza di Duccio nello sciegliere tavole così mature, e sane, che neppure da un tarlo vedonsi offese, e di un legno di tessitura facile, e leggera, ma nell'istesso tempo tale, che le parti componenti si abbraccino tenacemente nelle fibre, senza aggravarsi colla soverchia pressione.

Sopra le tavole vi sono alcuni scompartimenti di un quadrato irregolare, che se non erro, dovevano dare al tutto insieme la figura di sesto acuto.[13] Della parte che guardava la Chiesa, evvi la Vergine con alcuni Santi di figura naturale. Sicomme nell'altre tavole antiche, così in questa si vede unita la tela, che in alcuni luoghi appare di lino; sopra vi è una mano di gesso; quindi un'altra di azzurro; siegue l'oro; e finalmente il colorito a tempera.

La maniera è di Guido da Siena, sebbene di molto rammorbidita, e migliorata. Nelle figure grandi vi sono delle teste, de' piedi, e delle mani, che relativamente a que' tempi, sono bastantemente disegnati; alcune fisonomie non sono prive di grazia, ma per lo più portano in fronte il turbamento, e lo scompiglio dell'età, in cui furon fatte; le membra non hanno la secchezza della maniera greca d'allora. L'azzurro che è sotto alle figure, e massimamente al viso della Vergine, forse per essere invaso dall'umido, ha nella fermentazione turbati i colori soprapposti, e ne ha rose le tinte più delicate, per cui non sembrano sì belle, e come lo sono alcune altre figure; il bambino somiglia a quello di Guido; alcuni vecchj hanno nelle ciglia, e nel volto delle mosse spirtose, e significanti.

Nella parte, che guardava il coro in molti scompartimenti vi è dipinta la vita di G. C. con figurine alte un palmo circa, e copiose; dove è dipinta l'Annunziata vi è un architettura con archi sufficientemente rotondi; così in quella, dove si rappresenta il tradimento del Redentore commesso da Giuda in un atrio forse del Tempio; si vede lo sforzo del pittore per tirar gli archi in iscorcio secondo le leggi dell'ottica, e del vero, ma si vede riuscir vana l'opera per mancanza di sapere colla prospettiva ingannare l'oc-

chio, come riuscì ai maestri, che vennero dopo, Duccio cioè, e Giotto, ma più questi, che a' loro maestri aprirono in ciò la via sconosciuta.

Dal Limbo di Duccio molti moderni hanno imparato, e copiato più d'una cosa, e così dagli altri scompartimenti perchè più anni questa tavola dovette essere il regolo dell'arte. S. Pietro che nega il divin maestro alla serva nell'atrio di Pilato, mostra di lontano l'uomo trà il ribrezzo, e l'agitazione delle sopresa; vi sono in varj luoghi de' manigoldi pieni di fierezza, de' quali certamente non gli sarano mancati de' modelli in quel secolo. La sconficcazione ha più d'una figura, che al panneggiamento ricco insieme, e semplice, agli atti, e al volto sembra tolta dall'antico; nella morte della Madonna vi è dell'espressione. Giotto sicuramente non disegnò così li piedi, nè li posò così bene. Nell'apparizione di Cristo, e nel *mitte manum* &c. vi è dell'effetto, e dell'anima; vi si leggono i rimproveri all'incredulo &c. &c. Se non m'inganno, Duccio diede sù la pittura una lieve vernice, se pure quel lucente, che si vede, non nasce dall'impasto de' colori a tempera, e dalla patina.[14]

Following the above, Della Valle returned to sources, citing Tommasi, Ghiberti, Vasari, and Pecci; following those summaries, he described what he claimed was a model for the chapel on the Campo. He mentioned an altarpiece then in the refectory, or on the stairs to it, in the monastery of Mona Agnese. He also attributed another panel of the Virgin and Child to the painter, in the choir of San Francesco, Siena. Next comes a quotation from the October 1308 document concerning the *Maestà* and brief remarks about the pavements in the cathedral that he said he would discuss elsewhere.

Between 1780 and 1800, Della Valle corresponded with Lanzi, Ciaccheri, Séroux d'Agincourt, and Da Morrona, the principal exponents of the Italian artistic culture, among whom Della Valle occupied an important place. Many later scholars used and cited the *Lettere Sanesi*.

26. 1784

G. Faluschi, *Breve relazione delle cose notabili della città di Siena* (Siena: Rossi, 1784), 35-36:

Questa storia è intagliata in pietra bianca pura, e le figure sì di Uomini, che di Cavalli sono fatte con molta vivezza. L'Artefice si crede il celebre Duccio di Buoninsegna, di cui il Vasari scrivendo la Vita referì, che egli fu il primo, che nel Pavimento del Duomo dasse principio ai rimessi delle figure di chiaro oscuro, e ciò fu circa il 1350.

With the *Maestà* removed from the cathedral, Faluschi failed to mention it at all. His discussion of Duccio focused entirely on the marble pavements of the Duomo. Even there, he only noted that Duccio originated the technique—as Vasari had said—and that some people claimed that the pavement with Moses carrying the tablets of the commandments was by Duccio. Faluschi implies that he was unsure.

27. 1786

M. Prunetti, *Saggio pittorico* (Rome: Zempel, 1786), 55-56, 117:

55-56:

I Professori di questa Scuola ànno posseduto specialmente uno stile energetico dell'invenzione; graziose arie di testa; un colorito vistoso; e un buon disegno. Ma per lo più bizzari sono stati nella composizione; poco seguaci del Bello Ideale e dell'antico; e ànno usato, se se n'eccettuino taluni, colori alquanto risentiti e nemici di una dolce armonia *Duccio di Buoninsegna* Sanese, allievo del suddetto *Guido*. Egli sortì dalla natura dei talenti superiori a quei del Maestro; onde tentò una nuova via, come dimostra una sua Tavola grandissima dipinta da ambe le parti con infinito studio, e con fatica di trè anni. Questa Tavola fu eseguito nel 1310: non abbiamo un più prezioso monumento di quei tempi. Il Sig. Principe D. Sigismondo Chigi sì benemerito delle Belle Arti, . . . la stà facendo di presente incidere; perche tutto il mondo possa mirare una tavola che fa epoca nella Storia Pittorica. A *Duccio* noi dobbiamo l'invenzione di ornare i pavimenti con varj marmi ritagliati e connesssi. Il Chiaroscuro produce in questi l'istessa illusione, che sogliono i colori produrla in sulle tele. Fu trà i suoi allievi *Maestro Lorenzo*, Padre dei celebri Lorenzetti; Fra *Jacopo da Torrita*; e *Jacopo della Fonte*.

117:

Catalogo Cronologico
Della nascita e della morte dei più valenti Pittori già descritti, e combinato secondo la più esatta Critica.
Duccio di Buoninsegna, *Scuola San.* 1255-1340

The claim that Duccio was a pupil of Guido da Siena likely stems from Della Valle's remark in the *Lettere Sanesi* that the *Maestà* displayed an improved version of Guido's manner. Prunetti then concluded that Duccio was the master who trained Maestro Lorenzo (the supposed father of the Lorenzetti brothers), Jacopo da Torrita, and Jacopo della Fonte. There is no genuine documentary evidence con-

cerning a "Maestro Lorenzo," and "Jacopo della Fonte" is likely a reference to Jacopo della Quercia. Jacopo da Torrita plays a significant part in Della Valle's account of the Sienese school, which may be why he is included here.

28. 1787

A. da Morrona, *Pisa illustrata nelle arti del disegno da Alessandro da Morrona, Patrizio Pisano* (Pisa: Francesco Pieraccini, 1787), 1: 348:

> Una Madonna di *Duccio da Siena* della raccolta Zucchetti . . .

Nothing further is known of this work. Da Morrona, who was in direct correspondence with Della Valle, sought to distinguish the art of Pisa and to claim a place for it alongside the art of Florence and Siena in the rebirth of the arts.[15] Da Morrona's attribution of this work derives its authority from Vasari's assertion that Duccio had painted "moltissime cose" for various churches in Pisa (see IV.6).

29. 1789

L. Lanzi, *Storia pittorica della Italia* (Bassano: Remondini, 1789), 1: 281, 286-87, 292:

> 281:
> Egli [Della Valle] ha ben ragione di negare a Giotto certi alunni senesi, che non per altra ragione gli si ascrivevano, sennon per lo stile rimodernato: ecco trovato in Siena un artefice che nello stile moderno ha dato pur qualche passo prima di Giotto, che nel 1289 contava 13 anni: questo Mino e Duccio, di cui fra poco si parlerà, poterono sicuramente formar discepoli da competere con la scuola di Giotto; anzi lungamente vivendo da vincere Giotto istesso.

> 286-87:
> Altro maestro di quella età è Duccio di Boninsegna, del quale, come d'inventore d'un nuovo genere di pittura, tratto in altro luogo. Il Tizio lo dice istruito da Segna, nome oggidì quas'ignoto a Siena. Dovè però egli avere avuta a' suoi dì grandissima celebrità; affermando il Tizio aver dipinta in Arezzo una tavola con una immagine, a cui dà il titolo di egregia e di celebre assai. Da Duccio poi ci ha lasciata questa insegnie testimonianza: *Duccius Senensis inter ejusdem opificii artifices ea tempestate primarius; ec cuis officina veluti ex equo trojano pictores egregii prodierunt.* Quell'*ea tempestate* si reiferisce al 1311, quando Giotto era in Avignon; e Duccio condusse in tre anni la tavola che tuttavia esiste nella casa dell'opera; e fa quasi epoca d'arte. E' assai grande, come richiedeva il maggior altare della metropolitana, per cui era ordinata. Dalla banda che guarda il popolo vi collocò grandi figure di N. D. e di varii

SS., e dalla banda che guarda il coro, a Molti sparimenti vi fece istorie evangeliche di figure palmari e moltissime. Pio II ne' suoi *Annali Senesi* non mai editi riferisce, che costò due mila fiorini; altri fino a tre mila; non tanto pel pagamento dell'artifice, quanto per la profusione dell'oro e dell'Oltremarine. La maniera a giudizio comune ritiene del greco; è però la più copiosa in figure, e delle migliori di que' tempi. Duccio dipinse per più città di Toscana; e a S. Trinita di Firenze mandò una Nunciata, *la qual non lascia dubitare essere costui uscito dalla scuola di Giotto o de' suoi discepoli*, dice il Baldinucci a chi legge. Ma a chi vede non potra dirlo ad esser creduto; avendo quella tavola tutt'altro colore e tutt'altro stile. La cronologia stessa nol consente, se già non è turbata ancor qui da pittori omonimi: Duccio dipingeva fin dal 1282 (*L. Sen. T.I*, p. 277), e morì circa il 1340 (*T.II*, p. 69).

292:

Duccio fu il primo ad ornare quel pavimento [of the cathedral], e la parte che ne condusse è tessuta di pietre E' di Duccio nel coro una verginella che ginocchione con el braccia in croce implora, come ivi è scritto, "misericordia" dal Signore: è forse la Pietà cristiana; ed ha certamente e nell'atto e nel volto espresso ciò che domanda. Quei che continuaron l'opera dopo Duccio non sono ben cogniti.

Lanzi employed a wide range of sources for this account: Tizio, Vasari, Baldinucci, Landi, Mancini, Benvoglienti, Della Valle, and the *Annals* of Pius III, the last misidentified as Pius II. Although Lanzi was Florentine, he gave the Sienese school of painting, founded by Guido da Siena, a distinct character and, echoing Tizio (who had already been echoed by Benvoglienti), described Duccio as a pupil of Segna di Bonaventura.[16] Lanzi also cited Tizio's words regarding the followers of Duccio, saying that painters came forth from his shop as numerous as the men that once issued from the Trojan horse. He attributed to Duccio "una verginella che ginocchione con el bracca in croce" in the choir of Siena cathedral. This attribution disappeared in later literature.

30. 1790

V. Fineschi, *Memorie istoriche per servire alle vite degli uomini illustri del convento di Santa Maria Novella* (Florence: Cambiagi, 1790), xli-xliii, 99, 118, 321:

xli-xlii:

. . . [the Compagnia delle Laude in Santa Maria Novella] fece fare una gran Tavola della Madonna e Mess. *Duccio di Buoninsegna da Siena* Pittore molto accreditato, e la quale dubiterei che fosse quella, che da tutti si crede mano di *Giovanni*

Cimabue e avanti ad essa vedevasi la lampada accesa, ed ivi si cantavano le Laudi

99:

. . . per cui si alloga in tal anno [1285] à Duccio di Buoninsegna, Pittore celebre d'allora, la tavola per l'Altare della medesima Compania di S.M.N. dal che resulta che tal pittore non fu scholaro di Giotto, ma certamente contemporaneo di Cimabue.

118:

MCCLXXXV. Ind. XIII. die XV. Aprilis . . . [Fineschi quotes part of the contract for the Rucellai *Madonna*.]

321, note:

. . . fatta da Giovanni Cimabue, sebbene peraltro mi verrebbe da dubitare, che non fosse quella grande, e bellissima Tavola fatta da Duccio di Buoninsegna Pittore Senese.

Fineschi's discovery of the contract for the Rucellai *Madonna* remained unknown to almost all scholars until the notice was republished by Milanesi in his *Documenti per la storia dell'arte senese* (1854).

31. 1791-94

G. Della Valle, *Vite de' più eccellenti pittori scultori e architetti scritte da M. Giorgio Vasari, pittore e architette aretino, in questa prima edizione sanese arricchite più che in tutte l'altre precedenti di Rami, di giunte e correzioni per opera del P. Guglielmo Della Valle* (Siena: Pazzini Carli, 1791-94), 2: 285-90 (Vita di Duccio); 6: 9-10 (Preface):

2: 285:

Duccio fu il primo che mostrasse il modo di fare nei pavimenti di marmo figure di chiaro e scuro.

2: 286:

. . . più moderno e più brillante di Fr. Giacomo da Torrita; altri poi, come Ugolino, Duccio, i Lorenzetti ec. seguitarono quello di Guido da Siena, che conserva del vecchiume detto Greco de' bassi tempi, e allo sguardo più ingrato del primo. I Gaddi tra i Fiorentini furono quelli, che più degli altri se ne scostarono. Sigismondo Tizio scrive che Duccio fu scholaro di Segna Sanese.

2: 286-87:

Dall'istrumento di allogagione fatta di questa tavola [the *Maestà*] di Duccio (pag. 75 e 76 del tomo II delle *Lettere Sanesi*), che seguì nel giorno ottavo di

Ottobre 1308, apparisce che il pittore era figlio di Buoninsegna Cittadino Sanese, ed ebbe sedici soldi sanesi il giorno per la sola sua opera: E inoltre dalle Chronache del Bondone e Bisdomini si ha che la tavola "fu fornita da dipegnarsi" in questo tempo (1311); e tutti gli scrittori delle cose Sanesi convengono nell'affermare che fu con grandissima solennità detta Tavola trasportata dalla casa dell'artefice al Duomo. Finalmente è da avvertire ciò che scrisse di Duccio il Tizio soprannominato, che fu Vicario Generale di Siena e lasciò in parecchi grossi volumi mss. molte memorie dell'età sua, e delle precedenti: "Duccius Senensis inter eiusdem officii Artifices ea tempestate primarius pinxerat, etc., ex cujus officina veluti ex quo Trojano pictores egregii predierunt." Uberto Benvoglienti non poteva dopo tante asserzioni di Scrittori contemporanei e di altri poco distanti perdonare al Baldinucci, il quale, ancorchè il Vasari medesimo nulla ne dica, asserisce che Duccio fu scolaro di Giotto. Altre copiose notizie di Duccio si hanno nel citato luogo delle *Lettere Sanesi*. Pertanto chiudero questa nota, avvertendo che S. E. il Sig. Principe Sigismondo fece incidere questa tavola, la quale sebbene sia sfuggita alle ricerche del Vasari vedesi tuttavia a' nostri giorni segata e divisa in due tavole appesa alle pareti del Duomo accanto a' primi due altari laterali, e meritasi ogni elogio Il Vasari riferisce la morte di Duccio circa al 1350 nella seconda edizione, e all'anno antecedente nella prima; però dai libri pubblici a Siena sappiamo che egli morì circa il 1340.

2: 287, n. 1:
Si trova questa tavola [the *Maestà*] dipinta da ambo le parti nel detto Duomo allato all'altare di S. Ansano, e fu dipinta nel 1311. Nota dall'Ediz. di Roma.

2: 287, n. 2:
Questa tavola della Nunziata [in Santa Trinita, Florence] esiste tuttavia ben conservata in quel luogo. Nota dell'Ediz. di Firenze.

2: 287, n. 3:
Morì D. in Siena nel 1357, e fu seppellito nella Chiesa de' PP. Agostiniani. Il suo nome proviene da *Landuccio*, e questo da *Lando* troncato dal celebre nome di Orlando. Nota dell'Ed. di Roma.

2: 289, n. 3:
Ma tornando a ns. Duccio: Trovo che Duccio fu figliuolo di Boninsegna da Siena. Mori nel 1357 e fu sotterato nella chiesa dei PP. Agostiniani (+). Nota dell'Ed. di Roma.

(+) Dai libri pubblici di Siena detti di Gabella.

2: 290:

. . . spogliati con ogni diligenza da Celso Cittadini, sappiamo che due pittori furono col nome di Duccio in questo secolo; il primo fu figlio di Buoninsegna, come si disse, ed ebbe un figlio pittore detto Galgano; l'altro nacque di maestro Niccolò, al riferire delle citate Cronache di Siena. Questi sopravvisse molti anni al celebre Duccio, e si trovano memorie di esso fino al 1390. E quindi derivò l'equivoco del Vasari e dell'editore di Roma.

6: 9-10:

Having noted that Duccio had improved the distribution and grouping of figures in his work, Della Valle added a note:

Mi sia quì permesso l'aggiungere brevemente qualche cosa a commendazione del N. U. Sig. Cav. Giovanni Borghesi Rettore dell'Opera del Duomo di Siena. Pose questi ogni diligenza nel fare risarcire la spezzata Tavola di *Duccio*, che dipinta da ambe le parti nel 1308, fu sempre riguardata, come la prima opera, ove si vede disegno, composizione, e gusto migliore, che non è in quelle de' Maestri precedenti delle altre Scuole. Questa Tavola segata nella grossezza in due parti forma ora due quadri grandi che restano appesi nelle pareti laterali di detto Duomo presso i due primi altari dopo il maggiore per comodo degli studiosi. In quello che sta dal lato del Vangelo e che rappresenta l'Avvocata de' Sanesi corteggiata e circondata da Angioli e Santi, e precisamente a' piedi della sedia o trono, ov'Ella si assidé, si legge questo scritto:

MATER SCA. DEI SIS CAVSA SENIS REQUIEI.

SIS DUCIO VITA TE QVIA PINXIT ITA.

Questo iscrizione non fu da me riportata nelle notizie di Duccio che pubblicai nelle *Lettere Sanesi*, perchè non ni venne sott'occhio, stando allora la detta Tavola ridotta in pezzi in luogo oscuro ed angusto. [Della Valle then cited various inscriptions from two of the figured pavements in Siena cathedral.]

Although Della Valle had consulted earlier editions of Vasari and traditional sources, such as the history by Sigismondo Tizio, the Bondone and Bisdomini chronicles, the works of Benvoglienti, Prunetti, Baldinucci, and the collections of documentary evidence compiled by Celso Cittadini, he could do little to clarify the conception of the historical Duccio. In the end, Duccio remained Vasari's Duccio and the Duccio of the early chronicles. Della Valle did, however, provide his readers with a correct transcription of the inscription on the *Maestà*. At Della Valle's urging, the *Maestà* was returned to the cathedral from the Opera del Duomo by the rector, Giovanni Borghesi.

32. 1806

J. H. Füessli, *Allgemeines Künstlerlexikon oder kurze Nachricht von dem Leben und den Werke der Maler, Bildhauer, Baumenmeister, . . .* (Zurich: Füessli und Compagnie, 1806), 2: 304:

Duccio di Buoninsegna, d.h. Sohn von Buoninsegna. Nach Lanzi I.286 arbeitet derselbe bereits um 1282, nach Fiorillo I.258 vollends schon um 1275. Segna, ein heut zu Tage in Siena unbekannter Name soll, nach Einigen, sein Meister gewesen sein. "Man hält ihn" (sagt Fiorillo I.c) "fälschlich für einen Schüler des Giotto; allein er war unstreitig ein Zeitgenosse von Cimabue, und aus der Schule des Guidone von Siena." (Die ihn betreffenden Notizzen giebt Della Valle in den. Lett. Senese (2: 63) und den Unmerkungen zue Neuen Ausgabe des Vasari (2: 285). In 1275. erhielt er den Auftrag, in der kirche St. Maria Novella zu Florenz ein Altarblatt zu malen, wofür ihm librae centum: quinquaginta flor. bezahlt wurden: cum pacto pingendi figuram B.M.V. et ejus omnipotentis filii et aliarum figurarum ad voluntatem dictorum locatorum et deaurare etc. Für den Dom zu Siena dann verfertigte er ein grosses Gemälde, woram er um 1310. Drei Jahre lang artbeitete, und welches, nicht so fast der eigentlichen Kunst, als des vielen dabei angebrachten Goldes und Ultramarins wegen an die 3000 Gulden kostete. Die Manier an demselben sah noch ganz der sogenannten griechischen dieser Kunstwerke gleich, und gehörte zu dem Besten des Zeitaltars. Auch wird er in Bezug auf dieses Werk wirklich irgendwo inter ejusdem opificii artifices ea tempetate primarius, ex cujus officina veluti ex equo trojano pictores egregii prodierunt, genannt. In der kirche St. Trinita zu Florenz befand sich ehemals ebenfalls von ihm eine Verkündigung, aus welcher eben Baldinucci den irrigen Schluss (der sich durch die Arbeit selbst widerlegen soll) gezogen, dass unser Künstler aus Giottos Schule ursprungen sein (Lanzi I.c). Endlich soll Er es gewesen sein, der den bekannten musaischen Fussboden in dem Dome zu Pisa (noch heute zu Tage das ausführlichteste Werk dieser Art) angegfangen hatte. (S. Lettere Pitt. I, 309 und die Holzschnitte von Andr. Andreanni u.s.s.) Sein Tod word von Einigen, statt 1357, schon in 1340 gesetzt, was in That das weit wahrscheinliche Datum ist, wenn es anders mit seiner oberzahlten arbeit von 1275, sein Richtigzeit ist.

. . . de la Valle will die Entdeckung gemacht haben, dass obiger Duccio di Buoninsegna, von einem anderen Künstler aus Siena, gleichen Geschlechtsnamens, Sohn der meister Niccolo zu unterschieden sein, da denn aus Fiorillo I.445 wo wir dieses Notiz gefunden (vergleichen mit dem

This is the third and much expanded edition of a work originally published by his father, Johann Rudolf Füessli, in 1763 and 1799 (see Bibliography). This was one of the first German dictionaries of artists. Füessli cited the second edition of Lanzi to show that Duccio was already active in 1282. He cited Fiorillo (specific source untraced) for the fact that Duccio was a contemporary of Cimabue and, opposing Baldinucci's claim that the painter came from Giotto's following, he stated that Duccio came from the school of Guido. The passage quoted above is important, as Füessli had clearly taken note of Fineschi's publication of the contract for the Rucellai *Madonna*, although he mistakenly reported a date of 1275.

Romagnoli (IV.42) would cite Füessli and this edition of his work.

33. 1810

S. Ciampi, *Notizie inedite della sagrestia pistoiese de' belli arredi del campo Santo pisano e di altre opere di Disegno dal XII al XV. raccolte ed illustrate* (Florence: Molini e Landi, 1810), 89-90, 144:

89:

Nel anno 1301 (stil. pis.) pensarono i Pisani di ornare di un bel musaico l'apside della tribuna del Duomo, e deputarono per soprintendere all'esecuzione del lavoro due cittadini, Uguccione di Gruccio ed Jacopo di Muccio (Doc. 24). Il primo artista che nel Maggio del 1310 (stil. pis.) vi trovo come Capomaestro con lo stipendio di soldi X al Giorno è maestro Francesco pittore di Pisa (Doc. 25).

90:

Avea [Francesco] sotto di se il suo figlio Vittorio, Lapo Fiorentino (forse lo stesso che abbiamo veduto in Pistoia nel 1259), Michele, Duccio, Tura, Turetto, Dato, Tano, Bonturo, Puccinello figliuolo di Maestro Ciolo, nel Documento tutti chiamati pittori. Quel Duccio fu verisimilmente il celebre Duccio da Siena che allora dovea essere tutto giovanetto. Sia che Francesco mancasse la vita che abbondasse quel'opera, il fatto è che nel corso di quell'anno non più lo trovo nel registro degli artisti impiegati a quel musaico ed invece sua comparisce [*sic*] Cimabue collo stesso stipendio di soldi X per giorno (Doc. 26).

144:

Documento XXV

Dal Libro initiolato

Introitus et exitus e habiti a Burgundio Tadi Operaio Opere S. Maria pisane maioris ecclesie sub. An.D. MCCCII (stil. pis.) indict. XIII de mense madii incepti.

Magistri magiestatis Majoris

Magistri Franciscus pictor de S. Simone porte maris cum famulo suo pro diebus v quibus in Dicta Opera Magiestatis laborarunt ad rationem soldi X pro die—lib II, sol. x

Victorius ejus filius pro se et Sandruccio famulo suo, (etc.) Lapus de Florentia (etc.) Michael pictor (etc.) Duccius pictor (etc.) Tura pictor (etc.) Datus pictor (etc.) Tanus pictor (etc.) Bonturus pictor (etc.) Puccinellus pictor (etc.) filius magistri Cioli (etc.) Vannes floreninus pictor (etc.) Michael pis.[17]

Although this item was cited in the chapter on documents (I.32), it is repeated here because it became a source for later authors, although no one else succeeded in finding the original.

On the basis of this document, it has been argued that Cimabue and Duccio collaborated on the apse mosaic of Pisa cathedral, for which Cimabue created the figure of Saint John in 1301. Crowe and Cavalcaselle doubted that interpretation, and Lisini pointed out that where the "foreign" painters from Florence were specified as such, Duccio is not indicated as being from Siena. Thus, it is unlikely that the Sienese Duccio is meant, rather than a painter of the same name from Pisa.

A reading of the volume cited by Ciampi indicates that either the document is now lost or Ciampi erred in his citation. See the discussion of I.32.

34. 1812

L. de Angelis, *Prospetto della Galleria da farsi a Siena*, Siena, BC, Ms A.VIII.5, insert 8, ff. 333r (pencil); 347r (pencil):

After a first description of the *Maestà* and its place in the Duomo:
333r:

In ogni galleria vi sono delle opere in . . . [illegible word] alle quali perdo sempre il giudizio. Non così facilmente si distingono fra Mino da Simone, Ugolino da Duccio.

347r:

La bella Tavola di Duccio oggi divisa in due parti appesa, la prima rappresentante la Vergine in cornu Evangeli dall'Altare di S. Ansano, l'altra che può servire di scuola ad ogni pittore, in tanti compartimenti dipinta

perchè in cornu Epistole all'altare del Sacramento. Per fare idea della grandezza di questo artista, basta che l' . . . [illegible word] catone vi si pensi a questa tavola.

Noi abbiamo adunato dei piccoli quadretti, che dovettero servire come predella. E con questi diamo principio alla classe de' nostri pittori del XIV secolo, per continuare la serie dei nostri artisti.

Stanza IV SCUOLA SANESE DEL SECOLO XIV

Abbiamo posto bensì dopo le tavolette, il quadro di Ugolino.

Apre questa stanza un quadro di Duccio, da prendersi dal Conservatorio di Mon'Agnese e che sta salendo le scale che portono al refettorio. E siccome l'antecedente di questo artista rapportata in duomo nel 1311 sembra che appartenga più al secolo XIII, così con essa abbiamo terminato la stanza predetta, e con questa apriamo la presente da collocarsi a man destra dell' suo ingresso.

Ma quel Segna di cui abbiamo qui poco innanzi collocato la Tavola merita, che or noi vogliamo a rammentarlo per avere ammaestrato fra de primi nostri pittori del secolo xiii. Egli è Duccio di Buoninsegna, il di cui quadro che oggi diviso in due stassi lateralmente appeso alle pareti del nostro duomo, donde non sembra esservi potesse difficoltà di estrarlo. Compirebbesi con questo la terza stanza e vi si vedrebbero di già i progressi dell'arte che facevansi fra noi, immaginando il solo Baldinucci che questo pittore ritenga della Scuola di Giotto e de' suoi discepoli.

Published: Bacci, *BSSP*, n.s.10, 1939, 205-13 (partial transcription).

These passages come from a proposal for systematizing the paintings in the new Pinacoteca of Siena. In a column flanking the one cited above, de Angelis described Duccio as a pupil of Segna di Buonaventura. When, in 1816, the ordering of the Pinacoteca was complete, he published his *Ragguaglio del Nuovo Istituto di Belle Arti* (IV.36).

The publication of the *Prospetto* in the *Bullettino Senese di Storia Patria* reflects an inaccurate reading of the manuscript and presents it in abbreviated form.

35. 1813-18

L. Cicognara, *Storia della scultura* (Venice: Picotti, 1813-18), 1: Libro Secondo, 197-98.

Cicognara discussed only the pavements of Siena cathedral that he said were of a type first invented by Duccio in 1350.

36. 1816

L. de Angelis, *Ragguaglio del Nuovo Istituto delle Belle Arti stabilito in Siena con la descrizione della sala nella quale sono distribuiti cronologicamente i quadri dell'antica scuola sanese* (Siena: Bindi, 1816), 4, 19-20:

> 4:
>
> Per esempio, chi guarda l'opera del nostro Duccio, e specialmente quella tavola, che stassi appese vicino all'Altare del Sacramento nella nostra Metropolitana, la prende per Giotto.
>
> 19-20:
>
> Tornando alla linea del menzionato segno del secolo XIII vedensi due quadretti di *Duccio*, uno rappresentante la Natività del Signore, e l'altro l'Epifania del medesimo.
>
> Chi poi vedere, quanto questo nostro Pittore valesse mai, lo miri nelle due tavole appese in Duomo, una alla Cappella del Sacramento, e l'altra alla Cappella di S. Ansano.

For his project, De Angelis consulted the works of Carli, Benvoglienti, Mancini, Pecci, and Della Valle.

In 1842, the Pinacoteca was reorganized, and Carlo Pini compiled a new catalogue.[18]

37. 1818

O. Fratini and A. Bruni, *Descrizione del Duomo di Siena Dedicata a Sua Eminenza Reverendissima Anton Felice Zondadari Arcivescovo della Medesima Città* (Siena: Stamperia Comunitativa presso Giovanni Rossi, 1818), 8-9, 37-38, 73:

> 8-9:
>
> . . . devesi con tutta giustizia attribuire a Siena l'invenzione di sì smisurati nielli in marmo, cui manca soltanto il commodo di Vederli bene, a meno che non pongasi il curioso dall'alto della trabeazione del Tempio Il primo, che mettesse in uso questo singolar modo di decorazione fu Duccio Buoninsegni pittore e scultore Sanese.
>
> 37-38:
>
> Nella parete laterale vedesi un'antico quadro di Tavola esprimente la Madonna col S. Bambino in grembo. Quest'opera fu cominciata nel 1308, e terminata del 1310. da Duccio di Buoninsegna Sanese. Sono da notarsi in questa pittura gli Angioli per i loro vestiti, e per lo Scettro, che tengono nella destra, che quasi assomiglia a quella verga usata dall'Imperatore

dell'Oriente, e che *Ferula*, o *Nartheca* veniva chiamata: I Santi mm. S. Caterina delle Ruote, S. Crescenzio, S. Savino, ed altri sono vestiti con abito monacale detto non tanto dai Greci, che dai Latini Abito Angelico, e con una piccola Croce all'uso greco, conforme si vede nei Santi riportati nella Tavola di Du-Fresne. Convien notare, che la suddetta tavola fu dipinta ancora dalle parte di dietro, e che anticamente restò collocata per lungo tempo nell'altare Maggiore di questo Tempio. Questa pittura è nominata dall'Abate Prunetti nel suo Saggio Pittorico per uno dei più bei monumenti dell'Arte, e per un'opera che fa epoca nella Storia Pittorica, sotto a questo Quadro vedesi un basso rilievo quivi traslato dalla Pieve del Ponte allo Spino.

73:
Nella parete a mano destra si vede una Tavola rappresentante diverse Storie del Vecchio Testamento colorita da Duccio di Buoninsegna. E' questa la metà dell'altra Tavola già osservata lateralmente all' Altare di S. Ansano, giacchè nel 1789 fu fatta dividere da Nob. Sig. Giovanni Borghese Rettore dell'Opera.

This little guidebook is essentially a compilation from earlier sources. The description of the *Maestà* on page 37 comes in large part from the 1774 guide to the cathedral by Provedi and Fratini (IV.23). Discussion of the *Maestà* does not extend to the crowning panels or predella scenes that were, at the time, kept in the sacristy of the cathedral. Remarks about the pavements in Siena cathedral relate to those of Cicognara (IV.35).

38. 1820

Anonymous, *Guida di Firenze e d'altre Città Principali della Toscana* (Florence: Ricci, 1820), 2: 268, 530.

This work reiterates Vasari's attribution of the Rucellai *Madonna* to Cimabue (268), although Fineschi had published the contract with Duccio thirty years earlier. It also echoes Vasari's attribution of the pavements in Siena cathedral to Duccio (530).

39. ca. 1821

F. Tolomei, *Guida di Pistoia per gli amanti delle belle arti con notizie degli architetti, scultori, e pittori Pistoiesi* (Pistoia: Bracali, 1821), 84:

Nell'archivio si conservano una Deposizione dalla Croce, e un'altra tavola con la Ss. Vergine, la Maddalena, Gio. de Meda, e altri Santi d'antica e buona maniera, ambedue dipinte sull'oro, forse opere di Duccio da Siena. E' probabile che il nostro Vescovo Tommaso Andrei pur Senese, che nel 1290 fondò il Convento degli Umiliati, (dalla loro

Chiesa furon quà portati i quadri) ne ordinasse la pittura a questo suo
paesano e contemporaneo.

This passage may have been derived from Vasari's remark that Duccio had
painted many things in Pistoia, but its direct source would seem to be the 1621 *Guida
di Pistoia* cited in Carli's *Selva di Notizie* (f. 67r-67v). See III.12.

40. 1822

[E. Romagnoli], *Nuova Guida della Città di Siena per gli Amatori delle Belle Arti* (Siena:
Mucci, 1822), 15, 22:

> 15:
> Presso l'Altare del SSmo Sacramento . . . situata la gran Tavola dipinta
> pell'Altar maggiore di questa Basilica da *Duccio della Buoninsegna* nel 1310.
> Questo egregio Pittore nelle piccole Storie espressevi della Vita di G C
> mostrò un genio veramente sommo per quell'età, per cui il Ch. Ab.
> Prunetti nel suo Saggio Pittorico, asserì esser questo lavoro uno dei più bei
> monumenti dell'Arte "Opera (dic'egli) che al suo tempo D. Sigismondo
> Chigi = Farnese feceva incidere, perchè tutto il mondo potesse mirare
> una Tavola, che fa epoca nella Storia Pittorica".

> 22:
> Nella parete laterale esiste l'altra metà del Quadro dipinto da *Duccio della
> Buoninsegna* terminato nel 1310.

> See IV.27.

41. 1823 and 1829

J.-B. L. G. Séroux d'Agincourt, *Histoire de l'Art par les Monuments, depuis sa decadence au
IVe siècle, jusqu' à son renouvellement au XVIe*, 2 (Paris: Treuttel et Würtz, 1823), 207; and
*Storia dell'arte dimonstrata coi monumenti dalla sua decadenza nel IV secolo fino al suo risorgimento
nell XVI, di G.B.L.G. Séroux d'Agincourt*, 6 (Prato: Giacchetti, 1826-29), 454.

Séroux d'Agincourt's discussion of Duccio is limited to a discussion of the mar-
ble pavements of Siena cathedral.

42. before 1835[19]

E. Romagnoli, *Biografica cronologica de' bell artisti Senesi*, Siena, BC, Ms L.II.8, 1: 345-88
(facsimile edition, Florence S.P.E.S., 1976)[20]

> Duccio di Bino della Buoninsegna Pittore, architetto, mosaicista. [Added
> in margin: "*male: devo dire Duccio di Buoninsegna*"]

Duccio è l'artista cui il Vasari caratterizzò per maestro che "con giudizio savissimo diede oneste forme alle figure, le quali espresse eccellentissimamente nelle difficoltà di tal'arte" elogio che gli è giustamente dovuto come pittore, e come mosaicista merita commendazione, = (Vasari) = e lode infinita per cui sicuramente si può "annoverare fra i benefattori che allo esercizio nostro aggiungono grado e ornamento, considerando, che coloro, i quali vanno investigando la difficoltà delle rare invenzioni, hanno eglino ancora la memoria, che lasciasse trà l'altre cose maravigliose."

L'inarrivabile autore delle porte di S. Gio. di Firenze (Lorenzo Ghiberti) ne' suoi commentarj pittorici esistenti inediti nella Magliabecchiana, scrisse esser Duccio "pittor nobilissimo, la cui tavola nella Greca maniera condotta, eccellentemente, e dottamente lavorata, è magnifica cosa" e in altro posto riportato dal Vasari, leggesi, che il Ghiberti cambiò espressione al caratterizzare per greca maniera la gran pittura di Duccio (perché nulla ha del Greco) e disse "che Duccio con maniera quasi Greca, ma mescolata assai colla moderna, dipinse una coronazione di Nostra Donna" lo che neppure combina colla verità. Ma passando sopra queste minuzie, rifletti- amo piuttosto, che questa egregia pittura dall'aurora del secolo XVI al tra- montare del XVIII stette affatto incognita al guardo degli osservatori. Nota il Vasari, che per molto diligenza fatta, non puoté mai (nel passare per Siena) ritrovare quest'opera così un tempo famigerata. Ma in ogni genere di bell'arti succedono spesso questi disgraziati fenomeni. Un opera tale da: "trar'dal sepolcro, e far, che eterno viva" chi la condusse, ebbe la stessa sorte delle bellissime ottave attribuite al Boccaccio (e di lui degne) sulla Passione di G.C., che riporta il ch: Conte Giulio Perticati nel giornale arcadico dell'anno 1819: Tomo Prima: "quale in quei cantici più grande idea dei tre versi?" Due manigoldi, che coll'aspro e crudo "riso si volser prima all'egra afflitta madre poi poggiar la scale al legno" idea Michelangiolesca! Espressione veramente originale, come originale è Duccio in molte delle piccole storie da grande condotte in quella classica pittura.

Se del Buonarrota disse il Cavalier Puccini, che come figlio del genio sdegnò imitar chi che sia, e sino i Greci dei quali fu studiosissimo; noi non potremo dir cosi di Duccio perchè non conobbe i Greci, ma però originale è in quelle storiette, composte con quella semplicità, che è propria solo de' greci, come considerò un giudizioso osservatore nel vedere il Gesù in Emaus con i due discepoli, da Duccio, in quella tavola espressi. E' sentenza del egregio Zannetti "che a piccoli gradi la pittura ascese ad alto per man-

canza di esecuzione e più cose molto ben pensate ritrovansi nelle opere de' primi tempi; ma così debolmente eseguite, che ributtano la maggior parte delle genti, e non si possono mirare sensa noja." Si il dottissimo scrittore della pittura veneziana avesse esaminate alcune di queste storiette avrebbe moderata quest'ultima espressione, che è troppo generale.

Finalmente deggio farti notare o lettore, che questa tavola, che fè la meraviglia dei senesi nel secolo XIV, dopo quattro secoli d'oblio, tornò a risvegliare non solo l'ammirazione de' concittadini di Duccio, ma quella de' Benvenuti, de' Canova, de' Wicar, e in fine un dotto scrittore (l'abate Angelo Prunetti nel suo Saggio Pittorico) asserì esser questa "uno dei più gran monumenti dell'arte, cui il Principe D. Sigismondo Chigi faceva incidere, perché tutto il mondo potesse ammirare una tavola, che fa epoca nella Storia Pittorica." Duccio di Bino della Boninsegna in molti documenti è detto Duccio di Boninsegna: alcuni l'han detto Duccio di Niccolò, che è un altro artefice di cui scriverò al 1390: altri lo fanno figlio di Segna, (Pittore fiorito nel 1298): di cui il Tizio vuole scholaro Duccio, con errore cronologico. Io l'ho scritto Duccio di Bino della Buoninsegna per un documento riportato da uno dei più gran diplomatici dell'età sua qual fù il nostro Celso Cittadini. Nell'Archivio delle Riformagioni si conserva una bellissima serie di volumi fatti scrivere dall'egregio abate Galgano Bichi, i quali contengono gli Indici delle carte di tutti gli archivi della Città E' tra quelli un volume intitolato "Annotazioni di Celso Cittadini," nel quale si nota che nella presta o Tassa del 1342: nel Popolo di S. Gilio de' Rustichetti abitava "Ambrogio di Duccio di Bino di Buoninsegna dipentore": ed ecco il documento che m'ha tratto a credere Duccio figlio di Bino del Castello della Buoninsegna, col cui nome forse era chiamato Bino padre di Duccio, e come appresso vedrai, che si chiamava "Siena" in Orvieto un artista (chi sa di qual nome!) perché nativo di Siena.

Qui avverto che non si confonda il nostro celebre Duccio, con Duccio di Niccolò come sopra notai; né con Duccio dela Pietra nominato nel volume 78 della Biccherna anno 1286: abitante in Castelvecchio (che paga soldi 6 e denari 6 di Tassa) né si confonda con il Duccio pittore che nel 1302 lavorava di mosaico con Francesco da Pisa e con Cimabue nel Duomo Pisano come scrisse il Ciampi (Notizie inedite della Sagrestia Pistoiese) a c: 147 e c: 149.

Del 1282 è la prima memoria che lessi nel volume 74: Biccherna B = "a Duccio per dipintura de' Libri soldi 8." Il volume 75: anno 1285: a carte 374

nota "soldi 8 = die Lunedì octavo Octobr: Duccio pictori quos a dedim pro pictura quam fecit in libri camarl-et iiii."

Nell'anno 1290: fù inalzato il grandioso convento de' Gesuati della Città di Pistoia, da Monsignor Tommaso d'Andrea da Casole (Senese) Vescovo di Pistoia, il quale fece dipingere a Duccio una desposizione della croce in una tavola, e in altra la Maddalena con altri santi. Che queste due tavole siano del senese artista, sulle asserzione del Vasari (che dice avere molte opere dipinte Duccio in Pistoia e l'essere quella chiesa da Prelato Senese di patria eretta, come lo stile delle pitture, affatto essendo dello stile di Duccio) congettura il ch: Cav: Francesco Tolomei nella sua Guida di Pistoia (Bracali anno 1821) a carte 84. [Added in margin, in pencil: Questo non può essere. I Gesuati furono foundati dal B. Giovanni Colombini il 1355].

Nella stessa pagina accenna il Cav. Tolomei [in his Guide to Pistoia], che queste tavole esistono al presente nell'archivio del commissario dell'ospedale dell'Infermi detto il Ceppo, quivi trasportate dall'abolito convento de' Gesuati.

Dell'anno stesso 1290 è la memoria esistente nel volume 89 della Biccherna = B = che dice "1290 adì 26 Gennaio L. 10 a Duccio pictore per dipeg: librj Kamarlinghi e iiii." Vedi a c. 76 retro. Il tomo 345 della stessa classe anno 1291 nelle spese d'agosto nota che si danno "soldi 10 a Duccio dipictori pro pictura quam fecit a libris Cam. e iiii."

Altra notizia di Duccio ci presenta il volume 99 della stessa classe = B = a carta 155 anno 1301, eccola: "Dal detto Duccio dipegnitore per un altro Bando dato a lui de 42 soldi per decreto a petizione di Pacino Chiari siccome appare nel libro delle decime a E. a fo: 129. La decima si scontrò siccome appare nel libro delle Cavallate, il Sabato 7 aprile 1301 = Maggio Venerdì 4 soldi 5 da Duccio dipegnitore del popolo di S. Donato per bando dato a lui per decreto da Bruno Ranucci siccome appare nel libro a fo: 75."

Nel 1302 avendo dipinto una Tavola per la Cappella dei Signori IX: di Biccherna il pagamento di questo lavoro si trova registrato nel volume n.º 190 della classe = B = a carta 357, ove si dice che "ebbe L. 48 per suo salario d'una tavola o Maestà che fece, ed una predella che si pose nell'altare della Casa de' IX di Biccherna."

Di quest'anno 1302 è altro documento quasi simile a quello riportato indietro. "Da Duccio Boninsegna dipegnitore del popolo di S. Donato per

un bando dato a lui per decreto a petizione di Lapo Chiari sicome apare nel libro dele Decime a fol: 106: la decima si scontrò siccome appare nel libro delle Cavallate del Terzo di Città, soldi 5" vedi il volume 99 a carte 131 retro.

Infine del sucitato T.º 190 è registrato il pagamento fatto a Duccio della tavola sopracitata: "Anco L. 48 a maestro Duccio dipegnitore per suo salario d'una tavola maestà che fecie et una predella che si puosaro nel altare dela chiesa de Nove là due si dice lufficio et àvvene pulizia."

Nell'anno 1308 fu decretato di porre l'immagine della B:V: avvocata Senensium che stava nel maggiore altare del Duomo in una cappella laterale, e su quello riporre una tavola proporzionata alla grandezza dell'altare stesso. Usavasi già in altre cattedrali occupare tutto il dossale dell'altare da voluminosa Tavola sullo stile di quella posta in più remota età nel tempio di S. Marco di Venezia lavoro celebre appellato la Palla d'oro. Così vollero i senesi, che in pittura, come quella è di smalto, e di preziosi metalli a cisello condotta, lavorata fosse dal pennello del nostro Duccio.

Il contratto di questa pittura è notato nella cartapecora n:º 399 dell'archivio del Duomo, ed è il presente: [Romagnoli proceeds to quote the entirety of I.39]

Che immediatamente fosse incominciato il lavoro dopo il contratto lo dice con chiarezza la cartapecora N.º 125r dell'archivio del Duomo dell'anno 1308; nella quale si legge che Duccio Pittore del quondam Buoninsegna havea debito di 50 fiorini coll'opera del Duomo, ad esso imprestiti o dati a conto.

Dell'anno 1310 è l'altra cartapecora esistente in detto archivio, nella quale si nota, che s'invigili, che sia terminata la nuova tavola della B: V: [I.44]

Finalmente terminato questo grandioso lavoro dopo due anni, fù trasportato in duomo con solenne pompa della quale fan memoria i pubblici documenti, e i cronisti.

Il volume N.º 103 della Biccherna classe = B = anno 1310 si nota che fù spesa per questo trasporto L. 12 sol: 10 per avere fatta la "rincontrata" alla tavola della B: V: nel mese di Giugno, pagati a suonatori di Trombette, ciaramelle, e naccare [I.46]. Sigismond Tizio scrisse: "die interea Mercurii . . . [III.4] . . . tam egregia, atque tam celebri accuratissime depinxit."

Tura del Grasso nelle sue cronache scrisse che questa tavola fù posta in duomo "mezzedima 9 di Giugno" e fù la più bella tavola che mai si vedesse e faciesse, et chostò più di tremilia fiorini doro et penossi a fare più anni e feciela Duccio dipentore" [II.2]. Che costasse questa somma si nota in una memoria che era nei tempi scorsi prezzo gli eredi del Sig:r Emilio Piccolomini, e che la pose nel maggiore altare con gran solennità il Vescovo di Siena.

La cronaca di Buondone aggiunge di più che Duccio dipinse quest'opera in tre anni "et tutto dì fe festa . . . [II.3] . . . solenni maestri di dipegnare."

Pio II: pure "Ex annalibus Senensis" scrisse "et quinto nonas Julias tabula B: M: Virginis egregie picta in ara maxima majoris templi cum maxima Senensis populi veneratione . . . posita est impensa trium millium aureorum" [III.3]

Un codice della Libreria intitolato cronache sanesi dal 1202 al 1391, dice "la tavola dell'altare maggiore . . . [II.1] . . . e nimici di Siena."

Questo egregio lavoro nominato pure dal Proposto Muratori "Rerum Italicarum Tomo XV: carte 48:, dovea certamente avere eclissato (tolto Ser Mino) il merito d'ogn'altro senese artista e fatta era più che fece (?) la fama lor che esser solea sì bella" come dice l'ariosto; anco al tempo d'Alfonso Landi [IV.14] descrittore del Duomo senese (che che ne dica il Vasari) era situato presso l'altare di S. Ansano ove fù posto nuovamente dopo i tempi del P. della Valle, che lo vide nelle stanze dell'opera, dalle quali stanze, tolto, e segata la tavola fù d'essa formata due quadri. Il P. della Valle [IV.25] ne dà una bella descrizione nel citato Tomo II, c. 71: quale riporterò, incominciando da quella parte, situata al presente nella sinistra parete presso S. Ansano, per essere la parte che guardava la gran nave quando questa tavola era nel coro del Duomo, allora situato sotto la cupola. Osserva lo scrittore delle lettere Senesi, che questa tavola è di Pioppo con sopra gesso, poscia azzurro quindi oro, finalmente colorita a tempera. "La maniera è di Guido da Siena sebbene di molto rammorbidita e migliorata. Nella figure grandi vi sono delle teste, de' piedi e delle mani, che relativamente a que' tempi sono bastantemente disegnati: alcune fisonomie non sono prive di grazia, ma per lo più portano in fronte il turbamento, e lo scompiglio dell'età in cui furon fatte; le membra non hanno la secchezza della maniera Greca d'allora." Qui nota che le tinte del volto della Vergine per l'umido sofferto sono alterate (al presente non

si vede questo male) e non nota che il velo con cui è vestito il Bambino, è un capo d'opera di delicatezza, e di verità. Amabilissimi sono i diece angeli che per ciascun lato del maestoso seggio della Vergine fanno corteggio alla madre, e al divino infante, simili tra loro nel vestito, non meno che quasi che simili di fisonomia. Cinque santi situati nel primo presso a destra, ed altri cinque a sinistra, con loro attributi in mano, riempiono la spaziosa tavola da ambi i lati. I volti di questi sono come disse lo scrittore delle Lettere Senesi, burberi, e turbati, ma non mancano di espressone conveniente al soggetto che esprimono. I vestimenti di questi sono pure riccamente lavorati di fiorami di fogliami, di ricami a figure ec. I prossimi al seggio sono inginocchiati, o piegati con qualche grazia, gli altri situati in maniera, che formano una composizione, e distribuzione ammirabile pell'età in cui furono dipinti usandosi per lo più allora come è noto il situare le figure ritte senza verun principio di gruppo, o di pittoresca distribuzione. Cinque busti per lato dipinti in varie nicchie ornano in alto la tavola, e questi esprimono apostoli coloriti di piccola dimenzione. Nella prefazione del Tomo VI del Vasari scritta dal Delavalle a carte 10 notò quello scrittore essere ai piedi della sedia, o trono ove sta M.V., e G.B. un iscrizione gotica, che al presente appena si legge, ed è del tenore seguente: "Mater Sca Dei sis causa Senis requiei: sis Ducio vita te quia pinxit ita;" ed aggiunse in quella nota, che questo lavoro è riguardato dagli intendenti come il primo dipinto ove si veda disegno, composizione, e gusto migliore che non è in quelli de' maestri precedenti delle altre scuole; elogio meritatamente compartito se imparzialmente si esamina questa memoranda opera. Prosegue il dela Valle a dirci che "la parte che guardava il coro" ora situata presso l'Altare del Natale di G.C. ha in molti scompartimenti dipinta la "vita di N: S: con figurine alte un palmo in circa, e copiose; dove è dipinta l'Annunziata vi è un'architettura con archi sufficientemente rotondi, così in quella dove si rappresenta il tradimento di Giuda in un atrio del Tempio, ove si vede lo sforzo del pittore per tirare gli archi in scorcio secondo le leggi dell'ottica e del vero . . . Dal Limbo di Duccio molti moderni hanno imparato, e così dagli altri scompartimenti, perché più anni questa tavola dovette essere il regolo dell'arte" perché così in morale come in Fisica è applicabile quel detto di Marco Aurelio "che in breve tempo impariamo tutto il male e in lungo tempo non sappiamo fare alcun bene." La negazione di S. Pietro mostra di lontano l'uomo tra il ribrezzo e l'agitazione della sorpresa: vi sono in varj luoghi de' manigoldi, pieni di fierezza, de' quali certamente non gli saranno mancati de modelli

in quel secolo. La desposizione dalla croce ha più d'una figura che al pan-neggiamento ricco insieme, e semplice, agli atti, e al volto sembra tolta dall'antico: nella morte della Madonna vi è dell'espressione. Nell'appar-izione di Cristo" (egregia storietta d'un aurea composizione come sopra notai) "e nel mitte manum ec. vi è dell'effetto, e dell'anima, vi si leggono i rimproveri all'incredulo" ec. ec. Appresso questa descrizione riporta il P. della Valle, ciò che dice il Tommasi nella sua storia [IV.11]; ove con poca critica pone per meschina cosa una tant'opera, ma bene notò che fu col-orita al Laterino (come precisamente dice il Tizio, e l'anonimo) in casa di Duccio (o de' Muciatti) quale abitò a Stalloreggi di fuore come appresso vedrassi. Nella Sagrestia del duomo vedonsi a destra vari quadretti dello stesso Duccio, appartenenti ai molti triangoli, che esistevano nell'alto della descritta tavola, o forse nel gradino dell'altare, esprimenti essi pure fatti della vita di N.S.G.C. tutti pieni d'espressione, e in buonissimo stato. Sono questi X storie esprimenti = I = la Cena di G.C. = II = Unde emenius panes ut manducenthi (?) = III = G.C. che si congeda da M.V. = IV = M: V: sul letto che parla agli apostoli = V = L'Annunziata = VI = G.C. che benedice gli apostoli = VII = M.V. condotta al Sepolcro = VIII = M.V. nel sepolcro = IX = Gli apostoli che s'inginocchiano al feretro ove è M.V. = X = Il cenacolo, pezzo d'un disegno prezioso = XI = Gesu che chiama S. Pietro dalla Barca, ove è un marinaro che getta le reti, in bellissimo moto. XII G.C. che apparisce agli apostoli.

Considerato in quest'opera il nostro bravo Pittore, passiamo a consid-erarlo come architetto perché trall'anno 1308 e 1310 disegnò la facciata della Casa della Mercanzia riguardante la Piazza, al presente Casino dei Nobili. Il Tomo 198 della Biccherna = B = anno 1308/9: nota come appres-so: "Mezzedima 25 Giugno, a Nanni del Marchese operajo, per lo comune di Siena a far fare la chasa de' consoli dela mercanzia del comune di Siena a luogo la chiesa di Santo Pauolo, per suo salario di due mesi L: 9 =" Nel libro intitolato Annotazioni di Celso Cittadini (situato tra quelli della rac-colta Bichi nell'archivio delle Riformagioni) trovai che nel 1308 si fabbrica-va la Casa della Mercanzia e messer Giampolo di Jacomo Gallerani vendè ai mercanti una casa in via di S. Pavolo.

La facciata di questa casa fu intieramente rifatta nel 1763 coi disegni del Cav.r Fuga, e del Vanvitelli, ma dalle vedute della Piazza di Siena incise in occasioni di feste prima dal 1763 eseguite conserviamo la memoria del disegno da Duccio ideato, sul gusto appunto di come è condotto il Palazzo Sansedoni.

Ammirato Duccio come Pittore e architetto, consideriamolo ancora come inventore dei celebri musaici del Pavimento del Duomo Senese. Il gran Biografo degli artisti su questo soggetto disse di Duccio che "senza dubbio coloro che sono inventori . . . [Romagnoli quotes Vasari (1568) on Duccio and the Duomo pavements] . . . i moderni artefici hanno fatte le maraviglie, che in essi si veggono." Il Buddeo scrisse di quest'opera "huius modi hodie visitur in aede senensi pulcherrimum opus vermiculatum," e il Cicognara descrisse la maniera di eseguire questo musaico inventato da Duccio "coll'avvicinare, cioè, tra loro i marmi di varia tinta talché tassellando il piano con pezzi di marmo configurati secondo il disegno, si venisse a dare distacco, e rilievo alle figure; . . . e siccome un tale genere di lavoro non viddesi prima altrove usato, così devesi con tutta ragione attribuire a Siena l'invenzione di sì smisurati nielli in marmo, cui manca soltanto il comodo di vederli bene, a meno che non pongasi il curioso dall'alto della trabeazione del Tempio."

Una cartapecora dell'archivio dello Spedale accenna che nel 1310 furono fatti i musaici del pavimento del Duomo da Duccio, e tralle carte dell'Archivio dell'opera del Duomo la cartapecora N° 207 nota i maestri, che lavoravano nel 1310 al pavimento; i quali furono Andrea di Ventura, Camerino o Camaino di Crescenzio, Tofano di Manno, Vanni di Palmiero, Ventura di Paganischio, Ciolo di Maffeo, Corsino di Guidone, Tuccio della Fava, Vanni di Bentivenga, e Ceffo di Ventura.

Questa medesima cartapecora accenna che per deliberazione del comune si ordina che si proceda con ogni diligenza nel fare il mosaico già incomincato, e vi lavorino i dieci maestri nominati nella cartapecora detta.

Questi musaici consistono i[n] tre quadri situati presso gli scalini della divisione della croce dalla porzione corta del Duomo: Il primo figura i cinque Re amorrei estratti dalla grotta di Maceda dopo la battaglia vinta da Giosuè. E' intagliata in pietra bianca "e le figure di essa" dice il Landi nella sua descrizione bellissima del Duomo Senese "tanto uomini che cavalli mostrano molta vivezza, e vi sono rappresentate diverse operazioni, attitudini e positure tutte proprie, e naturali, e ben condotte. In un canto d'essa sono i Re appesi, e sotto a questi è rappresentata una spelonca. A basso è scritto: "Come co Gamorrei battaglia e vinse Fe(?) Giosue e cinque Re impiccare faciendo il sol fermare = con tempesta da frenar la nemica gente pesta." Questa storia del 1784 dal Rettore Borghesi fu fatta ritoccare nei tratti non solo, ma col disegno del suo fratello Luzio fu variato molto

dell'original' contorno, con poco buon criterio, perché dice un detto "sì nell'ortografia nel copiar preciso gli antichi scritti, e da pensare come delle medaglie rare delle quali come estimatissimo pregio è quella patina che attesta della loro antichità, così sarebbe somma barbarie lo spogliarle di quell'autentico distintivo. Quelli che si chiamano difetti ai nostri tempi eran forse vaghezze presso i nostri predecessori delle quali avevano essi diritto d'usare quanto possiamo aver noi d'adoperare altrimenti." Errore non piccolo fù il togliere a questo musaico quell'antico fare che destava la venerazione considerandolo lavoro d'un epoca così remota; errore in cui tanto si cade in questo illuminato secolo, nel restauro di pitture, nel rimodernamento di chiese, ec. La storia del Sansone è a destra [A description follows.]

La terza storia è quella dell'Assalonne appiccato alla quercia per il capelli. [A description follows.]

Scrisse il Mancini che Prospero Bresciano quando fù in Siena non isdegnò di studiare sopra i rimessi a chiaroscuro che Duccio fece in Duomo, e di servirsene nelle sue opere come si vede, dice Egli, nella battaglia fatta al Sig.r Ippolito Agostini.

Nel 1320 nella presta scritta in un volume non numerato della classe = O = nell'archivio delle Riformagioni, notasi che in contrada Stalloreggi di fuori "M.º Duccio dipentore die avere come para a livro a fo. 4 e posti a livro de le preste mandato in Biccherna a fo: 157: sol: 4: e mandato in Bicherna a fo: 156 sol: 4: resta 16: posto a livro del Kamarlingo a fo: 232 sol. 16."

Del 1339 nota il manuscritto del Benvoglienti Nº XXVII (nella Libreria pubblica) essere stata dipinta da Duccio una tavola per la Signoria come nel libro della Biccherna = B = Nº 186 a c: 21. Nel 1342 congettura il Benvoglienti che fosse già morto questo artista per aver trovato nei libri delle Gabelle di quell'anno nominato Galgano del già maestro Duccio. Monsignor Bottari portò l'anno mortuario di Duccio al 1357; e disse che fu sepolto in S. Agostino. Il Vasari appone a Duccio il disegno della Cappella di Piazza, che dice essere inalzata nel 1348; ma io lessi nel volume 152 delle Deliberazioni del Consiglio della Campana, in quello del 22 giugno 1352 fu decretato farsi la detta Cappella come bene osservò il Cav.r: Pecci nel Tomo II: delle sue Iscrizioni a pagina 159 [IV.19]. Questo dotto istorico disse, che Duccio disegnò questa Cappella, la quale in 24 anni fu guastata quattro volte e il cui modello ideato da Duccio crede il P. della Valle essere quell'ur-

netta marmorea a sinistra dell'altare di quella situato; lavoro pieno di sesti acuti, di secche piramidi, e rifiorite con dei simboli e figurine negli specchi, non disprezzabili, sopra due delle quali è scritto: "Arsmetricha. Geometria."

Del 1352 pure, nota il Richa (Chiese Fiorentine Tomo IV, c: 4) fu l'inalzamento ordinato da Gio: Guidotti della chiesa di S. Antonio a Porta Faenza di Firenze architettata da Duccio Senese. E' questo errore, e dovea leggere Moccio. Queste epoche le quali nulla combinano coll'osservazione del Benvoglienti pongono molta dubiezza sull'anno mortuario d'un artista così valoroso e degno certamente di una epigrafe del maggiore degli epigrafici Stefano Morcelli chiaro lume dei nostri tempi.

Ma che nel 1352 fosse morto me l'accerta una cartapecora dell'archivio dello Spedale riportata nel libro intitolata Donazioni, e oblazioni, a carte 16 ove leggesi che nel 1354 l'erede di Duccio dipentore è confinante a una casa posta nel fondaco di S. Antonio data in permuta a lo Spedale della Misericordia dallo Spedale di S. Maria, che riceve una casa nel popolo di S. Giovanni [I.59]. Questi eredi furono Galgano e Ambrogio dei quali scriverò al 1342 e al 1327. Altre opere da Duccio condotte, in epoca incerta, sono le seguenti:

In Siena esisteva una sua tavola dipinta per la Badia di S. Donato, notata nella rara descrizione di Siena (manoscritto di anonimo) fatta nel 1625: il cui originale è nella Liberia del Principe Chigi Farnese di Roma [IV.12]. In questa Tavola figurata eravi M:V:, e G:B:, e a basso era scritto: "Duccius Buoninsigne de Senis."

Il Padre della Valle nota nelle sue Lettere Senesi di aver veduta una tavola da altare allora situata a capo scala presso il Refettorio della monache di Mona Agnese a mano destra. Rappresentava la Vergine sedente col bambino ritto sulle ginocchia della madre con un uccellino in mano. Di dietro la residenza erano due angeli, e poco più in sù, sei altri, tre per parte a corteggiarla amorosamente. La Vergine haveva un vestito nero con piccola frangia d'oro, e sotto un velo che dal capo vedevasi arrivare al braccio. S. Niccolò, S. Agnese, S. Caterina delle ruote, S. Gregorio figurati al naturale le stavano intorno. Il primo di questi Santi haveva un vestito alla Pontificale; S. Agnese un vago panneggiamento, e sotto un abito di colore roseo. Negli scompartimenti erano quattro busti di Santi, e nel mezzo un crocefisso colla Vergine, e S. Giovanni ai piedi della Croce. Vi erano pure due storiette; nella

prima delle quali appare S. Niccolò a uno schiavo tolto dinanzi alla mensa del Re, e della Regina suoi padroni, e pe' capelli portato via dal Santo: quelli mostravano la sorpresa naturale in tale atto. Nella seconda rappresentavsi il S. Vescovo di Mira che comprava del grano da alcuni marinari per soccorrere il suo popolo travagliato dalla fame. Vi era qui una Nave, e una vela così disegnata, che vedevasi evidentemente che Simone inmitate aveale ne' suoi freschi di Pisa.

La Tavola della Badia non esiste più sicuramente, come credo non essere più a Mona Agnesa la seconda, per le vicende sofferte da quel' locale e per la rovina, che si è fatta in questi tempi di opere antiche. Nella retrosagrestia o per dir meglio nel coro d'inverno di S. Francesco eravi una piccola Tavola rappresentante la Vergine col Bambino, il quale tiene parimente un uccellino in mano condotta secondo il parere dell'autore delle Lettere Sanesi sullo stesso fare di quella di Mona Agnesa. Questa pure dubito che più non esista, perché nell'abolizione delle Religioni del 1810 molte opere sono mancante.

La Galleria del Cav.ᵣ Bellanti ha una piccola Tavola del fare di Duccio.

Fuori di Siena conservasi una pittura dello stile di questo maestro nella Pieve, cioè, di S. Lorenzo a Suvicille, situata nell'altare sinistro: questa è una piccola Tavola ove espressa si vede M:V: e G:B. Lo stesso delicato velo che copre il Bambino della gran tavola del Duomo, copre il G.B. di Suvicille. Questa vaga tavolina fu fatta indicere a spese del Cav:ᵣ Antonio Palmieri nel 1820 a Antonio Verico, dedicata alla madre del citato Cavaliere, Faustina Dei ne' Palmieri.

Il Vasari scrisse che Duccio dipinse un'Annunziata per la Chiesa di S. Trinita di Firenze, molte cose in Pisa, in Lucca, ed in Pistoia per diverse chiese, che tutte furono sommamente lodate, e gli acquistarono nome, ed utile grandissimo.

Di Duccio scrisse nel suo gran Lessico il Fuesslin, Zurigo 1806, a carte 304 [IV.32].

La raccolta dei quadri dalle Belle Arti di Siena ha varie pitture di Duccio veramente preziose. Tali sono un gradino con storia della guarigione della Donna mestrua, il ballo d'Erodiade, la decollazione di S. Gio: Battista, l'Epifania, S. Gio: nell'isola di Patmos, e un santo legato a un Toro furioso. Vari dittici sono pure lavori di Duccio, come quello bellissimo colla M.V. G.B. e quattro santi, ove dall'altro lato sono altri quattro santi, la Nunziata, e il Salvatore crocefisso.

Un avanzo di gradino da altare contiene il Natale, e l'Epifania bellissime
storiette, come lo sono la Nunziata e la crocefissione; il superbo dittico col
Natale, quattro Santi, la Nunziata e il Resurexit ha una figura vestita con
manto di color cinabro foderato di bianco cosi ben panneggiata che meglio
non si sarebbe condotta nel secolo di Leon X.

Mons. d'Agincourt parlò di Duccio superficialmente nella sua grand
opera "Histoire de l'art ec. nel Tomo VI. a c. 454 e c. 455 come nel Tomo
IV. a carte 499 e 500 [IV.41]. Nella Tavola 168 N° 7 v'è riportata l'incisione
del quadro del pavimento figurante i cinque Re amorrei disegnati ivi però
in così piccole dimensioni che poco da quel disegno si può apprendere
essendo 4 pollici in largo, e 2 1/2 in alto. Nel sopranotato volume IV a
carte 499 pone questo lavoro tra quelli di tarsia, e nel Tomo IV a c. 454
indice delle Tavole ne parla nuovamente.

Nel Borgo di Monteron Griffoli è sulla porta interna della Pieve una
tavola che già fù dell'antica diroccata Pieve. Essa è bislunga, e divisa in
cinque comparti contenenti ognuno una mezza figura di santo, e in quel-
lo del mezzo è M.V. con G.B. Sopra gli angoli superiori de' comparti sono
vari quadratini in ognuno de' quali è una figura intiera. Il tutto è assai in
cattivo stato, ma la maniera di Duccio vi si conosce apertamente.

In Pisa nelle Belle Arti è una tavola di Duccio, che si nota fatta nel
1340. Contiene questa tavola tre santi in fila separati l'uno dell'altro per
una cornicetta dorata. Ora questa tavola è in una Cappella del Campo
Santo, e il Pomba nella sua descrizione d'Italia (Turino 1834) nota questa
tavola come pittura di M.º Baccio da Siena del 1340 con manifesto errore
dovendo dir M.º Duccio.

Romagnoli's text represents both a beginning and an end. It offers us a reperto-
ry of all the notices, of whatever date, that deal with Duccio, but it does so in an
erratic manner, without a strict chronological order in treating either Duccio's life
and works or the chronological sequence of the sources used. The result is a mix-
ture of fact and fiction, drawn from documents, the chronicles, and earlier second-
ary sources, that gives equal credence to each.

Romagnoli not only traced and studied all the sources available to him, but he
also corresponded with "molti egregi moderni scrittori, artisti e intendenti," as he
described them, "Amatori delle Belle Arti," such as Gaye, Repetti, De Angelis, von
Rumohr, and others.[21]

Archival research was very important for Romagnoli's project. He traced and

reviewed all the documents that had been cited by earlier writers, and he discovered and transcribed still more notices. He did not find it necessary to provide his audience with precise citations, however, neither in his archival references nor in his use of secondary literature. In defense of Romagnoli, one ought to note that, in his time, medieval documents were not found in a single location but dispersed throughout various archives scattered across the city. They were not united in the new Archivio di Stato until 1858, which made note-taking and rechecking of transcriptions more complex than it is today. It is also true that Romagnoli made mistakes in his transcriptions and in his citations.[22]

A major part of Romagnoli's chapter on Duccio is devoted to the cathedral *Maestà*. He took on faith the history of the work and of its installation as found in the various Sienese chronicles and in Tizio. Landi and Della Valle provided him with the story of the work's fate over the centuries. Regarding the pavements in Siena cathedral, he accepted Vasari's attribution to Duccio and quoted writers such as Mancini, Prunetti, and Cicognara, as well as the works of Pecci, Füessli, and d'Agincourt.

The three marginal notes in the Duccio chapter were made by a certain "Palmieri," who identified himself on page 47 of volume 1.

NOTES

1 For Vasari, as well as for Giulio Mancini, Isidoro Azzolino, Baldinucci, Benvoglienti, Della Valle, Da Morrona, Luigi Lanzi, and Séroux d'Agincourt (all cited below), see G. Previtali, *La fortuna dei primitivi*, 2d ed. (Turin: Giulio Einaudi, 1989). [Ed.]

2 See V. Lusini, "Duccio e il Pavimento del Duomo," *Rassegna d'arte senese* V (1909): 71-92; A. J. Rusconi, *The Pavements of Siena's Cathedral* (Siena: Turbanti, 1948), and G. Schwarz Aranow, "A Documentary History of the Pavement Decoration in Siena Cathedral, 1362 through 1560" (Ph.D. diss., Columbia University, 1985). Some documents for the floor were published by Milanesi (1854, 1: 176-78).

3 Later editions of Vasari are not summarized here unless they contain new information of importance.

4 The reference is to Pietro Lorenzetti.

5 For the passage on Duccio in these other copies: ff. 24r-24v, and ff. 49-50, respectively.

6 Lisini/Iacometti, xvii, xxi.

7 In the original manuscript, this is spelled out as "Messer."

8 See my discussion of Baldinucci in *Painting in the Age of Giotto*, 39-41. [Ed.]

9 The relevant document (I.51), dated 25 May 1354, was published by P. Bacci (1932, 244) but with an inexact citation.

10 It seems quite extraordinary that, at this date, the *Maestà* should appear here as the work of Guido da Siena; it cannot derive from simple confusion over names. [Ed.]

11 A good deal of confusion surrounds discussions of this inventory. Brandi (1951, 147), citing Lusini (1912, 77), said that the *Maestà* was sawn into two panels on 1 August 1771, but Bacci (1936) had published these notices from what was, he said, the inventory of 1776. Indeed, AODS 1511 is an inventory begun in 1776. Stubblebine (1979, 1:35-36) followed Brandi in suggesting that the 1777 date in the marginal note was an error for 1771, and created confusion by omitting, in his translation, the section from "fu trasportato" to "Adì primo agosto," thereby making his following remarks about the church of San Ansano unintelligible. Della Valle (1785, 2: 71) said only that the *Maestà* was transported from the cathedral into rooms on the third floor of the house of the Opera del Duomo, and that the work was cut down to a size that made that possible. [Ed.]

12 The reference is to Simone Martini's *Maestà* in the Sala del Mappamondo in the Palazzo Pubblico of Siena. Della Valle thought Mino the author of that work based on a document of 1289. See my discussion of that document in the Introduction. [Ed.]

13 At this point, Della Valle introduces the following note: "Quasi tutte le tavole grandi da altare di quel tempo sono a similianza delle facciate tedesche, cioè a piramidi secche, scannellate, e ingombrate da molti ornati; pare che la facciata del Duomo di Siena ne fosse il modella a' Sanesi."

14 These observations are remarkable for the period. The description of the technical aspects of the *Maestà* and the attempt to account for the condition of the work are highly original. While we may find the comparison of Duccio's altarpiece with Guido's panel surprising, Della Valle indeed saw something that led to this remark. He was unaware that Guido's panel had been reworked (especially the heads of the figures) by a Ducciesque painter in the early trecento, but he recognized stylistic similarities. His note that signals the relation between altarpiece designs and architecture also reveals close attention to the visual, as does his juxtaposition of the *Maestà* with works associated with the *maniera greca*. Della Valle pointed to Duccio's treatment of architecture, especially his "archi sufficientemente rotondi," surely intended to associate the work with the coming Renaissance and distance it from the Gothic, and he reflected on the perspective of that architecture. In sum, Della Valle foreshadowed later scholarship. [Ed.]

15 See my *Painting in the Age of Giotto*, 41-47. [Ed.]

16 For Lanzi's characterization of the Sienese school, see my *Painting in the Age of Giotto*, 47-49. [Ed.]

17 The following document published by Ciampi (Doc. 26) lists the payments to Cimabue.

18 C. Pini, *Catalogo delle Tavole dell' Antica Scuola Senese* (Siena: Tipografia d'Ancora, 1842).

19 As indicated at the front of the first volume, Romagnoli gave the *Biografia Cronologica* to Siena's Biblioteca Comunale in 1835.

20 Although a facsimile of Romagnoli's manuscript has been printed, we decided to include this very long text because that facsimile is difficult to find, and because Romagnoli's work represents the culmination of the historiography traced in this book.

21 Romagnoli, 1: 7.

22 All these things make Romagnoli a source that should be approached with the greatest caution.

V Bibliography

The following bibliography is grounded in Satkowski's earlier version, prepared for her *tesi di laurea* at the University of Siena, but the author and editor have substantially expanded the number and variety of works cited. In so doing, they hope to provide readers with material permitting investigation of the historiographical tradition surrounding Duccio, as well as with direction to discussions of the painter and his works. While we do not claim that each bibliographical item dealing with Duccio is included here, the bibliography is significantly richer than those in any of the recent monographs on the artist.

With an artist of such importance and influence, it is sometimes difficult to decide how broad one should be in surveying the literature. Duccio's art provided the foundations for the work of the great masters of the next generation, Simone Martini and the Lorenzetti; but to have included the relevant items on those painters would have stretched this bibliography far beyond its present substantial length. Thus, we have limited the following to material dealing with Duccio and the artists who are generally styled Ducciesque: Segna di Bonaventura, Ugolino di Nerio, and the various anonymous followers termed "Master of . . ." It has also proved unfeasible to cite every edition and reprint of every author, but we have included the major editions of Vasari and provided citations for works translated to or from Italian after their original issue. Even this cursory treatment proves enlightening and will give the reader a sense of the relative importance and reception of various early studies. In pursuing these objectives, we have extended the Bibliography well beyond the chronological limits of the material treated in Chapters One through Four of this volume.

Where an author has published more than one work in any one year, the bibliographical items are numbered in superscript after the year.

1350	G. Boccaccio. *The Decameron*. Trans. J. Payne; revised and annotated by C. S. Singleton. Berkeley and Los Angeles: University of California Press, 1982.
1362-1400	*Cronaca Senese di autore anonimo dall'anno 1202 all'anno 1362, con aggiunte fino all'anno 1392*. Archivio di Stato di Siena, Ms D. 55bis; and Siena, Biblioteca Comunale degli Intronati, Mss A. III. 26; B.III.5; and Florence, Biblioteca Moreniana, Florence, Ms Pecci 126. (Cfr. years 1689, 1697, 1715, 1723) Published: A. Lisini/F. Iacometti, 1932, fasc. 2, vol. XV, 39-162; Garrison, 1960-62, 37 [in part].

1400 ca. F. Villani. *Liber de origine civitatis Florentie et eiusdem famosis civibus*, ed. G. Tanturli. Padua: Editrice Antenore, 1997.

1442 Niccolò di Giovanni di Francesco di Ventura. *La Sconfitta di Montaperto*. Siena: Biblioteca Comunale degli Intronati, Ms A. IV.5; A:IV.6. Published: D. Aldobrandini, 1836 and 1844.

1450 (?) *La Cronaca Senese di Andrea Dei, continuata da Agnolo di Tura del Grasso*. Siena: Biblioteca Comunale degli Intronati, Mss A.III.24; A. VII.45; and Biblioteca Moreniana, Florence, Pecci 1. (Cfr. years 1730-50). Published: U. Benvoglienti, in L. A. Muratori, 1729, vol. XV, cols. 11-126.

—————— *La Cronaca Senese di Agnolo di Tura del Grasso*. Archivio di Stato di Siena, Mss D.38-41; and Siena, Biblioteca Comunale degli Intronati, Mss A.III.23, A.XI.42. Published:Benvolglienti/ Muratori, 1729, vol. XV, cols. 125-28, 279-94; A. Lisini/F. Iacommetti, 1934 fasc. 4, vol. XV, pt. VI.

1450 ca. L. Ghiberti. *I Commentarii*. Florence: Biblioteca Nazionale, Ms II.I, 333 (former Magliabechiano XVII.33). Published: J. von Schlosser, 1912; O. Morisani, 1947; L. Bartoli, 1998.

1472 F. Piccolomini (Pope Pius III). *Senensis Historia Manuscripta ab Origine Civitatis usque ad Annum MCCCCLXXII*. Siena, Biblioteca Comunale degli Intronati, Ms B.III.3.

1481-1530 *Il Libro di Antonio Billi*. Florence: Biblioteca Nazionale, Mss CL.XXV, 636 f. 74r (former Strozzi 476, called Codice Strozziano). Published: C. de Fabriczy, 1891; C. Frey, 1892; F. Benedettucci, 1991.

1485 (?) *Cronaca Senese detta degli Aldobrandini, fino all'anno 1477*. Florence: Biblioteca Moreniana, Ms Pecci 123 (former 246); Siena: Biblioteca Comunale degli Intronati, Mss A.III.25; A.III.28; A.VI.8-9; A.VI.10; A.VI.11; A.VI.12; and Archivio di Stato di Siena, Ms. D.36. Published: G. Milanesi, 1854, I, 169 [partial quote]; Garrison, 1960, 47 [partial quote].

1490 (?) *Cronaca Senese dal 1170 al 1431 conosciuta sotto il nome di Paolo di Tommaso Montauri*. Siena: Biblioteca Comunale degli Intronati, Mss A.III.15; A.VII.44. (Cfr. 1720.) Published: A. Lisini/F. Iacometti, 1933, fasc. 1, vol. XV, pt. VI, 173-252.

1506 B. Benvoglienti. *De Urbis Senae origine et incremento opusculum.* Biblioteca Moreniana, Florence: Ms. Pecci 133. Published: F. Benvoglienti, 1571 and 1574.

1510 F. Albertini. *Memoriale di molte statue et Picture sono nella inclyta Cipta di Florentia Per mano di Sculptori et Pictori excellenti Moderni et Antiqui.* Florence: Antonio Turbini, 1510; Edition Wedding Mussini-Praggio, G. Milanesi and C. Gusati, eds., Florence: M. Cellini, 1863; J. Crowe and G. Cavalcaselle, supp. to *Geschichte der italiénische Malerei.* Leipzig, 1869, II; Facsimile edition: O. Campa, ed. Florence: Stamperie polacca di M. e S. Tyszkiewicz, 1932; P. Murray. *Five Early Guides to Rome and Florence.* Heppenheim: Franz Wolf/Gregg International Publishers, 1972.

1528-30 S. Tizio. *Historiarum senensium ab initio Urbis Senarum usque ad annum 1528.* Siena: Biblioteca Comunale degli Intronati, Mss B.III.6 to B.III.15; Biblioteca Vaticana; G.I.31-35 and G.II.36-40.

1537-42 *Il Codice Magliabechiano.* Florence: Biblioteca Nazionale, Ms Cl. XVIII, 17 (called Codice Gaddiano). Published: C. Frey, 1892.

1550 G. Vasari. *Le Vite de' più eccellenti architettori, pittori e scultori italiani, da Cimabue insino a' tempi nostri descritte in lingua toscana da Giorgio Vasari pittore aretino. Con una sua utile e necessaria introduzione a le arti loro.* Florence: Torrentino, 1550.

1563 *Il Libro di Antonio Billi.* Florence: Biblioteca Nazionale, Magliabecchiano 89, f. 41r (former Strozzi 285, called Codice Petrei). Published: C. de Fabriczy, 1891; C. Frey, 1892; F. Benedettucci, 1991.

1568 G. Vasari. *Le Vite de più eccellenti pittori, scultori et architettori scritte da M. Giorgio Vasari, pittore et architetto aretino, di nuovo dal medesimo riviste e ampliate con i ritratti loro e con l'aggiunta delle Vite de' vivi e de' morti dall'anno 1550 insino al 1567.* Florence: Giunti, 1568.

1571 F. Benvoglienti. *Trattato dell'origine ed accrescimento della Città di Siena,* ed. Fabio Benvoglienti. Rome: Giuseppe degli Angeli, 1571. [Italian translation of *De Urbis Senae origine et incremento opusculum*]

1584 R. Borghini. *Il Riposo di Raffaello Borghini in cui della pittura, e della Scultura si favella, de' piu illustri Pittori, e Scultori, e delle piu famose loro opere*

si fa mensione; e le cose principali appartenenti a dette arti s'insegnano.
Florence: Giorgio Marescotti, 1584. [Anastatic edition: ed. Mario
Rosci. Milan: Edizioni Labor, 1967.]

1591 F. Bocchi. *Le bellezze della città di Fiorenza.* Florence, 1591 [2d edition,
ed. G. Cinelli. Florence, 1677].

1599 O. Malavolti. *Dell'Historia di Siena.* Venice: Marchetti, 1599.

1617-22 G. Mancini. *Alcune Considerazioni intorno a quello che hanno scritto alcuni
autori in materia della pittura.* Ms., Biblioteca Comunale degli Intronati,
Siena, Ms. L.V.11. Published: A. Marucchi, 1956, and L. Salerno,
1957.

1620-25 G. Mancini. *Breve ragguaglio delle Cose di Siena.* Siena: Biblioteca
Comunale degli Intronati, Ms C.IV.18.

1621 ante G. Tommasi. *Dell'Historie di Siena.* Siena: Biblioteca Comunale degli
Intronati, Ms A.III.34.

1625 G. Tommasi. *Dell'Historie di Siena.* Venice: Pulciani, 1625.

1625-26 F. Chigi (Pope Alexander VII). *Elenco delle pitture, sculture e architetture
di Siena.* Rome: Biblioteca Vaticana, Ms Chigiano I.I.11. Published:
P. Bacci, 1939.[2]

post 1638 G. Piccolomini. *Siena Illustre per Antichità celebrata dal Sig. Giulio
Piccolomini Publ. Lettor'di Toscana favella nel Generale Studio Senese.* Siena:
Biblioteca Comunale degli Intronati, Ms C.II.23.

1647 F. Ughelli. *Italia sacra: sive De episcopis Italiae.* Vol. 3. Rome:
Bernardinum Tanum, 1647.

————— G. Vasari. *Delle Vite De' più Eccellenti Pittori, Scultori e Architetti,* ed.
Carlo Manolessi. 3 vols. Bologna: Dozza, 1647 [A reprint of the
1568 edition].

1649 I. Ugurgieri Azzolini. *Le Pompe Sanesi o' vero Relazione delli Huomini e
Donne Illustri di Siena e Suo Stato.* Pistoia: Fortunati, 1649.

1655 A. Landi. *Racconto di pitture di sculture ed altre Opere Eccellenti che si
ritrovano nel Tempio, e negli altri Luoghi Publici della Città di Siena, con i
Nomi, Cognomi, e Patrie degli Artefici d'esse per quanto però s'è potuto
trovare da me, Alfonso Landi, Figliuolo del Sig Pompilio di Lattanzio di*

Girolamo Landi cominciato fin dall'Anno 1655. Siena, Biblioteca Comunale degli Intronati, Ms L.IV.14. Published: E. Carli, 1992.

1672 G. P. Bellori. *Le vite de' pittori, scultori ed architetti moderni.* Rome: Per il succeso, al Mascardi, 1672.

1678 C. C. Malvasia. *La Felsina Pittrice, Vite dei Pittori Bolognesi,* 2 vols. Bologna: Ereole di D. Barbieri, 1678 [ed. G. Zanotti. Bologna: Forni, 1967; ed. M. Brascaglia. Bologna: ALFA, 1971].

1681 F. Baldinucci. *Notizie de' professori del disegno da Cimbue in qua,* Vol. 1. Florence: Franchi, 1681; Vol. 2. Florence: Matini, 1686; Vol. 3. Florence: Tartini and Franchi, 1687; Vol. 4. Florence: Matini, 1688; Vol. 5. Florence: Manni, 1702; Vol. 6. Florence: Tatini and Franchi, 1728.

1684 F. Baldinucci. *La Veglia o dialogo di Sincero Veri.* Florence: Paci, 1684.

1689 *Cronaca Senese di autore anonimo dall'anno 1202 all'anno 1362, con aggiunte fino all'anno 139,* transcribed by A. Sestigiani. Archivio di Stato di Siena, Ms D.55bis.

1690 F. Baldinucci. *La Veglia o dialogo di Sincero Veri.* Florence: Pietro Martini, 1690.

1697 *Croniche Senesi Copiato l'anno 1697 da un libro antico senza nome dell' Autore esistente appresso il Sig.r D.r Ansano Barci.* Siena, Biblioteca Communale degli Intronati, Ms. A.III.26, called the Barca copy. Published: Lisini, 1922 (incomplete); Lisini/Iacometti, fasc. II, 1932, 90; Garrison, 1960, 37.

1700 ca. *Miscellanea di Notizie Senesi.* [Extracts from the correspondence of U. Benvoglienti] Florence: Biblioteca Moreniana, Ms Pecci 93 [formerly Ms Pecci 8.A].

1704 P. A. Orlandi. *Abecedario pittorico nel quale compendiosamente sono descritte le patrie, i maestri, ed i tempi, ne' quali fiorino, circa quattro mila professori di pittura, di scultura e d'architettura.* Bologna: Const. Pifazzi, 1704.

1709-20 G. Macchi. *Memorie (Notizie di tutte le chiese che sono nella città di Siena).* Archivio di Stato di Siena, Ms D.107 vol.1, Ms D.110 vol.4.

1715 *Cronaca senese di autore anonimo dall'anno 1202 all'anno 1362, con aggiunte fino all'anno 1392.* Transcribed by G.A. Pecci, 1715. Florence: Biblioteca Moreniana, Ms Pecci 126.

1717	F. Montebuoni. *Notizie de' Pittori e Statuarij copiate dal T. 13 delle mescolanze*. Siena: Biblioteca Comunale degli Intronati, Ms L.V.14.
1720	*Cronache di Siena d'Autore incerto dal 1302 fino al 1391, ma in molti luoghi interrotta*. Transcribed by G.A. Pecci, 1720. Siena: Biblioteca Comunale degli Intronati, Ms A.III.15.
1720 ca.	A. M. Carapelli. *Notizie delle chiese, e cose riguardevoli di Siena*. Siena: Biblioteca Comunale degli Intronati, Ms B.VII.10.
1723	G. Gigli. *Diario sanese*. Lucca: Venturini, 1723.
———	*Cronaca senese di autore anonimo dall'anno 1202 all'anno 1362, con aggiunte fino all'anno 1392*. Transcribed by T. Mocenni, 1723. Archivio di Stato di Siena, Ms D55.
1724 ca.	U. Benvoglienti. *Sulla Scuola Pittorica Senese*. Siena: Biblioteca Comunale degli Intronati, Ms C.IV.12.
1729-51	L. A. Muratori, *Rerum Italicarum Scriptores*, 25 vols. Milan: ex typographia Societatis palatinae, 1729-51.
1730	R. Borghini. *Il Riposo di Raffaele Borghini*, ed. A.M. Bisconi. Florence: M. Nestenus e F. Moücke, 1730.
———	G. A. Pecci. *Raccolta Univers.Le di tutte l'Iscrizioni: Arme e Altri Monumenti si Antichi, Come Moderni, esistenti nel Terzo di San Martino fino a questo presente anno 1730*. Archivio di Stato di Siena, Ms D.5, t.II.
1730 ca.	*La Cronaca Senese di Andrea Dei continuata da Agnolo di Tura dall'Anno 1186 fino al 1352*. Transcribed by G.A. Pecci. Florence: Biblioteca Moreniana, Ms Pecci 1.
1733	P. A. Orlandi. *Abecedario pittorico*. Naples: Rispoli, 1733.
1748	G. A. Pecci. *Storia del Vescovado della Città di Siena*. Lucca: Marescandoli, 1748.
1750 ca.	G. G. Carli. *Selva di Notizie per la Compilazione delle belle arti a Siena*. Siena: Biblioteca Comunale degli Intronati, Ms L. V. 16.
1752	G. A. Pecci. *Relazione delle cose più notabili della città di Siena, Si Antiche, come Moderne*. Siena: Quinza, 1752.
1754-62	G. Richa. *Notizie istoriche delle chiese fiorentine*, 10 vols. Florence: Cocchi, 1754-62.

1757 G. Lami. *Dissertazione relativa ai pittori e scultori Italiani che fiorirono dal 1000 al 1300.* Florence: Biblioteca Riccardiana, Ms 59. Published: Florence: G. Pagani Libraio, 1757.

1759-60 G. Vasari. *Vite de' piu eccellenti pittori, scultori e architetti, scritte da Giorgio Vasari, pittore e architetto aretino, corrette da molti errori e illustrate con note,* ed. G. Bottari. Rome: Pagliarini, 1759-60.

1760 G. Pianigiani. *Il Duomo di Siena descritto per commodo de' forestieri da Giacomo Pianigiani custode anziano del medesimo.* Siena: Bindi, 1760.

1761 G.A. Pecci. *Ristretto delle cose più notabili della città di Siena a uso de' forestieri ricorretto, e accresciuto.* Siena: Rossi, 1761.

1763 J. R. Füessli. *Allgemeines Künstlerlexicon oder Kurze Nachricht von dem Leben und den Werken der Mahler, Bildhauer, Baumeister, etc.,* 1st ed. Zurich: Heidegger und Compagnie, 1763.

1767-72 G. Vasari. *Vite de' più eccellenti pittori, scultori ed architetti, scritte da Giorgio Vasari, pittore e architetto aretino. Edizione arricchita di note oltre quelle dell'edizione illustrata di Roma,* ed. T. Gentili, G.F. De' Giudici, I. Hugford. 7 vols. Livorno: Coltellini, and Florence: Stecchi e Pagani, 1767-72.

1767-74 F. Baldinucci. *Notizie dei professori del disegno da Cimbue in qua.* Florence: Stecchi e Pagani, 1767-74.

1768-1820 F. Baldinucci. *Notizie de' professori del disegno da Cimabue in qua.* Turin: Stamperia Reale, 1768-1820.

1774 G. Provedi/G. Fratini. *Il Duomo di Siena.* Siena: Bindi, 1774.

1779 J. R. Füessli. *Allgemeines Künsterlexicon oder Kurze Nachricht von dem Leben und Werken der Maler, Bildhauer, Baumeister, etc.,* 2d ed. Zurich: Drell, Füessli & Co., 1779.

1782-86 G. Della Valle. *Lettere senesi di un socio dell'Accademia di Fossano sopra le belle arti,* Vol. 1. Venice: Pasquali, 1782; Vol. 2. Rome: Salomoni, 1785; Vol. 3. Rome: Giovanni Zempel, 1786.

1784 G. Faluschi. *Breve relazione delle cose notabili della città di Siena.* Siena: Rossi, 1784.

1786 M. Prunetti. *Saggio pittorico.* Rome: Giovanni Zempel, 1786.

1787	R. Borghini. *Il Riposo di Raffaele Borghini*. Florence: Passini, 1787.
——	A. da Morrona. *Pisa illustrata nelle arti del disegno*, 3 vols. Pisa: Per Francesco Pieraccini, 1787.
1789	L. Lanzi. *Storia pittorica dell'Italia dal risorgimento delle belle arti fin presso la fine del XVIII secolo*. Bassano: Remondini, 1789. [Many later printings and editions. See Scholosser Magnino, 1977, 510.]
1790 [1]	V. Fineschi. *Il forestiere instruito in S. Maria Novella di Firenze dato in luce dal P. Vincenzo Fineschi*. Florence: Albizziniana da S. Maria in Campo, 1790.
—— [2]	V. Fineschi O.P. *Memorie istoriche per servire alle vite degli uomini illustri del convento di Santa Maria Novella*. Florence: Cambiagi, 1790.
1791-94	G. Vasari. *Vite de' più eccellenti pittori, scultori e architetti, scritte da M. Giorgio Vasari, pittore e architetto aretino, in questa prima edizione sanese arricchite piu che in tutte l'altre precedenti di rami, di giunte e di correzioni per opera del P. Guglielmo Della Valle*, 11 vols. Siena: Pazzini Carli, 1791-94.
1791-96	M. Lastri. *L'Etruria pittrice; ovvero, storia della pittura toscana, dedotta dai suoi monumenti che si esibiscono in stampa del secolo X, fine al presente*, 2 vols. Florence: Pagni and Bardi, 1791-96.
1792	G. Lami. "Dissertazione del Dott. Giovanni Lami relativa ai pittori e scultori Italiani che fiorirono dal 1000 al 1300," in *Trattato della Pittura di Leonardo da Vinci*. Florence: Pagani Grazioli, 1792.
1793-96	L. Lanzi. *Storia pittorica della Italia*. Bassano: Remondini, 1793-96.
1800-10	A. Picchioni. *Notizie sulle Chiese Senesi*. Siena: Biblioteca Comunale degli Intronati, Ms A.VIII.1.
1800-35	E. Romagnoli. *Biografia cronologica de' bellartisti Senesi*. Siena: Biblioteca Comunale degli Intronati di Siena, Mss L.II.1-13. [Facsimile edition: Florence: SPES, 1976.]
1805	D. Moreni. *Bibliografia storico-ragionata della Toscana*. Florence: Ciardetti, 1805.
1806-24	J. H. Füessli. *Allgemeines Künstlerlexicon oder Kurze Nachricht von dem Leben und den Werken der Maler, Bildhauer, Baumeister*, 3rd ed. Zurich: Drell, Füessli & Co., 1806-24.

1807 R. Borghini. *Il Riposo di Rafaello Borghini*. Milan: Soc. Tipografica de' Classici Italiani, 1807.

1807-11 G. Vasari. *Vite de' più eccelenti pittori, scultori e architetti, scritte da Giorgio Vasari pittore e architetto aretino, illustrate con note*, 16 vols. Milan: Società tipografica de' Classici Italiani, 1807-11.

1809 L. Lanzi. *Storia pittorica d'Italia*. Bassano: Remondini, 1809.

1810 S. Ciampi. *Notizie inedite della Sagrestia pistoiese e de' belli arredi del Campo santo pisano e di altre opere di disegno dal XII at XV, raccolte ed illustrate.* Florence: Molini e Landi, 1810.

1812 F. Baldinucci. *La Veglia, Dialogo di Sincero Veri*. Milan: Società tipografia de classici Italiani, 1812.

———— A. da Morrona. *Pisa Illustrata nelle Arti del disegno*, 3 vols. Livorno: Marenghi, 1812. [2d ed.]

———— L. De Angelis. *Prospetto della Galleria da farsi a Siena, presentato dall'ab. Luigi De Angelis conservatore della pubblica Biblioteca e del Gabinetto delle Belle Arti al sig. Maire ed al Consiglio municipale di detta città il di primo di aprile 1812.* Siena: Biblioteca Comunale degli Intronati, Ms A.VIII.5, inserto 8. Published in summary form: P. Bacci, *Bullettino Senese di Storia Patria* X (1939): 205-13.

1813-18 L. Cicognara. *Storia della scultura*, 3 vols. Venice: Picotti, 1813-18.

1816 L. De Angelis. *Ragguaglio del Nuovo Istituto delle Belle Arti stabilito in Siena, con la descrizione della sala nella quale sono distribuiti cronologicamente i quadri dell'antica scuola senese.* Siena: Bindi, 1816.

1818 O. Fratini and A. Bruni. *Descrizione del Duomo di Siena Dedicata a Sua Eminenza Reverendissima Anton-Felice Zondadari Arcivescovo della Medesima Città.* Siena: Stamperia Comunitativa presso Giovanni Rossi, 1818.

———— M. Prunetti. *Saggio pittorico ed analisi della pitture più famose esistenti in Roma con il compendio dalle vite de' più eccellenti pittori ec. ec.* Rome: Salvioni, 1818.

1820 *Guida di Firenze e d'altre Città Principali della Toscana*, 2 vols. Florence: Ricci, 1820.

ante 1821 A. Romani. *Note manoscritte a Fabio Chigi 'Elenco delle Pitture.'* Siena: Biblioteca Comunale degli Intronati, Ms E.VI.20.

1821 ca. G. Faluschi. *Chiese Senesi*. Siena: Biblioteca Comunale degli Intronati, Ms E.V.13.

1821 A. da Morrona. *Pisa Antica e Moderna*. Pisa: Prosperi, 1821.

——— F. Tolomei. *Guida di Pistoia per gli amanti delle belle arti con notizie degli architetti, scultori, e pittori Pistoiesi*. Pistoia: Bracali, 1821.

1822 E. Romagnoli. *Nuova Guida della Città di Siena per gli amatori delle belle arti*. Siena: Mucci, 1822.

——— G. Vasari. *Le vite de' più eccellenti pittori, scultori e architetti*, 6 vols. Florence: Stefano Audin, 1822.

1823 J.-B. Séroux d'Agincourt. *Histoire de l'art par les monuments, depuis sa décadence au IVe siècle, jusqu'à son renouvellement au XVIe*, 6 vols. Paris: Treuttel et Würtz, 1823.

1823-24 L. Cicognara. *Storia della Scultura*, 7 vols. Prato: Fratelli Giachetti, 1823-24.

1824 L. De Angelis. *Biografia degli Scrittori Sanesi*. Siena: Rossi, 1824. [Reprint: Bologna: Forni, 1976]

1826-29 J.-B. Séroux d'Agincourt. *Storia dell'Arte di mostrata coi monumenti, dalla sua decadenza nel IV secolo fino al suo risorgimento nel XVI*, trans. S. Ticozzi, 3 vols. in 1. Prato: Fratelli Giachetti, 1826-29.

1827 F. Kuypers. "Anfänge der italienischen Kunst, VI, Früheste Malerei in Siena." *Kunstblatt* 49-51 (1827): 193-203.

1827-31 C. F. von Rumohr. *Italienische Forschungen*, 3 vols. Berlin-Stettin: Nicolai'sche Buchhandlung, 1827-31.

1828 L. Lanzi. *The History of Painting in Italy from the Period of the Revival of the Fine Arts to the End of the Eighteenth Century*, trans. T. Roscoe, 6 vols. London: Simpkin & Marshall, 1828. [Translation of Lanzi, 1789]

1828-33 G. Vasari. *Vite de' più eccellenti pittori, scultori e architetti scritte da Giorgio Vasari pittore e architetto aretino, con la Giunta delle minori sue opere*, 19 vols. Venice: Antonelli, 1828-33.

1832 E. Romagnoli. *Guida della Città di Siena per gli amatori delle belle arti*. Siena: Ferri, 1832.

1832-38 G. Vasari. *Le opere di Giorgio Vasari pittore e architetto aretino,* ed. G. Montani and G. Masselli. Florence: Passigli, 1832-38.

1832-49 G. Vasari. *Leben der ausgezeichnet Maler, Bildhauer und Baumeister, von Cimabue bis zum Jahre 1567, beschieben von Giorgio Vasari, Maler und Baumeister. Aus dem Italienischen. Mit den wichtigsten Anmerkungen der früheren Herausgeber, so wie mit neuren Berichtigungen und Nachweisungen, begleitet und herausgegebem von Ludwig Schorn,* 11 vols. Stuttgart and Tübingen: Cotta, 1832-49.

1834 L. Lanzi. *Storia pittorica della Italia dal risorgimento delle belle arti presso alla fine del XVIII secolo.* Florence: Marchini, 1834.

1836 D. Aldobrandini. *La Sconfitta di Montaperto. Narrazione storica tratta da un antico manoscritto con note di Giuseppe Porri.* Siena: Porri, 1836.

——— E. Romagnoli. *Cenni storico-artistici di Siena e de' suoi suburbi.* Siena: Porri, 1836.

——— V. Fineschi. *Il Forestiero istruito in S. Maria Novella.* Florence: Ciardetti, 1836.

1836-38 R. Grassi. *Descrizione storica e artistica di Pisa e de' suoi contorni,* 3 vols. Pisa: Prosperi, 1836-38.

1837 F. Kugler. *Handbuch der Geschichte der Malerei in Italien.* Berlin: Dunacker und Humblot, 1837 [Republished many times].

1837-39 G. F. Waagen. *Kunstwerke und Künstler in England und Paris,* 3 vols. Berlin: Nicolai'schen Buchhandlung, 1837-39.

——— G. F. Waagen. *Works of Art and Artists in England,* 3 vols. London: Murray, 1838.

1839-55 G. Rosini. *Storia della pittura italiana esposta coi monumenti,* 9 vols. Pisa: Capurro, 1839-55.

1840 E. Romagnoli. *Cenni storico-artistici di Siena e suoi suburbii.* Siena: Porri, 1840.

——— J.-B. Séroux d'Agincourt. *Sammlung von Denkmälern der Architectur, Sculptur und Malerei, etc,* 3 vols. Berlin: Quast, 1840.

1841 J.-B. Séroux d'Agincourt. *Storia dell'arte col mezzo dei monumenti dalla sua decadenza nel IV secolo fino al suo risorgimento nel XVI,* 7 vols. Mantua: Fratelli Negretti, 1841.

1841-42 G. Vasari. *Vies des peintres, sculpteurs et architectes par Giorgio Vasaari. Traduites par Léopold Leclanché et commentées par Jeanron et Léopold Leclanché,* 10 vols. Paris: Tessier, 1841-42.

1842 C. Pini. *Catalogo delle tavole della antica scuola senese riordinate nel corrente anno 1842 ed esistenti nell'I. e R. istituto di belle arti di Siena.* Siena: Topografia dell'Ancora, 1842.

1844 D. Aldobrandini. "La Sconfitta di Montaperto. Narrazione tratta da un libro antico." In M. Bellarmati, *Il primo libro delle istorie sanesi.* Siena: Porri, 1844.

——— G. Marti. *Illustrazioni della Chiesa Metropolitana di Siena, corredata da tutte l'epigrafi sepolcrali e monumentali che si trovano nella medesima.* Siena: Bindi, 1844.

1844-48 L. Ilari. *Indice per materie della Biblioteca Comunale di Siena.* Siena: All'Insegna dell'Ancora, 1844-48.

1845-47 F. Baldinucci. *Notizie dei Professori del Disegno da Cimabue in qua,* ed. F. Ranelli, 7 vols. Florence: Batelli e Compagni, 1845-47.

1845-48 G. Vasari. *Le Vite de' più eccellenti pittori, scultori ed architetti scritte da Giorgio Vasari, con nuove annotazioni e supplementi per cura di Ferdinando Ranalli,* 2 vols. in 3 parts. Florence: Batelli, 1845-48.

1846-55 G. Vasari. *Le Vite de' più eccellenti pittori, scultori e architetti, pubblicate per cura di una Società di Amatori delle Arti belle,* ed. V. Marchese, C. Pini, C. and G. Milanesi, 13 vols. Florence: Le Monnier, 1846-55.

1847 J.-B. Séroux d'Agincourt. *History of Art by its Monuments,* 3 vols. in 1. London: Brown, Green and Longmans, 1847.

——— E. Braun. *Duccio di Buoninsegna, la passione de Gesù Cristo nella cathedrale di Siena dipintura di Duccio di Bino della Buoninsegna; ora pei disegni di Francesco von Rhoden, intagliata in rame di Bartolomeo Bartoccini.* Rome: 1847.

1850 S. Ciampi. *Notizie Inedite della Sagrestia di Pistoia e del Camposanto Pisano e di altre opere di disegno dal secolo XII al XV.* Florence: Molini, 1850.

1850-52 G. Vasari. *Lives of the most eminent painters, sculptors and architects, translated from the Italian of Giorgio Vasari, with notes and illustrations chiefly selected from various commentators, by Mrs. Jonathan Foster,* 5 vols. London: Bohn, 1850-52.

1852 G. Milanesi. *Catalogo della Galleria dell'Istituto di Belle Arti da Siena.* Siena: Landi and Alessandri, 1852.

——— P. Selvatico. *Storica estetico critica delle arti del disegno, ovvero l'architettura, la pittura e la statuaria,* 2 vols. Venice: Naratovich, 1852.

1854 G. Gigli. *Diario senese,* 3 vols. Siena: Landi and Alessandri, 1854. [Second, enlarged edition]

1854-56 G. Milanesi. *Documenti per la storia dell'arte senese,* 3 vols. Siena: Porri, 1854-56.

1855 J. Burckhardt. *Der Cicerone, Eine Anleitung zum Genuss der Künstwerke Italiens.* Basil: Schweighauser'sche Verlagsbuchhandlung, 1855.

1856 V. Fineschi, O.P. *Memorie Istoriche per servire alle vite degli uomini illustri del convento di Santa Maria Novella.* Florence: Ciardetti, 1856.

——— L. Labarte. "L'Église Cathédrale de Sienne et son trésor d'après un inventaire de 1467." *Annales Archéologiques* 25 (1865): 261-87.

——— *Relazione della Chiesa Metropolitana di Siena corredata di tutte l'epigrafi sepolcrali e monumentali che si trovano nella Medesima.* Siena: Bindi e Caesti, 1856.

1857 G. Vasari. *Opere di Giorgio Vasari, secondo le migliori stampe e con alcuni scritti inediti, a cura di A. Racheli.* Trieste: Sezione letterario-artistica del Lloyd Austriaco, 1857.

1859 G. Milanesi. "Della vera età di Guido pittore senese e della e della celebre sua Tavola in S. Domenico di Siena." In *Giornale Storico degli Archivi Toscani* (1859): 3-16; in *Indicatore Senese* II, no. 11 (March 1895); and in *Sulla storia dell'arte toscana. Scritti varij.* Siena: Lazzeri, 1873.

——— G. Vasari. *Le Vite de' più eccellenti pittori, scultori e architetti, di Giorgio Vasari, prima edizione napolitana con note per cura di G. De Stefano.* Naples: Rossi-Romano, 1859.

1860 F. Brogi. *Catalogo della Galleria del R. Istituto provinciale di belle arti di Siena.* Siena: Mucci, 1860.

1861 F. Kugler. *The Italian Schools of Painting Based on the Handbook of Kugler.* trans. C. Eastlake, 2 vols. London: Murray, 1861 [6th ed., revised by A. H. Layard, 2 vols. London: Murrary, 1907.].

1862 L. Lazzeri. *Siena e il suo territorio.* Siena: Sordomuti, 1862.

1863	F. Albertini. *Memoriale di molte statue e pitture della città di Firenze*, ed. G. Milanesi and C. Guasti (per nozze Mussini-Piaggio). Florence: Cellini, 1863 [Originally published in 1510].
——	E. Micheli. *Guida artistica della città e contorni di Siena*. Siena: Lazzeri, 1863.
1864	*Catalogo della Galleria del R. Istituto provinciale di belle arti di Siena*. Siena: Porri, 1864.
——	J. A. Crowe and G. B. Cavalcaselle. *A New History of Painting in Italy*, 3 vols. London: Murray, 1864
1866-79	C. Schnaase. *Geschichte der bildenden Kunst*, 8 vols. Düsseldorf: Buddeus, 1866-79.
1867	G. Heberle, ed. *Catalogue des collections d'objets d'art de Mr. Jean Ant. Ramboux, vente publique à Cologne le 23 mai, 1867*. Cologne: H. Lempertz, 1867.
1868	D. Premis. *Monete della Repubblica di Siena*. Turin: Stamperia Reale, 1868.
1869	J. Burckhardt. *Der Cicerone, Eine Anleitung zum Genuss der Künstwerke Italiens*. Leipzig: Seeman, 1869.
——	J. A. Crowe/G. B. Cavalcaselle. *Geschichte der Italienischen Malerei*, ed. M. Jordan, 2 vols. Leipzig: Verlag von S. Herzel, 1869.
1870	E. Förster. *Denkmale italiensicher Malerei vom Verfall der Antike bis zum sechzehnten Jahrhundert*. Leipzig: 1870.
1872	*Catalogo della Galleria del R. Istituto provinciale di belle arti di Siena*. Siena: Sordomuti, 1872.
——	E. Micheli. *Breve istoria della galleria nell'istituto di belle arti in Siena*. Siena: Lazzeri, 1872.
1873	G. Milanesi. *Sulla storia dell'arte toscana. Scritti varij*. Siena: Lazzeri, 1873 [Reprint ed., Soest: Davco, 1973.].
1874	J. Burckhardt. *Der Cicerone, Eine Anleitung zum Genuss der Künstwerke Italiens*. Leipzig: Seeman, 1874.
1875-98	J. A. Crowe/G. B. Cavalcaselle. *Storia della Pittura in Italia*, 11 vols. Florence: Le Monnier, 1875-98.
1878	E. Dobbert. "Die Sienisische Malerschule, I, Duccio." In R. Dohmes,

Kunst und Künstler des Mittelalters und der Neuzeit. Leipzig: Seeman, 1878.

—— W. Lübje. *Geschichte der Italienischen Malerei, von IV. bis XVI. Jahrhundert,* 2 vols. Stuttgart: Ebner & Seubert, 1878.

1878-85 G. Vasari. *Le Vite de' più eccellenti pittori scultori ed architettori, con nuove annotazioni e commenti di G. Milanesi,* 9 vols. Florence: Sansoni, 1878-85.

1879 J. Burckhardt. *Der Cicerone, Eine Anleitung zum Genuss der Künstwerke Italiens Mittelalter und Neuere Zeit.* Leipzig: Seeman, 1879.

—— E. Gebhart. *Les Origines de la Renaissance en Italie.* Paris: Hachette, 1879.

—— A. Woltmann. *Geschichte der Malerei des Mittelalters.* Leipzig, 1879.

1883 *Guida artistica della città e contorni di Siena, compilata da una Società d'Amici.* Siena: Lazzeri, 1883.

1885 E. Dobbert. "Duccio's Bild 'Die Geburt Christi' in der Königlichen Gemälde-Galerie zu Berlin." *Jahrbuch der Königlich Preussischen Kunstsammlungen* 6 (1885): 153-63.

—— C. Frey. "Studien zu Giotto." *Jahrbuch der Königlich Preussischen Kunstsammlungen* 6 (1885): 107-40.

—— J. P. Richter. *Notes to Vasari's Lives of the Painters.* London: Bell & Sons, 1885.

1886 J. Beloch. *Bevölkerungsgeschichte Italiens.* Leipzig, 1886 [Reprint: Berlin: W. de Guyter & Co., 1965.].

—— C. Frey. *Vita di Lorenzo Ghiberti, scultore fiorentino.* Berlin: W. Hertz, 1886.

1889 F. Wickoff. "Über die Zeit des Guido von Siena." *Mitteilungen für Geschichtsforschung* 10 (1889): 244-86.

1890 [1] H. Thode. "Studien zur Geschichte der Italienischen Kunst im XIII. Jahrhundert-Guido von Siena und die toscanische Malerei des 13. Jahrhunderts." *Repertorium für Kunstwissenschaft* 13 (1890): 1-24.

—— [2] H. Thode. "Sind uns Werke von Cimabue erhalten? Ein Nachtrag zum vorangehenden Aufsatz." *Repertorium für Kunstwissenschaft* 13 (1890): 25-38.

1891 C. Fabriczy. "Il Libro di Antonio Billi e le sue copie nella biblioteca nazionale di Firenze." *Archivio storico italiano,* ser. V, vol.

VII, 315-68. (1891) [Published in book form 1892.]

1892 J. Burckhardt. *Le Cicerone, Guide de l'Art Antique et de l'Art Moderne en Italie.* Paris: Firmin-Didot, 1892.

———¹ C. Frey, ed. *Il Libro di Antonio Billi esistente in due copie nella Biblioteca Nazionale di Firenze.* Berlin: Grote'sche Verlagsbuchhandlung, 1892.

———² C. Frey, ed. *Il Codice Magliabechiano.* Berlin: Grote'sche Verlagsbuchhandlung, 1892.

——— H. B. Stendall. *Histoire de la Peinture en Italie.* Paris: Lévy, 1892.

1893 A. Pérate. "Etudes sur la Peinture Siennoise- I: Duccio." *Gazette des Beaux-Arts* 9 (1893): 89-110; 10 (1893): 177-201.

1894 C. J. Ffoulkes. "L'Esposizione d'Arte Italiana a Londra." *Archivio storico dell'arte*, Series II, 7 (1894): 153-76.

——— J. P. Richter. "Die Ausstellung Italienischer Renaissancewerke in der New Gallery in London." *Repertorium für Kunstwissenschaft* 18 (1894): 235-42.

——— H. Ulmann. "Photographische Reproductionen in der New Gallery 1894 aus englischen Privatbesitz ausgestellten italienischen Bilder." *Repertorium für Kunstwissenschaft* 17 (1894): 489.

——— L. Zdekauer. *Lo Studio di Siena nel Rinascimento.* Milan: Hoepli, 1894 [Reprinted Bologna: Forni, 1977.].

1895 "Atti della Commissione senese di Storia Patria." *Bullettino senese di storia patria* 2 (1895): 172-74.

——— *Catalogo della galleria del R. Istituto provinciale di belle arti in Siena.* Siena: Tip. all'Ins. dell'Ancora, 1895.

——— F. Ellen. "Tavolette dipinte della Bicherna di Siena nel Museo di Berlino." *Bullettino senese di storia patria* 2 (1895): 101-10.

——— A. Lisini. "Gaetano Milanesi." *Bullettino senese di storia patria* 2 (1895): 182-96.

1896-1908 R. Davidsohn. *Forschungen zur Geschichte von Florenz*, 4 vols. Berlin: Mittler, 1896-1908.

1897 B. Berenson. *The Central Italian Painters of the Renaissance.* New York: G. P. Putnam's Sons, 1897.

——— F. Brogi. *Inventario generale degli oggetti d'arte della provincia di Siena.* Siena: Nava, 1897 [compiled 1862-65].

——— G. Vasari. *Lives of seventy of the most eminent pianters, sculptors and architects by Giorgio Vasari, edited and annotated in the light of recent discoveries by E.H. and E.W. Blashfield and A.A. Hopkins,* 4 vols. London: Bell, 1897.

——— [1] L. Zdekauer. *La vita privata dei Senesi nel Dugento.* Siena: Lazzeri, 1897.

——— [2] L. Zdekauer. *La vita pubblica dei Senesi nel Dugento.* Siena: Lazzeri, 1897.

——— [3] L. Zdekauer. *Il costituto del Comune di Siena dell'anno 1262.* Milan: Hoepli, 1897.

1898 S. Borghesi and L. Banchi. *Nuovi documenti per la storia dell'arte senese.* Siena: Torrini, 1898.

——— J. Burckhardt. *Beiträge zur Kunstgeschichte von Italien.* Basel: Lendorff, 1898.,

——— A. Lisini. "Notizie di Duccio Pittore e della sua celebre ancona." *Bullettino senese di storia patria* 5 (1898): 20-51.

——— J. P. Richter. *Lectures on the National Gallery.* London: Longmans, Green & Co., 1898.

1899 E. Muntz. *Firenze e la Toscana. Paesaggi, monumenti, costumi e ricordi storici.* Milan: Treves, 1899.

——— M. G. G. Zimmerman. *Voraussetzung und erste Entwicklung von Giotto's Kunst.* Leipzig: Seeman, 1899.

1900 R. Davidsohn. "Duccio di Buoninsegna von Siena." *Repertorium für Kunstwissenschaft* 23 (1900): 313-14.

——— R. Fry. "Art before Giotto, I." *Monthly Review* 12 (Oct. 1900): 126-51.

——— W. Kallab. "Die Toscanische Landschaftsmalerei im XIV. und XV. Jahrhundert, ihre Enstehung und Entwicklung." *Jahrbuch der Kunsthistorischen Sammlung des Aller. Kaiserh.* 21 (1900): 1-90.

1901 R. Davidsohn. *Forschungen zur (älteren) Geschichte von Florenz III.* Berlin: 1901.

——— W. Heywood. *The "Ensamples" of Fra Filippo Lippi. A Study of Medieval Siena.* Siena: Torrini, 1901.

——— A. Lisini. *Le tavolette dipinte di Biccherna e di Gabella del R. Archivio di Stato in Siena*. Siena: Lazzeri, 1901.

——— J. Luchaise. "Le Statut des Neuf Gouverneurs de la Comune de Sienne (1310)." *Mélanges d'architecture et d'histoire publiés par l'Ecole française de Rome* 21 (1901).

——— J. P. Richter. *Commentary containing notes and emendations from the Italian edition of Milanesi and other sources. An appendix to the edition of Vasari's Lives by Mrs. J. Foster*. London: Bohn, 1901

——— P. Schubring. "Die primitiven Italiener im Louvre." *Zeitschrift für christliche Kunst* 14 (1901): 353-82.

——— A. Venturi. *Storia dell'arte italiana*, 11 vols. Milan: Hoepli, 1901.

——— J. Wood Brown. "Cimabue and Duccio at Santa Maria Novella." *Repertorium für Kunstwissenschaft* 24 (1901): 127-31.

1902 S. Brinton. *Pisa-Florence, The Awakening of Life*. London: Simpkin, Marchall, Hamilton, Kent, 1902.

——— W. M. Conway. *Early Tuscan Art from the 12th to the 15th Centuries*. London: Hurst and Blachett, 1902.

——— R. L. Douglas. *A History of Siena*. London: Murray, 1902.

——— H. Guthmann. *Die Landschaftsmalerei der toskanischen und umbrischen Kunst von Giotto bis Raffael*. Leipzig: Hierseman, 1902.

——— F. Mason Perkins. *Giotto*. London: G. Bell & Sons, 1902.

——— J. Wood Brown. *The Dominican Church of S. Maria Novella at Florence: A Historical, Architectural, and Artistic Study*. Edinburgh: Schulze, 1902.

1903 *Catalogo della galleria del R. Istituto provinciale di belle arti in Siena*. Siena: Insegna dell'Ancora, 1903.

——— J. Destrée. *Sur quelques peintures de Sienne*. Brussels: Dietrich, 1903.

———[1] R. L. Douglas. "Cimabue and the Rucellai Madonna." Appendix in Crowe and Cavalcaselle, *The History of Painting in Italy*, Vol. 1. London: Murray, 1903.

———[2] R. L. Douglas. "Duccio and the Early History of Italian Painting." *Monthly Review* 12 (1903): 130-47.

——— 3 R. L. Douglas. "The Real Cimabue." *Nineteenth Century* 3 (1903): 453-65.

——— W. Heywood and L. Olcott. *Guide to Siena*. Siena: Torrini, 1903.

——— P. Piccolomini. *La Vita e l'Opera di Sigismondo Tizio*. Rome: Ermanno Loescher, 1903.

1903-14 J. A. Crowe and G. B. Cavalcaselle. *A History of Painting in Italy*, ed. R. L. Douglas, 6 vols. London and New York: Scribner & Murray, 1903-14.

1904 J. Burckhardt. *Der Cicerone. Eine Anleitung zum Genuss der Kunstwerk Italiens*. Leipzig: Seeman, 1904.

——— A. Chiapelli. "Duccio e Cimabue dinanzi alla odierna critica inglese." *Nuova Antologia* 113 (1904): 217-26.

——— L. Cust and R. L. Douglas. "Pictures in the Royal Collections II." *The Burlington Magazine* 5 (1904): 349-51.

——— P. d'Ancona. "La miniatura alla mostra senese d'arte antica." *L'Arte* 7 (1904): 377-86.

——— R. L. Douglas, ed. *Exhibition of the Pictures of the School of Siena and Examples of the Minor Arts of that City*. London: Chiswick Press, 1904 [Exhibition catalogue, Burlington Fine Arts Club, London].

——— G. Frizzoni. "L'esposizione d'arte senese al Burlington Fine Arts Club." *L'Arte* 7 (1904): 256-79.

——— 1 R. Fry. "La Mostra d'Arte Senese al Burlington Club di Londra." *Rassegna d'arte senese* 4 (1904): 116-18.

——— 2 R. Fry. "Sienese Art at the Burlington Fine Arts Club." *Athenaeum* 4/6 (1904): 728-29.

——— M. Logan. "L'exposition de l'ancien art siennois." *Gazette des Beaux-Arts* 32 (1904): 200-14.

——— 1 F. M. Perkins. "La pittura alla mostra d'arte antica in Siena." *Rassegna d'arte* 4 (1904): 145-53.

——— 2 F. M. Perkins. "The Sienese Exhibition of Ancient Art." *The Burlington Magazine* 5 (1904): 581-84.

——— 1 C. Ricci. *Il Palazzo Pubblico di Siena e la mostra d'antica arte senese.* Bergamo: Ist. Italiano d'Arti Grafiche, 1904.

——— 2 C. Ricci. *Mostra dell'antica arte senese.* Siena: Lazzeri, 1904.

——— W. Rothes. *Die Blütezeit der Sienesischen Malerei und ihre Bedeutung für die Entwicklung der Italienischen Kunst.* Strasbourg: Heitz & Mündel, 1904.

——— J. A. Rusconi. "L'Exposition de Sienne," *Revue de l'Art Ancien* 16 (1904): 139-50.

——— W. Suida. "Studien zur Trecentomalerei, I-II." *Repertorium für Kunstwissenschaft* 27 (1904): 385-89, 483-90.

——— O. von Wulff. "Zur Stilbildung der Trecentomalerei, I: Duccio und die Sienesen." *Repertorium für Kunstwissenschaft* 27 (1904): 89-112.

1905 A. Chiapelli. *Pagine d'antica arte fiorentina-Cimabue e la critica.* Florence: Lumachi, 1905.

——— L. Coletti. "Precedenza della scuola senese sulla scuola fiorentina." *Rassegna d'arte senese* 1 (1905): 95-106.

——— F. M. Perkins. "Pitture senesi negli Stati Uniti." *Rassegna d'arte senese* 1 (1905): 74-78.

——— W. Suida. "Einige florentinische Maler aus der Zeit des Übergangs vom Duecento ins Trecento, I. Die Rucellai Madonna." *Jahrbuch der Königlich Preussischen Kunstsammlungen* 26 (1905): 28-39.

1905-28 S. Reinach. *Répertoire de Peintures du Moyen Age et de la Renaissance (1280-1580),* 6 vols. Paris: Leroux, 1905-28.

1906 F. Bargagli-Petrucci. *Le fonti di Siena e i loro acquedotti,* 2 vols. Siena: Olschki, 1906.

——— R. Caggese. "La republica di Siena e il suo contado nel secolo decimoterzo." *Bullettino senese di storia patria* 13 (1906): 3-120.

——— L. Coletti. *Arte senese.* Treviso: Zoppelli, 1906.

——— P. D'Achiardi. "Una Madonna sconosciuta di Duccio di Buoninsegna." *L'Arte* 9 (1906): 372-73.

——— C. Gamba. "Di alcune pitture poco conosciute della Toscana." *Rivista d'arte* 4 (1906): 45-47.

——— A. Pérate. "La Peinture Italienne au XIV siècle." In A. Michel, *Histoire de l'Art* 2, part 2. Paris: Colin, 1906.

——— F. Rintelen. "Zur jüngsten Literatur über die italienische Malerei im Trecento." *Kunstgeschichtliche Anzeigen* 3 (1906): 33-45.

——— P. Schubring. "Notizie di Berlino." *L'Arte* 9 (1906): 384-87.

——— G. Vasari. *Le vite de' più eccellenti pittori, scultori . . .* , 9 vols. Florence: Sansoni, 1906.

——— A. Venturi. *La galleria Sterbini in Roma, saggio illustrativo.* Rome: Casa editrice de l'arte, 1906.

1906-7 A. Franchi. "Di alcuni recenti acquisiti della Pinacoteca di Belle Arti di Siena." *Rassegna d'arte senese* 2 (1906): 111-17; 3 (1907): 3-10.

1907 A. Aubert. *Die Malerische Dekoration der San Francesco Kirche in Assisi-Ein Betrag zur Lösung der Cimabue Frage.* Leipzig: Hiersdmann, 1907.

——— J. Burckhardt. *Der Cicerone, Eine Anleitung zum Genuss der Künstwerke Italiens.* Leipzig: Seeman, 1907.

——— A. Chiappelli. "Per la Madonna Rucellai." *L'Arte* 10 (1907): 55-59.

——— L. Cust. "La Collection de M. R. H. Benson." *Les Arts* 11 (October 1907): 2-32.

——— E. Jacobsen. *Sienische Meister des Trecento in der Gemäldegalerie zu Siena.* Strasbourg: Heitz & Mündel, 1907.

——— L. Justi. *Die italienische Malerei des XV Jahrhunderts.* Berlin: Fischer & Franke, 1907.

——— O. von Wulff. "Die umgekehrte Perspektive und di Niedersicht." In *Kunstwissenschaftliche Beiträge August Schmarsow gewidmet.* Leipzig: K. W. Hiersemann, 1907.

1907-50 U. Thieme and F. Becker. *Allgemeines Lexikon der Bildenden Künstler von der Antike bis zur Gegenwart,* 37 vols. Leipzig: Verlag von Wilhelm Englemann, 1907-50.

1908 B. Berenson. *The Central Italian Painters of the Renaissance.* New York: Putnam & Sons, 1908.

—— M. Cruttwell. *A Guide to the Paintings in the Churches and Minor Museums of Florence*. London: Dent, 1908.

—— G. De Nicola. "Quadretti senesi ad Utrecht." *L'Arte* 11 (1908): 386.

—— W. Kallab. *Vasaristudien*, ed. J. von Schlosser, K. Graeser, B. G. Teuber. Vienna: K. Graeser, 1908.

—— H. Omont. *Evangiles avec Peintures Byzantines du XIe siècle*. Paris: Frères Berthaud, 1908.

——1 F. M. Perkins. "Nuovi appunti sulla galleria delle Belle Arti a Siena." *Rassegna d'arte senese* 4 (1908): 48-61.

——2 F. M. Perkins. "Ancora dei dipinti sconosciuti della scuola senese." *Rassegna d'arte senese* 4 (1908): 3-9.

——3 F. M. Perkins. "La pittura alla mostra d'arte antica in Siena." *Rassegna d'arte senese* 4 (1908): 145-53.

1909 F. Albertini. *Il memoriale di molte statue et picture che sono nella inclyta cipta di Florentia*, ed. H. Horne. Letchworth: Florence Press, 1909.

—— B. Berenson. *The Central Italian Painters of the Renaissance*. New York and London: G. P. Putnam's Sons, 1909.

—— *Catalogo della galleria del R. Istituto provinciale di belle arti in Siena*. Siena: Insegna dell'Ancora, 1909.

—— V. Lusini. "Duccio di Buoninsegna e il Pavimento del Duomo di Siena." *Rassegna d'arte senese* 5 (1909): 74-92.

—— F. Schevill. *Siena, The Story of a Medieval Commune*. London: Chapmann & Hall, 1909.

—— W. Suida. "Studien und Forschungen zur Dugentomalerei." *Monatschefte für Kunstwissenschaft* 2 (1909): 64-67.

—— I. Vavasour-Elder. "La pittura senese nella Galleria di Perugia." *Rassegna d'Arte Senese* 5 (1909): 64-77.

—— C. Weigelt. "Contributo alla ricostruzione della 'Maestà' di Duccio di Buoninsegna, che si trova nel Museo Metropolitano di Siena." *Bullettino senese di storia patria* 16 (1909): 191-214.

1909-11 H. Posse. *Die Gemälde Galerie des Kaiser Friedrich Museums. Vollständiger beschreibender Katalog.* Berlin: Bard, 1909-11.

1910 C. A. Nicolosi. *Il literale maremmano: Grosseto-Orbitello.* Bergamo: Istituto italiano d'arti grafiche, 1910.

1910-12 P. Bacci, ed. *Documenti toscani per la storia dell'arte,* 2 vols. Florence: Gonnelli, 1910-12.

1911 R. *Archivio di Stato di Siena-La sala della mostra e il museo delle tavolette dipinte della Biccherna e della Gabella.* Siena: Lazzari, 1911.

———[1] G. De Nicola. "La vetrata dell'abside." *Rassegna d'arte senese* 7 (1911): 36.

———[2] G. De Nicola. Review of C. H. Weigelt, *Duccio di Buoninsegna. Bullettino senese di storia patria* 18 (1911): 431-39.

——— P. Misciatelli. *Mistici Senesi.* Siena: Tip ed. S. Bernardino, 1911.

——— P. Rossi. "Duccio di Buoninsegna." *Rassegna d'arte senese* 7 (1911): 76-80.

——— S. Sanpere and I. Miguel. *La Pintura Migeval Catalana.* Barcelona: L'Avenç, 1911.

——— G. Vasari. *Le Vite de' più eccellenti pittori, scultori e architettori, scritte da M. Giorgio Vasari pittore e architetto aretino,* ed. C. Frey. Munich: G. Müller, 1911 [Only one volume published].

——— C. H. Weigelt. *Duccio di Buoninsegna.* Leipzig: Hiersemann, 1911.

1911-12 A. Munoz and L. Pollak. *Pièces Choix de la Collection du Comte Grégoire Stroganoff à Rome,* 2 vols. Rome: Unione editrice, 1911-12.

1911-39 V. Lusini. *Il Duomo di Siena,* 2 vols. Siena: Tip. Ed. S. Bernardino, 1911-39.

1912 A. Colasanti. *L'arte bizantina in Italia.* Milan: Bestetti, 1912.

———[1] W. De Grüneisen. "I Ritratti di Monna Muccia e di un committente ignoto nella Mostra Ducciana di Siena." *Rassegna d'arte senese* 8 (1912): 52-59.

———[2] W. De Grüneisen. "Tradizione orientale-Bizantina, influssi locali, ed ispirazioni individuali nel ciclo cristologico della Maestà." *Rassegna d'arte senese* 8 (1912): 15-51.

———1 G. De Nicola. "Una copia di Segna di Tura della Maestà di Duccio." *L'Arte* 15 (1912): 21-32.

———2 G. De Nicola. *Catalogo della mostra di opere di Duccio di Buoninsegna e della sua scuola*. Siena: Lazzeri, 1912.

———3 G. De Nicola. "Arte inedita in Siena e nel suo antico territorio." *Vita d'Arte* 10 (1912): 138-47.

———4 G. De Nicola. "Duccio di Buoninsegna and his school in the Mostra di Duccio at Siena." *The Burlington Magazine* 22 (1912): 138-47.

——— L. Ghiberti. *Lorenzo Ghibertis Denkwürdigkeiten (I Commentarii) Zum ersten Male nach der Handschrift der Biblioteca Nazionale in Florenz vollstädig herausgegeben und erläutert von Julius von Schlosser*. Berlin: Bard, 1912.

——— L. Gielly. "Duccio di Buoninsegna à propos de l'exposition du sixième centenaire de la 'Maestà,' à Sienne." *Revue de l'art ancien et moderne* 22 (1912): 289-302.

——— B. Khwohninsky and M. Salmi. *I Pittori Toscani dal XIII al XVI sec.* Rome: Loescher, 1912.

———1 V. Lusini. "Di Duccio di Buoninsegna. Gli ultimi Riflessi di Duccio." *Rassegna d'arte senese* 8 (1912): 60-98.

———2 V. Lusini. "Mostra Ducciana. Catalogo dei Dipinti." *Rassegna d'arte senese* 8 (1912): 105-54.

——— F. Rintelen. *Giotto und die Giotto-Apokryphen*. Munich and Leipzig: Müller, 1912.

——— P. Rossi. "Mostra della pittura di Duccio di Buoninsegna e della sua scuola." [Inaugural Address to the Exhibition, 1 September 1912] *Rassegna d'arte senese* 8 (1912): 65-78.

——— M. Salmi. "Il crocefisso di Segna di Bonaventura ad Arezzo." *L'Arte* 15 (1912): 33-35.

——— R. Schiff. "Rinvenimento di due opere di Duccio di Buoninsegna ricordate dal Vasari." *L'Arte* 15 (1912): 366-370.

1912-15 G. Vasari. *The Lives of the Most Eminent Painters, Sculptors and Architects*, trans. G. du C. De Vere, 10 vols. London: Macmillan, 1912-15.

1913	J. Breck. "A Trecento Painting in Chicago." *Art in America* 1 (1913): 112-15.
——	L. Gielly. "L'Opera del Duomo à Sienne." *Les Arts* 12 (1913): 5-17.
——	W. De Grüneisen. *Studi su Duccio di Buoninsegna.* Siena: Lazzeri, 1913. [Re-publication of the articles of 1912]
——[1]	V. Lusini. "Per lo studio della vita e delle opere di Duccio di Buoninsegna." *Rassegna d'arte senese* 9 (1913): 19-32.
——[2]	V. Lusini. "Duccio di Buoninsegna e il pavimento del duomo di Siena." *Rassegna d'arte senese* 9 (1913): 74-92.
——	F. M. Perkins. "Appunti sulla mostra ducciana a Siena." *Rassegna d'arte senese* 9 (1913): 5-9, 35-39.
——	P. Rossi, et al. *In onore di Duccio di Buoninsegna.* Siena: Società degli Amici dei Monumenti, 1913.
——	P. Rossi. *I caratteri dell'arte senese dal Medioevo al Rinascimento.* Siena: Giutini-Bentivoglio, 1913.
——	A. I. Rusconi, ed. *Vita di Duccio di Buoninsegna, dalle vite di Vasari, con una introdzione, note, e bibliografie.* Florence: Bemporad, 1913.
——	E. Sandberg-Vavalà. *Sienese Studies, The Development of the School of Painting in Siena.* Florence: Olschki, 1913.
——	C. Weigelt. Report on the Rucellai *Madonna. Sitzungsbericht der Berliner Kunstgeschichtliche Gesellschaft* 7 (1913): 151-61.
1913-14	B. Berenson. *Catalogue of a Collection of Paintings and Some Art Objects: I. Italian Paintings.* Philadelphia: J.G. Johnson, 1913.
1914	T. Borenius. *Catalogue of Italian Pictures at 16, South Street, Park Lane, London and Buckhurst in Sussex collected by Robert and Evelyn Benson.* London: The Chiswick Press, 1914.
——	P. Toesca. *Il medioevo.* Turin: Unione Tipografico-Editrice Torinese, 1914.
——[1]	C. H. Weigelt. "Duccio." In Thieme-Becker, *Allgemeines Lexikon der Bildenden Künstler*, Vol. 10. Leipzig, 1914: 25-29.
1915	L. Dami. *Siena e le sue opere d'arte.* Florence: Lumachi, 1915.

————— G. F. Hills. *Twelve Scenes from the Life of Christ, After Duccio di Buoninsegna*. London: P.H. Warner, 1915 [Also: Toronto, Melbourne, and Bombay: Oxford University Press, 1915.].

1916 T. Borenius. *Pictures by the Old Masters in the Library of Christ Church, Oxford*. London and New York: Oxford University Press, 1916.

————— G. De Nicola. "Ugolino e Simone a San Casciano Val di Pesa." *L'Arte* 19 (1916): 13-20.

————— G. Vasari. *Die Lebensbeschrieben der berühmtesten Architekten, Bildhauer und Maler*, ed. G. Gottschewski and G. Gronau, trans. P. Schubring. Strasbourg: Heitz, 1916.

————— O. von Wulff. "Zwei Tafelbilder des Ducento im Kaiser-Friedrich Museum." *Jahrbuch der Königlich Preussischen Kunstsammlungen* 37 (1916): 68-98.

1917 E. Benkard. *Das Literarische Porträt des Giovanni Cimabue*. Munich: Bruckmann, 1917.

1918 B. Berenson. *Essays in the Study of Sienese Painting*. New York: Sherman, 1918.

1919 R. Offner. "Italian Pictures at the New-York Historical Society and Elsewhere, Part II." *Art in America* 7 (1919): 189-98.

1920 R. Fry. "Art before Giotto." *Monthly Review* 1 (Oct. 1900): 126-51 [Reprinted in *Vision and Design*. London: Chatto and Windus, 1920.].

————— U. Gnoli. "Una Tavola di Duccio di Buoninsegna." *Rassegna d'arte senese* 13 (1920): 94-96.

————— F. M. Perkins. "Some Sienese Paintings in American Collections." *Art in America* 8 (1920): 195-210; 272-292.

—————[1] R. van Marle. "La Pittura Senese prima di Duccio." *Rassegna d'arte antica e moderna* 7, no. 20 (1920): 265-73.

—————[2] R. van Marle. *Recherches sur l'Iconographie de Giotto et de Duccio*. Strasbourg: Heitz, 1920.

————— C. von Rumohr. *Italienische Forschungen*, ed. J. von Schlosser. Frankfurt: Frankfurter Verlags, 1920.

1921	B. Berenson. "Due dipinti del XII secolo venuti da Costantinopoli." *Dedalo* 2 (1921): 285-304 [Reprinted, in English, in Berenson's *Studies in Medieval Paintings*].
———	A. Venturi. "Un'opera di Duccio di Buoninsegna a Copenhagen e una di Simone Martini a Vienna." *L'Arte* 24 (1921): 198-201.
1921-22	M. Lamy. "La découverte des primitifs italiens au XIXe siécle." *Revue de l'art ancien et moderne* 1 (1921): 169ff.; 2 (1922): 182ff.
1922	W. Hausenstein. *Das Bild Atlanten zur Kunst*. Munich: Piper, 1922.
———	A. Pinetti. *Il Conte Giacomo Carrara e la sua Galleria secondo il Catalogo del 1796*. Bergamo: Arti Grafiche, 1922.
———	O. Siren. *Toskanische Malerei im XIII Jahrhundert*. Berlin: Cassirer, 1922.
1923	F. E. W. Freund. "Die vier Duccios der Sammlung Benson." *Der Cicerone* 20 (1923): 333-36.
———	R. van Marle. "Dipinti senesi nel museo arcivescovile di Utrecht." *Bollettino d'Arte* n.s. 2 (1923): 562-69.
1923-38	R. van Marle. *The Development of the Italian Schools of Painting*, 19 vols. The Hague: M. Nijhoff, 1923-38.
1924	J. Burckhardt. *Der Cicerone, Eine Anleitung zum Genuss der Künstwerke Italiens*. Leipzig: Körner, 1924.
———	L. Dami. *La Galleria di Siena*. Florence: Alinari, 1924.
———	W. Heywood and L. Olcott. *Guide to Siena, History and Art*. Siena: Turbanti, 1924.
———[1]	G. Soulier. *Les Influences Orientales dans la Peinture Toscane*. Paris: Laurens, 1924.
———[2]	G. Soulier. "Les caractères configures dans la peinture toscane." *Gazette des Beaux-Arts* 9 (1924): 347-58.
———	J. von Schlosser. *Die Kunstliteratur: Ein Handbuch zur Quellenkunde der neueren Kunstgeschichte*. Vienna: Anton Schroll & Co., 1924.
———	H. Weyhe. "An Altarpiece by Segna." *Bulletin of the Metropolitan Museum of Art* 19 (1924): 191-93.

1924-25 F. Antal. "Gedanken zur Entwicklung der Trecento-und Quattrocentomalerei in Siena und Florenz." *Jahrbuch für Kunstwissenschaft* 2 (1924-25): 207-39.

1925 V. Andreyeff. "Some Paintings of the Sienese School in the Museum of Fine Arts, Moscow." *The Burlington Magazine* 47 (1925): 151-60.

—— E. Cecchi. *Trecentisti senesi*. Rome: Casa editrice d'arte "Valori plastici," 1925.

—— A. Chiappelli. "Nuovi studi su Cimabue e la sua opera pittorica." In *Arte del Rinascimento (ricerche e saggi)*. Rome: Alberto Stock, 1925, 52-70.

—— E. Hutton. *The Sienese School in the National Gallery, London*. London and Boston: The Medici Society, 1925.

—— F. M. Perkins. "La Pittura alla mostra d'arte di Montalcino." *Rassegna d'arte senese* 18 (1925): 51-71.

1926 L. Gielly. *Les Primitifs siennois*. Paris: A. Michel, 1926.

—— R. van Marle. "Dipinti sconosciuti della Scuola di Duccio." *Rassegna d'arte senese* 19 (1926): 3-6.

—— E. Sandberg-Vavalà. *La pittura senese del Trecento e del primo Quattrocento*. Verona: Tipografica veronese, 1926.

—— O. Sirén. "Considérations sur l'oeuvre de Cimabue à propos de la Madonne de la Collection Gualino, à Turin." *Revue de l'art ancien et moderne* 49 (1926): 73-88.

——[1] L. Venturi. *Il gusto dei primitivi*. Bologna: Zanichelli, 1926.

——[2] L. Venturi. *La Collezione Gualino*. Turin: Bestetti e Tumminelli, 1926.

—— W. R. Valentiner. *A Catalogue of Early Italian Paintings Exhibited at the Duveen Galleries, New York, April to May 1924*. New York: Privately printed, 1926.

1927 Anonymous. "Duveen Buys the Famous Benson Collection." *Art News* 25, no. 38 (1927): 1, 4-5, 8.

—— P. Bacci. "Pittori senesi nella collezione Gualino." *Rassegna d'arte senese* 20 (1927): 40-41.

—— T. Borenius. "The Benson Collection." *Apollo* 6 (1927): 65-70.

—— R. L. Douglas. "I dipinti senese della 'Collezione Benson' passati da Londra in America." *Rassegna d'arte senese* 20 (1927): 99-106.

—— U. Gnoli. *La pinacoteca di Perugia*. Florence: Fratelli Alinari, 1927.

—— V. Lusini. "Elenco dei pittori senesi vissuti nei secoli XIII e XIV." *La Diana* 2 (1927): 295-306.

—— R. Offner. *Italian Primitives at Yale University: Comments and Revisions*. New Haven: Yale University Press, 1927.

—— E. Panofsky. "Die Perspective als symbolische Forme." *Vorträge der Bibliothek Warburg* 4 (1924-25): 258-330.

—— P. Toesca. *Storia dell'arte italiana I: Il medioevo*. Turin: Unione tipografi-co-editrice torinese, 1927.

—— G. Vasari. *Le Vite del Vasari nell'edizione del MDL*, ed. C. Ricci, 4 vols. Milan and Rome: Bestetti e Tumminelli, 1927 [First re-publication of the 1550 edition].

1928 E. Cecchi. *Trecentisti Senesi*. Rome: Valori Plastici, 1928.

—— F. M. Perkins. "Nuovi appunti sulla galleria belle arti di Siena." *Rassegna d'arte senese* 21 (1928): 99-115, 143-61, 183-203.

—— L. Venturi. *Prima mostra della Collezione Gualino nella R. Pinacoteca di Torino*. Milan: Bestetti e Tumminelli, 1928.

—— F. E. Washburn Frenner. "Die vier Duccios der Hg. Benson." *Cicerone* 2 (1928): 532-36.

—— C. H. Weigelt. "Über die Mütterliche Madonna in der Italienischen Malerei des 13. Jahrhunderts." *Art Studies* 6 (1928): 195-221.

1929 R. van Marle. "Quadri senesi sconosciuti." *La Diana* 4 (1929): 307-10.

—— E. Sandberg-Vavalà. *La croce dipinta italiana e l'iconografia della passione*. Verona: Apollo, 1929.

—— G. Soulier. *Cimabue. Duccio et les Premières Ecoles de Toscane à propos de la Madone Gualino*. Paris: Champion, 1929.

——— C. H. Weigelt. "The Madonna Rucellai and the Young Duccio." *Art in America* 18 (1929): 3-25.

1929-30 W. G. Constable. "Dipinti di raccolte inglesi alla mostra d'arte italiana a Londra." *Dedalo* 10 (1929-30): 723-67.

1930 [1] B. Berenson. *Studies in Medieval Painting*. New Haven: Yale University Press, 1930; London: Oxford University Press, 1930.

——— [2] B. Berenson. "Quadri senza casa: Il Trecento I." *Dedalo* 9 (1930): 263-84.

——— T. Borenius. "Early Sienese Crucifixion." *The Burlington Magazine* 56 (1930): 255-56.

——— R. Byron and D. Talbot Rice. *The Rebirth of Western Painting: A History of Colour, Form, and Iconography, Illustrated from the Paintings of Mistra and Mount Athos, of Giotto and Duccio, and of El Greco*. London: Routledge, 1930.

——— S. K. North. "The Conservation of the King's Duccio." *The Burlington Magazine* 67 (1930): 205.

——— P. Toesca. "Trecentisti Toscani nel Museo di Berna." *L'Arte* 33 (1930): 4-15.

——— [1] C. H. Weigelt. *La Pittura Senese del Trecento*. Bologna: Casa editrice Apollo, 1930.

——— [2] C. H. Weigelt. "The Problem of the Rucellai Madonna. Part 2: Sienese Characteristics." *Art in America* 18 (1930): 105-20.

——— [3] C. H. Weigelt. *Sienese Painting of the Trecento*. Paris: Pegasus, 1930; New York: Pantheon, 1930.

1931 F. M. Perkins. "Pitture senesi poco conosciuti." *La Diana* 6 (1931): 10-36, 90-109, 187-203, 244-60.

——— C. Brandi. "A proposito di una felice ricostruzione della celebre Madonna di Guido da Siena." *Bullettino senese di storia patria* n.s. 2 (1931): 77-80.

——— M. Fransolet. "L'Auteur de la Madone Rucellai." *Revue Belge d'Archéologie et de l'Histoire de l'Art* 1 (1931): 49-53.

——— L. Hautecoeur. *Les Primitifs Italiens*. Paris: Laurens, 1931.

—— V. Lasareff. "Duccio and Thirteenth-Century Greek Icons." *The Burlington Magazine* 59 (1931): 154-69.

—— R. van Marle. "Quadri ducceschi ignorati." *La Diana* 6 (1931): 57-59.

—— R. van Marle. "I quadri italiani della raccolta del castello Rohoncz." *Dedalo* 11 (1931): 365-92.

—— P. Misciatelli. "Arte antica senese." *La Diana* 6 (1931): 5-10.

—— G. Soulier. "Une Madone de Duccio aux Offices." *Gazette des Beaux-Arts* 6 (1931): 225-30.

1931-35 L. A. Muratori, *Rerum Italicarum Scriptores*. Vol. XV, part VI, ed. A. Lisini and F. Iacometti. Bologna: Zanichelli, 1931-35.

1932 [1] P. Bacci. "La R. pinacoteca di Siena." *Bolletino d'arte* 26 (1932): 177-200.

—— [2] P. Bacci. "Commentarii dell'Arte Senese III: Notizie su Duccio, I figli, il nipote e I bisnipoti, pittori." *Bullettino senese di storia patria* n.s. 3 (1932): 233-48.

—— B. Berenson. *The Italian Pictures of the Renaissance. A List of the Principal Artists and their Works with an Index of Places*. Oxford: Clarendon Press, 1932.

—— G. H. Edgell. *A History of Sienese Painting*. New York: The Dial Press, 1932.

—— M. L. Gengaro. "Sogno e realtà nella primitiva arte senese." *La Diana* 7 (1932): 151-59.

—— R. van Marle. *Le scuole della pittura italiana*. The Hague: M. Hijoff, 1932-34 [Italian translation of *The Development...*, 1923-28.].

—— J. W. Power. *Eléments de la construction picturale*. Paris: Anton Roche, 1932.

—— U. Procacci. "Opere sconosciute d'arte toscana." *Rivista d'arte* ser. 2, 4 (1932): 462-75.

—— E. B. Toesca. "Arte italiana a Strigonia." *Dedalo* 3 (1932): 933-60.

—— P. Toesca. "Duccio." In *Encyclopedia italiana di scienze, lettere ed arti*, vol. 13. Milan: Treves, Treccani, Tumminelli, 1932, 245-47.

1932-35 U. Procacci. "Opere sconosciuti d'arte toscana." *Rivista d'arte* ser. 2,

4 (1932): 341-53, 462-75; and ser. 2, 6 (1935): 405-11.

1933[1] C. Brandi. *La Regia Pinacoteca di Siena*. Rome: Libreria dello Stato, 1933.

————[2] C. Brandi. "Una Madonna del 1262 ed ancora il problema di Guido da Siena." *L'Arte* 36 (1933): 3-13.

———— R. L. Douglas. *Storia d'arte senese*. Siena: 1933 [Reprinted Bologna: Forni, 1975].

———— Florence, Convento di San Marco. *Mostra del tesoro di Firenze sacra*. Florence, 1933.

———— C. Gamba. "Opere d'Arte inedite alla Mostra del Tesoro di Firenze Sacra." *Rivista d'arte* ser. 2, 5 (1933): 65-74.

———— F. M. Perkins. "Due pitture senesi inedite." *La Diana* 8 (1933): 115-17.

———— L. Venturi. *Italian Paintings in America*, 3 vols. New York: E. Wyhe, 1933.

———— C. Weigelt. "Formen-Wachstum." *Pantheon* 11 (1933): 142-44.

1934 E. Sandberg-Vavalà. *L'iconografia della Madonna col Bambino nella pittura italiana del Dugento*. Siena: Stabilmento d'arti grafiche S. Bernardino, 1934 [Reprinted Rome: Multigrafica, 1983.].

———— E. Rowland. "A Sienese Painting of the Dugento." *Art in America* 23 (1934): 47-57.

———— R. van Marle. "La Pittura all'esposizione d'arte antica Italiana di Amsterdam." *Bollettino d'arte* 28 (1934-35): 293-313.

1935 P. Bacci. "Identificazione e restauro della tavola del 1336 di Niccolò di Segna da Siena." *Bollettino d'arte* 29 (1935): 1-13.

———— R. Biscaroli. *La pittura di paesaggio in Italia*. Bologna: 1935.

———— J. Lipman. "An Impressive Sienese Fragment." *Art in America* 23 (1935): 69-72.

———— P. Provasi. "Lettere ad U. Benvoglienti di R. Rawlinson e d'altri raccogliatori d'opere d'arte stranieri." *Bullettino senese di storia patria* n.s. 6 (1935): 28-47.

———— J. von Schlosser. *La letteratura artistica, manuale delle fonti della storia de'*

	arte moderna, trans. F. Rossi. Florence: La Nuova Italia, 1935.
——	R. Tatlock. "Ugolino da Siena's Predella Completed." *Apollo* 21 (1935): 64-66.
1936	P. Bacci. *Francesco di Valdambrino emulo del Ghiberti e collaboratore di Jacopo della Quercia*. Siena: Istituto Comunale d'Arte e di Storia, 1936.
——	B. Berenson. *Pitture Italiane del Rinascimento*. Milan: Hoepli, 1936.
——	R. van Marle. "Two Unknown Paintings by Duccio di Buoninsegna." *Apollo* 24 (1936): 213-14.
——	R. Offner. "Two Sienese Panels." *Bulletin of the Associates in Fine Arts at Yale University* 1 (1936): 5-7.
——	F. M. Perkins. "Segna di Bonaventura." *Thieme-Becker Künstlerlexikon* 30 (1936): 449-50.
1937	L. Coletti. "La mostra giottesca." *Bollettino d'arte* 31 (1937): 49-72.
——	C. A. Isermeyer. *Rahmengliederung und Bildfolge in der Wandmalerei bei Giotto und den Florentiner Malern des 14. Jahrhunderts*. Würzburg: 1937.
——	Palazzo degli Uffizi. *Mostra Giottesca. Aprile-Ottobre MCMXXXVII-XV*. Bergamo: Istituto Italiano d'Arti Grafiche, 1937.
——	J. Renate. "Die Ikonographie der Madonna in trono in der Malerei des Duegento." *Mitteilungen des Kunsthistorischen Institutes in Florenz* 5 (1937): 1-57.
——	M. Salmi. "La Mostra Giottesca." *Emporium* 48 (1937): 349-64.
1938	I. Emelli. *Lo Spirito di Giotto*. Cremona: Tip. Cremona Nuova, 1938.
——	F. Horb. *Das Innenraumbild des späten Mittelalters*. Zurich and Leipzig: 1938.
1939 [1]	P. Bacci. *Dipinti inediti e sconosciuti di Pietro Lorenzetti, Bernardo Daddi, ecc. in Siena e nel contado*. Siena: Accademia per le Arti e per le Lettere, 1939.
—— [2]	P. Bacci. "Elenco delle pitture, sculture e architetture di Siena, compilato nel 1625-26 da Mons. Fabio Chigi poi Allessandro VII, secondo il ms. Chigiano I.I.11." *Bullettino senese di storia patria*, n.s. 10 (1939): 197-213; 297-337.
—— [3]	P. Bacci. "Una pittura ignorata di Segna di Bonaventura." *Le Arti* 3 (1939): 12-16.

——— F. M. Perkins. "Ugolino da Siena." *Thieme-Becker Künstlerlexikon* 33 (1939): 542-44.

1940 M. S. Bunim. *Space in Medieval Painting and the Forerunners of Perspective.* New York: Columbia University Press, 1940.

——— V. Papi. *La Maestà di Duccio.* Siena: Turbanti, 1940.

——— W. Suida. "Die Sammlung Kress New York." *Pantheon* 12 (1940): 273-83.

1940-54 W. and E. Paatz. *Die Kirchen von Florenz,* 6 vols. Frankfurt: Klosterman, 1940-54.

1941 *Duveen Pictures in Public Collections of America.* New York: Bradford Press, 1941.

——— T. Hetzer. *Giotto. Seine Stellung in der europäischen Kunst.* Frankfurt a.M.: V. Klosterman, 1941.

1941-47 L. Coletti. *I Primitivi II. I Senesi ed i Giotteschi,* 3 vols. Novara: De Agostini, 1941-47.

1943 E. Carli. *Il Pulpito di Siena.* Bergamo: Istituto Italiano d'Arti Grafiche, 1943.

——— G. Sinibaldi and G. Brunetti, eds. *Pittura Italiana del duecento e trecento. Catalogo della mostra giottesca di Firenze del 1937.* Florence: Sansoni, 1943.

1944 [1] P. Bacci. *Fonti e commenti per la storia dell'arte senese; dipinti e sculture in Siena, nel suo contado e altrove.* Siena: Accademia degli Intronati, 1944.

——— [2] P. Bacci. *Documenti e Commenti per la Storia dell'Arte.* Florence: Le Monnier, 1944.

——— E. Carli. "Archivistica e critica d'arte." *Emporium* 99 (1944): 51-71.

——— H. Wieruszowski. "Art and the Commune in the Time of Dante." *Speculum* 19 (1944): 14-33.

1945 A. Bertini, intro. *Quattro secoli di pittura in Umbria: Mostra celebrativa del V centenario della nascità di Pietro Perugino.* Perugia: Grafica, 1945 [Exhibition catalogue].

——— L. Venturi. *Storia della critica d'arte.* Rome: Edizioni U., 1945.

1946 [1] E. Carli. *Capolavori dell'arte senese.* Florence: Electa, 1946.

———2 E. Carli. *Vetrata duccesca*. Florence: Electa, 1946.

———1 G. H. Edgell. "A Crucifixion by Duccio with Wings by Simone Martini." *The Burlington Magazine* 88 (1946): 107-12.

———2 G. H. Edgell. "An Important Triptych of the Sienese Trecento: Crucifixion by Duccio, with Wings Attributed to Martini." *Bulletin of the Museum of Fine Arts* 44 (1946): 33-41.

——— E. G. Garrison. "A Ducciesque Tabernacle at Oxford." *The Burlington Magazine* 88 (1946): 214-23.

——— M. Meiss. "Italian Primitives at Konopistě." *The Art Bulletin* 29 (1946): 1-16.

——— J. Pope-Hennessy. "An Exhibition of Sienese Stained Glass." *The Burlington Magazine* 88 (1946): 306.

1947 F. Antal. *Florentine Painting and its Social Background. The Bourgeois Republic before Cosimo de' Medici's Advent to Power: XIV and early XV centuries.* London: Kegan, 1947.

——— C. Brandi. *Carmine o della pittura con due saggi su Duccio e su Picasso.* Florence: Vallecchi, 1947.

——— G. Delogu. *Antologia della pittura italiana dal XIII al XIX secolo.* Bergamo: Istituto italiano d'arti grafiche, 1947.

——— L. Ghiberti. *I Commentarii*, ed. Ottavio Morisani. Naples: Ricciardi, 1947.

——— U. Procacci. *Mostra di opere di arte trasportate a Firenze durante la guerra e di opere d'arte restaurate.* Florence: Giuntina, 1947.

1948 F. Bologna. "Recensione al 'Giudizio sul Duecento' di R. Longhi." *Lo Spettatore italiano* II, 3 (March 1949): 51.

——— E. Cecchi. *I Trecentisti senesi.* Milan: Hoepli, 1948.

——— R. Longhi. "Giudizio sul duecento." *Proporzioni* 2 (1948): 5-54.

——— A. J. Rusconi. *The Pavement of Siena's Cathedral.* Siena: O. Jusandi, 1948.

——— P. Toesca. *Gli Affreschi del Vecchio e del Nuovo Testamento nella chiesa superiore del santuario di Assisi.* Florence: Artis Monumenta Photographice Edita, 1948.

1949 E. B. Garrison. *Italian Romanesque Panel Painting: An Illustrated Index.*
 Florence: L.S. Olschki, 1949.

1950 C. Brandi. "Il Restauro della Madonna di Coppo di Marcovaldo
 nella Chiesa dei Servi di Siena." *Bollettino d'arte* 35 (1950): 160-70.

—————— E. Carli. *Mostra delle Tavolette di Biccherna e di altri uffici dello stato di
 Siena.* Florence: Electa Editrice, 1950.

1951 [1] C. Brandi. *Duccio.* Florence: Vallecchi, 1951.

—————— [2] C. Brandi. "Le Analisi compiute dall'Istituto Centrale del
 Restauro." *Bollettino d'arte* 36 (1951): 252-59.

—————— E. Carli. "Relazione sul restauro della Madonna di Guido da
 Siena del 1221." *Bollettino d'arte* 36 (1951): 248-52.

—————— G. Cecchini. *Archivio di Stato di Siena, Guida-inventario.* Rome:
 Ministero dell'Interno, Pubblicazioni degli Archivi di Stato V, 1951.

—————— M. Davies. *The Earlier Italian Schools.* London: The National Gallery,
 1951; 2d ed., 1961 [Catalogue: National Gallery, London.].

—————— R. Longhi. "Prima Cimabue, poi Duccio." *Paragone* 23 (1951): 8-13.

—————— M. Meiss. "A New Early Duccio." *The Art Bulletin* 33 (1951): 95-103.

—————— P. Toesca. *Il Trecento, Storia dell'arte italiana II.* Turin: Unione
 Tipografico-Editrice Torinese, 1951.

1952 J. Burckhardt. *Il Cicerone, Guida al godimento delle Opere d'Arte in
 Italia.* Florence: Sansoni, 1952.

—————— E. Carli. *Duccio.* Milan: Electa, 1952.

—————— G. Coor-Achenbach. "A Dispersed Polytych by the Badia a Isola
 Master." *The Art Bulletin* 34 (1952): 311-16.

—————— D. Frey. "Giotto und die Maniera Greca, Bildgesetzlichkeit und
 psychologische Deutung." *Wallraf-Richartz-Jahrbuch* 14 (1952): 73-98.

—————— E. Lavignano and R. Salvini. *Trésors d'art du Moyen-Age en Italie.* Paris:
 Presses Artistiques, 1952 [Exhibition at the Petit Palais, Paris].

—————— M. Meiss. "Scusi, ma sempre Duccio." *Paragone* 27 (1952): 63-64.

1953 *Archivio di Stato di Siena. Inventario Archivio della Biccherna del Comune di*

Siena. Rome: Ministro dell'Interno, Pubblicazioni degli Archivi di Stato, 1953.

——— R. Oertel. *Die Frühzeit der Italienischen Malerei*. Stuttgart: W. Kohlhammer, 1953. [2d ed. 1966]

——— E. and E. Paatz. *Die Kirchen von Florenz*, 6 vols. Frankfurt a.M.: V. Klostermann, 1953

——— E. Sandberg-Vavalà. *Sienese Studies, The Development of the School of Painting in Siena*. Florence: Olschki, 1953.

1954 C. Brandi. *Duccio di Buoninsegna. La Maestà*. Rome: Sidera, 1954.

——— C. Gnudi. "Duccio, la tradition transfigurée." In *La peinture gothique*, ed. J. Dupont and C. Gnudi. Geneva: 1954.

——— D. C. Shorr. *The Christ Child in Devotional Images in Italy during the XIV century*. New York: Wittenborn, 1954.

——— C. Volpe. "Preistoria di Duccio." *Paragone* 49 (1954): 4-22.

1955 C. Brandi. *Un Candelabro dipinto da Lippo Vanni*. Bern: Abegg-Stiftung, 1955.

———[1] E. Carli. *Dipinti senesi del contado e della Maremma*. Milan: Electa, 1955.

———[2] E. Carli. *La pittura senese*. Milan: Electa, 1955.

———[3] E. Carli. "Recent Discoveries in Sienese Painting." *Connoisseur* 136 (1955): 94-99.

———[1] G. Coor. "Contributions to the Study of Ugolino di Nerio's Art." *Art Bulletin* 37 (1955): 153-65.

———[2] G. Coor. "A New Attribution to the Monte Oliveto Master and Some Observations Concerning the Chronology of His Works." *The Burlington Magazine* 97 (1955): 203-7.

——— E. T. De Wald. "Observations on Duccio's Maestà," in *Late Classical and Medieval Studies in Honor of A.M. Friend*, ed. K. Weitzmann. Princeton: Princeton University Press, 1955, 363-86.

——— W. R. Hovey. *The Frick Collection, An Illustrated Catalogue of the works of Art in the Collection of Henry Clay Frick*. New York: The Frick Reference Library, 1955.

——— G. Marchini. *Le vetrate italiane*. Milan: Electa, 1955.

——— M. Meiss. "Ancora una volta Duccio e Cimabue." *Rivista d'arte* 30 (1955): 107-13. [This article appears as the first section of the larger article " Nuovi dipintie e vecchi problemi," 107-45.]

——— H. C. Peyer. *Stadt und Stadtpatron im mittelalterichen Italien*. Zurich: Europa Verlag, 1955.

——— C. L. Ragghianti. *Pittura del Dugento a Firenze*. Florence: Vallechi, 1955.

1956 *Archivio di Stato di Siena. Catalogo: Le Sale della Mostra e il Museo delle Tavolette Dipinte*. Rome: Ministero dell'Interno, Pubblicazioni degli Archivi di Stato, XXIII, 1956.

——— G. Bandmann. "Die Perspektive-ihr Sinn und ihre Grenzen." *Radius* 1 (1956): 27-35.

———[1] G. Coor. "Trecento-Gemälde aus der Sammlung Ramboux." *Wallraf-Richartz Museum Jahrbuch* 18 (1956): 111-31.

———[2] G. Coor. "The Missing Panel from a Dispersed Polyptych by the Badia a Isola Master." *The Art Bulletin* 38 (1956): 119.

——— J. van Goidsenhoven. *Adolphe Stoclet Collection: Selection of the Works Belonging to Madame Feron-Stoclet*. Brussels: Laconti, 1956.

——— L. Marcucci. "Un crocifisso senese del duecento." *Paragone* 77 (1956): 11-24.

——— S. Orlandini. "La Madonna di Duccio di Buoninsegna e il suo culto in Santa Maria Novella." *Memorie Domenicane* 12 (1956): 205-17.

——— G. Previtali. "Guglielmo della Valle." *Paragone* 77 (1956): 3-11.

——— M. Rosa. "Atteggiamenti culturali e religiosi di Giovanni Lami nelle Novelle Litterarie." *Annali della Scuola Normale Superiore di Pisa* (1956): 260-333.

——— L. Salerno. "Giulio Mancini e le 'Cose di Siena.'" In *Scritti di storia dell'arte in onore di Lionello Venturi*, Vol. 2. Rome: De Luca, 1956, 9-17.

———[1] F. Santi, ed. *La galleria nazionale dell'Umbria in Perugia*. Rome: Istituto poligrafico e Zecca della Stato, 1956.

———[2] F. Santi, ed. *The National Gallery of Umbria in Perugia*. Rome: Istituto

poligrafico e Zecca della Stato, 1956 [Translation of preceding item].

——— M. Schapiro, "On an Italian Painting of the Flagellation of Christ in the Frick Collection." In *Scritti di storia dell'arte in onore di Lionello Venturi*, Vol. 1. Rome: De Luca, 1956, 29-53.

——— C. Volpe. "Sulla mostra dei dipinti senesi del contado e della maremma." *Paragone* 73 (1956): 47-53.

1956-57 A. Marucchi. *Giulio Mancini-Considerazioni sulla Pittura*. Vol. 1, ed. A. Marucchi. Rome: Accademia Nazionale dei Lincei, 1956; Vol. 2., commentary, L. Salerno. Rome: Accademia Nazionale dei Lincei, 1957.

——— M. Meiss. "The Case of the Frick Flagellation." *Journal of the Walters Art Gallery* 19-20 (1956-57): 43-63.

1957 G. Coor-Achenbach. "The Earliest Italian Representation of the Coronation of the Virgin." *The Burlington Magazine* 99 (1957): 328-30.

——— P. D'Ancona. *Duccio*. Milan: Silvana, 1957.

——— C. Sterling, ed. *Exposition de la collection Lehman de New York*. Paris: Editions de Musées Nationaux, 1957 [2d edition].

——— J. Stubblebine. "The Development of the Throne in Dugento Tuscan Painting." *Marsyas* 7 (1957): 25-39.

——— J. White. *The Birth and Rebirth of Pictorial Space*. London: Faber and Faber, 1957.

1958 E. Carli. *Guida della Pinacoteca di Siena*. Milan: Martello, 1958.

——— G. Gnudi. *Giotto*. Milan: Martello, 1958.

——— L. Marcucci. *Gallerie nazionali di Firenze-I dipinti toscani del secolo XII al secolo XVII*. Rome: Poligrafico dello Stato, 1958.

——— K. Michaelsson. "Le livre de la taille de Paris, l'an 1296." *Arsskrift, Acta Universitatis Gotheburgensis* 64 (1958): 269.

——— G. Rowley. *Ambrogio Lorenzetti*, 2 vols. Princeton: Princeton University Press, 1958.

——— W. R. Valentiner. "Notes on Duccio's Space Conception." *The Art Quarterly* 21 (1958): 353-81.

—— G. Vigni. "Duccio di Buoninsegna." In *Enciclopedia universale dell'arte*, Vol. 4. Venice and Rome: 1958.

—— F. Zeri. "Un polittico di Segna di Buonaventura." *Paragone* 103 (1958): 63-68.

1959 R. Arb. "A Reappraisal of the Boston Museum's Duccio." *The Art Bulletin* 41 (1959): 191-98.

—— C. Brandi. *Il restauro della "Maestà" di Duccio*. Rome: Istituto Poligrafico dello Stato, 1959.

—— E. Carli, G. Gnudi, and R. Salvini. *Medioevo romanico e gotico*. Vol. 1, *Pittura italiana*. Milan: Martello, 1959.

—— K. Lankheit. *Das Triptychon als Pathosformel. (Abhanglungen der Heidelberger Akademie der Wissenschaften, Phil.-hist. Klasse)*. Heidelberg: C. Winter, 1959.

—— A. Liberati. "Chiese, Monasteri, Oratori e Spedali Senesi." *Bullettino senese di storia patria* 66 (1959): 167-82.

—— P. Murray. *An Index of Attributions made in Tuscan Sources before Vasari*. Florence: Olschki, 1959.

—— L. Gori-Montanelli. *Architettura e paesaggio nella pittura toscana dagli inizi alla metà del Quattrocento*. Florence: Olschki, 1959.

—— R. Salvini and L. Traverso. *Predelle dell'200 al'500*. Florence: Vallecchi, 1959.

—— P. Thoby. *Le crucifix, des origines au Concile de Trente, étude iconographique*. Nantes: Bellanger, 1959.

—— G. Vigni. "Duccio di Buoninsegna." In *Encyclopedia of World Art*. Vol. 4. New York, 1959, 203-10.

1960 F. Bologna. "Ciò che resta di un capolavoro giovanile di Duccio." *Paragone* 125 (1960): 3-31.

—— E. Borsook. *The Mural Painters of Tuscany from Cimabue to Andrea del Sarto*. London: Phaidon, 1960.

—— G. Coor. "The Early-Nineteenth-Century Aspect of a Dispersed Polyptych by the Badia a' Isola Master." *The Art Bulletin* 42 (1960): 142.

——¹ E. B. Garrison. "Toward a New History of the Siena Cathedral Madonnas." In *Studies in the History of Medieval Italian Painting*, Vol. 4. Florence: L'Impronta, 1960, 2-22.

——² E. B. Garrison. "Sienese Historical Writings." In *Studies in the History of Medieval Italian Painting*, Vol. 4. Florence: L'Impronta, 1960, 23-58.

—— G. Millet. *Recherches sur l'Iconographie de l'Evangile aux XIVe, XVe et XVIe siècles*. Paris: Boccard, 1960.

—— E. Panofsky. *Renaissance and Renascences in Western Art*. Stockholm: Almqvist & Wiksells, 1960 [Reprinted New York: Harper & Row, 1969.].

—— J. Pope-Hennessy. *Heptatych, Ugolino da Siena*. Williamstown, Mass.: The Sterling and Francine Clark Art Institute, 1960.

1961 R. Carità. "Il restauro de 'La Maestà' di Duccio." *Terra di Siena* 15 (1961): 3-12.

—— E. Carli. *Duccio di Buoninsegna*. Milan: Fratelli-Fabbri, 1961.

—— E. DeWald. *Italian Painting, 1200-1600*. New York: Holt, Rinehart and Winston, 1961.

—— J. Marette. *Connaissance des primitifs par l'étude du bois, du XIIe au XVIe siècle*. Paris: Picard, 1961.

—— K. Michaelsson. "Le livre de la taille de Paris, l'an 1297." *Arsskrift, Acta Universitatis Gotheburgensis* 67 (1961): 421.

—— T. Schneider. "Die Restaurierung der 'Maestà' von Duccio di Buoninsegna." *Maltechnik* 67 (1961): 36-43.

1962 B. Berenson. *Italian Pictures of the Renaissance: Florentine School*, 2 vols. London: Phaidon, 1962.

—— F. Bologna. *La pittura italiana delle origini*. Rome: Editori Riuniti, 1962.

—— H. Hager. *Die Anfänge des italienischen Altarbildes. Untersuchungen zur Entstehungsgeschichte des toskanischen Hochaltarretabels*. Munich: Verlag Anton Schroll & Co, 1962.

1962-66 G. Vasari. *Le Vite de' più eccellenti pittori, scultori e architettori*, ed. P. Della Pergola, L. Grassi, and G. Previtali. Milan: Club del Libro, 1962-66.

1963 E. Battisti. *Cimabue*. Milan: Istituto editoriale italiano, 1963.

—— A. Cairola and E. Carli. *Il Palazzo Pubblico di Siena*. Rome: Editalia, 1963.

—— P. Dal Poggetto, ed. *Arte in Valdelsa dal sec. XII al sec. XVII*. Florence: S.T.I.A.V, 1963 [Exhibition catalogue].

—— E. R. Eglinski. "Sienese Dugento Painting: A Catalogue of Painting before Duccio." Ph.D. diss., State University of Iowa. Ann Arbor, Michigan: University Microfilms, 1963.

—— C. Volpe. *I primitivi*. Novara: 1963.

—— F. Zeri. "La mostra 'Arte in Valdelsa,' a Certaldo." *Bollettino d'arte* 48 (1963): 245-58.

1964 W. M. Bowsky. "The Impact of the Black Death upon Sienese Government and Society." *Speculum* 39 (1964): 1-34.

——[1] E. Carli. *Arte senese nella Maremma Grossetana. Catalogo*. Grosseto: Associazione "Pro Loco," 1964.

——[2] E. Carli. *Duccio. I Maestri del Colore*, Vol. 16. Milan: Fabbri, 1964.

—— U. Morandi. *Le Biccherne senesi*. Siena: Monte dei Paschi, 1964.

—— E. Orlandi. *La Maestà di Duccio di Buoninsegna*. Milan: 1964.

—— G. Previtali. *La fortuna dei primitivi dal Vasari ai neoclassici*. Turin: Einaudi, 1964.

—— J. von Schlosser Magnino. *La letteratura artistica*, trans. F. Rossi, ed. O. Kurz. Florence: La Nuova Italia; Vienna: Anton Schroll & Co., 1964 [Italian edition of *Die Kunstliteratur*, 1924].

—— P. Toesca. *Il Trecento*. Turin: Einaudi, 1964.

—— L. Venturi. *History of Art Criticism*. New York: Dutton & Co., 1964.

1965 M. Boskovits, M. Mojzer, A. Mucsi, eds. *Christian Art in Hungary. Collections from the Esztergom Christian Museum*. Budapest: Hungarian Academy of Sciences, 1965.

—— J. Canaday. *Giotto and Duccio*. New York: Horizon, 1965.

—— E. Carli. "Recuperi e restauri senesi, I. Nella cerchia di Duccio." *Bollettino d'arte* 50 (1965): 94-99.

——	F. Cooper, "A reconstruction of Duccio's Maestà." *The Art Bulletin* 47 (1965): 155-71.
——	M. Frinta. "An Investigation of the Punched Decoration of Medieval Italian and Non-Italian Panel Paintings." *The Art Bulletin* 47 (1965): 261-65.
——	L. Marucci, ed. *I dipinti toscani del secolo XIV.* [Florence: Gallerie nazionale di Firenze] Rome: Istituto poligrafico dello stato, 1965.
——	L. Tintori and E. Borsook. *Giotto: The Peruzzi Chapel.* Turin: Fratelli Pozzo, 1965.
——	C. Volpe. *Simone Martini e la pittura senese da Duccio ai Lorenzetti.* Milan: 1965.
1966	M. Boskovits. *Early Italian Panel Paintings.* Budapest: Corvina, 1966.
——	M. Cämmerer-George. *Die Rahmung der Toskanischen Altarbilder im Trecento.* Strasbourg: Heitz, 1966.
——	E. Carli. *Il Duomo di Siena.* Florence: Sansoni, 1966.
——	E. Kitzinger. "The Byzantine Contribution to Western Art of the Twelfth and Thirteenth Centuries." *Dumbarton Oaks Papers* 20 (1966): 25-47.
——	R. Oertel. *Die Frühzeit der italienischen Malerei.* Stuttgart: W. Kohlhammer, 1966 [2d edition].
——	E. Panofsky. *La prospettiva come 'forma simbolica' e altri scritti,* ed. G. D. Neri and M. Dalai. Milan: Feltrinelli, 1966.
——	F. R. Shapley, ed. *Paintings from the Samuel H. Kress Collection: I. Italian Schools, XIII-XV Century.* London: Phaidon, 1966.
——[1]	J. Stubblebine. "Byzantine Influences in Thirteenth Century Italian Panel Painting." *Dumbarton Oaks Papers* 20 (1966): 87-101.
——[2]	J. Stubblebine. "Two Byzantine Madonnas from Calahorra, Spain." *The Art Bulletin* 48 (1966): 379-81.
——	J. White. *Art and Architecture in Italy, 1250-1400.* London: Penguin, 1966.
1966-71	G. Vasari. *Le Vite de' più eccellenti pittori, scultori e architettori, nelle redazioni del 1550 e 1568,* ed. R. Bettarini and P. Barocchi. Florence: Sansoni, 1966-71.

1967	E. Battisti. *Cimabue*. University Park: The Pennsylvania State University Press, 1967.
——	R. Borghini. *Il Riposo*, ed. M. Rosci. Milan: Labor, 1967.
——	W. M. Bowsky. "Medieval Citizenship: The Individual and the State of the Commune of Siena, 1287-1355." *Studies in Medieval and Renaissance History* 4 (1967): 195-243.
——	J. Byam Shaw, ed. *Paintings by the Old Masters at Christ Church, Oxford*. London: Phaidon, 1967.
——	P. P. Donati. *La Maestà di Duccio*. Florence: Sadea and Sansoni, 1967.
——	S. Fehm. "A Pair of Panels by the Master of Città di Castello and a Reconstruction of their Original Altarpiece." *Yale University Art Gallery Bulletin* 31 (1967): 17-29.
——	L. Ghiberti. *I Commentari*. Milan: 1967.
——	A. Pigler, ed. *Katalog der Galerie alter Meister*, 2 vols. Budapest: Akadémiai Kiodó, 1967 [Budapest: Szépmüvészeti Museum].
——	G. Previtali. *Giotto e la sua bottega*. Milan: Fabbri, 1967.
——	M. Salmi. "La donazione Contini-Bonacossi." *Bollettino d'arte* 52 (1967): 222-32.
——	A. Venturi. *Storia dell'arte italiana V. La pittura del trecento e le sue origini*. Liechtenstein: Kraus, 1967.
——	L. Vertova. "What goes with what?" *The Burlington Magazine* 109 (1967): 668-72.
1967-68	B. Cole. "A Madonna Panel from the Circle of the Early Duccio." *Allen Memorial Art Museum Bulletin* 25 (1967-68): 114-22.
1968	B. Berenson. *Italian Pictures of the Renaissance: Central Italian and North Italian Schools*, 2 vols. London: Phaidon, 1968.
——	B. Davidson, ed. *The Frick Collection*. New York: Frick Collection, 1968.
——	B. Degenhart and A. Schmitt. *Corpus der italienischen Zeichnungen 1300-1450*. 4 vols. Berlin: Mann, 1968.

—— C. L. Ragghianti, ed. *National Gallery di Washington*. Milan: Mondadori, 1968.

—— R. Oertel. *Early Italian Painting to 1400*. New York: Praeger, 1968.

—— E. T. Prehn. *Visual Perception in XIII-Century Italian Painting*. Rome: Tipografia Risorgimento, 1968.

—— R. Steiner. "Die Berner Maestà von Duccio di Buoninsegna." *Mitteilungen* (Berner Kunstmuseum) 103 (1968): 1-7.

1969 M. Ayrton. *Giovanni Pisano sculptor*. London: Thames and Hudson, 1969.

—— E. Carli. "Duccio di Buoninsegna." In *L'Arte in Italia, II: Dal secolo XII al Secolo XIII*. Rome: 1969.

—— M. Davies. "Duccio: an Acquisition." *The Burlington Magazine* 111 (1969): 4-7.

—— H. W. van Os, et al., eds. *Sienese Paintings in Holland*. Groningen: Wolters-Noordhoff, 1969.

—— H. W. van Os. *Marias Demut und Verherrlichung in der sienesischen Malerei, 1300-1450*. The Hague: Staatsuitgeverij, 1969.

—— F. Santi, ed. *Dipinti, sculture e oggetti d'arte di età romanica e gotica*. Rome: Instituto poligrafico dello stato, 1969.

—— J. von Schlosser. *Sull'antica storiografia italiana dell'arte*. Vicenza: Neri Pozza, 1969.

——[1] J. Stubblebine. "The Angel Pinnacles in Duccio's Maestà." *The Art Quarterly* 33 (1969): 131-52.

——[2] J. Stubblebine. "Segna di Buonaventura and the Image of the Man of Sorrows." *Gesta* 8 (1969): 3-13.

—— L. Vertova. "Un frammento duccesco." *L'Arte illustrata* 22-24 (1969): 38-47.

—— C. Volpe. "La formazione di Giotto nella cultura di Assisi." In *Giotto e i giotteschi in Assisi*, ed. G. Palumbo. Rome: Canesi (1969): 15-60.

—— J. De Voragine. *The Golden Legend*, ed. and trans. W. G. Ryan. New York: Arno Press, 1969 [Partial publication].

—— H. J. Ziemke. "Ramboux und die sienesiche Kunst." *Städel-Jahrbuch* n.f. 2 (1969): 255-300.

1970 F. Arcangeli. "La Maestà di Duccio a Massa Marittima." *Paragone* 249 (1970): 4-14.

—— W. M. Bowsky. *The Finance of the Commune of Siena. (1287-1355).* Oxford: Clarendon Press, 1970.

—— G. Cantoni. *Libri dell'entrata e dell'uscita del comune di Siena detti della Biccherna*, Registro 30 (1259, second semester). Rome, 1970.

—— C. H. Krinsky. "Representations of the Temple of Jerusalem before 1500." *Journal of the Warburg and Courtauld Institutes* 33 (1970): 1-19.

—— L. Vertova. "A New Work by the Monteoliveto Master." *The Burlington Magazine* 102 (1970): 688-91.

1971 H. Anderson. "Cimabue and Perspective." In *Giotto and his Times*, ed. P. Amerson et al. University Park: The Pennsylvania State University Press, 1971, 33-39.

—— E. Carli. *I pittori senesi*. Milan: Electa, 1971.

—— J. Larner. *Culture and Society in Italy, 1290-1420*. New York: Scribner and London: Batsford, 1971.

—— A. Parronchi. "Una crocefissione duccesca." In *Giotto e il suo tempo, Congresso internazionale, Assisi-Padua-Florence, 1967*. Rome: De Luca, 1971, 311-18.

1972 E. Baccheschi and G. Cattaneo. *L'Opera completa di Duccio, Classici dell'Arte* 60. Milan: Rizzoli, 1972.

—— T. B. Butler. "Giulio Mancini's 'Considerations on Painting.'" Ph.D. Diss., Case Western Reserve University, 1972. Ann Arbor: University Microfilms, 1989.

—— E. Carli. "Nuovi studi nell'orbita di Duccio di Buoninsegna." *Antichità viva* 11 (1972): 3-15.

——[1] J. Stubblebine. "Duccio's *Maestà* of 1302 for the Chapel of the Nove." *The Art Quarterly* 35 (1972): 239-68.

—— 2 J. Stubblebine. "The Frick Flagellation Reconsidered." *Gesta* 11 (1972): 3-10.

—— 3 J. Stubblebine. "The Role of Segna di Buonaventura in the Shop of Duccio." *Pantheon* 30 (1972): 272-82.

—— L. Venturi. *Il gusto dei primitivi*. Turin: Einaudi, 1972.

—— C. Versini. "Duccio et l'école siennoise." *Cahiers Acad. Augustin* 14 (1972): 25-37.

1973 G. Marchini. "Le vetrate." In *Atti del I Convegno sulle Arti Minori in Toscana (Arezzo 11-15 Maggio 1971)*. Florence: 1973.

—— A. Preiser. *Das Entstehen und die Entwicklung der Predella in der italienischen Malerei*. Hildesheim: Olms, 1973.

—— 1 J. Stubblebine. "Cimabue and Duccio in Santa Maria Novella." *Pantheon* 30 (1973): 15-21.

—— 2 J. Stubblebine. "Duccio and His Collaborators on the Cathedral Maestà." *The Art Bulletin* 55 (1973): 185-204.

—— G. Tommasi. *Dell'Historie di Siena*. Bologna: Forni, 1973 [Reprint of original publication].

—— 1 J. White. "Carpentry and Design in Duccio's workshop: The London and Boston Triptychs." *Journal of the Warburg and Courtauld Institutes* 35 (1973): 92-105.

—— 2 J. White. "Measurement, Design and Carpentry in Duccio's Maestà." *The Art Bulletin* 55 (1973): 334-66, 547-69.

1973-74 V. Stoichita. "Note sull'iconografia della Madonna dei Francescani." *Annuario dell'Istituto di storia dell'arte*, Università degli Studi di Roma (1973-74): 156-68.

1974 G. Ercoli. "Il Vasari Storiografo e Artista." In *Atti del Convegno Internazionale del IV Centenario della Morte*. Florence: Istituto Nazionale di Studi sul Rinascimento, 1974, 93-100.

—— G. Gigli. *Diario senese*. Bologna: Forni, 1974 [Reprint of 1854 edition].

—— C. Knapp Fengler. "Lorenzo Ghiberti's Second Commentary: The Translation and Interpretation of a Fundamental Renaissance

Treatise on Art." Ph.D. diss., University of Wisconsin. Ann Arbor: University Microfilms, 1974.

—— R. Longhi. "Giudizio sul duecento." In *Opera Completa*, Vol. 7. Florence: Sansoni, 1974, 1-53.

—— H. Wagner. *Italienische Malerei 13. bis 16. Jahrhunderts* (Sammlungskataloge des Berner Kunstmuseum). Bern: 1974.

—— C. H. Weigelt. *Sienese Painting of the Trecento*. New York: Hacker Art Books, 1974 [Reprint].

—— L. Zdekauer. *Il costituto del comune di Siena dell'anno 1262*. Sala Bolognese: Forni, 1974 [Reprint].

1975 E. Carli. *Duccio di Buoninsegna: l'opera autografa*. Florence: Edizioni Scala, 1975.

—— J. Stubblebine. "Byzantine Sources for the Iconography of Duccio's Maestà." *The Art Bulletin* 57 (1975): 176-85.

—— G. Szabó, ed. *The Robert Lehman Collection*. New York: The Metropolitan Museum of Art, 1975.

1976 C. Belting-Ihm. *Sub Matris Tutela. Untersuchungen zur Vorgeschichte der Schutzmantelmadonna* (Abhandlungen der Heidelberger Akademie der Wissenschaften, Phil.-Hist. Klasse). Heidelberg: Winter, 1976.

—— E. Carli. *L'Arte a Massa Marittima*. Siena: Centrooffset, 1976.

—— B. Cole. *Giotto and Florentine Painting 1280-1375*. New York: Harper and Row, 1976.

—— E. T. Prehn. *Aspetti della pittura medievale toscana*. Florence: Vallecchi, 1976.

—— V. J. Stoichita. *Ucenicia Lui Duccio di Buoninsegna*. Bucharest: Meridiane, 1976.

1977 D. Balestracci and G. Piccinni. *Siena nel Trecento: assetto urbano e strutture edilizie*. Florence: Clusf, 1977.

—— H. Belting. *Die Oberkirche von San Francesco in Assisi. Ihre Dekoration als Aufgabe und die Genese einer neuen Wandmalerei*. Berlin: Mann, 1977.

—— J. Brink. "Measure and Proportion in the Monumental Gabled

Altarpieces of Duccio, Cimabue and Giotto." *Revue d'Art Canadienne/Canadian Art Review* 4 (1977): 69-77.

—— F. Deuchler. "Die Einzug Christi in Jerusalem. Zu Duccios neuer Gestaltung des Themas." *Neue Züricher Zeitung* 82 (7/8 April 1977): 65.

—— H. B. J. Maginnis. "The Literature of Sienese Trecento Painting, 1945-1975." *Zeitschrift für Kunstgeschichte* 40 (1977): 276-309.

—— J. Schlosser Magino. *La letteratura artistica*, ed. O. Kurz. Florence: Nuova Italia, 1977.

—— J. Stubblebine. "The Back Predella of Duccio's Maestà." In *Studies in Late Medieval and Renaissance Painting in Honor of Millard Meiss*, ed. I. Lavin and J. Plummer. Vol. 1. New York: New York University Press, 1977, 1: 430-36.

—— P. Torriti. *La Pinacoteca nazionale di Siena. I dipinti dal XII al XV secolo*. Genoa: SAGEP, 1977.

1977-78 G. Ercoli. "L'antica pittura senese e il Vasari." *Bullettino senese di storia patria* 84-85 (1977-78): 93-112.

1978 J. Brink. "Carpentry and Symmetry in Cimabue's Santa Croce Crucifix." *The Burlington Magazine* 120 (1978): 645-52.

—— H. Loyette. "Une source pour la reconstruction du polyptych d'Ugolino da Siena à Santa Croce." *Paragone* 343 (1978): 15-23.

—— M. Prokopp. "Nuova proposta sull'attribuzione di un dipinto del Trecento nel Museo Cristiano di Esgtergom." *Acta historiae artium Academiae Scientiarum Hungaricae* 24 (1978): 67-77.

—— C. Ressort, S. Beguin and M. Laclotte, eds. *Retables italiens du XIIIe au XVe siècle*. Paris: Editions de la Réunion des Musées Nationaux, 1978.

—— A. Smart. *The Dawn of Italian Painting 1250-1400*. Oxford: Phaidon, 1978.

—— 1 J. Stubblebine. "The Ducciesque *Maestà* for Massa Marittima." In *Essays presented to Myron P. Gilmore*, ed. S. Bertelli and G. Ramakus, Vol. 2. Florence: La Nuova Italia, 1978, 357-67.

—— 2 J. Stubblebine. "The Boston Ducciesque Tabernacle, a Collaboration." In *Collaboration in Italian Renaissance Art*, ed. W. S. Sheard and J. T. Paoletti. New Haven: Yale University Press, 1978, 1-19.

———[3] J. Stubblebine. "The Face in the Crowd: Some Early Sienese Self Portraits." *Apollo* 108 (1978): 338-92.

——— B. Tosatti Soldano. *Miniature e vetrate senesi del secolo XIII*. Genoa: Università di Genova, 1978.

——— D. Wilkins. "Early Florentine Frescoes in Santa Maria Novella." *Art Quarterly* n.s. 1 (1978): 141-74.

1979 E. Carli. *Il Duomo di Siena*. Genoa: SAGEP, 1979.

——— F. Deuchler. "Duccio Doctus: New Readings for the *Maestà*." *The Art Bulletin* 61 (1979): 541-49.

——— C. Gardner von Teuffel. "The Buttressed Altarpiece: A Forgotten Aspect of Tuscan Fourteenth-Century Altarpiece Design." *Jahrbuch der Berliner Museen* 21 (1979): 36-44.

——— R. Goffen. "Nostra Conversatio in Caelis est: Observations on the Sacra Conversazione in the Trecento." *Art Bulletin* 41 (1979): 198-222.

——— J. Hook. *Siena. A City and its History*. London: 1979.

——— S. Padovani and P. Torriti. *Mostra di opere d'arte restaurate nelle provincie di Siena e Grosseto*. Genoa: SAGEP, 1979 [Exhibition catalogue].

——— F. R. Shapley, ed. *Catalogue of the Italian Paintings*. Washington, D.C.: The National Gallery, 1979.

——— V. J. Stoichita. "Duccio e la maniera greca." *Revue des études sud-est européennes* 17, no. 3 (1979): 497-522.

——— J. Stubblebine. *Duccio di Buoninsegna and His School*, 2 vols. Princeton: Princeton University Press, 1979.

——— J. White. *Duccio. Tuscan Art and the Medieval Workshop*. London: Thames and Hudson, 1979.

1980 F. Bisogni. "Problemi di interpretazione e di normalizzazione del linguaggio tecnico delle fonti sei-settecentesco nella memorizzazione dei dati sulle pitture Senesi sui Duecento." In *Atti del Convegno Nazionale sui Lessici Technici del Sei-Settecento*. Pisa: Scuola Normale Superiore di Pisa, 1980, 1: 262-83.

——— E. Borsook. *The Mural Painters of Tuscany*. Oxford: Clarendon Press, 1980 [2d edition].

——— B. Cole. *Sienese Painting. From its Origins to the Fifteenth Century*. New York: Harper and Row, 1980.

——— A. Conti. Review of *Duccio, Tuscan Art and the Medieval Workshop*, by John White. *Prospettiva* 23 (1980): 98-101.

———[1] F. Deuchler. "Siena and Jerusalem: Imagina und Realität in Duccio's neuem Stadtbild." In *Europäische Sachkultur des Mittelalters*. Vienna: 1980, 13-20 [Sitzungbreichte Österreichische Akademie der Wissenschaften. Pholosophisch-Historische Klasse, 374.].

———[2] F. Deuchler. "Duccio: zum Gold als Farbe." In *Von Farbe und Farben: Albert Knoefli zum 70. Geburtstag*. Zurich: Instituts für Denkmalpflege an der Eidgenössischen Technischen Hochschule Zürich, 1980, 303-7.

——— G. Ercoli. "Il Trecento senese nel 'Commentarii' di Lorenzo Ghiberti." In *Lorenzo Ghiberti nel suo Tempo*. Florence: Olschki, 1980, 317-41.

——— U. Feldges. *Landschaft als topographisches Porträt. Der Wiederbeginn der europäischen Landschaftmalerei in Siena*. Bern: Benteli, 1980.

——— C. Pietramellara. *Il Duomo di Siena. Evoluzione della forma dalle origini alla fine del Trecento*. Florence: Edam, 1980.

——— J. Pope-Hennessy. "A Misfit Master." *The New York Review of Books* 27, no. 18 (20 Nov. 1980): 45-47.

1981 W. Bowsky. *A Medieval Italian Commune: Siena under the Nine 1287-1355*. Berkeley, Los Angeles, and London: University of California Press, 1981.

——— J. Cannon. Review of *Duccio di Buoninsegna and His School*, by J. Stubblebine. *The Burlington Magazine* 123 (1981): 168.

——— E. Carli. *La pittura senese del Trecento*. Milan: Electa, 1981.

———[1] F. Deuchler. "Duccio et son cercle." *Revue de l'Art* 51 (1981): 17-22.

———[2] F. Deuchler. "Le sens de la lecture. A propos du boustrophédon." In *Etudes d'art médiéval offertes à Louis Grodecki*, ed. S.C. Crosby et al. Paris: Ophrys, 1981, 251-58.

——— E. Fahy. "Duccio and After." *Apollo* 114 (1981): 130-31.

—— H. W. van Os. "Duccio." *The Burlington Magazine* 123 (1981): 165-67.

—— A. Perrig. "Formen der politischen Propaganda der Commune von Siena in der ersten Trecento-Hälfte." In *Bauwerke und Bildwerke im Hochmittelalter. Anschauliche Beiträge zur Kultur und Sozialgeschichte*, ed. K. Clausberg, et al. Giessen: 1981, 213-34.

1982 L. Bellosi. "'Castrum pingatur in palatio.' 2. Duccio e Simone Martini pittori di castelli senesi 'a l'esempio come erano.'" *Prospettiva* 28 (1982): 41-65.

—— H. Belting. "The 'Byzantine' Madonnas: New Facts about their Italian Origin and Some Observations on Duccio." *Studies in the History of Art* 12 (1982): 7-22.

—— J. Cannon. "Simone Martini, the Dominicans and the Early Sienese Polyptych." *Journal of the Warburg and Courtauld Institutes* 45 (1982): 79-82.

—— E. Carli. *La Maestà di Duccio*. Florence: 1982.

—— K. Christiansen. "Fourteenth-Century Italian Altarpieces." *Metropolitan Museum of Art Bulletin* 40, no. 1 (1982): 6.

—— *Il Gotico a Siena, miniature, pitture, oreficerie, oggetti d'arte*. Florence: Centro Di, 1982 [Exhibition catalogue].

—— A. Hoenigswald. "The 'Byzantine' Madonnas." *Studies in the History of Art* 12 (1982): 25-31.

—— M. Seidel. "'Castrum pingatur in Palatio.' 1: Richerche storiche e iconografiche sui dipinti nel Palazzo Pubblico di Siena." *Prospettiva* 28 (1982): 17-40.

—— J. Zink. Gottschauen. *Christusbegegungen nach Bildern des italienische Malers Duccio di Buoninsegna*. Eschbach: Verlag am Eschbach, 1982.

1983 L. Bellosi. "Anni 1280-90. La gestazione del trecento pittorico italiano." In *Europäische Kunst um 1300*. Vienna: 1983, 12-27.

—— F. Bologna. "Crowning Disc of a Duecento Crucifixion and Other Points Relevant to Duccio's Relationship to Cimabue." *The Burlington Magazine* 125 (1983): 330-39.

—— J. Gardner. "Fronts and backs: setting and structure." In *La pittura nel XIV e XV secolo. Il contributo dell'analisi tecnica alla storia dell'arte*, ed. H. W.

van Os and J. R. J. van Asperen de Boer. Bologna, 1983, 297-322.

—— H. W. van Os. "Discoveries and Rediscoveries in Early Italian Painting." *Arte Cristiana* 71 (1983) 69-80.

——[1] J. Pope-Hennessy. "Some Italian Primitives." *Apollo* 118 (1983): 10-15.

——[2] J. Pope-Hennessy. "Civitas Virginis." *Du* 5 (1983): 31.

—— J. Shearman. *The Early Italian Pictures in the Collection of Her Majesty the Queen*. Cambridge: Cambridge University Press, 1983.

—— J. Stubblebine. *Dugento Painting: An Annotated Bibliography*. Boston: G.K. Hall & Co., 1983.

—— T. J. Wollesen. "Vasari, Cimabue und Duccio. Aspekte zu Norm, Form und Funktion in der malerei des späten Dugento." *Kunstchronik* 36 (1983): 28-30.

1984 G. Barker and R. W. Walker. "Getty Fails to Acquire Duccio." *Art News* 83 (1984): 21-22.

—— L. Borgia, et al. *Le Biccherne: tavole dipinte delle magistrature senesi (secoli xiii-xviii)*. Florence: Le Monnier, 1984.

——[1] F. Deuchler. "Offene Türen: räumliche Inszenierungen in der Malerei des Mittelalters." *Daedalus* 13 (1984): 79-86.

——[2] F. Deuchler. *Duccio*. Milan: Electa, 1984.

—— T. Hoving. "The Ones that Got Away." *Connoisseur* 214 (1984): 44-51.

—— H. W. van Os. *Sienese Altarpieces, 1215-1460. Form, Content, Function*. Vol. I. Groningen: Bouma's Boekhuis BV, 1984.

—— G. Previtali. Review of *Duccio*, by Florens Deuchler (Milan: Electa, 1984). *Prospettiva* 37 (1984): 72-76.

—— A. Smart. "A Duccio discovery: An Early Madonna Prototype." *Apollo* 120 (1984): 226-37.

1985 H. Belting. "The New Role of Narrative in Public Painting of the Trecento: Historia and Allegory." *Studies in the History of Art* 16 (1985): 151-68.

—— J. Gardner. Review of *Duccio, l'opera completa*, by Florens Deuchler.

The Burlington Magazine 127 (1985): 43-44.

——— G. Schwarz Aranow. "A Documentary History of the Pavement Decoration in Siena Cathedral, 1362 through 1506." Ph.D. diss., Columbia University, 1985.

——— R. W. Sullivan. "The Anointing in Bethany and Other Affirmations of Christ's Divinity on Duccio's Back Predella." *The Art Bulletin* 67 (1985): 32-50.

——— J. White. "Archaeology, Documentation and the History of Sienese Art." *Art History* 3-4 (1985): 484-87.

1986 A. Brilli, *Viaggiatori Stranieri in Terra di Siena*. Siena: Monte di Paschi di Siena, 1986.

——— R. W. Sullivan. "Some Old Testament Themes on the Front Predella of Duccio's *Maestà*." *The Art Bulletin* 68 (1986): 597-609.

——— F. Zeri and E. F. Gardner. *Italian Paintings. A Catalogue of the Collection of the Metropolitan Museum of Art. Sienese and Central Italian Schools*. New York: The Metropolitan Museum, 1986.

1987 E. Carli. "Un nuovo Duccio." *Antichità viva* 26, no. 4 (1987): 5-9.

——— A. Brilli. *English and American Travellers in Siena*. Siena: Monte di Paschi di Siena, 1987.

——— P. Hills. *The Light of Early Italian Painting*. New Haven and London: Yale University Press, 1987.

——— I. Ragusa and R.W. Sullivan. "On Duccio's Cycle of the Infancy of Christ: The Flight and the Return." *The Art Bulletin* 69 (1987): 646-49.

1988 L. Bellosi, ed. *Simone Martini, Atti del Convegno, Siena, Marzo, 1985*. Florence: Centro Di, 1988.

——— C. Bertelli. "Gli ultimi sei giorni della Vergine Maria (Vita e Opere di Duccio di Buoninsegna)." In *Il romanzo della pittura. I. Giotto e i maestri del Trecento*, Supplement, *La Repubblica* 26 (October 1988).

——— M. Davies. *The Early Italian Schools Before 1900*, revised by D. Gordon. London: National Gallery Catalogues, 1988.

——— N. W. Desloge and L. L. Meyer. "Italian Paintings and Sculpture."

Saint Louis Art Museum Bulletin 19 (1988): 3-63.

——— E. L. Goldberg. *After Vasari. History, Art, and Patronage in Late Medici Florence*. Princeton: Princeton University Press, 1988.

——— R.W. Sullivan. "Duccio's *Raising of Lazarus* Reexamined." *The Art Bulletin* 70 (1988): 374-87.

——— W. Tronzo. "Between Icon and the Monumental Decoration of a Church: Notes on Duccio's *Maestà* and the Definition of the Altarpiece." In *Icon*, ed. G. Vikan. Baltimore: The Trust for Museum Exhibitions, 1988, 36-47.

1989 H. Belting and D. Blume, eds. *Malerei und Stadtkultur der Dantezeit. Die Argumentation der Bilder*. Munich: Hirmer, 1989.

——— D. Bomford, J. Dunkerton, D. Gordon, and A. Roy. *Art in the Making. Italian Painting before 1400*. London: The National Gallery, 1989 [Exhibition catalogue].

——— H. W. van Os, et al. *The Early Sienese Paintings in Holland*. Florence: Centro Di/Gary Schwartz SDU, 1989.

——— G. Ragionieri. *Duccio, catalogo completo dei dipinti*. Florence: Cantini, ca.1989.

——— H. Tanaka. "Oriental scripts in the paintings of Giotto's period." *Gazette des Beaux-Arts* 113 (1989): 214-26.

1990 H. Belting. *Bild und Kult. Eine Geschichte des Bildes vor dem Zeitaltar der Kunst*. Munich: C.H. Beck'sche Verlagsbuchhandlung, 1990.

——— M. Cämmerer. "La cornice della 'Madonna Rucellai.'" In *La Maestà di Duccio restaurata*. Florence: Centro Di, 1990, 47-56.

——— O. Casazza. "Analisi, diagnosi e documentazione in un sistema informativo per l'archiviazione di testi e immagini." In *La Maestà di Duccio restaurata*. Florence: Centro Di, 1990, 81-89.

——— M. D. Edwards. "A Roman Source for a Panel in Duccio's *Maestà*." *Source* 10, no. 1 (1990): 9-13.

——— "Maestà di Duccio restaurata con il contributo della Banca Toscana." *Kermes* 3, no. 8 (1990): 40-41.

—— I. Hueck. "La tavola di Duccio e la Compagnia delle Laudi di Santa Maria Novella." In *La Maestà di Duccio restaurata*. Florence: Centro Di, 1990, 33-46.

—— A. Petrioli Tofani et al., eds. *La Maestà di Duccio restaurata*. (Gli Uffizi. Studi e Richerche 6) Florence: Centro Di, 1990.

—— B. Santi. "'De pulcerima pictura . . . ad honorem beate e gloriose Virginis Marie': vicende critiche e una proposta di lettura per la Madonna Rucellai." In *La Maestà di Duccio restaurata*. Florence: Centro Di, 1990, 11-19

—— A. Del Serra. "Il restauro." In *La Maestà di Duccio restaurata*. Florence: Centro Di, 1990, 57-80.

1991 F. Benedettucci, ed. *Il Libro di Antonio Billi*. Rome: Du Rubeis Editore, 1991

—— A. Cecchi. "Il restauro della Maestà di Duccio agli Uffizi." *Kermes* 4, no. 10 (1991): 31-36.

—— C. Jannella. *Duccio di Buoninsegna*. Florence: Scala; New York: Riverside, 1991.

—— H. P. Riedl. *Das Maestà Bild in der Sieneser Malerei des Trecento: unter besonderer Berücksichtigung der Darstellung im Palazzo Communale von San Gimignano*. Tübingen: Wasmuth, 1991.

—— D. Waley. *Siena and the Sienese in the 13th Century*. Cambridge: Cambridge University Press, 1991.

1992 B. Erche. *Architeturdarstellung in der Florentiner und Sieneser Malerei des Trecento*. Frankfurt a.M.: 1992 [Dissertation, Frankfurt, 1990].

1993 *The National Gallery Complete Illustrated Catalogue*, compiled by C. Baker and T. Henry. London: National Gallery Publications, 1993.

1994 H. Belting. *Likeness and Presence. A History of the Image before the Era of Art*, trans. E. Jephcott. Chicago: University of Chicago Press, 1994 [Translation of *Bild und Kult*, 1990.].

—— [1] H. B. J. Maginnis. "Places Beyond the Seas: Trecento Images of Jerusalem." *Source* 18, no. 2 (1994): 1-8.

—— 2 H. B. J. Maginnis. "Duccio's Rucellai Madonna and the Origins of Florentine Painting." *Gazette des Beaux-Arts* 123 (1994): 147-64.

1995 S. Moscadelli, ed. *L'Archivio dell'Opera della Metropolitana di Siena*. Munich: Bruckmann, 1995.

—— 1 D. Norman. "Duccio: the recovery of a reputation." In *Siena, Florence and Padua: Art, Society and Religion 1289-1400*. London and New Haven: Yale University Press in association with the Open University, 1995, 1: 49-72.

—— 2 D. Norman. "'A noble panel': Duccio's Maestà." In *Siena, Florence and Padua: Art, Society and Religion 1280-1400*. London and New Haven: Yale University Press in association with the Open University, 1995, 2: 55-82.

—— 3 D. Norman. "The three cities compared: patrons, politics and art." In *Siena, Florence and Padua: Art, Society and Religion 1280-1400*. London and New Haven: Yale University Press in association with the Open University, 1995, 1: 7-28.

—— 1 D. Norman, ed. *Siena, Florence and Padua: Art, Society and Religion 1280-1400*. Vol. 1, *Interpretative Essays*, New Haven and London: Yale University Press in association with the Open University, 1995.

—— 2 D. Norman, ed. *Siena, Florence and Padua: Art, Society and Religion 1280-1400*. Vol. 2, *Case Studies*, New Haven and London: Yale University Press in association with the Open University, 1995.

—— "The Crucifixion by Duccio." *Art Review* 47 (1995): 46-47.

—— P. L. Rubin. *Giorgio Vasari. Art and History*. London and New Haven: Yale University Press, 1995.

1996 D. Gordon. "Duccio (di Buoninsegna)." In *The Dictionary of Art*, vol. 9. London: Macmillan, 1996, 9: 341-50.

—— D. Popp. *Duccio und die Antike, Studien zur Antikenvorstellung und zur Antikenrezeption in der Sieneser Malerei am Anfang des 14 Jahrhunderts*. Munich: Scaneg, 1996.

1997 H. B. J. Maginnis. *Painting in the Age of Giotto, A Historical Reevaluation*. University Park: The Pennsylvania State University Press, 1997.

1998 L. Bellosi. *Cimabue*. Milan: Federico Motta, 1998.

—— L. Ghiberti. *I commentarii*, ed. L. Bartoli. Florence: Giunti, 1998.

—— Mojmir S. Frinta. *Punched Decoration on Late Medieval and Miniature Painting. Part I. Catalogue Raisonné of All Punch Shapes*. Prague: Maxdorf, 1998.

1999 E. Bénézit. *Dictionnaire critique et documentaire des Peintres, Sculpteurs, Dessinateurs et Graveurs*. Vol. 4. Paris: Gründ, 1999.

—— E. Carli. *Duccio*. Milan: Electa, 1999.

2001 H. B. J. Maginnis. *The World of the Early Sienese Painter*. University Park: The Pennsylvania State University Press, 2001.

Appendix I

Historiography Concerning the Siena Cathedral Oculus

In the past, this window from the apse wall of Siena cathedral was attributed to Jacomo (or Jacopo) di Castello on the basis of a 1369 document published by Milanesi (1854, 1: 311) that reads:

> A maestro Jachomo di Castello cinquanta e due fior: d'oro e trenta e quat-tro soldi per una finestra di vetro dietro all'altare maggiore. Fu misurata XVII e mezzo braccia per iii fior: d'oro al bracio. Vagliano a danari CLXXXVIII lib. e X soldi

De Nicola (1911, 36) noted that the document cannot relate to the oculus because it is so Ducciesque in character and the measurements given in the document do not correspond to the size of the window. He therefore attributed the oculus to an unknown follower of Duccio working ca. 1320, because by that time, the apse wall of Siena cathedral had been constructed.

Lusini (1912, 80-98), however, offered documentary evidence that the apse wall was begun only in 1325 and argued that it was impossible to date the window earlier. He therefore dated it to after 1360. On the basis of payments made during 1365 to Andrea di Mino and others for work on the cathedral's window(s), he attributed the oculus to Andrea, working in 1364/65. Lusini explained the payment to Jacomo di Castello by saying that he had been hired merely to restore the window.

In 1946, Enzo Carli examined the problem of the attribution for the window and indicated that Duccio designed it. He suggested that the 1369 payment to Jacomo was actually for a lancet or double lancet window below the oculus, a window later walled up. Taking note of a document of March 1365, in which a certain Bindo del Maestro Pavolo was paid for a pound and four ounces of "filo di ferro per la rota del vetro," and of two other notices of April and May 1364, Carli argued that it was then that the window of 1287/88, mentioned in the documents here, was installed in the new apse wall.

White (1979, 137-40), in his Duccio monograph, rejected the idea of a Sienese artist as author of the oculus and, instead, attributed it to Cimabue. He argued that the window was commissioned only two years and five months after Duccio's commission for the Rucellai *Madonna* and that Duccio could not have executed such diverse works separated by so short a time.

Van Os did not find White's stylistic arguments convincing and returned to the Duccio attribution, noting iconographical connections between the window and Duccio's *Maestà*.

Stubblebine (1979, 1:13-14) disputed Carli's attribution to Duccio and returned to the argument that made Jacomo di Castello its author. He suggested that Jacomo had borrowed certain iconographical features from Duccio's *Maestà*, without clearly understanding them.

J.I.S.

———•———

The debate over the Siena oculus must strike readers less familiar with the state of research on early Sienese art as puzzling in the extreme. Even setting aside the matter of authorship, they will surely be surprised that datings have ranged from 1287/88 to 1369. It is difficult to think of any other major work that could be dated so variously. In large part, the problem lies in the fact that we have no comparable major object from Siena in the later years of the dugento or early years of the trecento. For some time now (1999), the window has been removed from its place in the cathedral for restoration. Thus, it has been available for much closer examination than was heretofore possible.

The documentation published here (I.60-63) is not without problems. The first notice (I.60), of September 1287, indicates that the commune, through the treasurer and four *provveditori* of the Biccherna, is to pay for the project, but it contains the highly unusual stipulation of a fine of 10 lire for each of those officials should they fail to provide the necessary funds. One may speculate on what provoked that condition, but nothing I know offers a definitive solution. This notice occurs among communal statutes of 1287 and is repeated in statutes of 1288 (I.61). Such repetition of specific legislation in later redactions is quite common and thus does not necessarily mean that the Biccherna was in violation of the 1287 ordinance.

In June of 1288, the *operaio* of the cathedral was given 100 lire toward the cost of the window, "which is to be made above the altar of Saint Mary," and in December of the same year, he received a further 25 lire for the window "being made." Most scholars automatically assume that these payments relate to the surviving window, but the documents do not record the name of an artist, nor do they say that the window is to be of stained glass. Although I have read all the surviving Entrata e Uscita volumes for 1289, I have not discovered any further relevant documentation. We also lack other documents concerning stained glass and its cost from the same period. We do know that the *operaio* of the commune received, on 29 January 1339, 100 lire for a glass window (certainly not stained-glass) in the Palazzo Pubblico. On 31 December 1357, the Biccherna paid 380 lire, 8 soldi, and 4 denari for three glass windows in the Sala del Consiglio of the Palazzo Pubblico, and on 29 June 1359, the treasury paid 341 lire, 13 soldi, and 4 denari again, rather strangely, for three windows in the Sala del Consiglio. These sums might seem to

suggest that the 125 lire spent on the oculus in 1288 was inadequate for the window that survives, but the chronological gap between 1288 and the mid-trecento makes comparison unhelpful.

Stubblebine's late dating for the oculus must be rejected. Among the images of Siena's four patron saints in the central register of the window, we find San Bartolomeo, Sant'Ansano, San Savino, and San Crescenzio. By the early trecento, certainly by the time of Duccio's cathedral *Maestà*, San Bartolomeo had been replaced by San Vittorio in the city's affections. Far more important, the style and compositions of the oculus are firmly situated ca. 1300 or, as I maintain, slightly earlier. Similarly, I am unpersuaded by White's attribution of the window to Cimabue. The stylistic elements he finds indicative of Cimabue's involvement seem to me quite possible for the artistic genius of the Rucellai *Madonna*. Although it is anything but hard evidence, I would note that if the oculus were by Cimabue, it would be the only major work in Siena by a non-Sienese artist in the century between 1262 and 1362.

There are features of the window similar to the Rucellai *Madonna*, especially the drapery of the Virgin and the patterned background in the *Assumption*. Although the repetition of colors in the paired angels, kitty-cornered from each other, is bolder and perhaps less subtle, it, too, calls the Florentine *Madonna* to mind. We are at first startled by the way elements in every compartment fall before the framing borders. (The Rucellai *Madonna* is, by contrast, so startling for its keeping every element behind the picture plane.) But it carries the connotation that everything emerges miraculously from the cerulean heaven to enter our earth-bound experience and, though different, seems possible for the painter of the Laudesi picture, in which Mary's throne settles into the world of men.

Yet, there remains a problem regarding chronology. The marble throne of the *Coronation* resembles that in Duccio's *Maestà* for Siena cathedral, and, indeed, the angels that lean over the throne's back clearly remind us of the arrangement on the face of the altarpiece. While the work of Duccio's followers indicates that marble thrones had appeared in his images before the *Maestà*, it does seem surprising that such a throne appears in a work made in 1288, perhaps even before the Rucellai *Madonna* was finished. Perhaps the documents do not refer to the surviving window, but to an earlier project? Perhaps Duccio's commission came later? There is no necessity to link the surviving documents with the surviving oculus.

H.B.J.M.

APPENDIX II

THE RUCELLAI *Madonna*

If, today, we rightly recognize the Rucellai *Madonna* as one of the greatest works by Duccio and as the most important Sienese work of the thirteenth century, that recognition is entirely modern. The literature preserves no early discussions of the work, but by the early sixteenth century the *Madonna* was held to be a panel by Cimabue, even though the contract for it existed in the archives of Santa Maria Novella. It is as Cimabue's creation that it appears in the *Libro di Antonio Billi*, in the 1510 *Memoriale* of Francesco Albertini, and in *Il Codice Magliabechiana*. That attribution was repeated in both editions of Vasari's Lives and unsurprisingly echoed by Baldinucci in his *Notizie de' Professori del Disegno*.

For centuries, Vasari's authority meant that the Cimabue attribution passed without question, but toward the end of the eighteenth century, two scholars raised doubts concerning the panel's authorship. In his *Lettere Sanesi*, Della Valle suggested that the Rucellai *Madonna* was the work of "another brush, much superior to that of Cimabue," but did not associate the panel with Duccio. Then, in 1790, Vincenzo Fineschi published his history of distinguished men associated with Florence's church of Santa Maria Novella. Fineschi had, in his research, found the contract for the Rucellai *Madonna* but did not associate it with the work given by tradition to Cimabue.

Fineschi's discovery and publication of the text had a very minor impact on scholarship immediately following. Perhaps the most important exception comes from the work of J. R. Füessli, a Swiss scholar who, knowing Fineschi's publication, spoke in 1806 of the discovered contract. It would be many decades before the scholarly community associated that contract with the Rucellai *Madonna*. Even Gaetano Milanesi, when he published the contract in 1854, did not associate the document with the picture. In fact, it was only after the chronological limits of this study, in 1889, that Franz Wickoff made a closely argued attribution of the panel to Duccio. Even subsequent to that argument, many scholars tried to find a compromising solution to save, at least in part, Vasari's attribution. Berenson, for one, created a mythical "Master of the Rucellai *Madonna*," an artist stylistically between Cimabue and Duccio. It was only in the second half of the twentieth century that the Duccio attribution became, with few exceptions, accepted by the scholarly community at large.

In the Introduction to this volume, I have pointed out the very serious consequences that this mis-attribution had for the study of Duccio and, in consequence, for our understanding of the history of early Sienese art. Without the *Madonna*, there is no work by Duccio securely dated prior to the Siena cathedral *Maestà*,

installed on the high altar in 1311. Although various documents survive that demonstrate Duccio's career began by 1278, no extant work can be associated with them. In short, scholars were without knowledge of Duccio's early style.

Although the acceptance of Duccio's authorship for the *Madonna* had a great impact on the history of early Italian painting, the full genius of the work remained hidden until very recently. As we now know, the robes of the Virgin were overpainted in the early nineteenth century, presumably with the aim of "refreshing" color dimmed by centuries of dust and candlesmoke. Only in 1988 and 1989 was the nineteenth-century overpaint removed to reveal not merely a perfectly preserved tempera surface, but also a mantle for the Virgin carefully modeled to respond to the figure and to the complex movements of drapery hems.

The general literature on early Italian painting, the first stage of the Renaissance, still has to take full note of the profound revision of history that the recovery of Duccio's image necessitates. Many authors still cling to Vasari's vision, substituting Cimabue's Santa Trinita *Madonna* for the Rucellai *Madonna*, the latter panel Vasari regarded as the foundation work of the Renaissance. The combination of secure date and recovered image, however, will lead to significant reevaluations in our larger views on thirteenth- and fourteenth-century painting in Tuscany.

H.B.J.M.